DIGITAL ART MASTERS

: VOLUME 6

DIGITAL ART MASTERS

: VOLUME 6

3dtotal
PUBLISHING

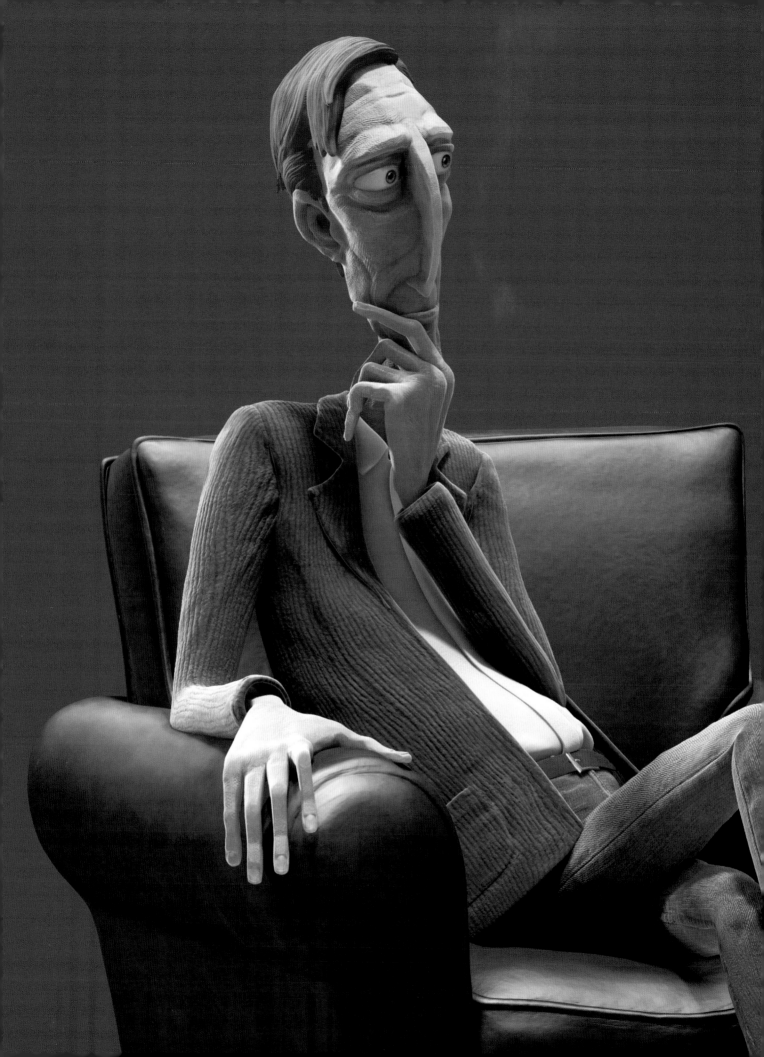

3DTOTAL PUBLISHING

Correspondence: publishing@3dtotal.com

Website: www.3dtotal.com

First published in the United Kingdom, 2011, by 3DTotal Publishing

Softcover ISBN: 978-0-9551530-4-4

Printing & Binding
Everbest Printing (China)
www.everbest.com

Visit www.3dtotal.com for a complete list of available book titles.

"AND HOW DOES THAT MAKE YOU FEEL, HMM?". DR THINOSE CHARACTER © YIANNIS TYROPOLIS

CONTENTS

 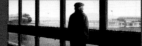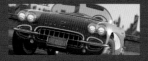 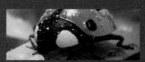 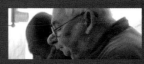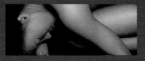 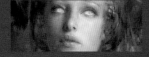 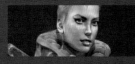

CONTENTS

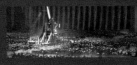 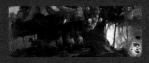
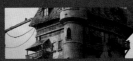 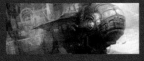
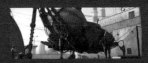 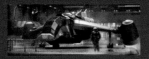
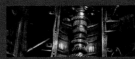 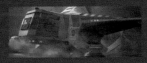

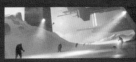

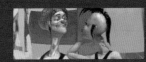 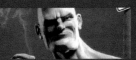

DIGITAL ART MASTERS

: VOLUME 6

COMPILED BY THE 3DTOTAL TEAM

TOM GREENWAY SIMON MORSE JO HARGREAVES CHRIS PERRINS RICHARD TILBURY

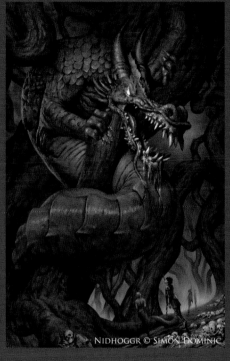

NIDHOGGR © SIMON DOMINIC

INTRODUCTION

Since joining 3DTotal in January 2010 I have had the privilege of working on a variety of fantastic projects, but right from the beginning of my time here it was clear that the *Digital Art Masters* series was the jewel in 3DTotal's crown. However, the more I explored the world of digital art, the more it became apparent that *Digital Art Masters* is not just the jewel in our crown, but a priceless gem in the CG community too. What you hold in your hands represents not only the expert handiwork of a team of graphic designers, editors and printers, but also the blood, sweat and tears of fifty of the most talented artists in the world today.

Despite all the beautiful images gracing these pages, to call *Digital Art Masters: Volume 6* a simple gallery book would be selling it short. As each new volume of the series is released we get another opportunity to track the developments and advances made in what is an ever-growing and developing industry. Each book is unique and showcases fresh artwork driven by exciting new influences, which has been created through the use of cutting-edge techniques and software.

But it's not just the techniques and methods that are new: we also welcome a whole new host of talented international artists to *Digital Art Masters: Volume 6*. Some are seasoned industry professionals, who hold top positions at some of the biggest movie and games studios in the world, while others are up-and-comers who are well on their way to CG fame and glory – we hope this book helps them on their journey in some small way!

The process to create this jaw-dropping sixth volume began back in September 2010, with a simple advert on the 3DTotal site asking for submissions. Within days my email inbox was crashing with the volume of fantastic images that were arriving. That was when I knew that this book was going to be great. Really, how could it not be with that much talent out there?

Somehow we had to whittle the thousands of submissions down to a mere fifty. This was so much harder than it sounds! We could have made *Digital Art Masters: Volume 6* five times over with images that weren't used. Eventually, with help from Simon Dominic Brewer and Nykolai Aleksander (who provided home-made cookies), we managed to settle on the final fifty.

We owe a great debt to those fifty artists, who have not only shared their amazing images with us, but have also provided a unique insight into their inspiring workflows. We take our hat off to you for your time and effort, and for being Digital Art Masters!

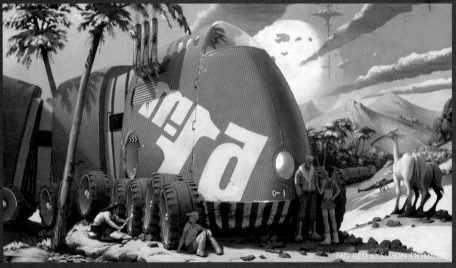

BIG RED © SIMON DOMINIC

SIMON MORSE
Content Manager – 3DTotal

Every effort has been made to locate copyright holders of materials included in this book in order to obtain their permission to publish them.

If you need to contact us, please email: publishing@3dtotal.com

FOREWORD

Mention the word "artist" to someone and their first thought might be of a solitary figure in a dusty attic, grinding together pigment and binder, or wrestling with an obelisk of clay. Perhaps they'll even imagine a wild-eyed recluse clad in a smock, stained with splashes of Absinthe, or a gentleman in a straw hat, standing shin-deep in buttercups and angling his paintbrush against the horizon. Whatever the stereotype, I'd guess few people would picture a relatively normal-looking individual sitting in an office chair with a tablet on their lap and a monitor on the desk in front of them. Prefacing the word "artist" with the word "digital" won't necessarily help either, and you could find yourself fending off a well-meant, "Oh, you mean Photoshopping? My grandson does that; he's an expert." There might also be talk of filters and lens flares, like they're the modern equivalent of smoke and mirrors in a magic act, and if you're particularly lucky you'll get to hear my favorite: "Digital is cheating, you know. The computer does it for you." Right now, with three deadlines looming, I wish it did.

> ## IT'S THE ARTIST WHO, THROUGH YEARS OF DEDICATION TO THEIR CRAFT, HOLDS THE MAGIC

If it wasn't for the digital medium I wouldn't be an artist right now, and definitely not a working artist. I sort of drifted into the creative arena pretty late in life with no particular aim or ambition. Having recently split from my girlfriend I was eager for a cheaper and more entertaining pastime, and perhaps more importantly, something I could switch off when I'd had enough. One day I happened to find myself on a software website and without any plan or expectation I bought a basic 3D graphics package for about £50. From the moment I started using it I was hooked and not long after I shifted into the realm of digital painting, using a Wacom and a copy of Painter. One thing became apparent early on: being digital is most certainly not an easy option.

THE DRAGON KYTES OF BARON V © SIMON DOMINIC

There was no secret button labeled "create painting" by which I could circumvent all the hard work and study of the fundamentals. I quickly discovered 101 nifty features I could use to create any manner of effect, but none were able to magically improve my skills. To improve the only solution was to practice, practice and practice. So that's what I did, and that's what I'm still doing.

In this book, the sixth volume in a very successful and informative series, a whole bunch of the world's finest digital artists share with us their artwork and their creation processes. Judging the hundreds of submissions was really tough at times and it was humbling to witness the quality of artwork that littered 3DTotal's office tables and floor. At the time of writing, despite not having seen the actual workshops that accompany the artwork, I can confidently predict that everyone will be unique in terms of tools, method, style and output. There are as many ways of digitally working as there are artists. Whilst each workshop and artwork in this book is a clear testament to the skill inherent in the creation process, and the ability of the artist to expertly

manipulate these digital tools, there's more to it than that. Scratch the surface of any one and you'll reveal the years of hard work that has gone into preparing the creative groundwork. Rumor has it that Picasso, on being asked to produce a sketch, did so and requested £10,000 to hand it over. When the requester asked why so much for a five minute sketch, Picasso replied, "Madam, that sketch took me 30 years." Now whilst the story is probably a myth (a friend of the family actually did meet Picasso who produced a sketch for her and handed it over without undue demands for payment) the principle behind it is still sound. It's the artist who, through years of dedication to their craft, holds the magic. All the digital tools in the world, be they 3D- or 2D-based, are just a means to an end. So the next time someone tells you digital art is easy, or the computer does it for you, pass them your copy of *Digital Art Masters: Volume 6*. Or better still, tell them to go and buy it.

SIMON DOMINIC

Freelance Illustrator and Concept Artist
si@painterly.co.uk
http://www.painterly.co.uk

Scenes

A scene is like a character. It has its own personality and makes us feel emotions. I think that the setting is as important as the people and figures that are acting in it. Depending on the image composition, palette and mood, the tension and story will be differently interpreted.

In video games, immersion is extremely important, and a big challenge for level artists and art directors. Strong and immersive settings play a big role in successful video games. Regarding feature films, you have to also believe in the setting because this is how you will be moved into the atmosphere and story of the film. Even though environment art is sometimes called invisible art in the entertainment industry, I really think that it has a more important role to play these days when we need a break from our daily routine.

Raphael Lacoste

raphael.lacoste@gmail.com

http://www.raphael-lacoste.com

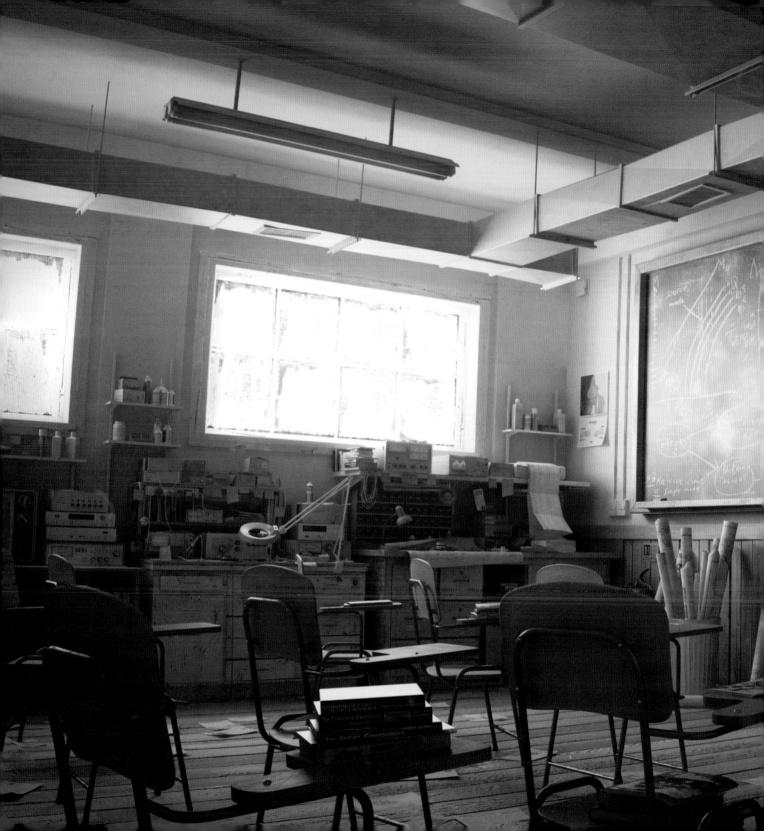

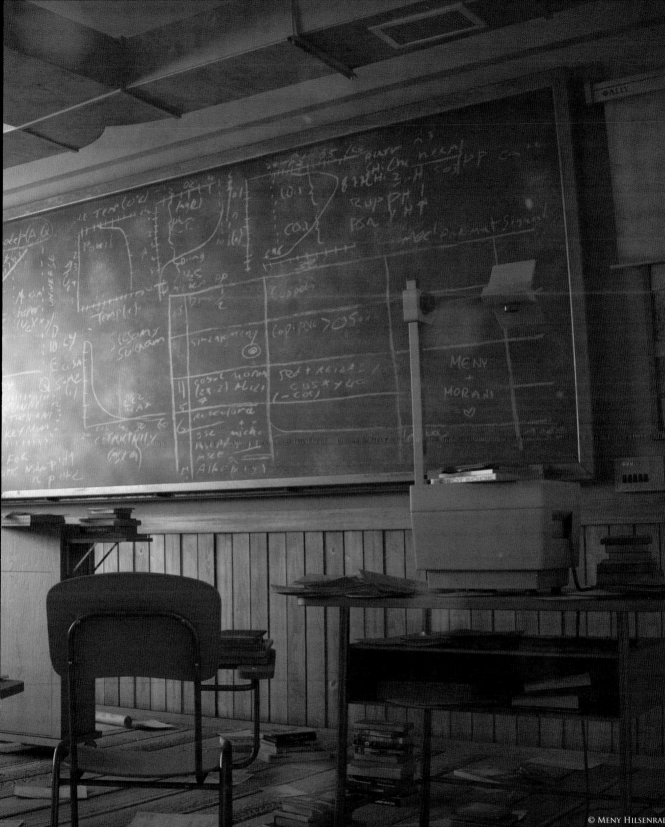

CLASSROOM
BY MENY HILSENRAD – STUDIO AIKO

JOB TITLE: Creative Director, 3D Artist and Co-founder of Studio Aiko
SOFTWARE USED: 3ds Max, V-Ray, Photoshop and After Effects

INTRODUCTION

During this project, I focused my attention on certain aspects more than others. In order of priority these were: the modeling, textures and shaders, followed by the four different light setups and finally the post-production. Throughout this article I will explain and demonstrate my workflow, which may help you to better understand the creative process behind the scene.

> ❝ THE BIGGEST CHALLENGE CONCERNING THE MODELING PROCESS WAS CREATING AND DEALING WITH THE AMOUNT OF DETAIL APPARENT WITHIN THE SCENE ❞

An important issue that needs to be mentioned before proceeding is that a lot of research is necessary before beginning anything in 3D. Almost every object was created after long hours of observing photos I found on the web or took myself. This research continued throughout the entire process and I believe it couldn't have been done otherwise.

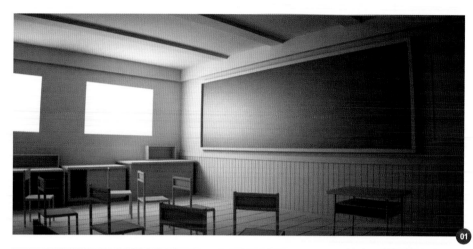

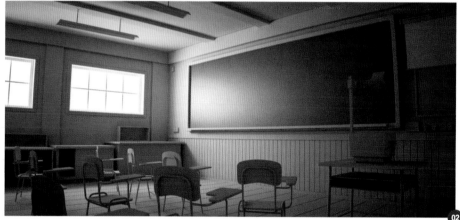

MODELING

The biggest challenge concerning the modeling process was creating and dealing with the amount of detail apparent within the scene. My goal was to create an impressive amount of detail, which would help create the realism I was aiming for. The first step was to create the basic composition while focusing on only one camera position that encompassed the entire classroom. I created basic blocks representing the main objects, which I would later add more detail to (walls, chairs, desks, blackboards etc.,) and arranged them in space while adjusting the camera angle (**Fig.01**).

After I had a better understanding of the scene, I then started getting deeper and deeper into the detail on the chairs, desks, floor, and projector – essentially the objects that had the most presence in the composition (**Fig.02**).

The further I progressed with the modeling, the more I got into the details such as the books and pages etc. I was careful to maintain the original camera position and avoided testing

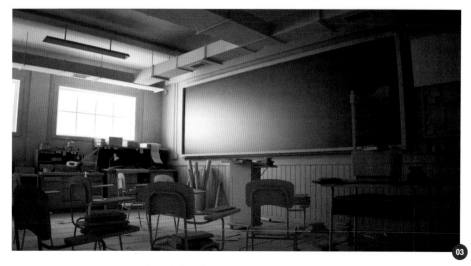

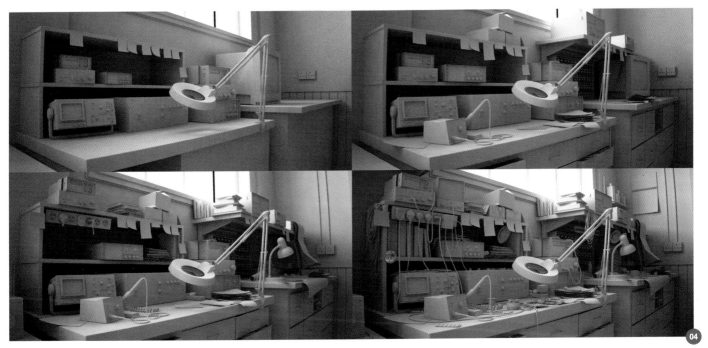

other viewpoints as I wanted to avoid being distracted from the original idea behind the project (**Fig.03**).

Whilst nearing the end of the general compositional work, I started to focus on the desk area where I wanted to place a lot of emphasis. The modeling method was similar to the previous approach; I started with the most significant objects in the composition (the nearest electronic devices, magnifying glass, drawers etc.,) and then moved to the surrounding areas. Slowly I increased detail by first refining the electronic devices and then eventually moved onto the surrounding area (electronic wires, circuits parts, screwdrivers, paper/books etc.,) and all the small pieces that merged everything together. This process took a lot of time and was quite frustrating initially, but it became worthwhile as I started to see some results (**Fig.04**).

TEXTURING AND SHADERS

After completing the modeling phase (more or less), I moved onto the textures and shaders. All in all this phase was very long and difficult, but the research helped a lot. As before, I started on the objects that commanded the most presence, such as the walls, floor, and blackboard. Then I moved to the smaller but no less crucial objects, such as the chairs, desks and projector. Many of the textures have been created from scratch in Photoshop, but I also

used photos I found on the web (mostly for the books and magazine covers, papers, and sticker). They were modified in Photoshop to add dirt and blended with other layers.

The next stage was to texture the electronic devices and objects on the desk. There weren't any shortcuts here and the task was extensive, incorporating numerous reference photos of old electronic appliances, which were then used to create the textures from scratch.

The scene was rendered using the V-Ray engine and V-Ray's shaders. Because of the complexity of the scene and amount of detail, my first thought was to keep the shaders as simple as possible otherwise the test renders could be endless. Besides areas here and there I mainly used the basic shader parameters, experimenting with the

Fresnel reflections and the amount of reflection glossing along with a little displacement. I let the textures do the work and only on specific objects, like the blackboard, chairs, and desks, did I use more complex shaders incorporating Specular and Glossiness maps etc.

LIGHTING

Initially whilst planning this scene, I didn't conceive the four different light setups I eventually developed, but as the scene progressed I saw the potential and wanted to take advantage of it. I started with the originally intended lighting setup, which was the "daylight" version. I used two V-Ray lights and placed them in the window openings. I used this method instead of sunlight because I wanted to get a soft kind of look devoid of any harsh contrast (**Fig.05**).

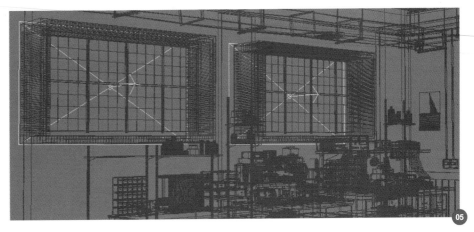

The second light setup was the "sunny day", set around morning and early noon. For this I used a V-Ray sun and adjusted it in conjunction with the V-Ray physical camera parameters until I got it right. If you compare this setup to the previous one the difference is obvious, however both occur during the daytime. In this mood the contrast is higher with a more pronounced range between the lights and darks and the sun's rays now suggest a sunny day (**Fig.06**).

The third lighting setup was the "night-time" version. I wanted to try a different approach and show the room in a completely different mood: a dark room lit mostly by artificial lights together with a subtle bluish light emanating from the exterior. Once again, V-Ray lights were placed in the windows and their job was to bring a subtle bluish light into the room, imitating the nocturnal light. Now that the scene was illuminated purely from the weak bluish light, it was a good time to position the artificial lights: the fluorescent light, desk lamp and the appliance lights, which create a yellowish contrast to the blue (**Fig.07**).

The fourth and final light setup represents the "camera flash". The idea for this came up whilst I was doing some render tests for the "night-time" setup. The trick was to use only one Omni light that aligned to each camera and was slightly offset on the top. This was done to imitate the way camera flash works. An important task lay in adjusting the attenuation of each Omni in order to illuminate the scene more in the foreground and make it diminish gradually towards the background. This required lots of render tests before it looked satisfactory (**Fig.08**).

POST-PRODUCTION

The post-production in this project was very important and is what gave the final images that all important touch (**Fig.09**). It was done

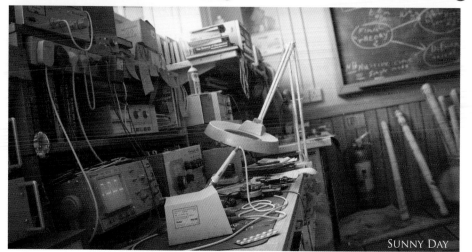

SUNNY DAY

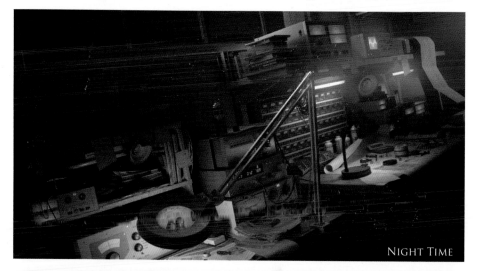

NIGHT TIME

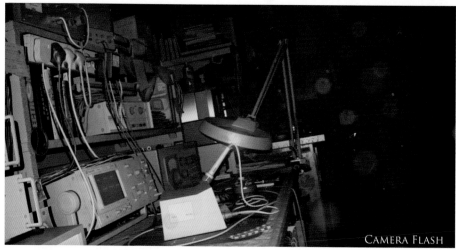

CAMERA FLASH

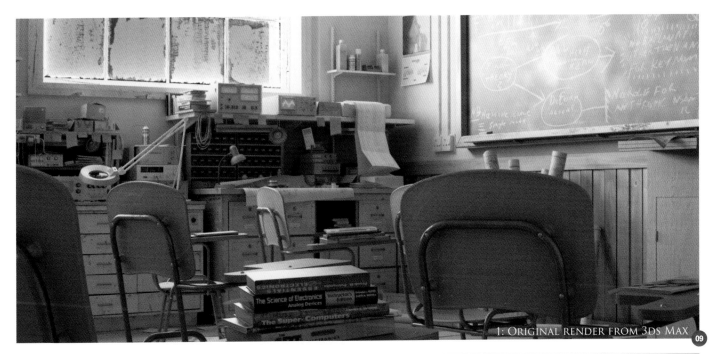

1: ORIGINAL RENDER FROM 3DS MAX

with After Effects because I find it easier to use, not only when working with stills but also for animation sequences. The reason for this is the control it affords, such as turning effects on and off when working with filters and being able to adjust them for each new render without repeating them each time.

I started on the camera's Depth of Field, which was done by utilizing a Z-Depth pass rendered in 3ds Max (**Fig.10**). Faking the depth of field and not rendering it in Max not only helped me to tremendously decrease the render time, but it also allowed me to control and adjust the

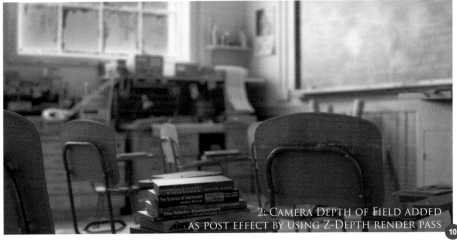

2: CAMERA DEPTH OF FIELD ADDED AS POST EFFECT BY USING Z-DEPTH RENDER PASS

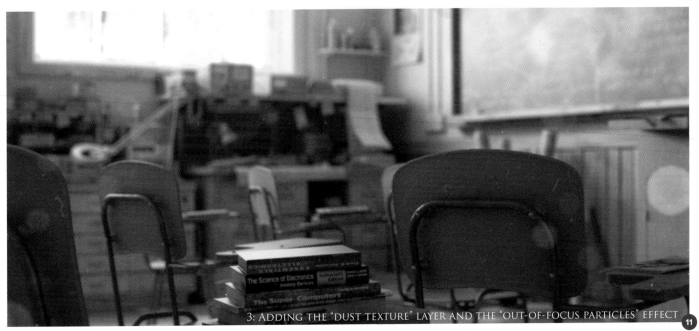

3: ADDING THE "DUST TEXTURE" LAYER AND THE "OUT-OF-FOCUS PARTICLES" EFFECT

amount of focus in real-time. This proved to be a huge advantage and looking at the final result it is almost impossible to see the difference.

The out-of-focus dust particles were created as a post effect as well (**Fig.11**). I used a particle system of simple spheres that filled the entire 3D scene, which were then rendered before applying the Out of Focus filter in After Effects to achieve the effect of dust particles being out of focus because of the close proximity to the camera. I also added a dust and noise texture and composited it on top of everything to blend with the blurred dust particles.

For the final touch I applied some color corrections (**Fig.12**). I adjusted the Levels to achieve a good contrast and also used Color Balance. I then added some colored layers to wash the entire frame and to blend everything together (**Fig.13**).

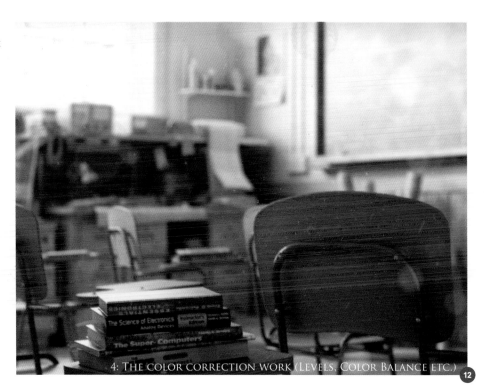

4: THE COLOR CORRECTION WORK (LEVELS, COLOR BALANCE ETC.)

12

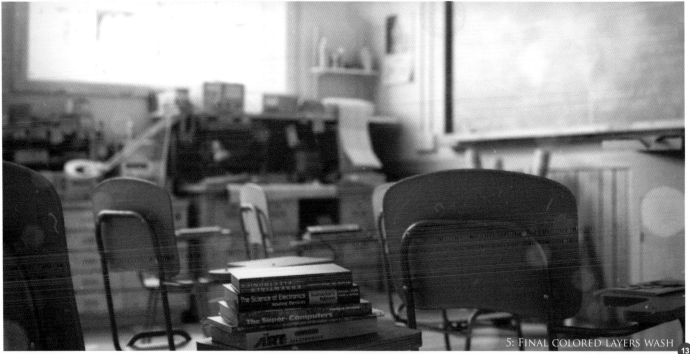

5: FINAL COLORED LAYERS WASH

13

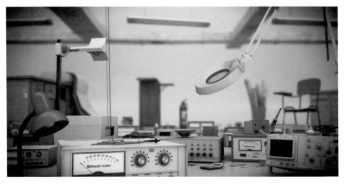

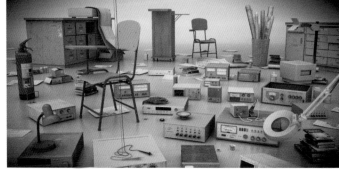

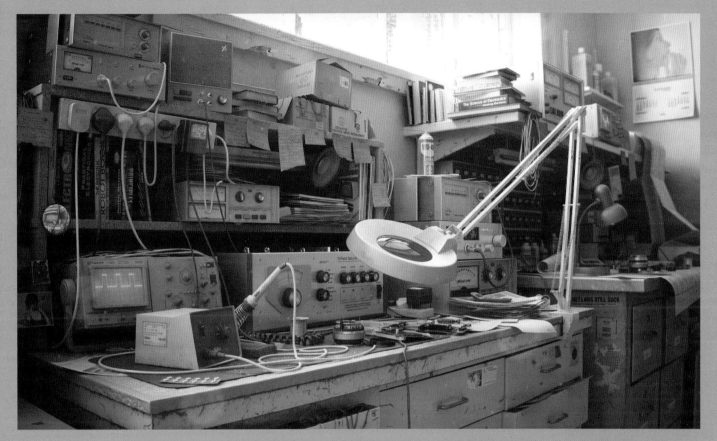

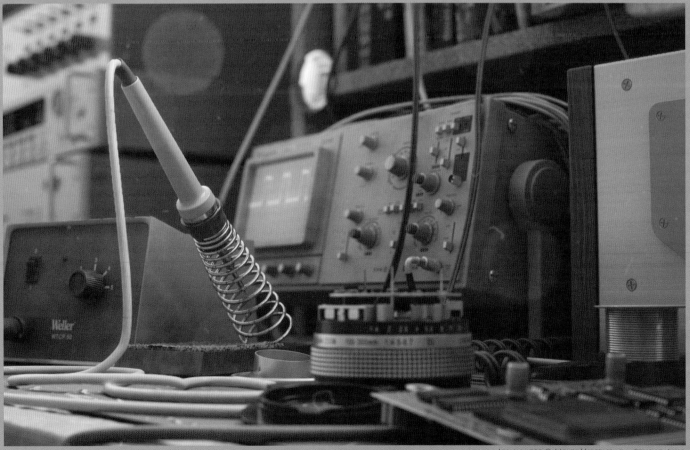

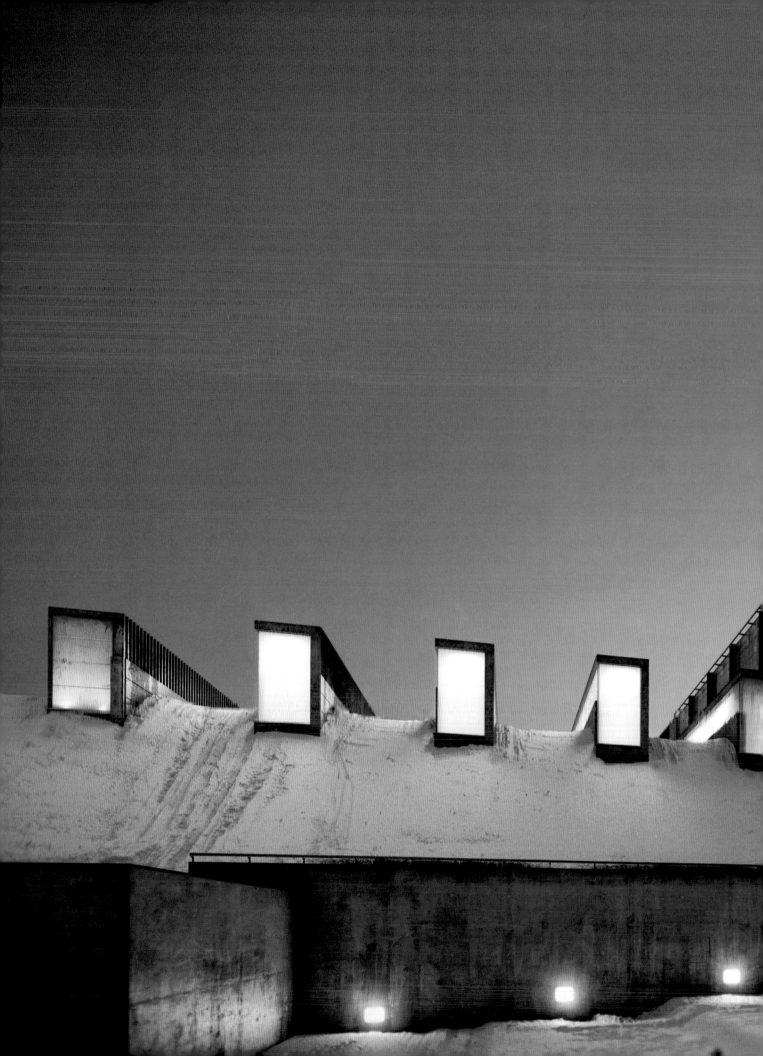

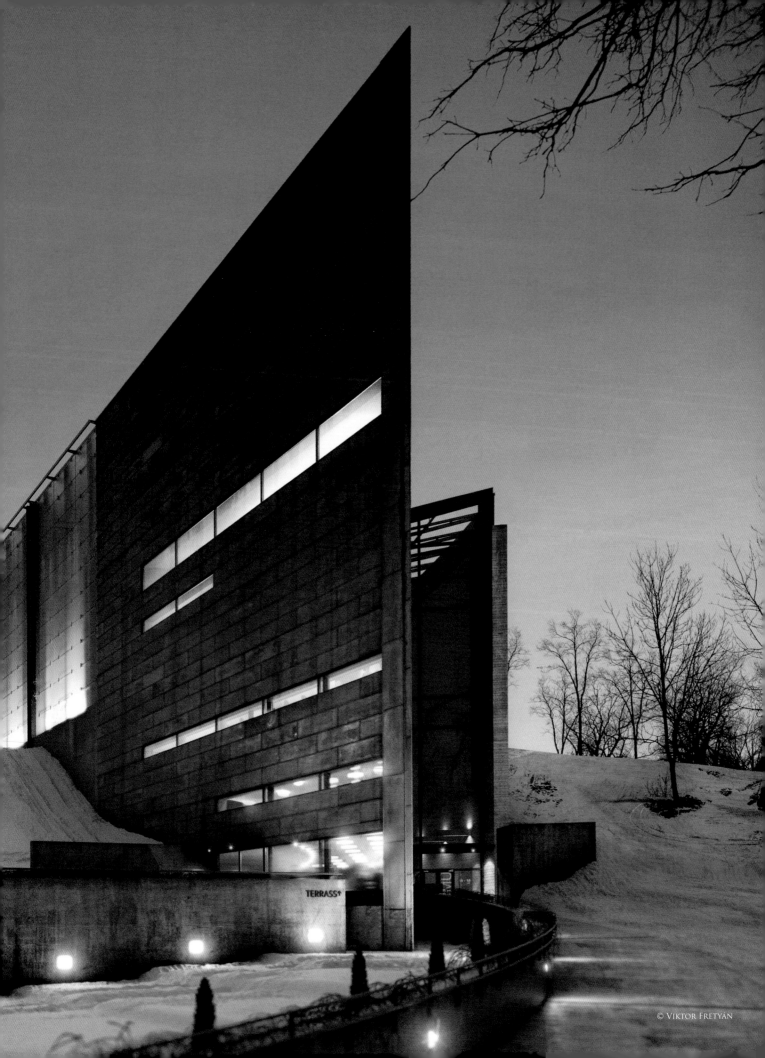

© VIKTOR FRETYÁN

Kumu, Art Museum of Estonia
By Viktor Fretyán

JOB TITLE: Architect

SOFTWARE USED: 3ds Max, V-Ray and Photoshop

INTRODUCTION

First of all I would like to thank you all for reading this tutorial. I really hope it proves helpful to everyone who is interested in this particular project. The selected render is the sixth image in a series of ten relating to this particular building. I had the chance to see this building personally a few years ago and after doing so decided to base some renders on it as it was one of the most inspiring examples of architecture I have come across.

I started by downloading all the photos I could find on the web in order to begin modeling. In the end I managed to gather about 150 photos, out of which only a few were truly useful.

> ❝ THE MOST IMPORTANT THING TO MENTION HERE IS THAT I PAID HUGE ATTENTION TO THE DETAILS IN THE MODEL ❞

MODELING

A big help was that during my research on the internet I found a digital model of the building. I contacted the owner and they shared all their resources with me. Even though I eventually had to remodel each and every element I still owe Ankit Surti and Samuel Gwynn my gratitude. Their model was mandatory!

I didn't want to model the environment since there are a vast number of renders out there on the subject and I've already done my share of that in a previous project. In fact, I wanted to avoid that as much as I could. All the trees in the background and foreground are 2D elements and put in place courtesy of Photoshop. Using elements like this was kind of new for me since I am used to rendering everything in a scene.

01a / 01b

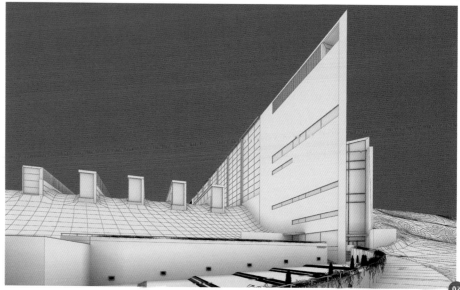

02

DIFFUSE / REFLECT / DISPLACEMENT

03

The most important thing to mention here is that I paid huge attention to the details in the model (**Fig.01a – b**). I tried to model every little element of the structures, even those in the background. Basically everything was modeled using standard primitives and splines. The tools I used were Edit Mesh, Lathe, Sweep, FFD box and Symmetry (**Fig.02**)

TEXTURING

There are two very dominant materials in the scene; one being the metal cladding on the wall and the other is the snow. Most of the problems I experienced concerned the metal material since it featured on such huge surfaces with some camera shots being very close in certain instances. I therefore needed

DIRT IN
DIFFUSE
AND NOISE
IN BUMP

huge bitmaps of around 10 x 10 meters, the
equivalent to 10,000 x 10,000 pixels. Here are
some of the map details (**Fig.03 – 05**).

The snow is partly modeled and partly uses
displacement. I formed the planes to follow
the slopes using primitive tools such as FFD
box. I used Edit Mesh smooth selection to lift
the terrain a bit closer to the walls and show
the snow sloping upward slightly (**Fig.06a –
b**). I always apply a Noise and Turbosmooth
modifier, or employ Tessellate, to make the
ground both uneven and smooth.

The tracks and marks in the snow were done
using a simple Displacement modifier. I took
a snapshot from the top view and then drew
a map in Photoshop from images I found on
the net. Pretty simple again, but it worked just
fine (**Fig.07**). It uses a translucent, hard, waxy
refractive material with a bluish back color.

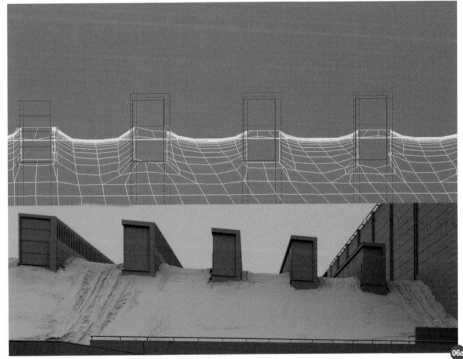

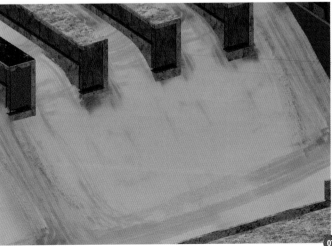

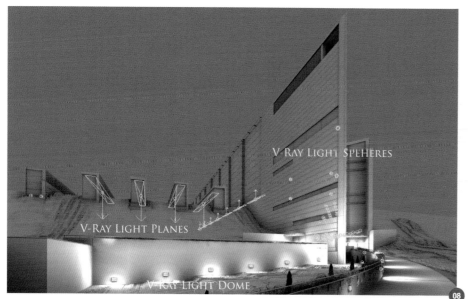

V-Ray Light Spheres

V-Ray Light Planes

V-Ray Light Dome

> ## THE ROLE OF
> ## PHOTOSHOP IS AT
> ## LEAST AS IMPORTANT
> ## AS THE ACTUAL
> ## RENDERING

LIGHTNING AND RENDERING

I used a quite basic setup, which comprised
of a V-Ray Dome light combined with a HDRI
in the texture slot. The interior was lit using a
bunch of small V-Ray Sphere lights and the
small lights along the steps and walls took
advantage of V-Ray light planes (**Fig.08 – 10**).

POST-PRODUCTION

I have a lot to say about this in particular
because the role of Photoshop is at least as
important as the actual rendering. I will try to
walk you through this process step-by-step and
hopefully you will understand why. Here is the
original render exported from Max (**Fig.11**).
This was saved out as a tga file and loaded
into Photoshop. First of all, I put a background
behind the render – which is easier said than
done. I spent about an hour just altering the
blue hue to match the scene (**Fig.12**).

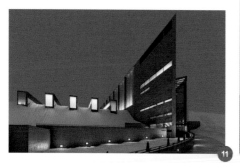

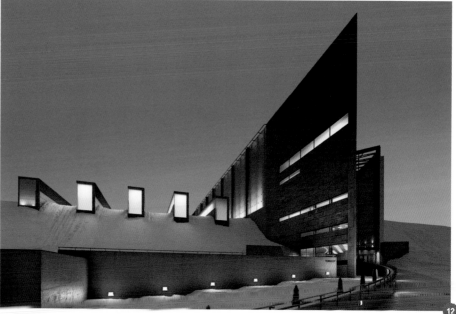

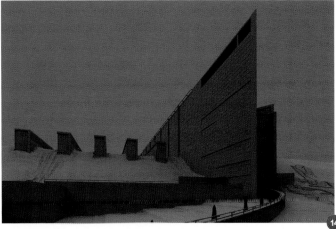

The next step is one of the most important ones and concerns the dirt on the walls. It's actually a surprisingly easy trick. Just copy and paste a dirty wall bitmap into the psd file and skew it to fit the relevant part of the image. Then set the blending mode to Overlay, adjust the opacity and use the Eraser tool to blend it in. Here is a snapshot of the dirt layer seen in Normal blending mode in order to show you how it looks (**Fig.13**).

> ## SOME ELEMENTS OF ACTIVITY WERE ADDED TO THE INTERIOR, ALONGSIDE TREES AND OTHER DETAILS IN THE BACKGROUND

Next is the Ambient Occlusion pass (**Fig.14**). At a first glance it didn't seem to make much of a difference, but it actually brought out a lot of the details – especially on the snow (**Fig.15**).

Following on from this I included some images to enhance the scene somewhat.

Some elements of activity were added to the interior, alongside trees and other details in the background (**Fig.16**).

Now comes something really interesting: the color balancing. This was achieved by using both the Color Balance tool and Exposure. As

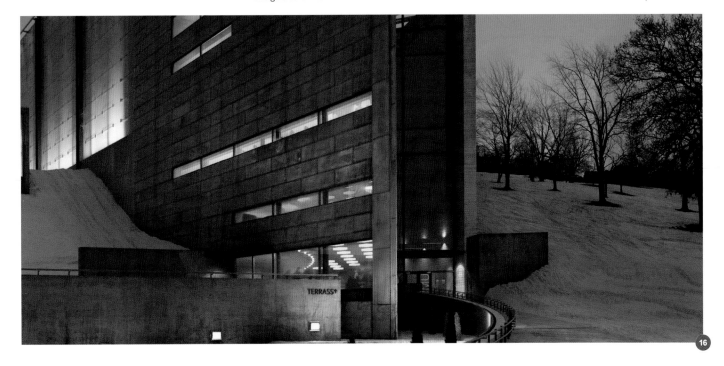

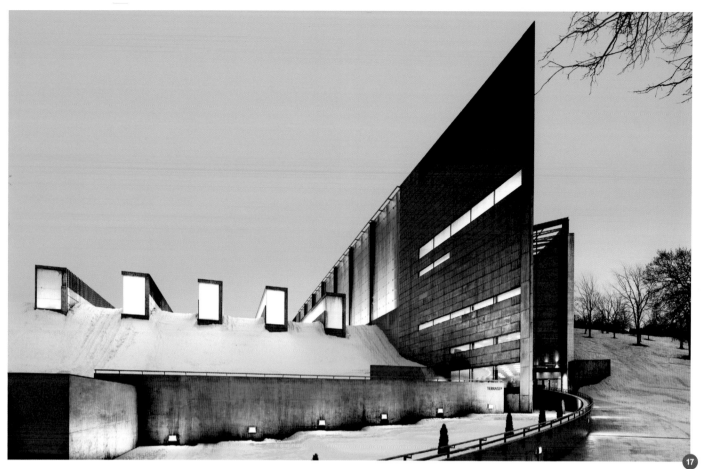

17

you can see it was done in three stages on three separate layers. The first one employs some over-exposure using a cool tone (**Fig.17**). The next represents a darker version utilizing warmer tones (**Fig.18**) and the final one is a balance (**Fig.19**).

18

19

The balanced layer obviously stays at full opacity in the background, followed by the warm version and the concluding cold layer on top. When I start the blending I usually set both the cool and warm layers to fifty percent and then repeatedly raise or lower the opacity of each layer until everything is satisfactory. This is not a fast process but it is important to allow it some time and avoid rushing (**Fig.20**).

This concludes the "manual labor" of the post-production and all that remains are the effects relating to different plugins: Lens Flare (Knoll Light Factory), Depth of Field (Alienskin), Chromatic Aberration (55mm Film Tool), Tonal Contrast (NIK color effects), Vignetting (55mm Film Tool) and Film Effect (NIK color effects). Each of these small effects combined create the final version!

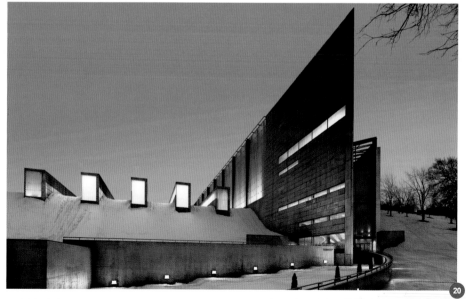

20

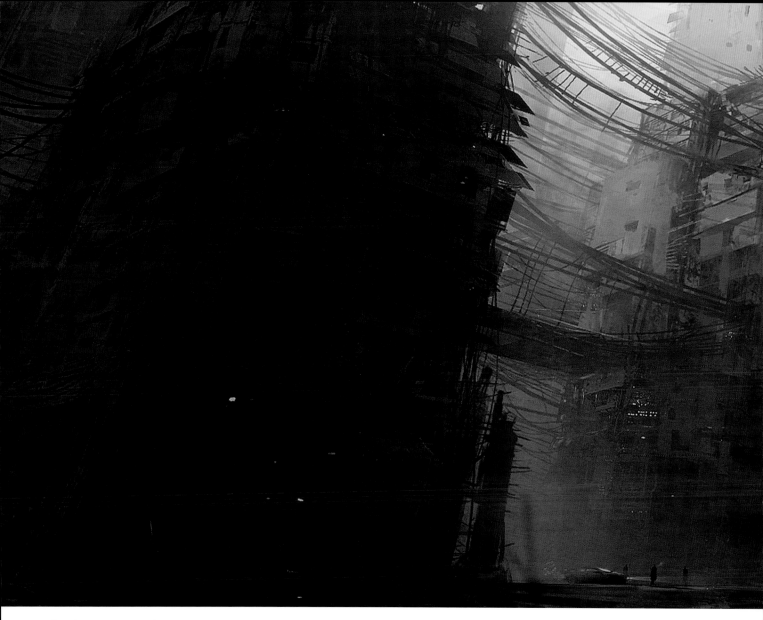

THE EXCHANGE
BY EDUARDO PEÑA A.K.A CHINO-RINO

JOB TITLE: Concept Artist
SOFTWARE USED: Photoshop CS4

Before introducing you to a technical account of this piece, I first want to share with you the story behind the image. As opposed to thinking in terms of a visual language, I prefer to explore the narrative content of an image in order to develop exciting and visually interesting pieces.

It all started whilst I was exploring some interesting places to use as references in my environments. During this period I wanted a Cyberpunk aesthetic mixed with a chaotic

futurism. I remembered that I've always visually loved the legendary Kowloon district in Hong Kong. In some ways I fell in love with everything there, artistically speaking. As such I

wanted to create a context more or less similar to the old Kowloon, establishing and adding elements according to the story and context I had in mind.

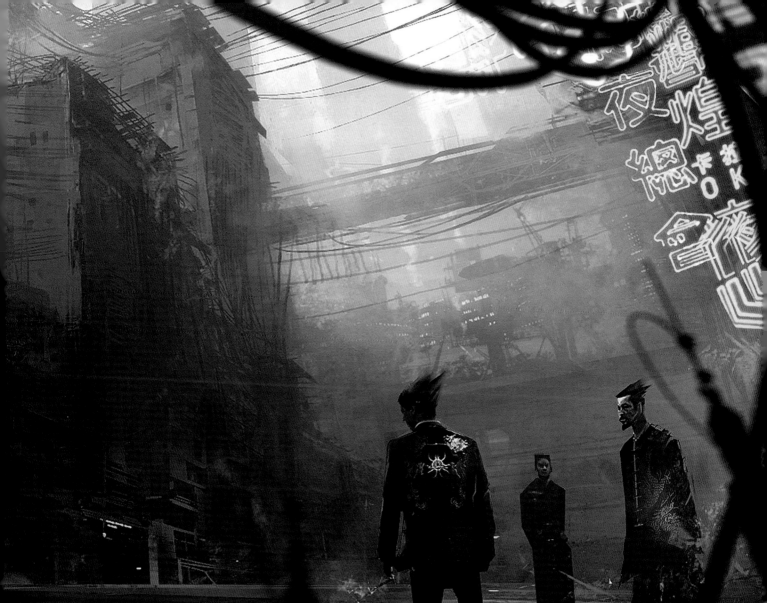

In the majority of my work, including this example, I like to use the lowest number of layers as possible, with a maximum of three, This allows me to leave aside my insecurities and forces me to address any errors and better understand what I'm looking for in the image. The workflow in this piece is really simple. I started with some speed painting techniques, using a lot of strokes, shapes and brush testing. Starting in grayscale with a black

> **I STARTED COMBINING THE VIRTUAL CHAOS WITH SOME VISUAL STRATEGIES, SUCH AS ADDING VANISHING POINTS THAT CREATE THE SENSATION OF A THREE DIMENSIONAL SPACE**

and white canvas helps organize the visual elements better and establishes a good sense of composition and saturation (**Fig.01 – 02**). From then on you can work with the correct palette and don't have any color issues further down the line.

I started combining the virtual chaos with some visual strategies, such as adding vanishing points that create the sensation of a three dimensional space. Meanwhile I continued adding brush strokes until I saw some structure within the piece (**Fig.03**).

Little by little I defined the sense of space, suggesting objects and structures in different sectors to help describe the context of our story. I even began building the main focal point of this story, which forms the title of the piece *The Exchange* (**Fig.04**). It alludes to some illegal business between the Triads in this forgotten neighborhood.

At this point I conceived the notion of incorporating some abandoned architecture, from somewhere in Hong Kong. In some ways this abandoned place echoed part of the social emptiness of the time.

I worked in black and white when organizing the composition, but when I was happy I felt the almost biological need to add color, even though it may not have been the ideal time. In order to start adding some visual flavor I began searching for some visual references (e.g., Hong Kong markets, alleys, pathways and neon) for an understanding of the aesthetic that matched the story.

Using my mood board of references, I started adding some color to the piece. I applied a layer of color with the blending mode set to Color, introducing a layer of texture from a prior experiment. In this way I was able to

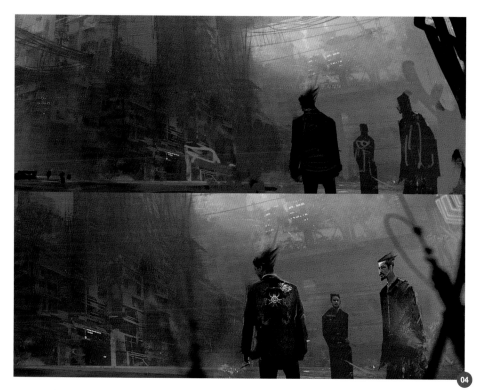

accommodate some textures and interesting forms that went towards helping the visual wealth of my image. As another option you can also use Overlay and Softlight depending on how you experiment with the tools. These methods also prove to be a good resource, able to help in creating new concepts that at times can be difficult to make tangible (**Fig.05**).

It is always necessary to try different approaches and develop new methods of working. Obviously this is nothing new, but how you go about implementing and taking advantage of this is personal. I continue doing this for some time until I say, "Hey, that's enough". There is always a limit, but how do we know when to stop? As usual I believe the

best judge remains our eye, which is the one gauge that knows when to stop or when to continue (**Fig.06**).

I continued working with my chromatic palette, using cool and warm colors, whilst at the same time continuing to build all kinds of elements. These included the buildings and also our charismatic characters. Little by little I tried to give a more defined form to the whole piece, trying to make it bigger and more impressive, as well as creating a sense of harmony. I like this idea of contrast, since I did not want to show the aggressive conditions associated with this environment, but rather try to suggest them and allow the viewer to feel part of this world. My goal was to transport the viewer to this peculiar and chaotic space. I like to explore these techniques, and use it as an excuse to create these kinds of stories.

I hope you like it.

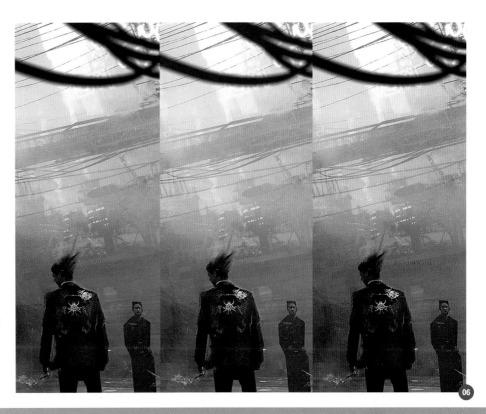

ARTIST PORTFOLIO

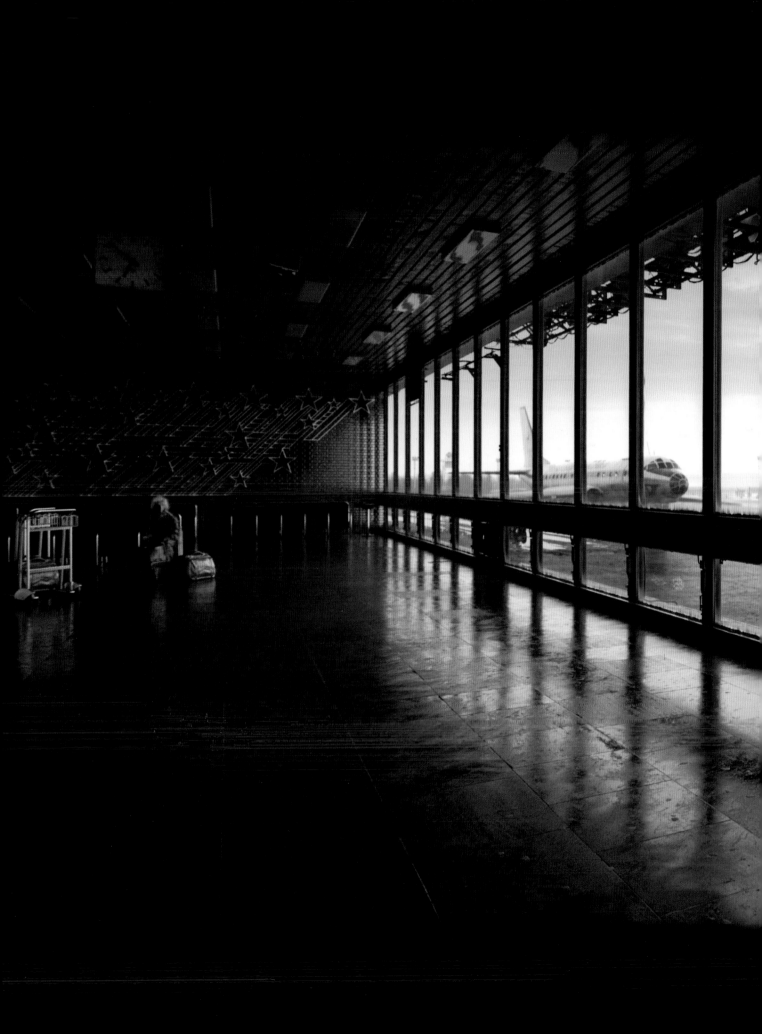

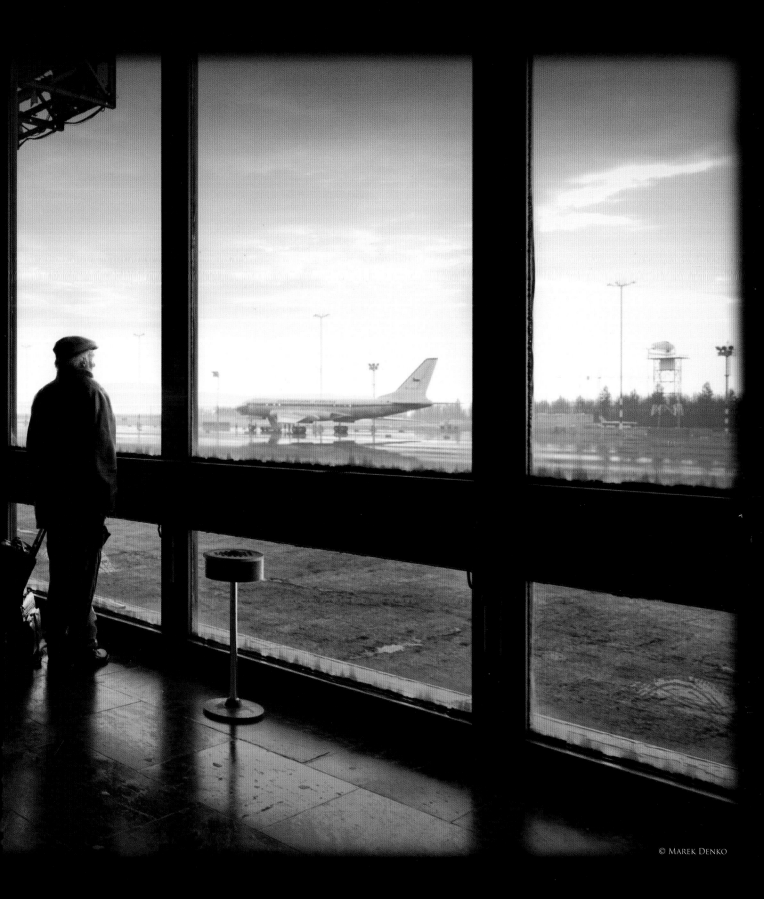

EVERYTHING BEAUTIFUL IS FAR AWAY
BY MAREK DENKO

JOB TITLE: CEO – Neomotion s.r.o

SOFTWARE USED: 3ds Max 2009, V-Ray and Photoshop

INTRODUCTION

Everything Beautiful is Far Away is partly based on my photography from 2005. I took pictures in the waiting area of the central bus station in Bratislava when I was waiting with my girlfriend for a bus to take us "far away". In the following article I'll describe how I made it and show you readers some tricks I'm using in my everyday personal and professional workflow.

CONCEPT AND REFERENCES

In terms of the message this image should deliver, here is what I wrote about it on my website: "It's about being far away from family, friends and from everything you love and care about. Just an anonymous cold waiting area containing airport gates with strangers all around. I know airports are quite modern and fancy these days… but I think it's even more impersonal with all those duty-free shops, fake Irish pubs and pizza restaurants. So take a minute and enjoy it."

> ## IT'S HARD TO ADMIT, BUT THE PLANE WAS THE MOST COMPLICATED MODEL IN THE SCENE.

I began with the modeling and then developed the image itself. I decided to make it an airport or train station. In the end an airport seemed more magical, with a nice view that hinted at anonymous and distant destinations. I also

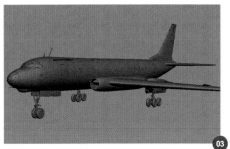

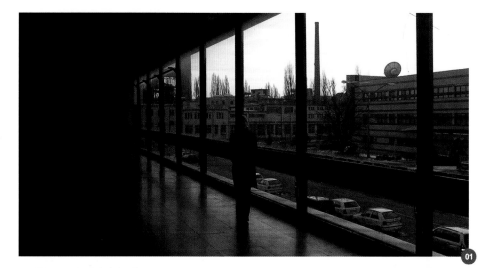

used lot of different pictures as references for several elements in the scene. Other inspiration came just from observing things around me.

This is the fifth article I have written for the *Digital Art Masters* series, so I'll definitely be repeating myself for a fifth time when I say that I always find references an essential part of my work. So I advise that you just look around and observe things, feel things and construct them as you see them. There isn't too much to mess up if you follow what you see in the real world (**Fig.01 – 02**).

MODELING

Almost all the modeling work was done in 3ds Max 2009, with a little help from the Polyboost plugin for modeling the aeroplane. I used ZBrush to model the character details and for the bag and luggage props. The modeling workflow is simple if you know what

you need to model, so good references are, again, important. If you are simply doodling the creative process can become more complicated. I've always had to exaggerate the modeling in ZBrush in order for it to look correct in my lighting setup after rendering.

I spent most of the time on those parts of the characters that were going to be visible in the render, since I was almost sure where they would be. My usual workflow is to start from a simple shape or object, then convert it to an Editable Poly and use the common features such as Extrude, Bevel, Connect, Weld etc. The most modifiers I tend to use most frequently are Turbosmooth, Displace, Noise and Symmetry. In the following paragraphs I'll describe some of those techniques I used on several of the scene models.

It's hard to admit, but the plane was the most complicated model in the scene. I had to use a

04

05

lot of Booleans to cut out the cabin windows in the front of the plane. Try to Google this plane and have a go yourself. I really can recommend it as a training exercise in modeling and I am still left wondering what techniques were used by the original designers. It was quite a day when I first tried doing it by way of standard topology and subdivisions without Boolean operations (**Fig.03**).

Modeling the luggage was a little more fun than working on the plane. I started with a base mesh and moved to ZBrush for the high res sculpting. I then went back to 3ds Max to add details like the zip and metal accessories. Again a little exaggeration was required on the model to achieve the desired look when rendered (**Fig.04**).

I'm not that much of a character modeler and rarely create them, but in this case it was necessary. I used an old mesh for the head and then proceeded to model the base mesh for the clothes. Following a couple of sessions working between 3ds Max and ZBrush, the job was done (**Fig.05**).

The floor is the area that I spent the most time on. It doesn't look like a complicated model, but there are some extra features I'd like to describe. Every tile is a separate object and each has a little bit of variation in rotation and position (only about 2%). Between the tiles there are very subtle, tiny cylinders to simulate the dirty edges and every tile has several UV coordinate channels. Using these channels I was able to add a lot of variation to the Diffuse

values, and especially the Reflection and Reflection Glossiness. The final stage involved adding hundreds of old chewing gum spots across the floor, which although disgusting are nevertheless a reality. The gum pieces were placed using the Advanced Painter script (**Fig.06**).

This was one of the background objects so there was no need for any real detail. It was composed using a combination of splines and the Sweep modifier. The radar dish is made from a base model and the Lattice modifier, which for non-3ds Max users means that the edges are converted to splines (**Fig.07**).

This was pretty straightforward and done using the standard polygonal modeling tools (**Fig.08**).

06

07

08

I used Onyxtree to create the trees. After importing obj files into 3ds Max I scattered tons of small objects (little noised planes) across the branches. I had originally planned to have some trees closer to the foreground otherwise detail like this wouldn't be necessary (**Fig.09**).

TEXTURING AND SHADING

There wasn't too much texture work in this project. There were a couple of textures used for the floor, but I had to mix a ton of marble textures from internet libraries such as CG Textures.com (**Fig.10 – 11**). Since I used V-Ray for this image, I used VRayMtl as a base shader for all the geometry. I used Raytraced reflections for almost every single material in the scene. To simulate the dirt on the windows I used a combination of V-Ray Dirt maps and custom made bitmap textures.

LIGHTING AND RENDERING

For rendering I used V-Ray by Chaosgroup. Basically, there are two lights in the scene. One is a directional light (Key light) simulating the sun using a yellowish color and really soft shadows to mimic the sunset behind the clouds. The second light (Fill light) is a Skydome using a V-Ray Sky map. I also used Global Illumination bounces to produce a more realistic result. The image was rendered at around 5000 pixels wide to an OpenEXR file format. The scene was really intensive and I had to use Dynamic BSP (Binary Space Partitioning) in V-Ray in order to render the whole image. As a rough guide the trick with Dynamic BSP is that it is taking all instanced objects to memory only once, and for the remaining instances it is only taking transformation information, which does not really consume much memory (**Fig.12**).

POST-PRODUCTION

I rendered out the beauty pass and one extra reflection pass, which was added on top of the render during post-production. The fog was rendered directly along with the rest of the image. The reason for this is that it's easier to incorporate fog directly compared to creating

masks for dirty windows and compositing everything and therefore you can save time creating custom materials for masks and rendering them repeatedly. For the post-production I usually use Adobe Photoshop or Eyeon Fusion, but on this occasion I used both. I did some color correction in Photoshop and then moved to Fusion to add some extra effects like Chromatic Aberration and so on. Everything was done in 16-bit/channel color depth to protect the color information as much as possible. I also did some overpainting in Photoshop across the hair of the characters and the sky and there are a lot of custom masks to aid the color correction.

CONCLUSION

So that's it. It was not really that difficult to make this scene and perhaps the hardest part was to find the will and time to finish it. I believe that if you have read all of this then you understand some of my techniques and how I work. I'm not saying that my way is the right way and, indeed, the only way. This was just a fun project done in my free time, which diminishes year by year. I dedicate this to my family who support me a lot.

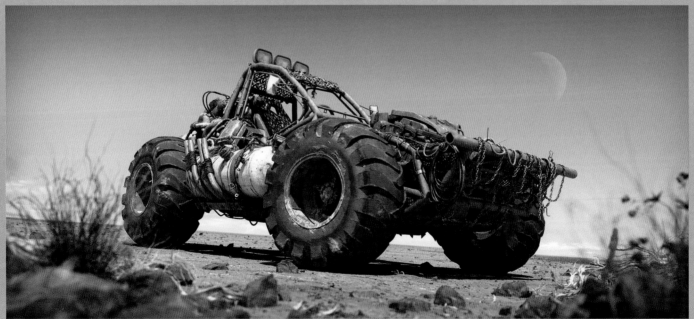

All Images © Marek Denko

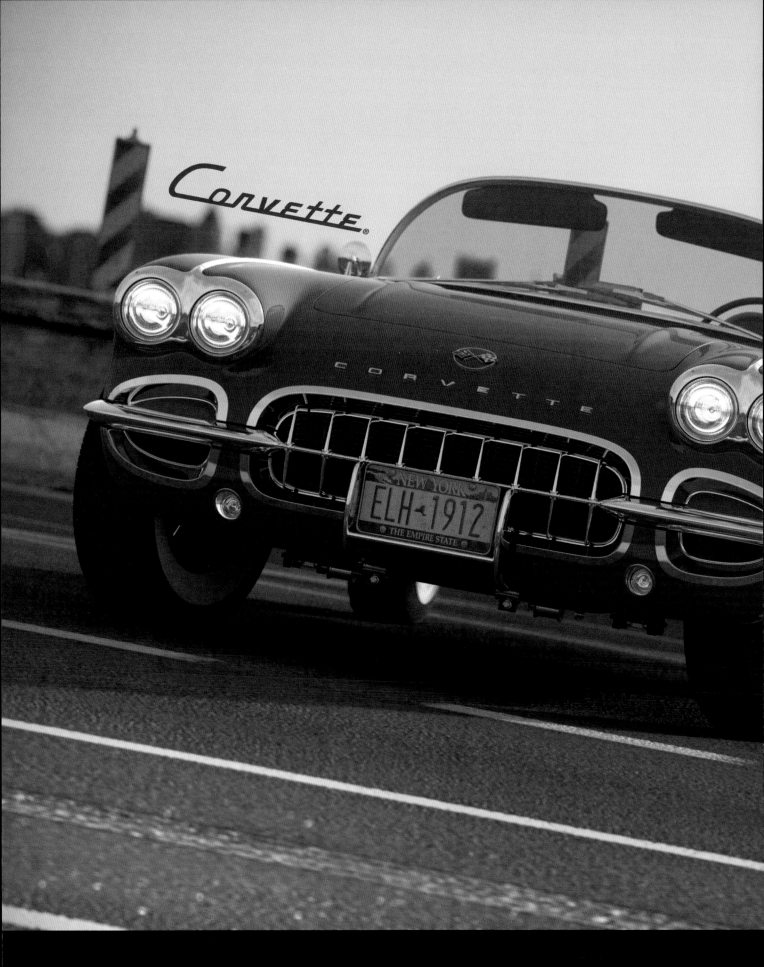

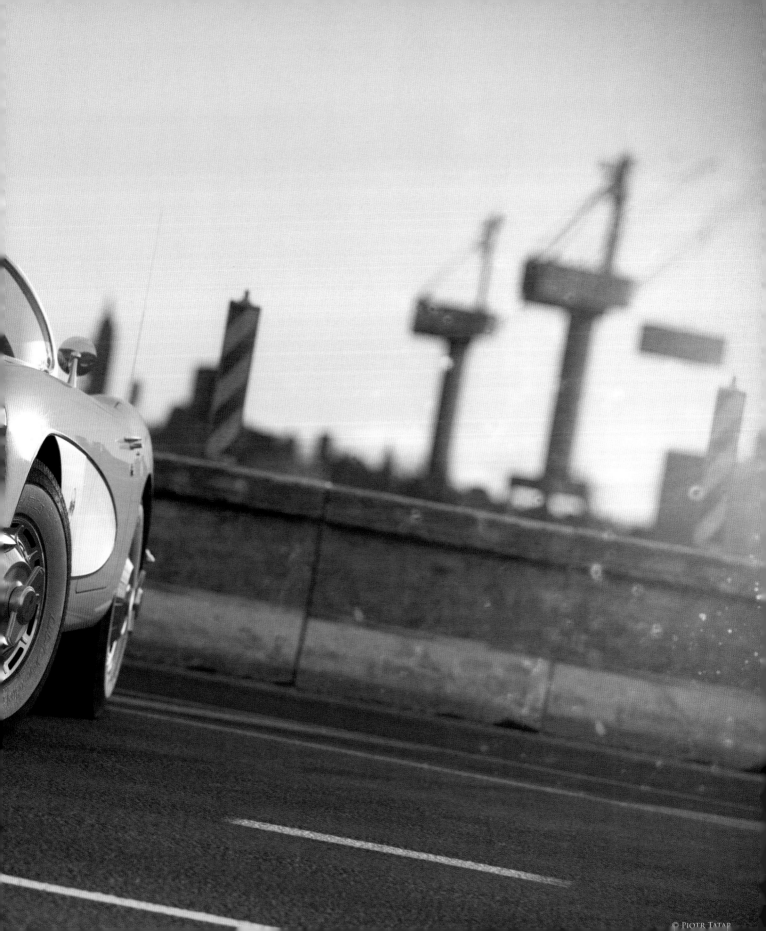

CORVETTE C1
BY PIOTR TATAR

JOB TITLE: 3D Artist
SOFTWARE USED: 3ds Max, V-Ray, After Effects and Photoshop

INTRODUCTION

The idea for this C1 Corvette evolved during the formation of another, more important, project for me – namely an animation using the same scene. The animation focused on a duel between two more recent vehicles (Ford Mustang GT and Ford GT) on the tarmac at New York's JFK airport. It was essentially an educational exercise, as well as a way of exploring new ideas in the field of graphics and animation. Whilst working on the animation I had the opportunity to prepare a detailed model of the Corvette C1, which would have disappeared somewhere in the depths of my hard drive had I no desire to test the animation. The test renders proved so rewarding that I decided to focus more on this beautiful classic car as opposed to the animation itself. The result is a collection of several images, which serve only to confirm the fact that it was worth deviating from the animation.

MODELING

The modeling alone didn't cause any major problems. It is always very important to be well prepared before you start, requiring suitable blueprints and a few hundred megabytes of photos before proceeding. It pays to group your photos and compose similar shots into one image. When using blueprints in the composition I like to create an additional setup with the same images in order to accurately align (match) them with blueprints. Apart from the obvious differences, it is often better to refer to the photographs and, in some cases, even make a compromise.

The body of the car almost begged for a "general to specific" approach. The first phase involved modeling the shape of the overall car and ignoring the details (**Fig.01**). At this point I considered the mesh topology and took into account the cuts that would be added at a later stage.

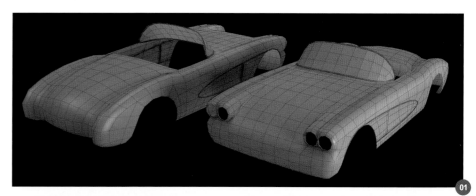

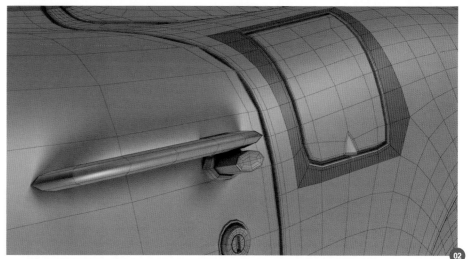

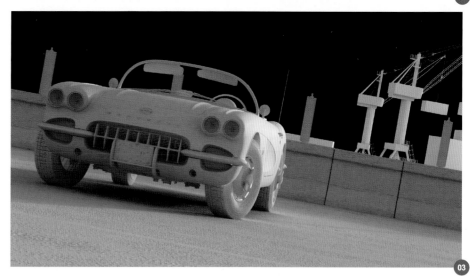

The next phase involved inflating the density of the base mesh by converting the model into an Editable Poly and combining this with the Meshsmooth modifier. When the detail is sorted, you can re-condense the grid, but

it may have a high density and an excessive number of polygons in the final version. However if you care about the smoothness of the model and a faithful reproduction, such steps might be advisable. It is worth

remembering to model and organize the detail similarly to the actual object in question, thus creating a better end result (**Fig.02**). Here is the entire scene without any materials (**Fig.03**).

TEXTURING AND MATERIALS

Although the main focus in the scene is the Corvette, an important role is also played by the environment which required a few more substantial textures. Help at this stage came via **www.cgtextures.com**, which offers a huge number of high quality textures. Among other things I found the textures relating to asphalt, concrete blocks and hangars; however, in order to use them in the scene they had to be modified. For example, when creating the asphalt texture I used three different pictures and combined them in Photoshop using the Stamp tool. The results provided a seamless texture that could be used along the entire length of the road (**Fig.04**). I followed a similar approach in the case of the tires, which comprised of two pictures.

© CGTEXTURES.COM

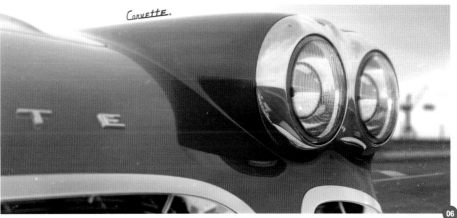

To achieve some nicely detailed close-ups with small imperfections, I commonly use the Displacement modifier. This can be quite demanding on the computer, but produces a good end result which compensates for the loss of time. Displacement proves very useful for objects such as asphalt, tires and cement blocks etc. All of these elements had a texture

so it was easy to generate a Displacement map. More work was required to produce maps for the headlights (**Fig.05**), which have been restored with great attention to detail as the plan was to render some close-ups (**Fig.06**).

As for the shaders in the scene, it turned out that the coating material was to be the most

important. Usually I use a base coat that I later modify to satisfy the project requirements, which is exactly what I did in this case. The paint shader is based on the shellac material in 3ds Max. It is mixed with two layers of reflections, the first one being crisp and the second one providing a more diffuse and glossy look (**Fig.07**). I also used Bump maps

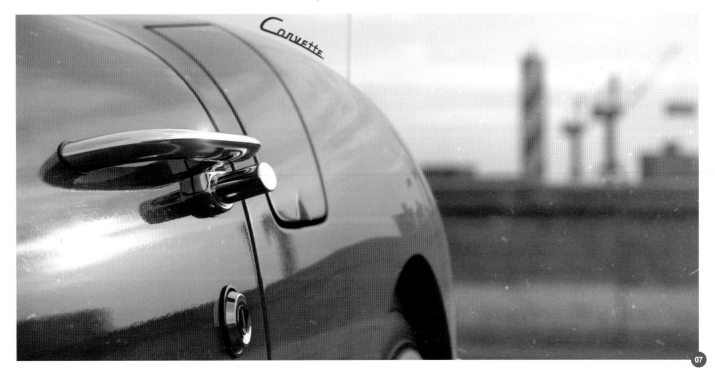

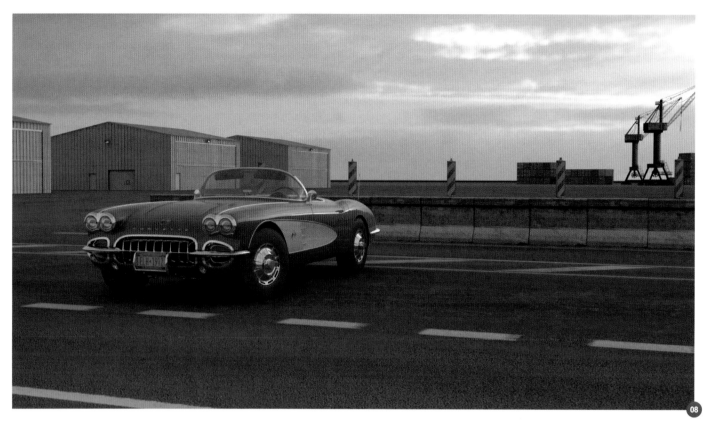

consisting of a Mix map and various degrees of noise. Their intensity must be small to create a fine paint texture close-up (**Fig.08**).

LIGHTING AND RENDERING

Lighting proved to be quite problematic due to the fact that the scene had been prepared for animation. I tried to create a natural ambient lighting suitable for a wide variety of shots. Achieving this was a lengthy process and initial tests were not promising. Here is how it looked in one of the first lighting tests (**Fig.09**). I used HDRI maps of the sky to simulate a light approaching sunset. When rendering I recommend using a HDRI map since it generates more interesting shadows and reflections. I had to relinquish this type of lighting for the animation because of the longer rendering times. In earlier projects HDRI maps were usually accompanied by additional Direct Light in order to add character to global

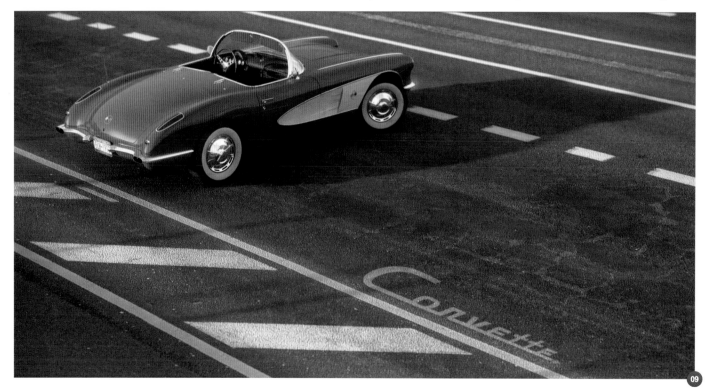

10

shadows. However with this project I used V-Ray Sun, which generated much better shadows closer to the setting sun.

During the rendering I tried to achieve an optimal result in order to have more control during the post-production. All renders were made into 32 bit png files, which allow a fairly deep contrast and color correction at a later stage. Along with the main render I tried to generate a lot of different passes from render elements. Helpful passes proved to be V-Ray Reflection, V-Ray Refraction, V-Ray Z-Depth and V-Ray Wire Color to create masks for the individual elements (**Fig.10**).

In addition, I prepared a separate scene to create a shadow pass, which required

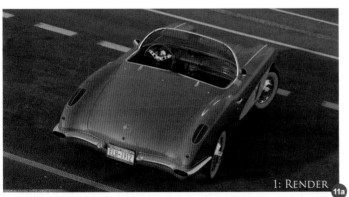

1: Render

11a

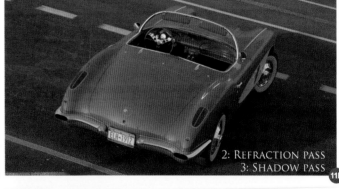

2: Refraction pass
3: Shadow pass

11b

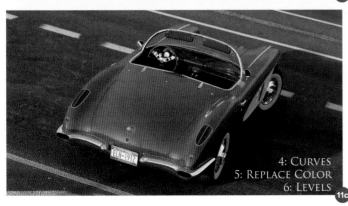

4: Curves
5: Replace Color
6: Levels

11c

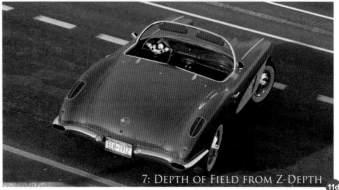

7: Depth of Field from Z-Depth

11d

some post-production work (**Fig.11a – f**). To do this it was necessary to assign a standard white material to each object with the Self Illumination set to 100 and make the background a matte object. You must remember to turn off the HDRI map as it could brighten the shadows unnecessarily.

POST-PRODUCTION

Post-production proved to be one of the nicest stages in this project as I could inject a definitive character through the renders. I used all the rendered passes prepared in advance to help achieve the desired result. Elements such as dirt across the lens and headlight beams were also added at this stage (**Fig.12**).

CONCLUSION

The project, which was initially to be a lighting test, ended up revolving around this particular aspect. I'm glad that I managed to escape the main theme of the animation and devote some time to rendering the Corvette. Had this not been the case it is unlikely that I would have appeared in this book. I am delighted to have had the chance to show you my work and hope that there will be people who have gained just a little bit of knowledge from this account.

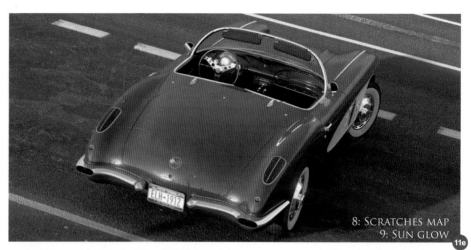

8: SCRATCHES MAP
9: SUN GLOW
11e

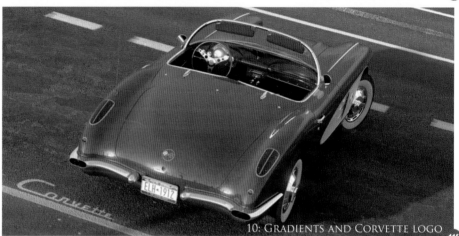

10: GRADIENTS AND CORVETTE LOGO
11f

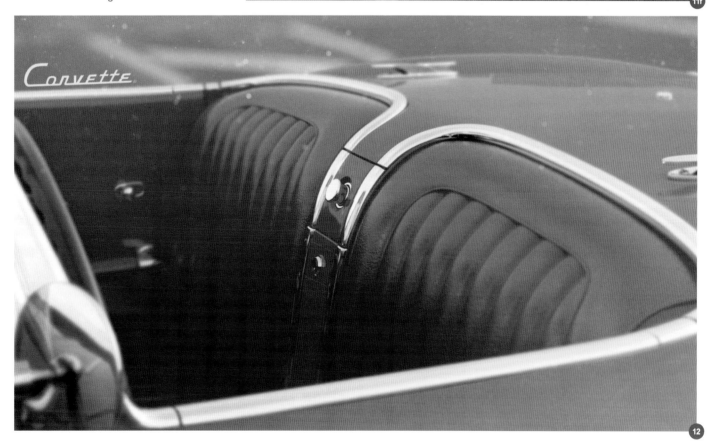

12

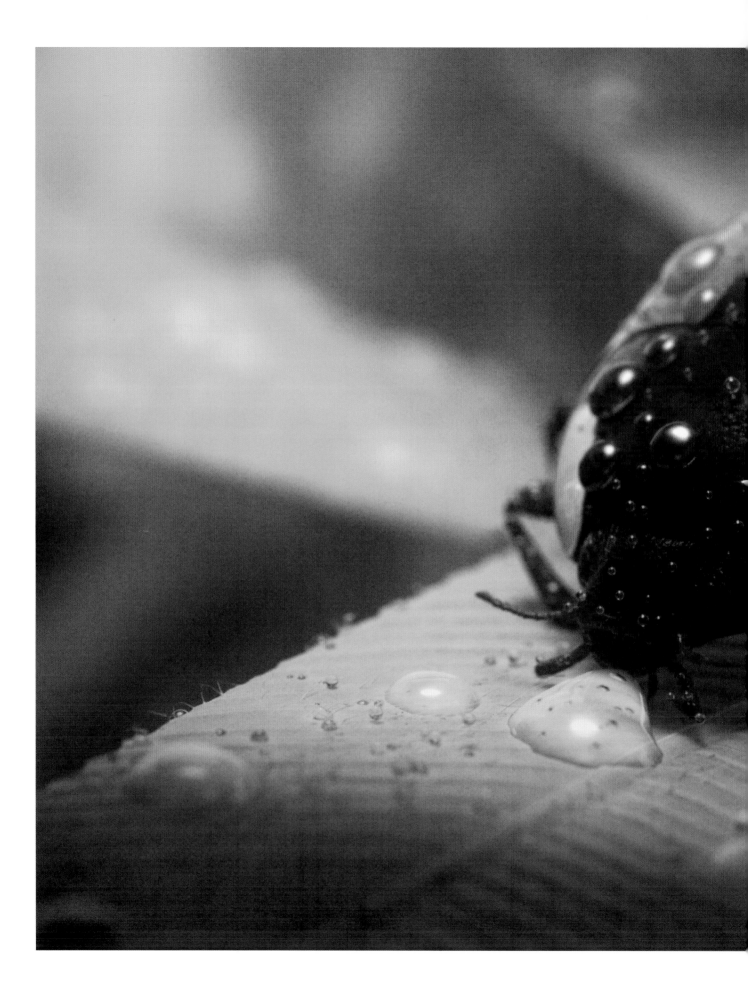

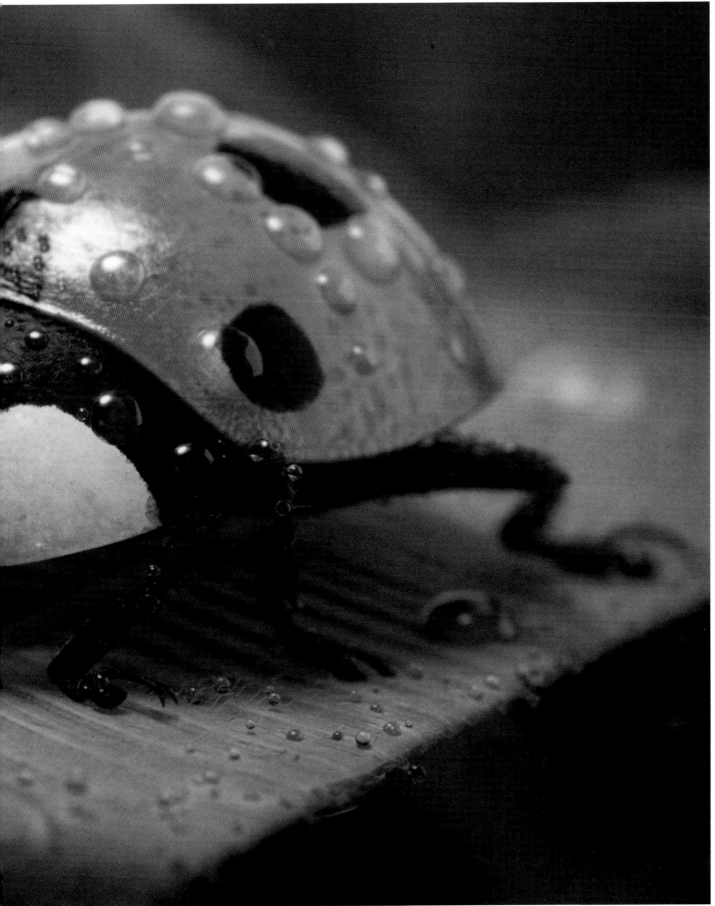

LADYBUG
BY ANDRZEJ SYKUT

JOB TITLE: Freelancer

SOFTWARE USED: 3ds Max, Wings 3D, ZBrush, Photoshop and After Effects

INTRODUCTION

Ladybug is something of a happy accident. I made the bug model for another project, where it was just one of many pieces. Nevertheless, just to be sure, I made it detailed enough so it would look good on its own. I had the time and will to put in the extra work so I thought, why not? As an afterthought, I considered composing a portrait of just the bug as it is nicely detailed and that is how this image evolved.

MODELING

For a model such as this, gathering references is crucial. I don't simply mean one or two images, but rather a whole library. A ladybug seems like a simple shape to model, but it has a lot of hidden details and unless you know how it's structured and how it works, you'll have a hard time getting it to look right. Fortunately, with Google image search and Flickr, it was easy to quickly amass a large library of photos from numerous angles. As a result a few things became apparent. First were the inner wings and the way they fold away under the spotted, red outer covers (which also happen to be wings), opening and rotating in a specific way. Next was the body, which from a side view is not straight, but follows a shallow curve with the "middle" being higher than the head and the rear. Due to a lowered, flattened rear, the inner wings have a cavity to fold into. Following

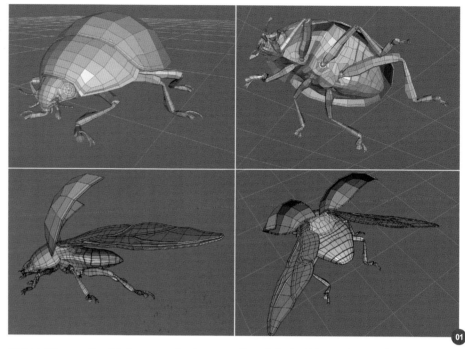

on from this were the details concerning legs, mouth apparatus, mandibles, coloring etc...

Having established the basic "bug layout", I started modeling the base mesh. I used Wings 3D for the principal modeling and UVs, ZBrush for sculpting, and 3ds Max for everything else. As per usual, I started with a box, subdivided it, applied Virtual Mirror and proceeded with some cutting, shaping and transforming etc. It's pretty straightforward because what matters most in this case is the main shape, silhouette, roundness and simple edge loop structure, as opposed to the details. Of course, I could have modeled more detail at this stage, but sculpting

them is faster. I devoted most of my time to the legs and all those antennae, of which many sections were duplicated. However they all needed to be tweaked individually as each leg or mandible required separate UV coordinates (**Fig.01**).

Speaking of UVs, I used Wings 3D Auto UV to unfold all of the components and Max to tweak the final layout. Tweaking and moving UV shells, especially when there are a lot of them, is faster to do in Max. None of the UVs overlap because ZBrush doesn't appreciate this. In other words, it crashes during displacement generation, causing unnecessary stress to the user, apart from which clean UVs are always advisable. I started with size-normalized UVs and tweaked their relative sizes based on the importance/visibility of the various body parts. It was then time to move onto the sculpting.

The sculpting part is usually fun, and this was no exception. Most of the detail is on the underbelly/legs area and not so much on the top, which is made up of a hard, smooth shell. The underbelly is a concoction of numerous creases, recessions and segments for which I

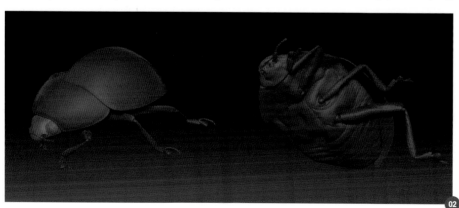

DIFFUSE/SSS COLOR REFLECTION NORMAL BUMP

03

mainly used the DAM Standard, Rake, hPolish, and FormSoft brushes, to name a few. Most of that detail is not visible as it turns out, nevertheless it was fun to make and maybe someday I'll compose another image where it may come in handy. After completing the sculpting phase I generated Displacement, Normal, and Cavity maps in readiness for the texturing (**Fig.02**).

TEXTURING AND RENDERING

The diffuse texture is a combination of flat base colors, overlaid with assorted grunge/detail maps, supported by modified Cavity/Displacement maps, and refined with some painting. Reflection, Glossiness and Bump maps were derived from tweaking the layers

making up the diffuse texture and altering or inverting the color and intensity of them. The textures were tweaked repeatedly during the shading process as it's hard to get them right on the first attempt (**Fig.03**).

For shading and rendering I used 3ds Max and V-Ray. Taking a cue from the reference images, I wanted the bug to be slightly translucent as well as appearing shiny. To achieve this I used a V-Ray FastSSS2 material, with Raytraced reflections and Refractive Scattering. It's probably one of the most computer intensive approaches, but it still rendered in a reasonable time. Something worth mentioning here is the issue of scale. It's generally a good idea to keep things to a real-world scale, but

there are things to consider. With the bug sized accordingly (5-10mm or so), working with bones for rigging would be uncomfortable. To make the rigger's life easier, I scaled it up to roughly 5-10cm.

Tip: Reset the X-Form to "bake" the scaling transformations, which helps avoid any consequent frustration. Bearing this in mind, I tweaked the SSS Radius and Scale parameters until things looked correct (**Fig.04**).

At some point I added the tiny hairs, mostly along the legs. They were done using the Hair and Fur modifier and share the same material as the object they are attached to and are therefore nicely translucent. I also added fur to the leaves, hoping to retain some detail when adding depth of field during the post work.

Next the model went off to be rigged and animated, and to fulfill its primary purpose. It was quite satisfying, since I got to finally light and render it too.

A few weeks later, during a bit of downtime from work, I started assembling this image. I started by setting up a camera angle. I then proceeded by adding some leaves, tweaking the camera a bit, adding more leaves, and a little more tweaking. All in all, it was pretty simple. The dew droplets proved to be somewhat more problematic. I employed two methods to place them, the first being Scatter which was used for the smaller drops on the leaves and hair. The larger, flattened ones were placed using the Advanced Painter script, and tweaked manually thereafter. It was time-consuming to tweak the arrangement without disrupting the composition. Getting them to look right was another matter, which involved caustics and therefore a degree of trial and

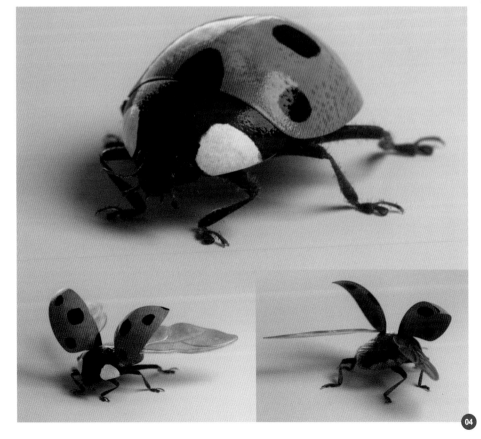

04

error where the settings were concerned. Those nice bright spots under the drops – that's caustics.

LIGHTING

The scene is lit by a few large V-Ray Area lights and a HDR Environment map. There's also a HDR map used to reflect an environment. The trick here is to use a low res (diffusely convoluted) version of the map for lighting, and a high res one for the reflections. That way Global Illumination is faster, smoother and contains less noise. sIBL is a great little app to generate (among other things) the convoluted version of any HDR map. HDR Shop is also effective and some maps can be bought or downloaded ready-prepared.

The lights themselves consist of a large, warm Spherical Key light (to represent the sun) and a few blueish Rectangular Area lights, acting as fill and rim lights, used to simulate the light from the sky. There are also two smaller, additional lights, highlighting certain parts like the head (**Fig.05**).

In addition to the lights, there are a few invisible, shadow-casting objects in the scene. They provide some shadows in the corners, acting as a natural vignette in order to focus the viewer's eye on the bug. They also occlude the reflected environment, creating the illusion of more leaves off-camera (**Fig.06**).

Apart from the caustics settings, all other rendering settings are straightforward. These included Exponential Color Mapping, a subtle Irradiance map (with lower settings for the final render), and DMC Sampling.

POST-PRODUCTION

The post-production was simple. I used After Effects coupled with a few plugins. I added some Depth of Field to mimic

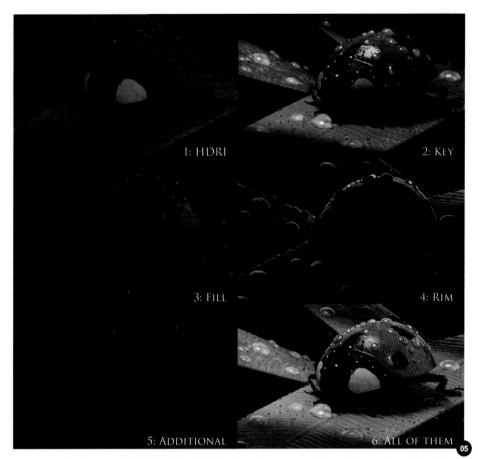

1: HDRI 2: KEY
3: FILL 4: RIM
5: ADDITIONAL 6: ALL OF THEM

05

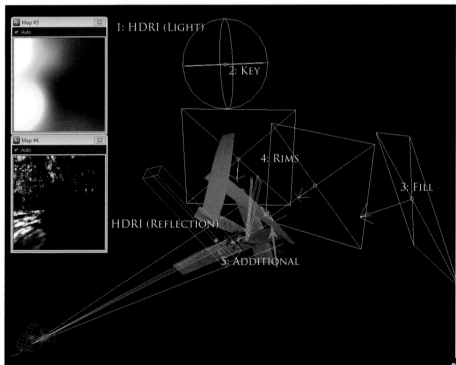

1: HDRI (LIGHT)
2: KEY
4: RIMS
3: FILL
HDRI (REFLECTION)
5: ADDITIONAL

06

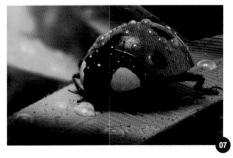

07

macro photography together with a blurred background, some color correction, a vignette, some bright spots in the background (to add some depth), a bit of glare (with a subtle red and blue color shift), and a bit of Look Suite.

To enhance the "macro" quality, I added some chromatic aberration and a touch of grain. Despite being pretty simple and requiring no painting, the difference before and after is significant (**Fig.07**).

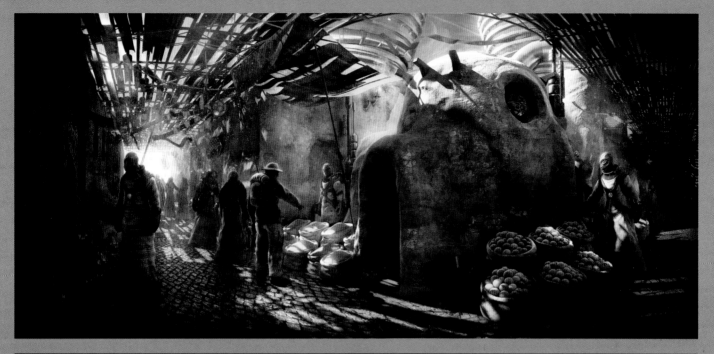

RUNNING AWAY
BY TONI BRATINCEVIC

JOB TITLE: Scene Assembly Lead at Blur Studios
SOFTWARE USED: 3ds Max, V-Ray, Fusion and Photoshop

INTRODUCTION

The first version of this image started as a test for the finalRender render engine (**Fig.01**). This was a couple years ago when I was a beta tester for that engine. I remember leaving this image in an unfinished folder for a long time, but I always knew I'd do something more with it. I always knew this image was somehow different, with the potential to convey a strong message. Compared to my other works, which are mostly environments, this one was more character based. Eventually in 2010 I decided to finish this image and that is where everything began. It took me around two to three weeks to complete it, working for a couple of hours every day. The progress I made over those couple of weeks can be seen in **Fig.02**.

> " SIMPLY CREATING BEAUTIFUL ILLUSTRATIONS DOESN'T SATISFY ME, IT NEEDS TO BE SOMETHING MORE, AND SOMETHING THAT GETS ME EMOTIONALLY INVOLVED "

IDEA AND CONCEPT

From the beginning, this image was made as a test and didn't have any story behind it. Once I decided it was a good candidate, I thought a lot about what this could represent. For me the idea behind the image is the most motivational aspect and keeps me going until it is finished. Simply creating beautiful illustrations doesn't satisfy me, it needs to be something more, and

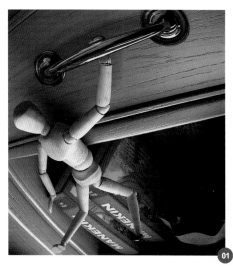

something that gets me emotionally involved. I thought a lot about what this should represent and I figured it out in the end and it is as follows: Remember when you were young and you didn't know what was good and bad, and

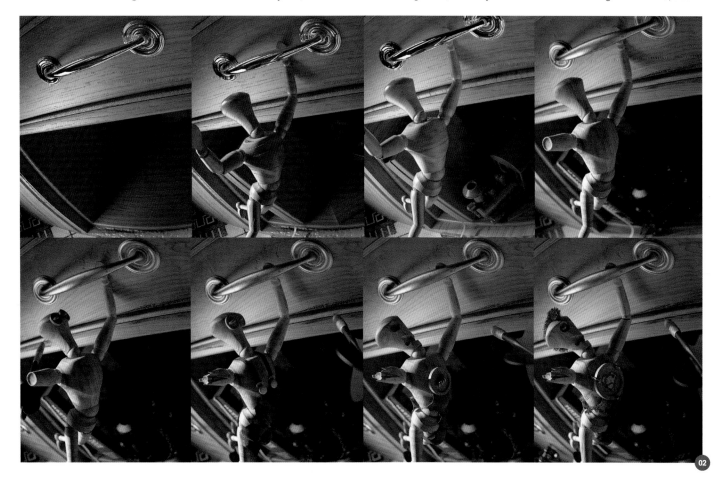

how you sometimes destroyed your toys. Your parents would tell you how wrong that was, and that you should try to imagine that the toy was a real person or an animal. Well, most of us developed that emotional intelligence at a young age. We learned that what we did to that toy was wrong. But there is also a dark side of humanity and there are some that actually enjoyed hurting toys, and as they grow up they leave their tortured toys behind. Here's to all the peace-loving folks around the world!

After the initial idea was conceived I decided to paint over the first draft render to figure out what else to create in the image. I brought the original render into Photoshop and started painting over it, which took about 30 minutes

(**Fig.03**). Having a concept is a great help and allows me to figure out how much time it's going to take to complete everything, including objects and textures etc.

MODELING

Modeling was an easy task with the only complex components being the train and character; everything else was really easy to do (**Fig.04**). Most of my time was spent modeling these two particular objects and after collecting some reference from internet, the rest was straightforward. I usually start with a simple box or cylinder and, using the Edit Poly tools such as Extrude, Inset, Connect, and Cut etc., I am able to add all the necessary details. When modeling it's good to keep an

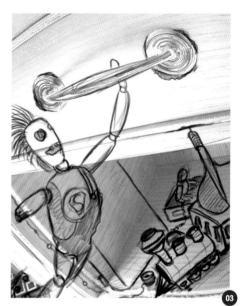

03

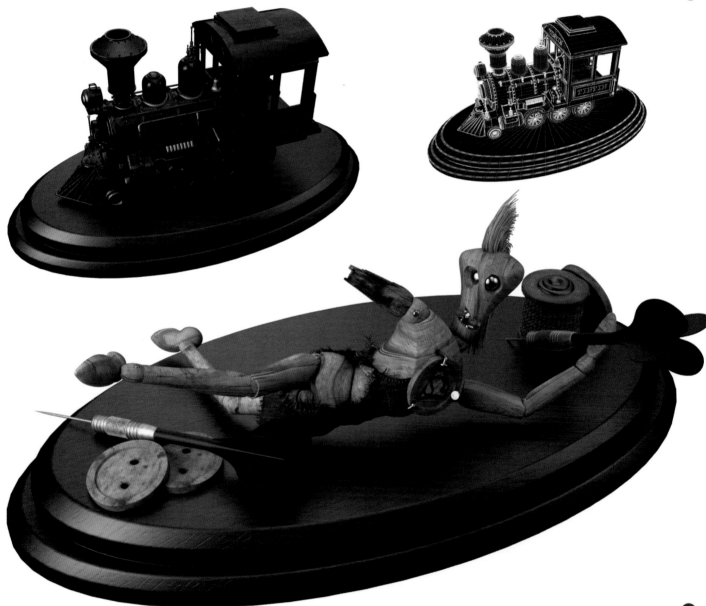

04

SCENES

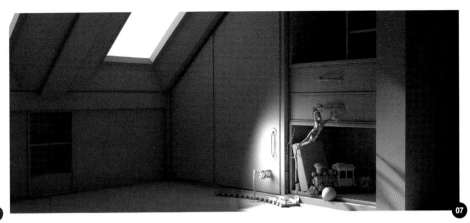

eye on the topology in case your intention is to use smoothing. This is what I did for the wooden doll, although for some objects such as the train I decided to stick with the resulting tessellation and ultimately didn't need the Turbosmooth modifier.

I used the 3ds Max Hair and Fur modifier to create the hair, and within the render settings set the output to Geometry since I wanted to render it in the scene and not as a post-processing effect (**Fig.05**). The direction of the hair was created with Curves, using a copy of the original head and deleting the unwanted faces to generate the hair growth (**Fig.06**).

The edge of the jeans also utilizes the Hair and Fur modifier to create the frayed look. I selected only the edges of the jeans, copying the relevant faces and using them as a source object for the growth. The final scene model is low poly, with detail restricted only to what is visible in the camera. The remainder of the room is pretty simple and was modeled purely to generate some nice bounce light and glossy reflections across the objects (**Fig.07**).

TEXTURING AND MATERIALS
As with modeling, texturing and materials were easy to do. I used just a couple of textures for everything. There is only one texture used for

the wood, a couple of different ones for the floor and train, and some custom-made ones for the book. Most of the materials used in this image can be seen in **Fig.08**. Almost all of the materials use Glossy Reflection, except perhaps the carpet and rope. When building scenes in V-Ray I only use V-Ray materials, because 3ds Max materials can produce some rendering problems and slow the process.

LIGHTING
The lighting in this image was one of the most important aspects. I tried to do everything with just one light (Sunlight) but it didn't work (**Fig.09**). The next thing I did was to place one

V-Ray Area Light in each window. This helped generate the color from the sky and created direct lighting, which is more defined than pure Global Illumination. For these Area lights I used the Skylight portal feature in V-Ray. What this effectively does is color the Area lights based upon an Environment map, which in this case is a V-Ray sky. Adding Area lights in the windows helped define the shadows, but still didn't create the effect I wanted. I was aiming for some specular reflections across the wood and back of the character, so I decided to add one more Area light on the left side of the character.

RENDERING – CAMERA

V-Ray was the rendering engine I chose to use. There were several reasons for this, the most important of which was the ability of the Depth of Field pass, as V-Ray tends to be faster than competing render engines. I used Irradiance mapping for primary bounces and Lightcache for secondary ones. Using Lightcache is useful in interior scenes because there is a lot of light bouncing from the windows, and Lightcache

10

11

actually provides an infinite number of secondary light bounces. For the camera I used a V-Ray physical camera with some Quadratic distortion, which introduced a certain dynamic to the final render (**Fig.10**). The lines

ceased to be parallel and everything looked more rounded, as if seen through a wide-angle lens (**Fig.11**).

For the DoF camera settings I used 64 samples because I wanted a really smooth effect, although it is quite intensive. Since I was using camera DoF, I decided to use DMC Adaptive Sampling in V-Ray. This sampler works in a very specific way, influencing every glossy (subdiv) value in the scene based on the Max DC subdiv value. Sometimes it's possible to get a lower quality image just by increasing the Max DMC samples. This is not particularly intuitive, so I suggest that when using a DMC sampler you are fully acquainted with it. I actually wrote one detailed tutorial about this, but for more info just visit my webpage. The final image took around two days to render in 4k resolution. The reason why it took so long is because it takes a lot of rendering calculations to achieve a clean DoF without any grain. If I had rendered without DoF it would probably have taken a couple of hours to render in high resolution.

COMPOSITING

Since everything was rendered in one pass, I didn't do much in the way of compositing. There were only a few color corrections needed to achieve the desired values and color scheme (**Fig.12 – 13**). Most of the time I use Fusion for compositing since it works

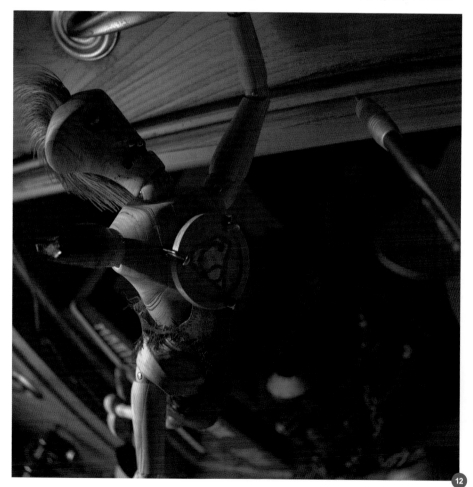

12

in a nondestructive way and once I've set all the color corrections it's just a matter of re-plugging a new, raw render into the existing flow and I basically get the final image in couple of seconds. Fusion is more flexible than Photoshop, but if I wanted to do some additional painting on top of the render, Photoshop would probably be my choice. The beauty of working in a node-based compositing application is that you can output Reflection, GI and Direct Light passes etc., from V-Ray and it's much easier to combine and tweak these in Fusion than in Photoshop.

CONCLUSION

As mentioned earlier, I didn't spend too much time on this image and actually didn't expect a good public response, but in the end people really liked it. In fact they liked it more than my previous image, which took much more time when it comes to modeling and texturing etc. This taught me a valuable lesson in that I don't need to overcomplicate every image to get positive feedback. Some things can stay simple and as a consequence I'll do more images of this type and invest more time in expanding my knowledge of character modeling.

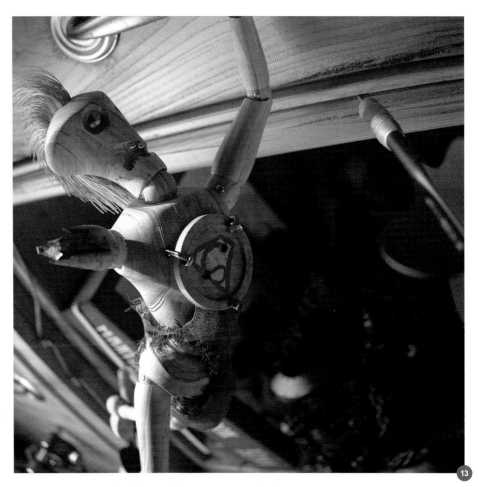

13

ARTIST PORTFOLIO

© TONI BRATINCEVIC

© REBECA PUEBLA

CHARACTERS

I think that to create cool characters plenty of things are necessary, but you don't have to use a huge variety of tools. There isn't a magic button that can provide you with good technique and lots of patience. What you do need though is time and references!

There are many different styles of characters, from cute cartoons to complicated and realistic models, but the same things are important with all of these: you have to have a good idea and model a good pose. Once you have these, modeling, materials, texturing and lighting are important. However, a character is not just a simple shape with arms and legs. They need to look alive, have a personality, and show expressions and emotion. There are different techniques that can be used to do this in 2D and 3D, but the important thing to do is create a character that has soul.

REBECA PUEBLA
rebecapuebla@hotmail.com
http://rebecapuebla.blogspot.com

3324 NORTH CALIFORNIA

BY JASON SEILER

JOB TITLE: Illustrator
SOFTWARE USED: Photoshop CS

INTRODUCTION

Many artists can draw a decent likeness of a well-known face, but the challenge is more in capturing not just the likeness but the character of the person as well. For me, capturing this truth, or essence, is the most important factor in considering a portrait successful or not. By observing the unique qualities of the individual, I am able (hopefully) to render a realistic depiction beyond mere likeness. One of my favorite ways to do this is through exaggerated form; the slightest push of an expression or posture in just the right place can tell the viewer quite a bit, as well as make for a more interesting image.

> " DOING THUMBNAILS IS A SIMPLE AND QUICK WAY FOR ME TO FIND INTERESTING COMPOSITIONS AND EXPLORE CHARACTER SHAPE AND PROPORTION "

I am a traditional painter at heart. I love working with oil, acrylic and watercolor. However, due

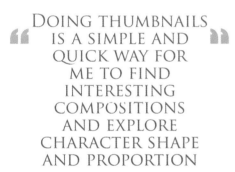

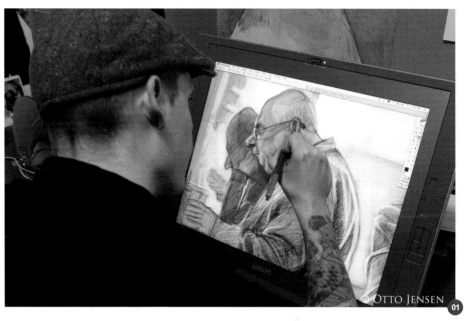

© OTTO JENSEN

to the fast-paced world of publishing, I have taught myself how to paint digitally using a Wacom21" Cintiq. The Cintiq allows me to work naturally, intuitively drawing and painting directly on the LCD display (**Fig.01**).

MY PAINTING

My technique when painting digitally is very similar to the way I paint with oils or acrylics. I tend to work from dark to light, focusing on values and color harmony. I never use any form

of photo manipulation. The work that I create digitally is hand-drawn and painted. Working digitally has its advantages for both myself and art directors as there is no fuss or time spent scanning and color correcting. It also provides the ability to make changes quickly and easily, and the time it takes me to create a painting digitally versus traditionally is cut in half. The best part is that the final result looks like a traditional painting. The results are so similar that people often confuse my traditional and digital paintings, unable to tell which is which.

Before beginning a piece I generally create several thumbnail sketches (**Fig.02 – 04**).

Doing thumbnails is a simple and quick way for me to find interesting compositions and explore character shape and proportion. I use my thumbnail sketches like short-hand notes. I don't share them with art directors, unless they ask, as they can be confusing to anyone but myself. After developing the thumbnails, I quickly move on to the sketch.

By this stage, having the idea and composition set, I begin to take pictures for reference. Using friends and myself as models, I can control the lighting, folding in clothing, poses, hand gestures and expressions (I have used my own face many times for creating expression for

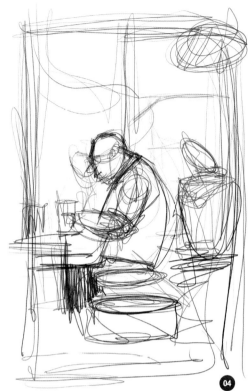

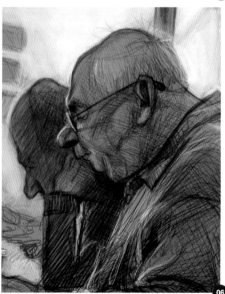

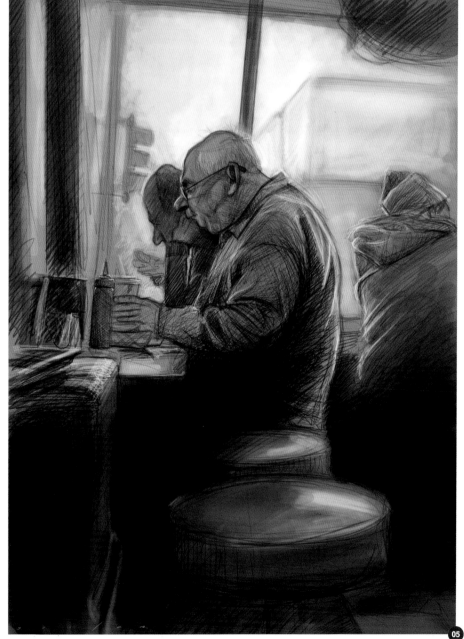

my subjects; it pays to have a rubber face!). After gathering all the references I need, I do a final sketch (**Fig.05 – 06**). I love to draw and because I believe that drawing is the foundation for my art, I take special care to get it just right. If the drawing is right, the painting will be right. A strong drawing and composition must come first. I often prefer sketching on a toned background as opposed to white. This helps me lay down my line work and quickly establish light and darks, giving my sketch depth and a life of its own in a very short amount of time.

CHARACTERS

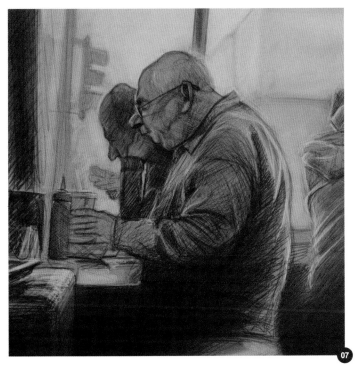

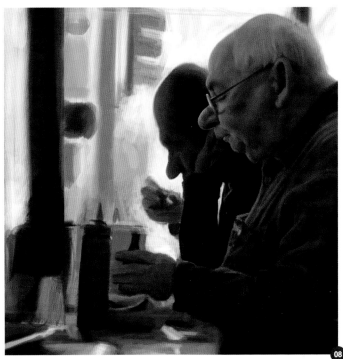

Once the sketch is approved, I prepare it for painting. I typically cover my entire sketch with a thin layer of raw umber, using the sketch in the same way an under-painting is utilized in traditional painting (**Fig.07**). My paintings tend to have a lot of detail, but don't let that fool you. The details are only the final touches. The most important thing is the drawing, and once that meets with my satisfaction I focus on capturing light and establishing strong values.

> **I DIDN'T WANT TO KEEP IT TIGHT AND WHEN YOU LOOK AT THE PIECE AS A WHOLE, IT LOOKS PHOTOREALISTIC. BUT WHEN YOU ACTUALLY LOOK CLOSELY YOU CAN SEE THAT THE PAINTING WAS BUILT, ALMOST SCULPTED, ONE BRUSH STROKE AT A TIME**

Before I start to paint I create a palette of colors that I will use throughout the painting process. These colors are not pre-mixed to match the exact colors that I will need. Instead, they are colors that I typically use when painting traditionally, like Yellow Ochre,

Cadmium Yellow/Red, Alizarin Crimson, French Ultramarine Blue, black and white. I will mix these colors together to get what I need for the painting and then I'll click on the color picker to bend or change the color if need be. I can easily add warms or cools, saturate or desaturate. Sometimes I'll begin by blocking in a series of warm grays that I've created, primarily focusing on getting the values how I want them. Once I've established my values, I begin adding light washes of color over my

grays. I'll do this on another layer so that I can use the Eraser tool to softly erase certain areas, enabling me to blend my color into the grays seamlessly (**Fig.08**).

Once I have my colors pretty much blocked in, I'm ready to zoom in closer to work on rendering the details (**Fig.09**). This is the part that takes the longest because not only do you have to focus on getting the color temperature and values right, you also have to pay attention

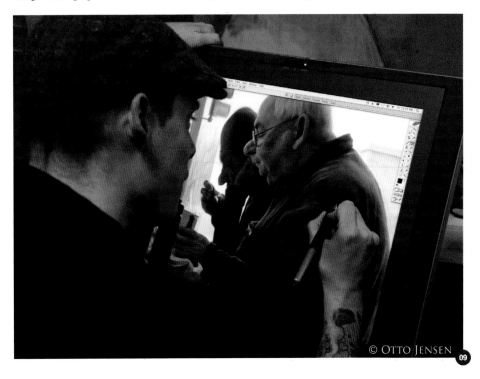

© OTTO JENSEN

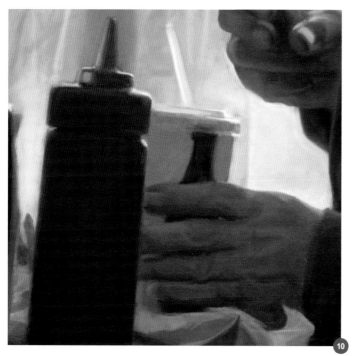

to anatomy, structure and character alongside soft edges, reflective light and so on. I can easily spend hours and hours rendering, so I have to have a plan so I know how far I want to go with the particular piece that I am working on. For this piece, I didn't want to keep it tight and when you look at the piece as a whole, it looks photorealistic. But when you actually look closely you can see that the painting was built, almost sculpted, one brush stroke at a time.

I think of painting in a similar way to putting together a puzzle. As mentioned earlier, this painting looks photorealistic when looked at as a whole because the correct values and colors were laid down next to other correct values and colors. If you look closely at the stop lights and stickers on the glass to the left of the man in shadow, you can see how simple the brush work is – there's nothing fancy about it. In fact if I were to crop it and share it close up and

out of context, it wouldn't really be much to look at. This is how I work, section by section. Each section on its own wouldn't be particularly special, but together they create a neat picture (**Fig.10 – 13**).

I often get asked about the software and types of brushes that I use. I have not yet bought the latest version of Photoshop but plan to, eventually. The truth is I don't need all that

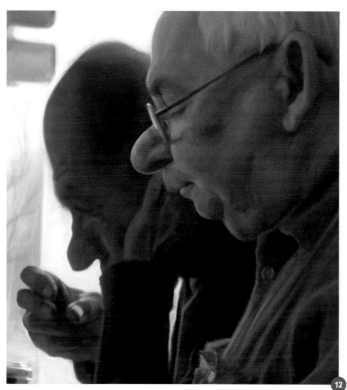

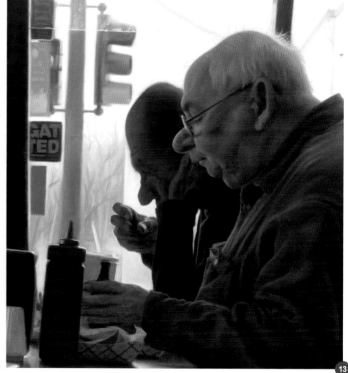

CHARACTERS

much. In fact, the version of Photoshop that I currently work with, and have worked with for years, is just plain old Photoshop CS. It does all that I need in order to create a painting. The brushes that I use are Photoshop brushes. #24 is my favorite because it is "brushy" and I can get painterly effects with it, but I also like using the Round brushes. If used correctly they can lend a painting a layered watercolor effect that I enjoy. I feel that it is really important for digital artists to paint traditionally, even if only for personal practice. The more you paint with real paint, like watercolor and oil, the easier digital painting will become.

Because of my experience with painting in oil and acrylic, painting digitally comes naturally; mixing color digitally is done basically the same way it is done traditionally, only more easily and quickly. It can be a temptation for digital painters to get carried away and create near photorealistic results, but, for me, this approach is against all that I love about painting. I enjoy finding a thumbprint on a painting or seeing loose hairs from a paintbrush entombed forever in the art. I purposely leave brush marks visible, knowing that as long as the lighting and values are correct, the painting will still have a very realistic look and quality alongside its traditional feel.

ARTIST PORTFOLIO

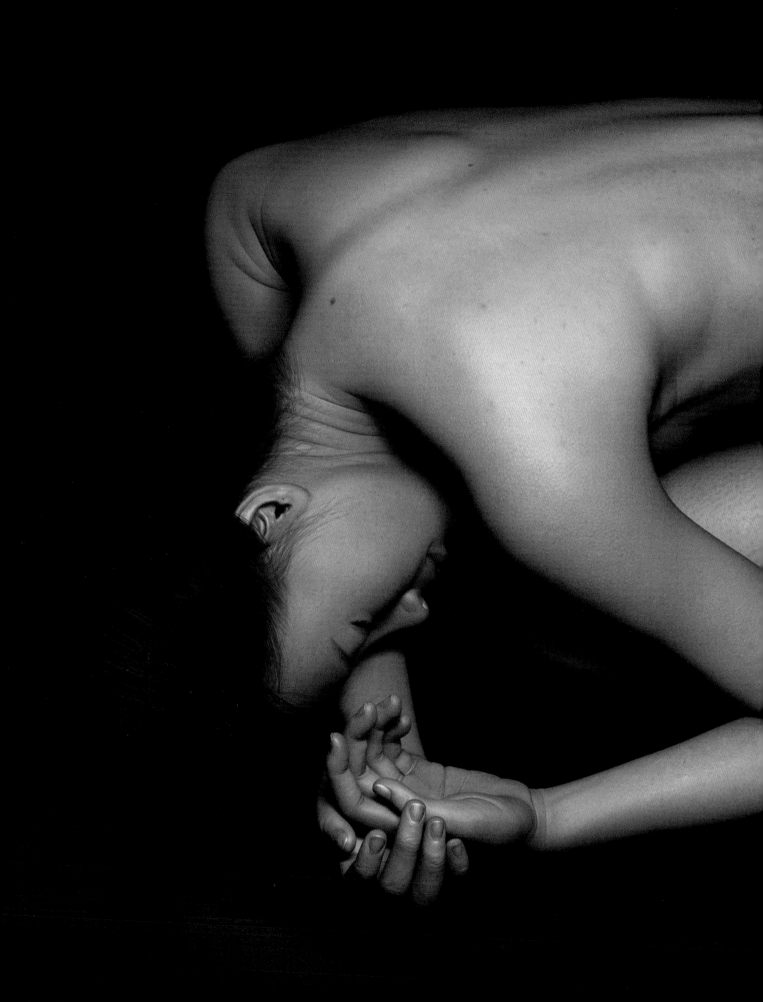

NUDE WOMAN
BY JIAN XU
JOB TITLE: Modeler
SOFTWARE USED: 3ds Max, ZBrush and Photoshop

INTRODUCTION

I have seldom worked with female anatomy. My portfolio includes work relating to soldiers, animals and different male categories. On this occasion I decided to try and create the body of a woman in a unique pose. A woman's body is soft and capable of displaying beautiful form and certainly presents a challenge! During the preparatory phase, I focused on choosing a unique pose which I considered critical for this work. Initially I searched through a great number of photographs of women's bodies to find an idea. Some proved enlightening and inspirational, however, I did not want to copy a photograph so I found a female model and shot almost one hundred photos. On the whole, I don't like to show frontal nudity and sensitive parts of the anatomy, but rather opt for a sense of implied, aesthetic feeling. Eventually I chose a curled up pose on the floor, suggesting she was resting or deep in thought. This conveyed a great shape that I liked and so I took a host of photos from different angles of this pose in preparation for the modeling phase.

MODELING

Sufficient preparation provided a good direction during the modeling stages. To begin I found a basic female body I had previously made and introduced some simple rigging to create the posture (**Fig.01**). After fixing the pose, I increased the mesh in order to work in ZBrush later where the main job was modifying the

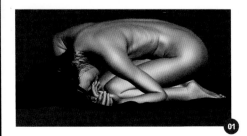

01

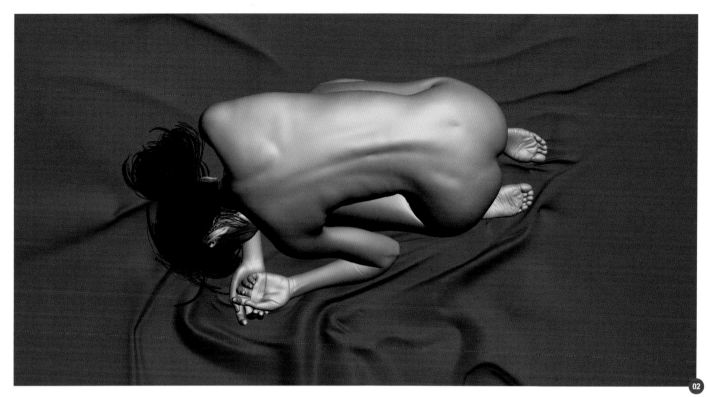

shape and creating details. During this phase, I tried to make the model match the reference from different angles, which cost me a lot of time (**Fig.02**). But I think it was necessary as modeling is the most important part of an entire work. Small variations can produce big differences once lighting is introduced (**Fig.03**). I also spent a lot of time on the hands, which

is very important and an aspect I wanted to focus on as, for me, creating soft, natural and realistic hands is a big challenge (**Fig.04**).

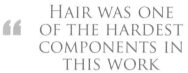

> ## " HAIR WAS ONE OF THE HARDEST COMPONENTS IN THIS WORK "

TEXTURING

I have always been used to hand-painting textures instead of using photos. Photo textures already contain specular highlights and shadows, which probably do not match the final effect of light and rendering. I used three maps to paint the texture (Color map, Bump map and Specular map) as well as integrating

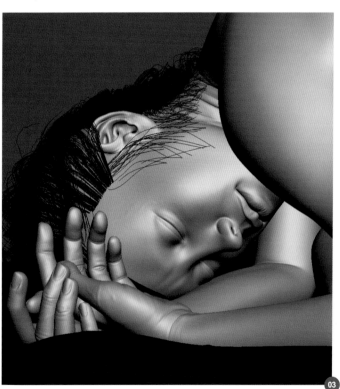

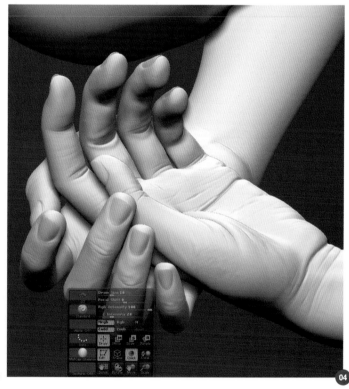

SSS in mental ray. Regarding the Color map, the challenge was making a real skin color and texture. I first painted a general color and gradually added more and more details, such as moles, vessels and spots. I then used the Bump map to create some slight details, such as pores. The Specular map was used to control the area and size of highlights, such as the details on the lips and nose (**Fig.05**).

HAIR

Usually I create hair using Hair FX, but I tried the default 3ds Max hair this time as it renders well in mental ray and achieves high quality shadows and shader solutions. There is, however, a problem in terms of rendering duration. Hair was one of the hardest components in this work. She has long hair, which is hard to control, so I needed to separate the hair into several groups, each controlled by a lot of curves (**Fig.06**). I think it was the simplest way to sculpt a good hairstyle. **Fig.07** shows the settings I used.

LIGHTING

I wanted to portray an indoor environment full of artistic feeling and a photographic style, and

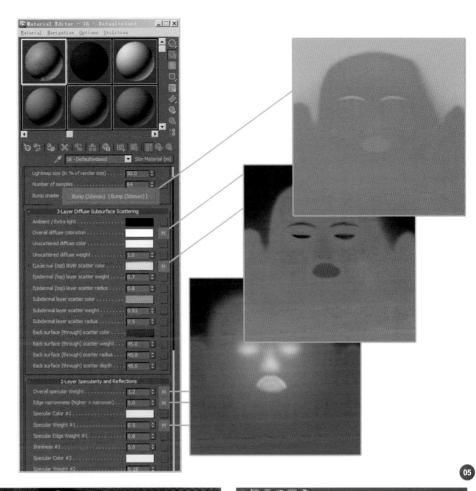

05

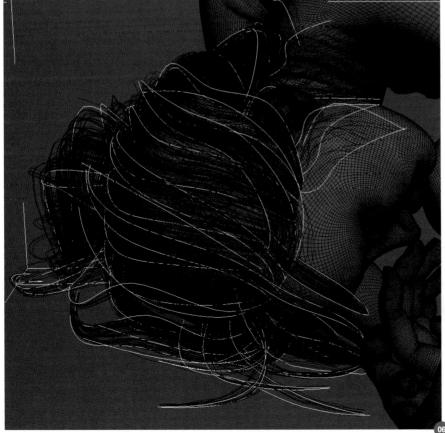

06

07

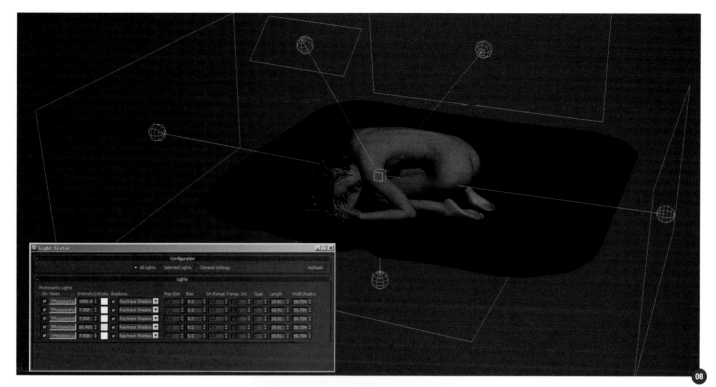

chose a black background to emphasize the body shape. I settled on two main lights on the top and front, and then four side lights to simulate reflection. The light aimed at the back of the body added a subtle green color with the remaining three lights being very subtle. I made hundreds of tests to get the right solution with different locations and strengths of light creating totally different effects (**Fig.08**).

COMPOSITION

I did not render out different passes, but instead opted to just render the whole scene in one go. Once done, I improved and modified the mood, contrast and color balance in Photoshop. This helps enrich the picture and makes it look more real. **Fig.09 – 10** show the renders with the different settings.

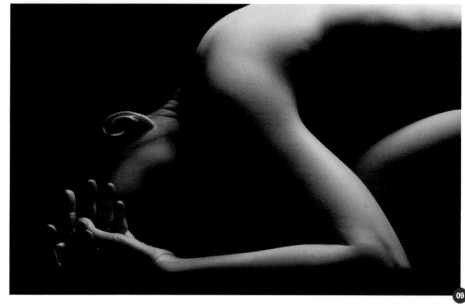

CONCLUSION

Well, that's it! Overall, I am pretty pleased with the image as it comes close to what I originally intended. I think it is a successful attempt at portraying a female nude and also helped me to understand the female body and master rendering shadows more successfully. I rendered some other views I liked and also tried several styles of lighting. I think I will move onto another personal project soon in my spare time and hopefully they will be well received and fun to work on.

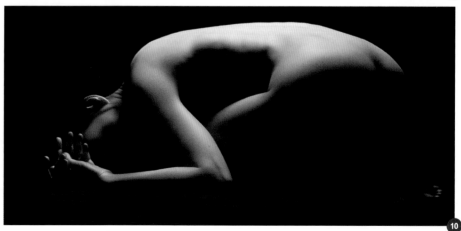

© JIAN XU

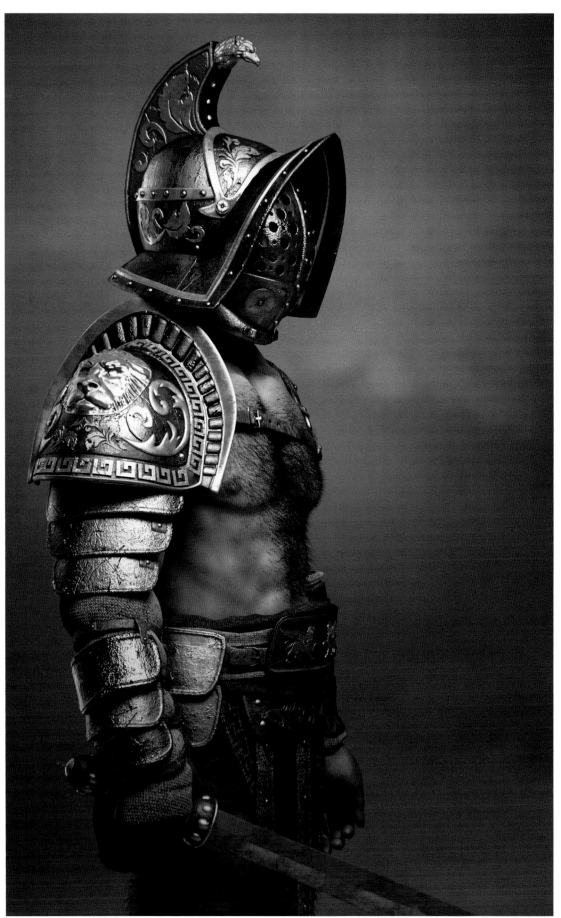

GLADIATOR
BY ERIC DURANTE

JOB TITLE: 3D Generalist – Blur Studio
SOFTWARE USED: 3ds Max, V-Ray, ZBrush and Photoshop

INTRODUCTION

I wanted to do a project that would really push my skills in anatomy and character props, and a gladiator seemed like the perfect choice. This topic required me to show enough skin to demand a focus on anatomy, but also necessitated a number of interesting and varying armor pieces and gear. Not only did I have to create the armor, but these featured an extensive amount of decoration and detail that required the use of ZBrush. Creating the gladiator model was a great experience that taught me a great deal and forced me to push myself to become a better artist.

CONCEPT AND MODELING

I was going for something that was more historically correct as opposed to a fantastical interpretation. I did a lot of research online and in art books. Jean-Léon Gérôme's vision

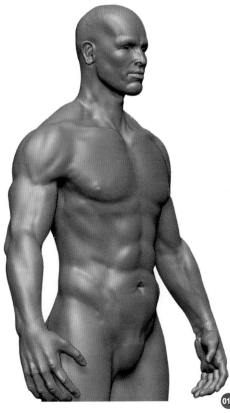

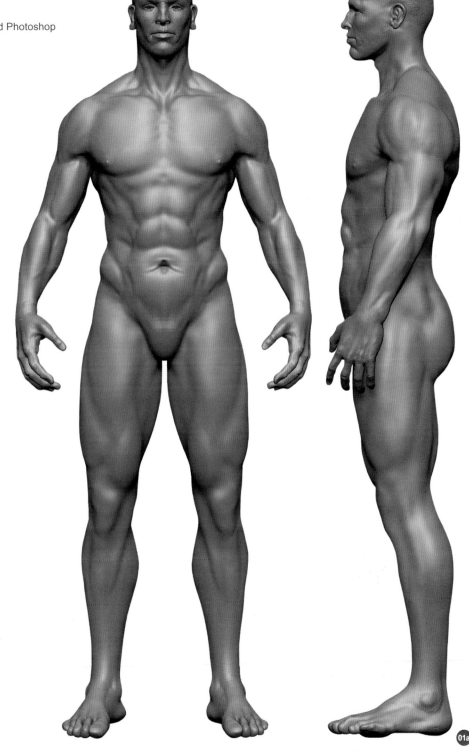

of gladiators painted in 1872 was the main inspiration and chief reference for this piece, particularly in terms of the clothing and tone. First and foremost, I wanted to create a good base mesh that I could use to practice my anatomy skills and also have on file for future projects (**Fig.01a – b**). The body was box modeled in 3ds Max and, once complete, was exported into ZBrush to create the finer details.

Once I had a good base mesh I could start adding the armor and clothes, beginning with

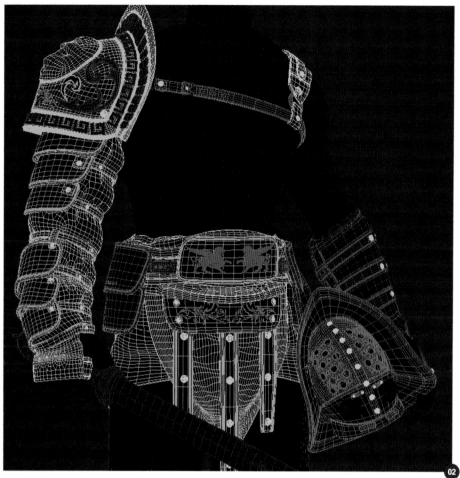

the bigger shapes such as the shoulder pad, helmet, leg guard, belt, and skirt. All of these pieces were box modeled (**Fig.02 – 03**).

The next step was to create the fine detail using splines to trace filigree elements adorning the helmet, belt and shoulder pad. The details that were too complicated to box model were taken into ZBrush (**Fig.04 – 05**).

The helmet, eagle, leg guard, and shoulder pad lion were all sculpted within ZBrush using Normal and Displacement maps exported and applied in 3ds Max (**Fig.06**).

TEXTURES AND SHADERS
The human body was poly-painted and unwrapped in ZBrush. The armor was done with a variety of different methods. Parts

were unwrapped using Max's UVW Unwrap and some were simply box-mapped with a procedural texture, e.g., the metals.

For the body I used V-Ray's Fast SSS2. With regards to the skin shader, I employed most of the standard settings and different maps to control the look. Black and white maps painted in ZBrush and Photoshop were used

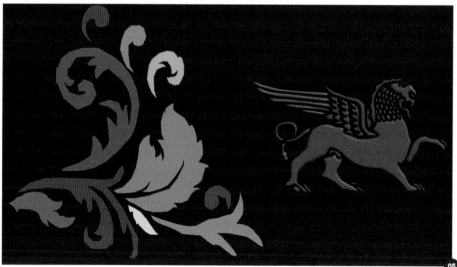

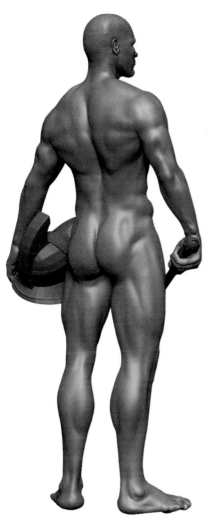

06

07

to control the specular and SSS scatter radius amounts. In terms of the SSS color, I used 3ds Max to color correct my diffuse map to make a deeper red tone and avoid the need to go into Photoshop.

For his chest, head, and leg hair I used Max's Hair and Fur modifier. I selected and duplicated the separate parts of the body that I wanted to add hair to and made the geometry non-renderable. The hair was set to render as geometry so I could then render the whole image as one. I used a lot of composite maps to add in extra detail, adding scratch maps on a separate UV coordinate so I could independently move the composite textures around and place them on the model without touching the base texture (**Fig.07**).

LIGHTING AND POST-PRODUCTION

Once all the modeling and texturing was near completion, I posed the model using the

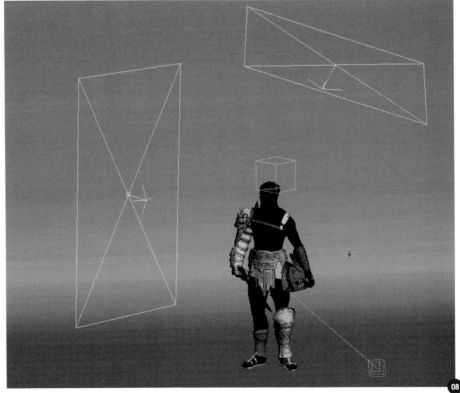

08

transpose tools in ZBrush. I had to make some manual adjustments to some of the clothes in 3ds Max to ensure they sat correctly on the model.

I used two V-Ray lights: a Key and a Rim light. The Key light was positioned above him and employed a warm tint, with the Rim light angled to the back and side using a blue hue. V-Ray has an amazing renderer, capable of some great results using a simple setup (**Fig.08**).

The render settings used Adaptive DMC as my image sampler and V-Ray Triangle as an anti-aliasing filter. I had my gamma settings set

to 2.2. My render settings weren't too high as I was only producing a still. Adaptive DMC was set to Min subdiv: 1 and Max subdiv: 8, with the "Use DMC sampler thresh" box checked.

The next, and arguably one of the most important stages, was the post-production process. This is the part that allows you to really perfect your image. I usually use Fusion for my post-work, but in this instance

I used Magic Bullet's LooksBuilder after a recommendation from a co-worker.

The final touches were done with Magic Bullet, using a warm tint to set the whole image in a certain tonal range, after which I added a slight vignette and some film grain. I de-saturated the image slightly and, to conclude things, brought the overall contrast and brightness of the mid-tones up (**Fig.09**).

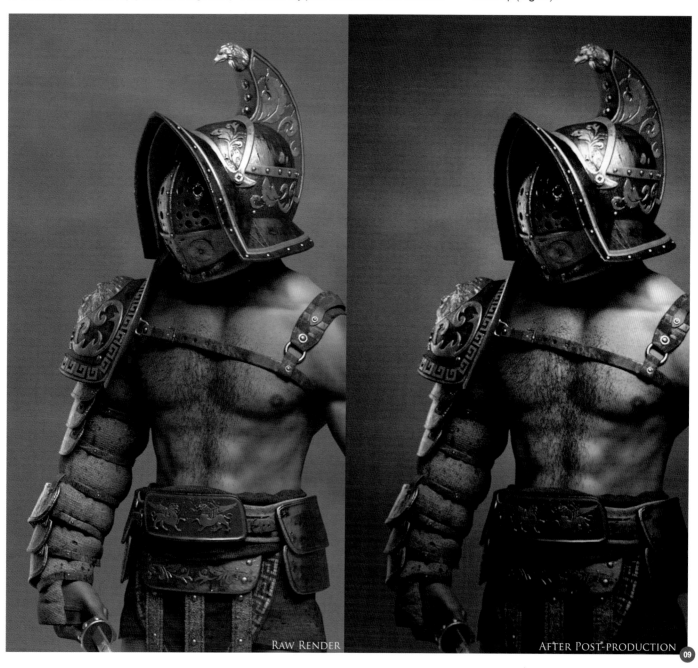

RAW RENDER

AFTER POST-PRODUCTION

09

CHARACTERS

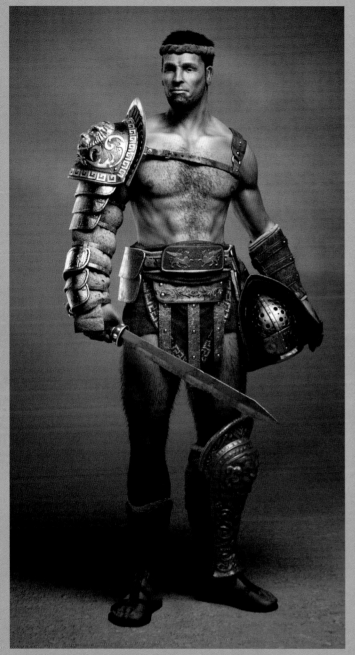
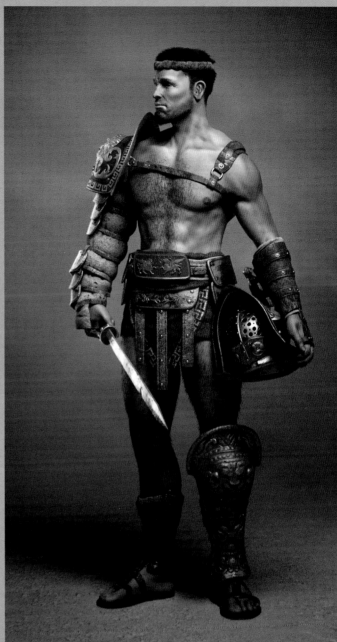

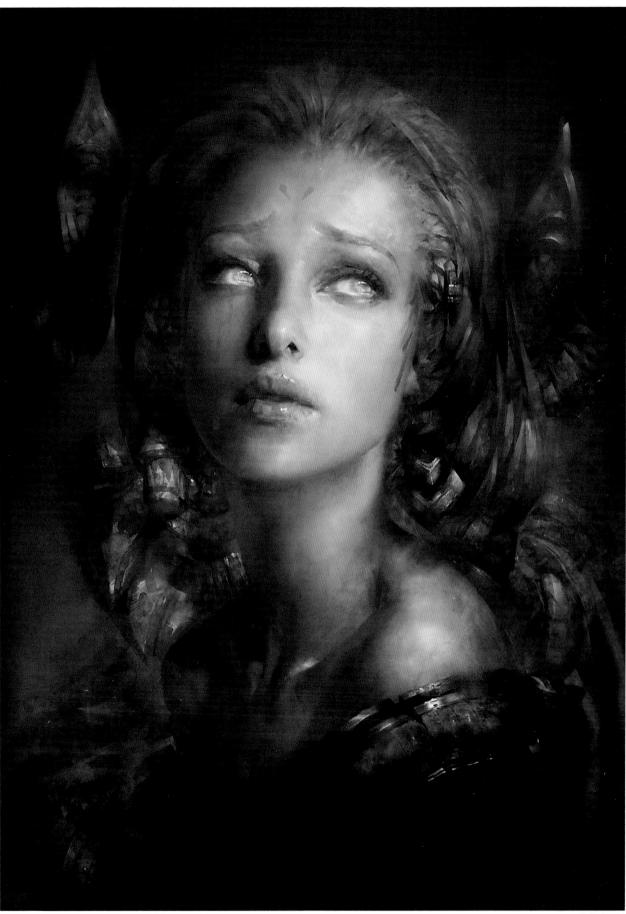

VANISHNESS
BY RUAN JIA

JOB TITLE: Artist at Volta Studios
SOFTWARE USED: Photoshop 8.0

CONCEPT

The character in this picture is a maiden who is constantly waiting for someone she loves to return and find her, but even after a long period of absence they are yet to appear. Despite this, she never gives up hope due to the everlasting love she holds in her heart. It is just this kind of feeling that triggered me to start drawing, and with this mood in mind I finished the first draft in a relatively short time (**Fig.01 – 02**).

MY PAINTING

The idea behind the picture comes from a role-playing computer game called *Planescape: Torment*. It is an amazing game, which interests me a great deal. When I discovered it in 2007, I was so impressed and became hooked. It really is a wonderful game, which I find fascinating, and I couldn't stop playing it. At that time I had to work during the day and had a lot of trivial stuff to deal with, so it wasn't until

very late at night that I was able to settle down and play, and I would usually play until early the following morning. I was totally enthralled whilst playing the game and was especially impressed by a character called Deionarra, a ghostly apparition. I'm not really sure why, but

perhaps it was because each time you met her the music in the background would become much louder.

Whilst trying to depict the idea in more depth, I came across some problems. Due to my

loose painting technique, I made repeated attempts to depict the face the way I imagined, but each time it proved unsuccessful. This is the most important part of the picture and so I made a number of studies starting from the fundamentals such as skull structure and then working on towards completing the face. (**Fig.03 – 05**). I sketched everything in black and white and over the course of one year, created a lot of drawings. I then continued to develop my image (**Fig.06 – 07**).When I got to picture **Fig.08** I decided to stop, but later realized that the orientation was not right, so I continued to make further adjustments. I finally came up with **Fig.09**.

Yellow and purple made up the main color scheme, but during the process I began to find it a little dull and so I added in some blue. In order to emphasize the purple I adjusted the saturation and darkened the values.

The earrings were intended to be shiny at first. However, after much deliberation I opted to reject the decision, because I felt that they might distract the eyes from the focal point, which was the face.

CHARACTERS

The most enjoyable part of the process was superimposing and refining the colors which gradually improved the image. My choice of brushes included Blur's Good brush and some Massive Black brushes. I used a transparent watercolor brush to overlay colors depending on the situation. Throughout the process I superimposed colors and subdued the light.

As mentioned earlier, the most painstaking part of this picture was the face. Since I wasn't able to find an appropriate model to refer to, most of the details and colors were conjured from my imagination. I often spent several days painting, only for the results to prove unsatisfactory and consequently prompt me to restart.

I hope this insight into my creation process has been interesting and given you some tips that you can apply to your own work.

ARTIST PORTFOLIO

© RUAN JIA

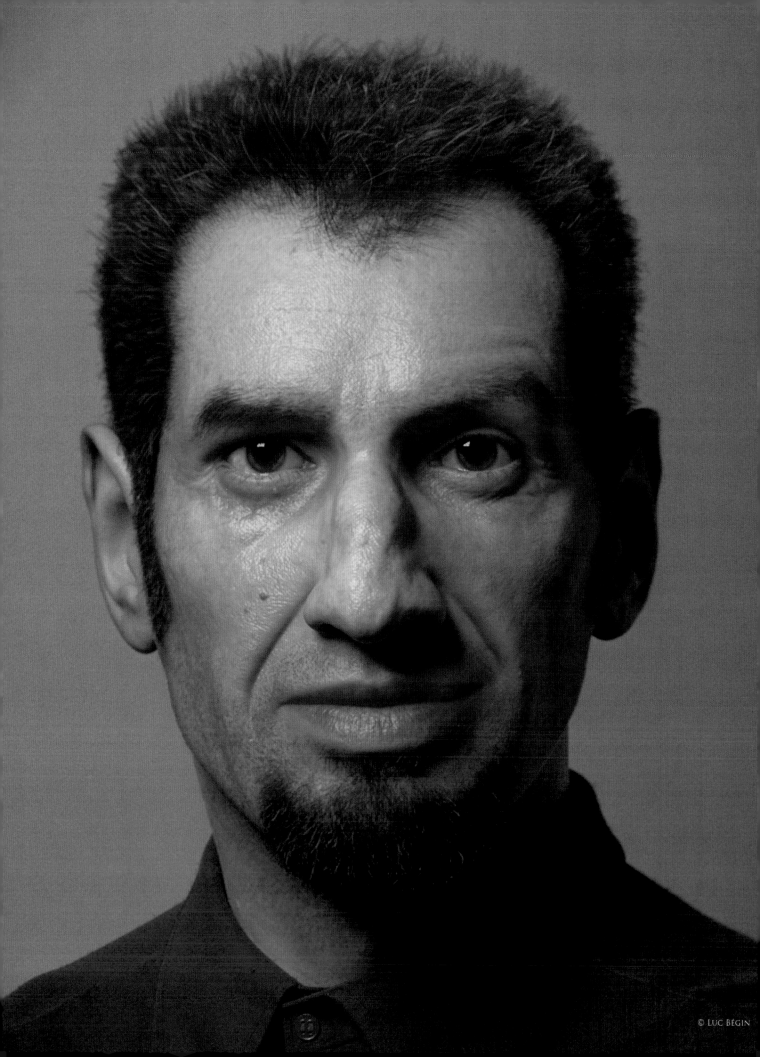

THE PORTRAIT
BY LUC BÉGIN
JOB TITLE: 3D Artist
SOFTWARE USED: ZBrush

INTRODUCTION

When I started this project, I did not think I would finish it. It was done simply as a skin shader test and a way of creating a realistic head, which meant doing it all by hand. I gathered some reference images for the model, but as opposed to replicating them I used them for inspiration only. I wanted to create someone that was not perfect, with imperfect-looking skin and face shape, and with a personality.

> **I THEN RECREATED THESE DETAILS MANUALLY WITH SPECIAL BRUSHES IN PHOTOSHOP, ADDING LITTLE VEINS AND SMALL REDDISH DOTS ETC., TO SIMULATE THE SKIN**

MODELING

I began to model a head, adding details in ZBrush and assigning different details to different layers, such as the main form, skin pores, cellular layer, wrinkles, beard, imperfections etc. That way I had full control over the maps in case I needed to make any modifications. I always sculpt the details and shapes in the highest subdivision and love to use Lazy Mouse and the Repeat option frequently (**Fig.01 – 03**).

TEXTURING

I tried the new V-Ray SSS2 shader, which is really good, and while testing it I made the Diffuse texture by hand (**Fig.04**). I started with a picture, first of all applying a Gaussian Blur in Photoshop to remove the skin pores (since I already had them sculpted and wanted to use them instead of the texture), and then removed the shadows, eyebrows etc (**Fig.05**). I then recreated these details manually with

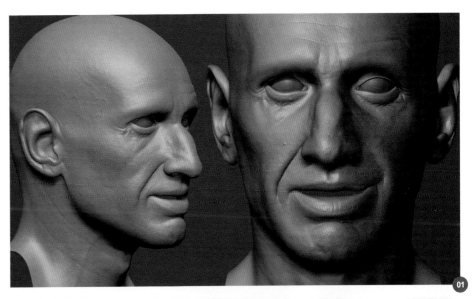

01

02

03

04

05

> ## ONE OF THE MOST IMPORTANT THINGS IS THE EYES. TO MAKE THEM LIFE LIKE, I HAD TO REDO THEM FROM SCRATCH SO THAT THEY MIMICKED THE MANNER IN WHICH LIGHT SCATTERS

special brushes in Photoshop, adding little veins and small reddish dots etc., to simulate the skin. I also created Specular, Reflection and Glossiness maps to control the effect of the skin's oiliness. I generated a Cavity map that I set to Overlay in Photoshop at a very low opacity so as to simulate a little occlusion on the pores. The Bump map alone was not enough so was used in conjunction with the Displacement maps to get the best result with the SSS2 shader.

I utilized a V-Ray blend material, which incorporated a V-Ray material in the second

slot for the Fresnel reflection and back scattering of the ears to give me more control.

One of the most important things is the eyes. To make them life-like, I had to redo them from scratch so that they mimicked the manner in which light scatters. The eye socket is also very

important, with some little details that need to be apparent. The eyes are very complex and everything needs to fit together in terms of color, reflection, eyelashes etc.

I used HairFarm for the hair and beard, which is a very nice plugin for 3ds Max. It's so fast

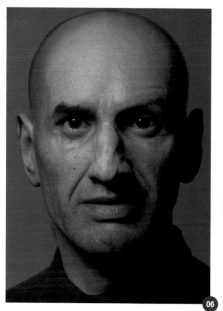

06

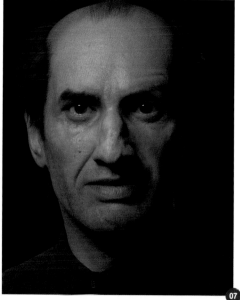

07

CHARACTERS

that I was able to do many different haircuts in a single day. It is not only maximized for the Scanline renderer, but is extremely swift and of a high quality. I simply had to match the lighting and render it separately. I rendered out just the hair, and for the shadows and scattering of the skin I reproduced a spline version of the hair which cast shadows, but was not visible to the camera (**Fig.06 – 08**). To do this, I went into the properties of the hair splines, ensuring they were invisible to the camera whilst keeping the "Cast Shadow" box active.

> *I always work in a linear way and try to avoid Global Illumination while working with the SSS2 shader*

LIGHTING

The lighting was straightforward, involving just two V-Ray lights and no Global Illumination as I wanted to emulate the high contrast of studio lighting (**Fig.09**). I always work in a linear way and try to avoid Global Illumination while

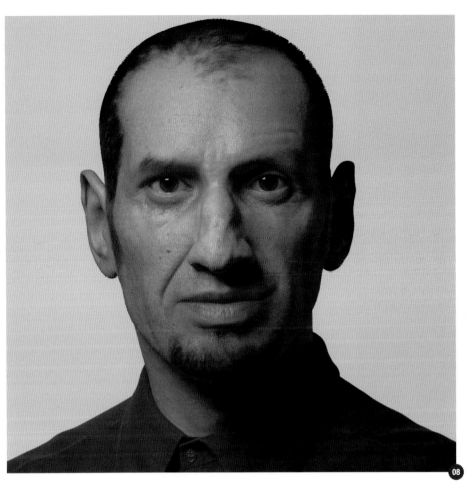
08

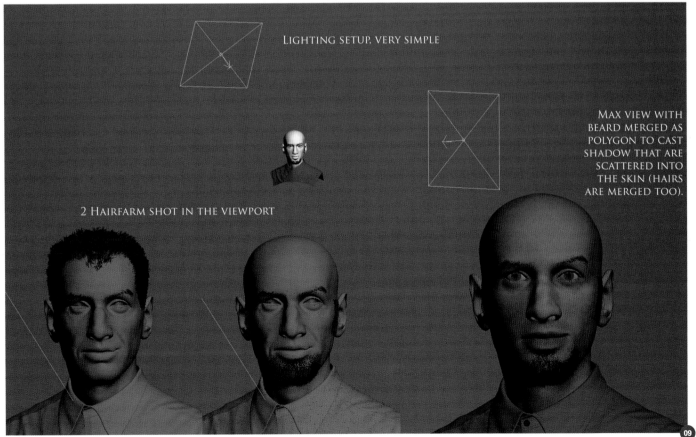

LIGHTING SETUP, VERY SIMPLE

MAX VIEW WITH BEARD MERGED AS POLYGON TO CAST SHADOW THAT ARE SCATTERED INTO THE SKIN (HAIRS ARE MERGED TOO).

2 HAIRFARM SHOT IN THE VIEWPORT

09

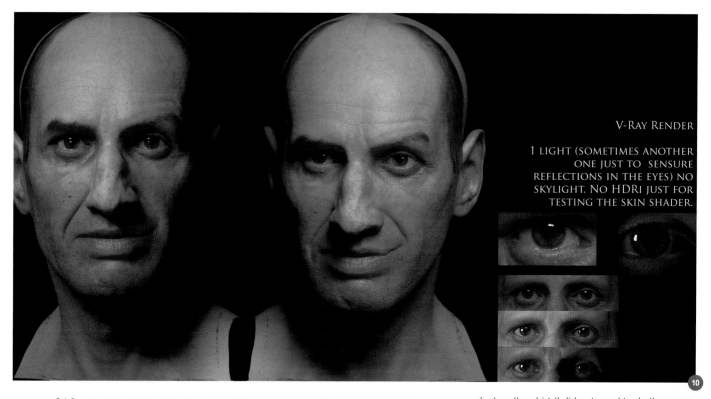

> ## WHILST TESTING A NEW WAY OF CREATING REALISTIC FACES, I DISCOVERED THIS METHOD AND WILL CONTINUE TO DEVELOP IT WHEN I WORK ON MY NEXT MODEL.

working with the SSS2 shader. If you want to scatter the indirect light, you need to activate it within the shader, but render times are increased, hence I try to avoid it and simulate it with V-Ray lights (**Fig.10**).

POST-PRODUCTION

Afterwards, in Photoshop, I composited in the hair and all was looking good (**Fig.11**). I followed the same procedure for the shirt, but used the hair pass and shadow pass of the

dust on the shirt (I did not need to do the same for the head because there is no scattering in the cloth). For the final image, I played with the levels in Photoshop to fine-tune it.

Whilst testing a new way of creating realistic faces, I discovered this method and will continue to develop it when I work on my next model as I learned a lot from this amusing personal project.

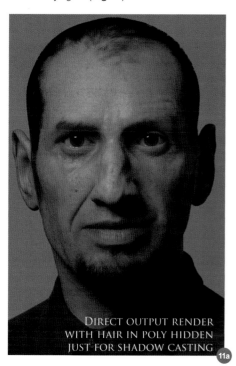

DIRECT OUTPUT RENDER
WITH HAIR IN POLY HIDDEN
JUST FOR SHADOW CASTING

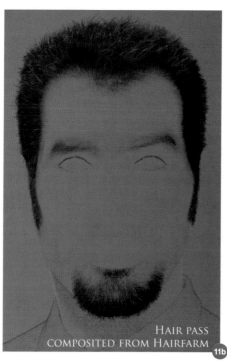

HAIR PASS
COMPOSITED FROM HAIRFARM

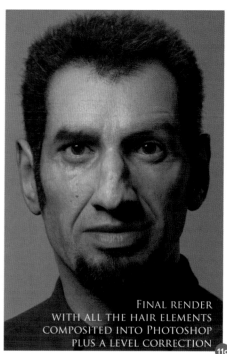

FINAL RENDER
WITH ALL THE HAIR ELEMENTS
COMPOSITED INTO PHOTOSHOP
PLUS A LEVEL CORRECTION

CHARACTERS

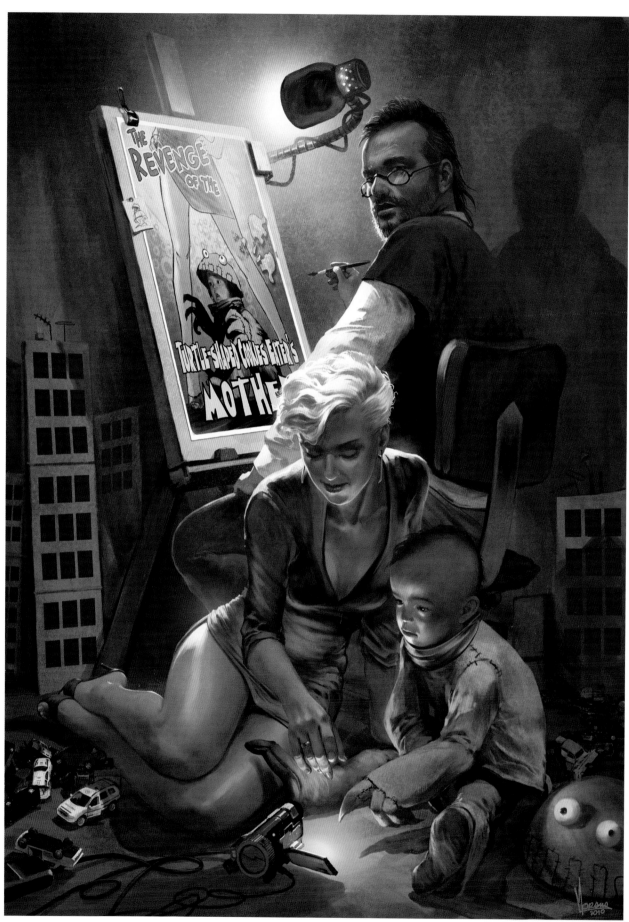

9 SQRM PRODUCTION
By Tomasz Jedruszek

JOB TITLE: Freelancer
SOFTWARE USED: Photoshop

INTRODUCTION

I am excited every time CGSociety announces their new challenge, as it is currently the best way to both express yourself as digital artist and get tons of new experience. Plus a world class jury guarantee your art will be fairly judged and individually viewed. In view of this there was only one thing left to do, which was to give it my best shot... and win!

> ❝ THE MOST DIFFICULT, AND YET MOST IMPORTANT, ASPECT THAT DICTATES THE SUCCESS OR FAILURE OF ART IS THE IDEA ❞

This challenge required artists to paint an image resembling early 50-60s low budget B-Movies. At first it seemed simple, as with most CG challenges, but I soon realized how tricky and difficult it really was. Of course, the simplest approach was to paint some kind of a creature from outer space and throw it in a town with streets full of pedestrians. This would be easy, but would it be enough to win the challenge? Well, maybe, but I doubt it. Remember, those guys back in the 50s had a totally different vision of the future and space and hadn't been to the moon yet! The creatures they created were unique in their own way and it would demand a tremendous effort to design monsters with a similar impact today. It would be easy to create a ridiculous and inferior version of a pre-existing concept, which is why I dropped the idea and tried to tackle the subject from another angle as I always do in my challenges.

APPROACH

The most difficult, and yet most important, aspect that dictates the success or failure of art is the idea. A brilliant idea determines whether

the audience acknowledges you or not. As I said, I decided to take a totally different approach, so it took me quite some time to evolve a brilliant idea that was different from other entries. Something that was original, powerful, and yet still set in that B-Movie mood – maybe even funny or a little scary. Then I found an image on the internet. It was of a smiling child as he sat by the feet of his mother, who was standing next to him.

That was it; I had my idea! From this single picture I was able to build up my entire story

and finally generate the motivation and atmosphere to proceed. As I said, it takes time but is critical for the success of your work. It is a little arrogant to always pay compliments to oneself, so I will only share with you one example of a previous CG challenge called "Icarus Day ". It followed the same methodology and approach, which is what made it so powerful and successful. The painting itself wasn't polished or detailed, but the story and idea carried emotions strong enough to win over the jury. I didn't know how my *9 sqrm Production* would end, but the point

is that with a good idea an image is already successful, if not to the world then at least to myself as an artist.

STORY

Why did this photograph catch my eye? Well to be honest, at first it was the magnificent legs – but then I liked the relation between the two characters. On the one side we have an adult, probably a strong independent woman, and on the other we have a fragile child playing on the floor with a very different perspective on the world. There was also a protective feeling to the picture as the women stood above the child. Even though I am unaware if she is his mother, my first impression was, "Here's Mummy!" and this was something I wanted to include. It is possible to see innocent play in a catastrophic context, and I did observe this once. Whilst playing, my son will rip the heads off LEGO miniatures or throw die-cast cars around the house and occasionally even manage to wrench their tires off using his teeth. He usually screams during all this, but remarkably is still able to eat cookies shaped like safari animals (his favorite being turtles). Consequently I decided to go into his world, where he assumes the role of a "giant monster", spreading chaos and destruction within a toy world. At this point I decided I would also portray his mother as an even more terrifying "monster".

From the very beginning I planned to take part in both the image and movie categories. When I had this idea I already had a concept for the movie and had decided to tell the story of a little monster and his mother. I would then show a small team creating the B-Movie poster for the image category (**Fig.01**).

After realizing I would not be able to finish the movie picture I was afraid my image would not work anymore, so I made a few changes and included a few clues so I hope it is clear now. Obviously it is not telling the story as deeply as the movie picture would, but I hope I made the poster interesting and fun enough to hold viewers' eyes for at least a second (**Fig.02**).

> DO NOT BE AFRAID TO MAKE CHANGES; AFTER ALL, THIS IS THE REASON FOR SKETCHING. IT WILL SAVE TIME TO MAKE ADJUSTMENTS NOW RATHER THAN LATER

TECHNIQUE

Starting with a loose sketch, the most important thing is to plan the composition and body postures to avoid them looking stiff. It's important to pay special attention to perspective, as it is tricky to show correctly and can easily ruin your pose. To avoid this trap you should translate your figure into basic solids, making it easier to achieve the correct perspective and proportions. You will, of course, need to be able to visualize 3D space and simple geometry to do this, but I assume you already posses these basic skills. I remember drawing circles in countless perspective views during my studies, which was both painful and boring, but after all those years the hard work has paid off. I am now able to pose my characters however I like and change them in seconds without the help of 3D applications. I can make construction sketches almost entirely in my mind and see these construction lines during the entire process.

At first it might look terrifying, but when you look closer you will realize it is all about the axis getting shorter when changing the point of view. When one axis gets shorter all other dimensions in the same direction get shorter too –simple (**Fig.03**).

Do not be afraid to make changes; after all, this is the reason for sketching. It will save time to make adjustments now rather than later when it is finished and polished. When this was finished I added a contour, which is something I usually don't do, but I was trying to give it a 50s movie poster feeling.

After I had created the line work I cleared the construction lines, but kept the layer to use again later. I then added the color. This is not my regular way of working as I usually block in the composition in color, but this approach suits the comic book style (**Fig.04**).

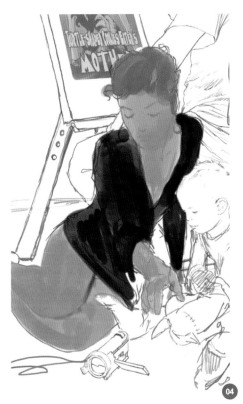

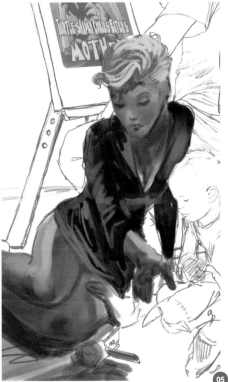

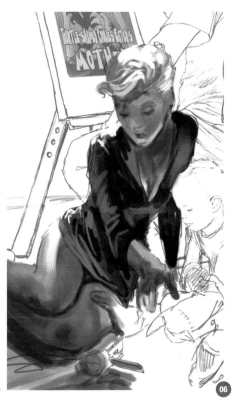

I now added volume to the shapes by way of shadows and lights, using the construction lines as a guide to check the position of the bones (**Fig.05**).

Of course this is only a rough account of the process, as I never record my work. I work too fast to think about capturing it, but I hope you can grasp the idea. Mixing colors, translating

color palettes into shapes, painting curves and gently smoothing etc., is something you learn over the years, picture by picture. Skills improve slowly over time through the hundreds, as opposed to dozens, of art projects. If you wonder how I did it, I can provide this answer: you just need to be patient, work hard and eventually you will find yourself doing things almost automatically. Naturally you are not

obligated to understand every bone and muscle and how they react with light; there are countless possibilities and so obviously you will require some reference. If you have a beautiful wife that can be fun, but if not you can still use photos. Be mindful however, as painting from reference images is much more difficult than from real life as it requires more artistic imagination (**Fig.06**).

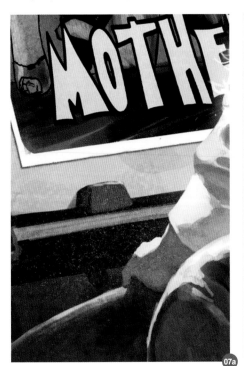

Finally I injected some life into the picture by way of a few strong highlights using a brush set to Color Dodge. I placed the strongest highlights in the air to suggest dust etc., which gives the environment a lived-in quality and also adds depth (**Fig.07a – d**).

And there we have it! Sounds easy and fast! For me it is, but years ago when I decided to go professional I promised myself never to give up all the pleasure and fun I get from painting (**Fig.08 – 09**).

I hope you enjoyed this short article. It was my primary goal to avoid discussing the painting itself too much; as I mentioned earlier, this is ultimately a matter of your individual approach, patience and self-determination. However I believe most of you will read this article as a tutorial to help in your own work and that is why I focused more on the "theory". Make your art as disturbing, dynamic, universal and eye-catching as possible as this will attract more attention from viewers, as well as present more job opportunities. When you dedicate yourself as much as possible to work, it is just impossible to fail or remain unnoticed. Have great fun with your work and good luck in your career.

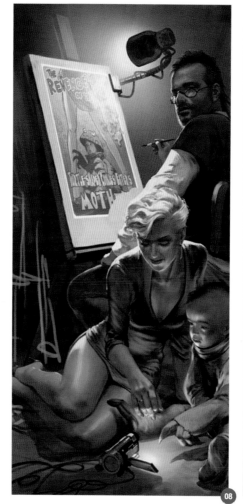

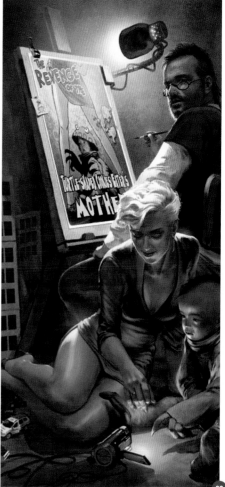

CHARACTERS

@ Tomasz Jedruszek 2010

RICOCHET
By Loïc e338 Zimmermann

JOB TITLE: Concept Artist – Character Lead at Luma Pictures
SOFTWARE USED: Photoshop and Painter

INTRODUCTION

Considering the lack of step-by-step images on my hard drive, and the fact that I am out of new ideas for a novel, I was having a hard time writing anything about this image. Then, thinking again, I realized that it was one of the most "popular" images I had at a solo exhibition last year. Size mattered and since it was designed for print, I'll provide you with anecdotes as we scroll along the surface of the image. Hopefully you'll find bits you like, or get to understand what I had in my mind at least.

During the last few years, regardless of if it's been sci-fi, landscape, more abstract or purely illustrative, I've been blending the genres and constantly looking for new ways to mix them all together. I'm searching for something; I don't know exactly what and to be honest I'm not sure that I even care. The quest is genuine and I want people to enjoy spending time looking at my images.

After analyzing what I personally like I've started to go down the route where the subject and its form encourage you to come back and look again. Do you ever come back to an image not only because it's technically mind-blowing, but mostly because it triggers something in you? When you can see where the artist had fun and where he's playing with you it reveals part of the process behind a painting. This forms part of its appeal and is where I hope to find a good balance.

MY PAINTING

Ricochet started from a collage of ideas incorporating sci-fi, illustration, jumping brunettes and kicking robots! One day, on my way to work, I shot a photo of a ruined electric thingy next to a gas station (**Fig.01**). It was morning, I was looking at it from a distance and with this foggy head of mine I thought: robot!

Whilst browsing the internet, I noticed a picture of a chick skateboarding. The pose was fun, extreme, very tense and inspiring. I combined these two ideas and they slowly mutated into this "frozen-in-time" moment where the character is jumping on some strange, ill-defined 14ft tall metallic thing.

When working on the image my focus was not to make it real, but rather to push things such

as light, surreal illumination and the material feel. Since I'm self-taught in everything, I have a lot of weaknesses and am still learning with every new image. Again, realism wasn't my thing when doing 3D. It still isn't now that I'm back into 2D. That, however, doesn't mean you should misunderstand the principles behind realism.

Compositionally the image is built along a diagonal and develops into a spiral (**Fig.02**). I wanted the eye to roll around the image. By juxtaposing blocks of colors, patterns and highly figurative things, the eye always has something to hold on to on its path. The clouds are almost used in the way they would be in tattoos. They blend things together, but they're also the link between what is flat and what has depth (**Fig.03**).

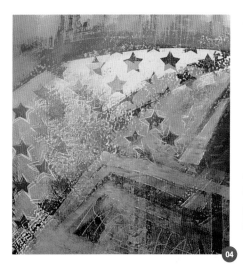

"I DON'T PLAN MUCH,
I REACT. CLIENTS
PRETEND THEY HAVE
PLANS. MY JOB IS
TO DESIGN STUFF
ACCORDING TO THE
PLANS"

I used stars as a graphic motif (**Fig.04**). They were applied in a purely freestyle and wallpaper fashion along the top part, becoming part of this yellow mass; a sort of a body that has escaped from a Cubist piece, almost Suprematist in actual fact. Gosh, I don't think about those references when I work – that'd be pompous!

Patterns found their way onto the socks of the character, as did the classical signature of the shoes (**Fig.05**), the Japanese fabric in the dark collar on the robot (**Fig.06**), and the bright stars at the top. It's about keeping the eye well nourished.

I don't plan much, I react. Clients pretend they have plans. My job is to design stuff according to the plans. Banks have plans (well, they thought they had). Bad guys and boring people make plans. When it comes to me, I use every single bit of chaos I can find to create things instead of repeating the same routine over and over. There's no plan, that's my plan.

Most of the time, for every bad image there's a few potential average ones. I'm not talking about taste, but rather spending five seconds in front of a bad image where you wouldn't even stay for two. I believe that the last piece of advice I offered in the last *Digital Art Masters* book was about composition. The new advice is composition. *Ricochet* could have been a purely sci-fi image if I had chosen to frame it differently. Not that that's a bad thing, just

saying. Then it's colors, masses, lightness and darkness. I wince a lot when I work, mainly because I'm angry, but also to get the essence of the image. The blotch you see when you wince at your work. Is it cool or is it just a blotch? It should be sexy, rich, confusing and crazy. So I calibrate my use of colors and light according to that principle as well as the inner realism of the elements I'm depicting. You need to find a balance, but you don't want to even everything out either.

One thing that I've been working on forever is the textural aspect. It was always an obsession of mine and I try to reach a balance these days and treat it with the same rhythm that I do the rest of my work. Some areas feel like raw paper and ink, others have the density of an impasto or perhaps an acrylic on wood. In the real world I add a varnish to enhance some textures.

Those are the things I have in mind when I work; the things that matter to me and the things I can relate to. It's like facing a table with lots of pens, pencils, colors and paper. An infinite palette of cool things you can play with. What works with what? And what if I move this over there?

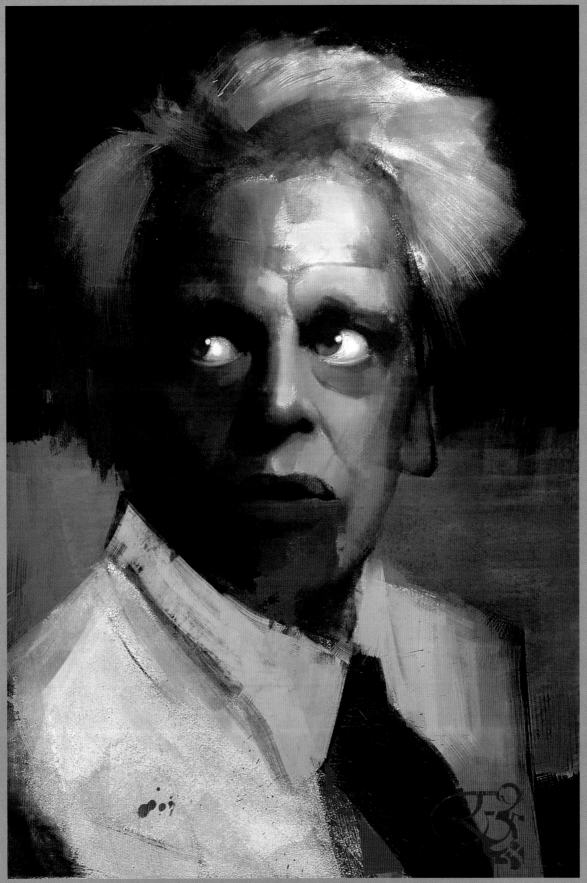

CHARACTERS

Red Fox
By Marta Nael

JOB TITLE: Illustrator and Concept Artist
SOFTWARE USED: Photoshop CS4

Introduction

To understand the reason behind this image, I have to declare my full admiration for the Impressionist movement. At school and university I was always told my work could be described as a "game of light and color". Maybe I fell in love with Impressionism due to that, since it seemed it was really similar to what I enjoyed doing in my traditional works. I decided that I should try it out and apply this same technique to digital illustration, something which turned out to be a great means for improvisation and acquiring even more knowledge of color.

Before starting this painting, I had already begun a "femme fatale" series of mysterious and seductive women whose charms ensnare their lovers in bonds of irresistible desire, often leading them into compromising, dangerous, and deadly situations. My goal was to put these two facts together: digital impressionism and the femme fatale. I took some photographs of myself as reference for the pose. I didn't want a realistic scene, but to preserve a sketchy and impressionist feeling, full of color and emotion.

> **I TRY TO FORGET ABOUT THE SUBJECT I'M PAINTING. I'M MOSTLY CONCERNED ABOUT GETTING AN ABSTRACT FOUNDATION FULL OF TEXTURE AND LARGE STROKES**

My Painting

I created a new file that was big enough for what I was aiming to use it for afterwards. I always display at 300dpi as I never know when I may feel like printing an image someday. I started by filling the whole background layer with a solid neutral color, which was neither dark nor too bright, and that would logically fit

CHARACTERS

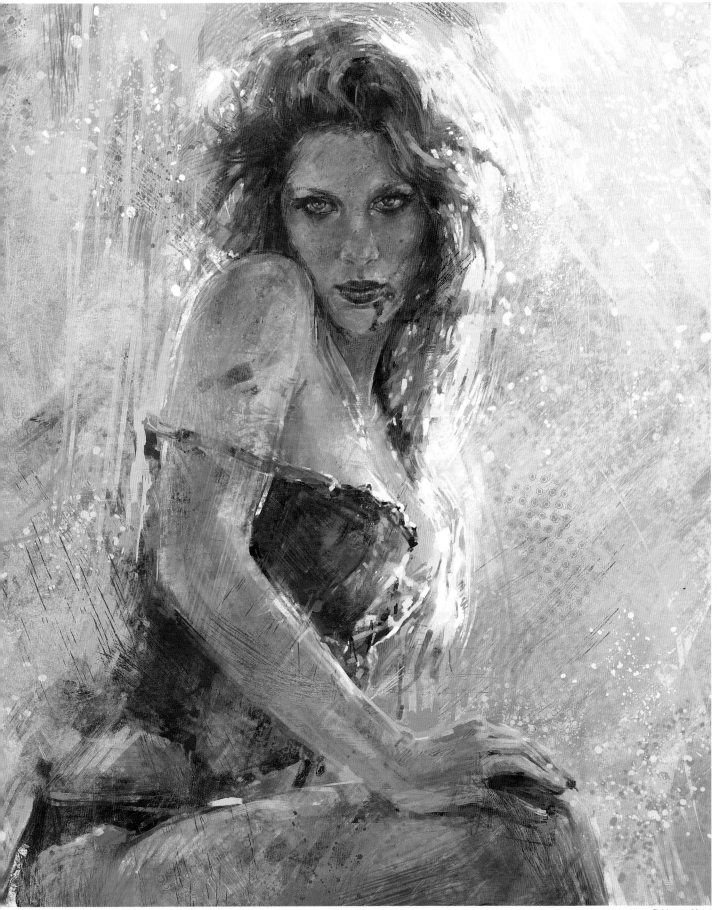

© MARTA NAEL

CHARACTERS

the color scheme for the piece. I usually tend to paint from dark to light, which means the initial flat color and the first strokes should be darker than the palette for that piece.

Unlike many artists I don't like starting with a line sketch. I think this is something which I learnt at university whilst doing my fine arts degree. I spent about eight hours a week painting nudes, and I found myself always starting by shading the whole canvas with a neutral color before moving on to defining surfaces by adding color. I don't feel comfortable using previous drawn line work that I then have to apply color to, because I feel the detail involved in the sketching distracts me and makes it difficult to preserve the freshness and painterly feel that I strive to achieve.

So I always start by adding some strokes, spots and indefinite forms to a new layer, using several custom brushes and erasers with some texture, to block in the whole scene. Throughout this stage, I try to forget about the subject I'm painting. I'm mostly concerned about getting an abstract foundation full of texture and large strokes. It's really useful to have a big library of textures to browse through. For this image I picked some and tried several layer modes to see which one created the coolest effect (**Fig.01**). The painting at

> ## IN ORDER TO USE VIVID COLORS YOU NEED TO LEARN TO SEE AN OVER-SATURATED REALITY AROUND YOU

this point provided a rough template to work with. Consequently, the background and initial strokes were used as a foundation to build surfaces by adding light and color (**Fig.02**). Once I got an abstract foundation, I went about roughing out the general shapes and slowly bringing out the forms. It was now that I began to paint in accordance with the reference image. However, at this stage, my aim was not to explore details but to improvise and experiment with large and different types of strokes. It's good to explore different possibilities along the way, since it often leads to interesting and happy accidents (**Fig.03**).

It's useful to establish a preliminary chromatic palette with the brightest and most vivid tones of the whole color scheme you have in mind (**Fig.04**). In order to use vivid colors you need to learn to see an over-saturated reality around you. If you see a gray surface you've always

got the possibility of interpreting it as a "blue-gray" or as a "red-gray", which in turn will make you decide which direction you want to take and paint with a light blue or red, rather than a boring shade of gray. This results in an image with vivid colors and dynamic lighting that brings the essence of the piece to life.

At this stage of the painting, I tried to make it look as similar as possible to the reference image, but merely suggested detail, painting with vivid and saturated colors and using brave, long strokes. At this point of any image, the composition, lighting and mood you create will very likely stay with you until the end, so you must pay special attention to it rather than

invest time in details. It's important to paint from a distance and not zoom in too close. I also avoided adding border lines and focused on painting surfaces and shapes (**Fig.05**).

One thing which I think is really important to mention is that I usually treat the character just like the background and paint everything at once. To the eye, there's no difference between the colors you have in the background or in the character. To keep the Impressionist style I try to define surfaces with thick strokes, and just add some border lines at this later stage in order to clearly separate the character from the background (**Fig.06**). I also tend to add some lines to the background around the character to

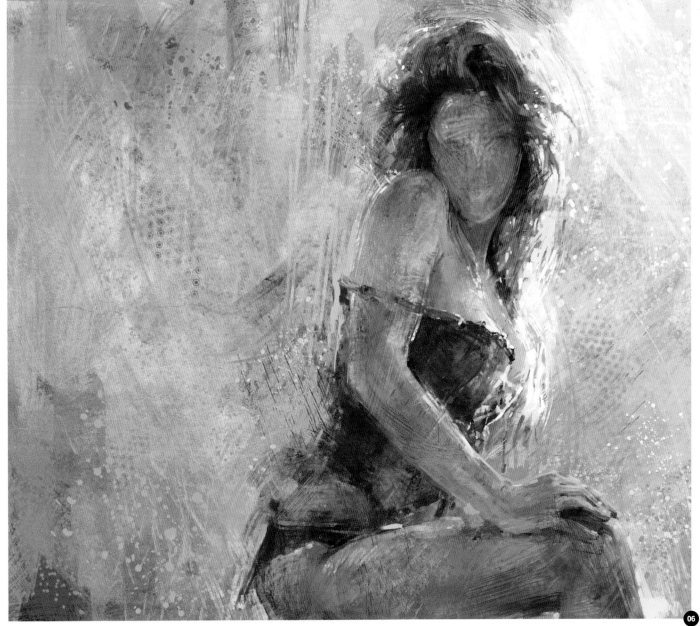

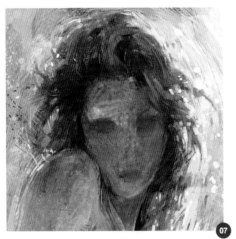

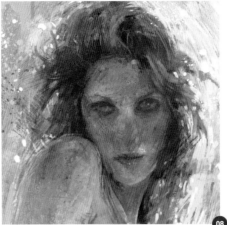

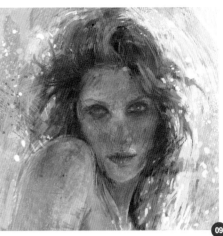

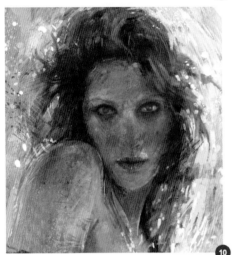

improve its contrast and definition. In addition, I also like to add splatters and speckled strokes.

In **Fig.07 – 12** we can see how I started building up the face. I like spending more time working on the face since, to me, it is the most important part of a character and provides all the emotion. At this point, I had to zoom in a lot to add in the details. I decreased the brush size, but continued using textured brushes to keep it rough.

> SINCE THE BACKGROUND WAS TOTALLY ABSTRACT, IT WAS NECESSARY TO INTRODUCE SOME COMPLIMENTARY COLOR TO HELP PULL THE CHARACTER AWAY FROM THE BACKGROUND AND ACHIEVE A SENSE OF DEPTH

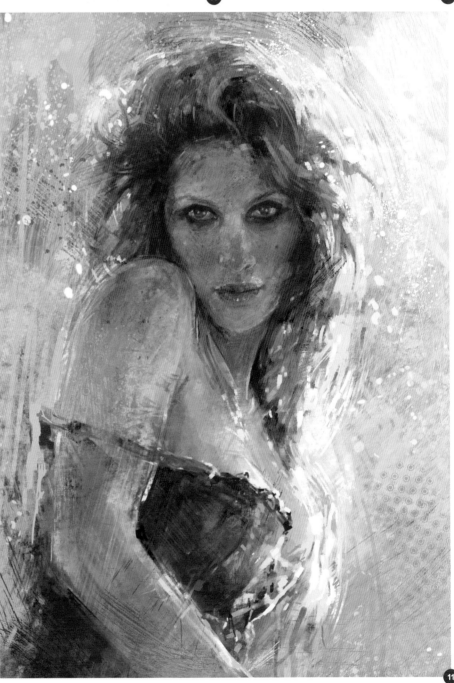

CHARACTERS

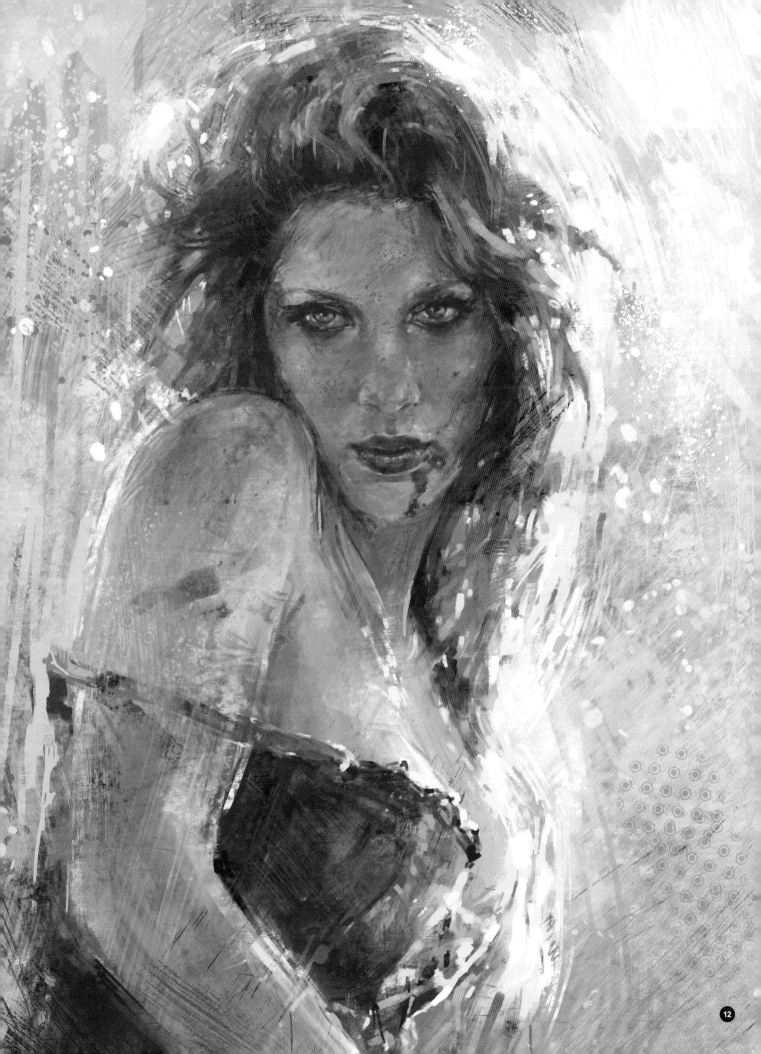

I was pretty close to the final image now (**Fig.13**). Since the background was totally abstract, it was necessary to introduce some complimentary color to pull the character away from the background and achieve a sense of depth. I like to add a thick stroke of one solid color, like the yellow one you see on the left and some thinner strokes. In this case, the colors I used the most were orange, red and purple. Eventually I used yellow instead, which is the complementary color of purple (**Fig.14**).

Once happy with the picture, I flattened all the layers from the top. In the resulting layer, I finally used the Sharpen filter as this helped to improve the overall look of the final image.

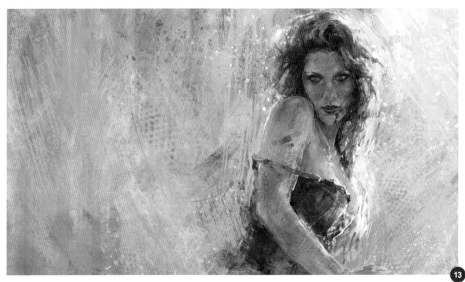

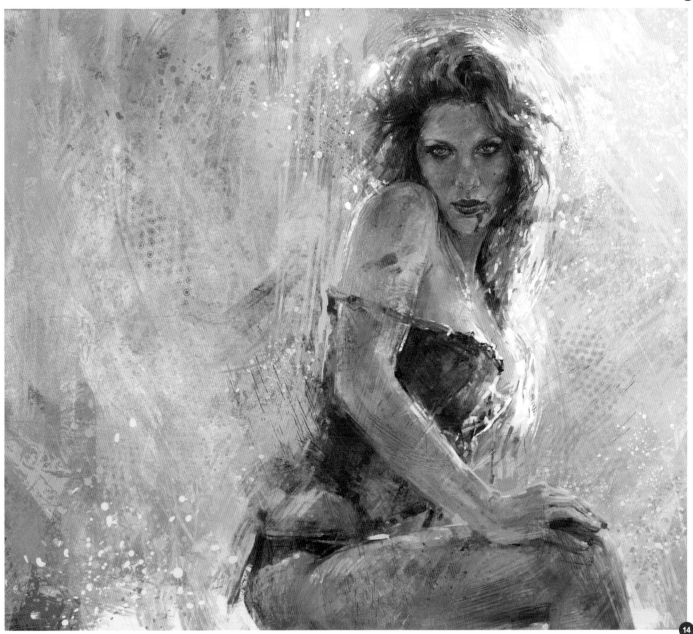

CHARACTERS

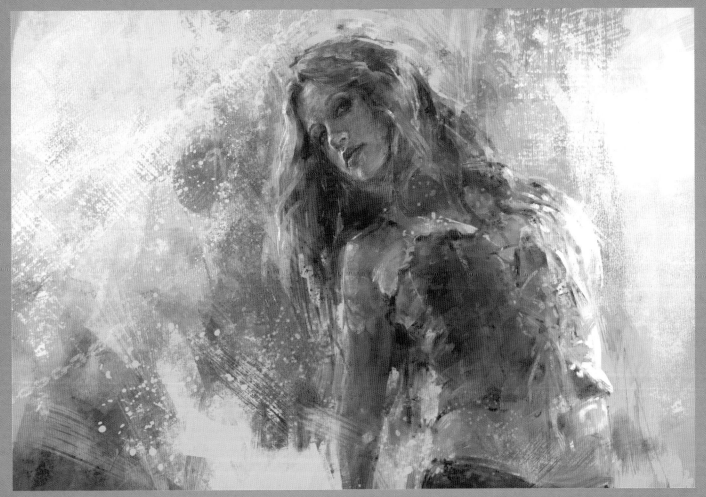

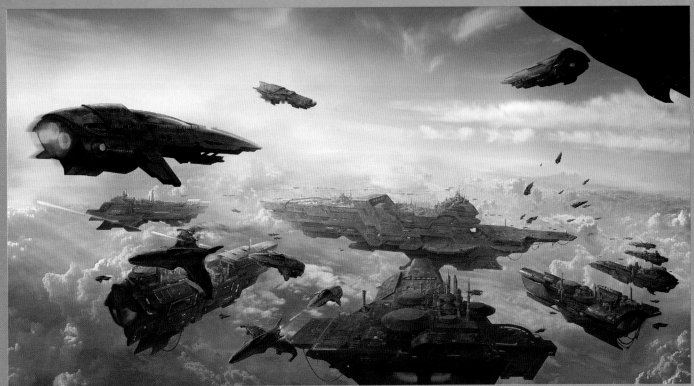

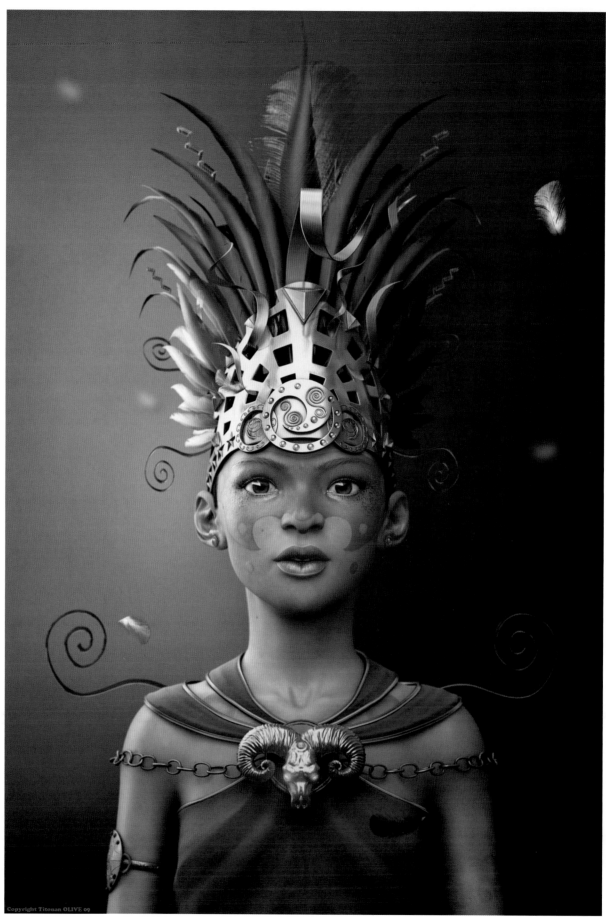

YOUNG PRINCESS
BY TITOUAN OLIVE

JOB TITLE: Freelance CG Artist

SOFTWARE USED: Maya, mental ray, ZBrush and Photoshop

INTRODUCTION

When I start a new project the first thing I do is sketch my ideas down on paper (**Fig.01**). I like experimenting with different ideas and it's better to do that in 2D first, since it's much faster than in 3D. I wanted to create an original young girl with an elaborate hairstyle and make-up, something colorful and detailed with some mysterious elements, aiming towards a particular and charismatic mood. I always try to create an original concept even if using obvious references for inspiration and to keep my work solid and accurate. There's no use spending too much time on this stage though since I'll develop and improve the idea along the way.

MODELING

When I was happy with the concept I opened Maya and started by creating the base mesh. As with all my characters I kept everything as clean as possible. I am always thinking about animation and take this into consideration when I build a base mesh. I was not planning to animate this character, but if I ever wanted to it would be possible without causing any problems. As a consequence of this way of thinking I take great care over the edge loop placement. As you can see on the wire, I placed the edge loops around the mouth and the eyes (**Fig.02**).

> ## I FOCUS ALL MY ATTENTION ON THE MAIN SHAPE AND BUILD EVERYTHING FROM THIS BASE.

Another big advantage with logical edge flow is that it will help you later to make nice UVs, and the sculpting process will also be easier. Since I was going to sculpt this character in ZBrush I kept all the polygons in quads.

Once my base mesh was finished I exported it into ZBrush and started the sculpting process. Before I had done this I searched for several references on the internet and in books. When starting to sculpt I focused all my attention on the main shape and built everything from this base. If the basic shapes are not good, the detailed model won't be good either.

With the overall shape defined I started to subdivide my model, blocking in areas like the mouth, eyes and nose. As I sculpted I also tried

to create the feeling of there being bones and muscles under the skin. When modeling I often look at references gathered earlier and have my sketch attached just above my screen to help me as I work.

A young girl is not easy to sculpt and small changes can dramatically alter her appearance and age, which is why a few subtle tweaks can make all the difference. Proportions are also very important here. Since she's young her face is fairly clean and so the only details I added were pores, some relief on the make-up and some subtle skin imperfections. I also broke up the symmetry to create a more natural look (**Fig.03**).

When I was finally happy with my model, I exported the low res mesh into Maya and worked on the UVs. This part can be a bit boring, but is nevertheless important which is why I always take care to unwrap it in order to produce clean UVs with as little distortion as possible. When it was done, I then went back to ZBrush and imported the low res mesh with clean UVs. The base meshes for the clothes and skull pendant were done in Maya and then imported into ZBrush to be sculpted (**Fig.04**).

The crown was done entirely in Maya using hard modeling techniques as sculpting would not add anything here. The other elements were created in the same way (**Fig.05**).

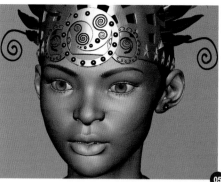

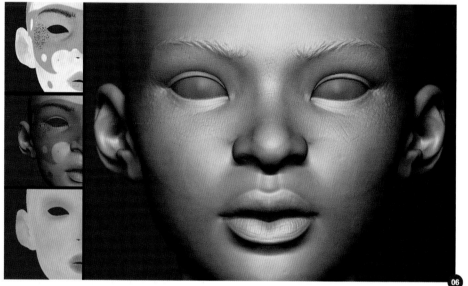

Texturing
I started the texturing process in ZBrush, using poly-painting, by trying to find a good skin tone and block in the main colors. When the moment came to ramp up the details I transferred the color information into a texture and continued in Photoshop, adding the finer details. All the textures are hand-painted using this same method (**Fig.06**).

Rendering
For the rendering I first positioned my lights and carried out some render tests without any textures. This helps you to see the impact of

> THE EYES ARE A VERY IMPORTANT AND PARTICULAR PART OF THE FACE. THEY CAN EXPRESS MANY THINGS, AND ARE AN ASPECT THAT REQUIRES A GREAT DEAL ATTENTION AND MUST NOT BE NEGLECTED

each light on the model. When I was happy with the lighting I added my textures and tweaked the shaders (**Fig.07**).

It was during this stage that I noticed some of the textures needed to be tweaked (too much or not enough specular on some areas for example) and consequently I made some final adjustments in Photoshop, alongside the addition of some finer details.

The eyes are a very important and particular part of the face. They can express many things,

and are an aspect that requires a great deal attention and must not be neglected (**Fig.08**).

Once happy with the final look I rendered out several passes in high res and composited them in Photoshop, in order to have more control over particular areas and develop the final image. I kept the background simple since all the attention needed to be focused on the character (**Fig.09**). I finished by making some color corrections and adding some blur and soft noise, which concludes this article.

As an afterthought, and if I had to offer some advice, I would say always think before you create a character. Think about originality even when you create something that has already been explored by many other artists before you. Try to keep a style (yours) and try to add something unique to your work. Look at things with an artistic eye and also rely on your imagination. Keep your mind alert and always remaining open to experimentation. I believe this will always make a difference.

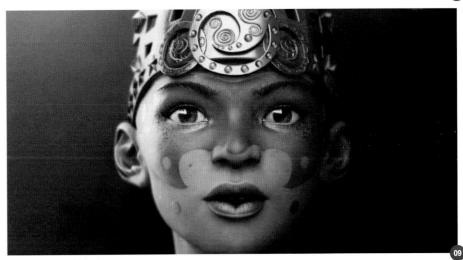

ARTIST PORTFOLIO

ALIEN TAKO SASHIMI

BY SERGE BIRAULT

JOB TITLE: Illustrator

SOFTWARE USED: Photoshop

INTRODUCTION

This is my second picture of Maria Gibson, a lovely Swedish model, a good friend of mine and now, my Egeria. Maria is a big fan of science-fiction movies which is why I chose to go with that theme for this image.

MY PAINTING

It was not my first idea (which was funny, but very complicated to do) although I retained her face because I liked her expression (**Fig.01a – b**). Once again, I slightly deformed my character as I am more concerned with curvature as opposed to realism.

> ## THE GIRL WITH THE BIG GUN KILLED THE ALIEN, CUT UP ONE OF HIS TENTACLES AND ATE IT AS SASHIMI

My method is always the same. I add a tint area, create the volume with a basic brush and then blend all the colors with a soft round brush (airbrush) with a very low opacity. I create a lot of layers during the process and merge them

frequently. I always work with a large format (at least A3) and a high resolution (300 dpi).

The composition was one of the most important parts of this illustration, which had to tell a little story (**Fig.02**). The girl with the big gun killed the alien, cut up one of his tentacles and ate it as sashimi. It's a very simple story, but I needed to create a lot of elements and organize them wisely.

> ❝ I MADE THE NIGHT GOGGLES A VERY REFLECTIVE PLASTIC MATERIAL WITH REFLECTIONS THAT WERE, OF COURSE, WRONG, BECAUSE THEY LOOKED BETTER LIKE THAT ❞

One problem to consider was the silhouette of Maria and the alien; with so many details, I had to create enough contrast in order to keep my picture coherent.

I found a lot of references on the internet as I'm not particularly familiar with military stuff. I don't think this kind of shiny outfit would be

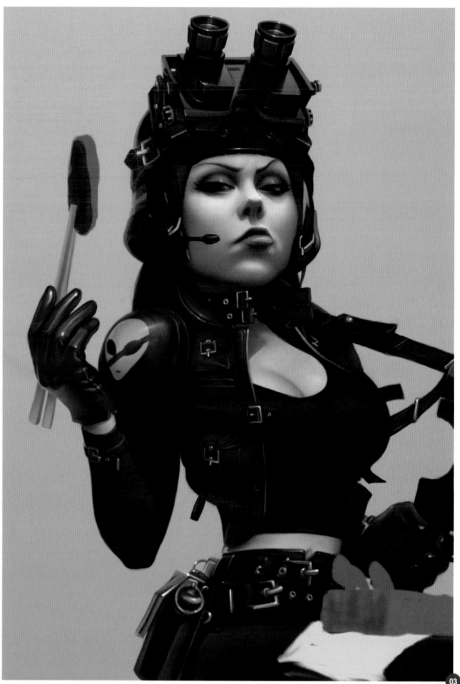

very efficient, but who cares! I added all the elements (the night goggles, the jacket etc.,) little by little, using a lot of layers over the black silhouette (**Fig.03**).

The light came from the sky and so there were no big difficulties with that. I added the face I had already done and then painted the breasts with an airbrush at a low opacity. The face determined the level of detail across the entire picture. I made the night goggles a very reflective plastic material with reflections that were, of course, wrong, because they looked

better like that. The legs and gloves were the others reflective parts with the pants being plastic/vinyl and the gloves made of leather. Military boots with high heels would not be very useful, but pin-ups demand high heels and they were amusing to paint!

Yes I know, the gun is really big and would no doubt be very heavy for Maria to hold, but the exaggerated size makes the picture more humorous (**Fig.04**). I repeated this same method again and again, creating several layers over the black silhouette.

CHARACTERS

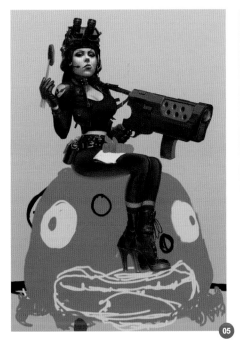

The alien was the most challenging part of this picture. I wanted to do something interesting and had several ideas, but was unsure which was best. I simply asked the opinions of my blog followers. It was quite interesting and I decided that the alien would be a kind of gelatinous, transparent octopus (**Fig.05**).

My friend Gary Newman gave me some great advice: to keep the brain visible beneath the alien skin. This idea made my picture seem more logical: how could you kill a giant gelatinous monster? Shoot it in the brain (**Fig.06**).

I used strange references for the alien's rendering, the first of which was candy. For his mouth, I tried to emulate the sweet smile of Hayao Myazaki's Totoro and the globulous eyes were inspired by Pixar. The alien is very cartoon-like and I wanted it to be cute with simple curves, big eyes (and his little

CHARACTERS

113

teardrops), cow-like teeth and little tentacles. The reflections and refractions are again inaccurate, but once again, realism wasn't my priority. The brain was added in a separate layer (**Fig.07**). I finalized my monster by adding his tongue, bullet holes and the knife.

> « **FOR THE FIRST TIME, THE MOST DIFFICULT PART WASN'T THE PAINTING ITSELF BUT CONVEYING THE STORY BEHIND THE IMAGE** »

The background wasn't difficult and simply comprised of a road, sky, some clouds, mountains and trees. As the giant octopus is transparent, the background directly behind him had to display some visible distortion (**Fig.08**). The last elements were the little UFOs trying to escape from this planet full of psychopathic girls with big guns.

The tones were relatively simple in this picture, utilizing a clear, blue ambient light that influenced the entire color palette. I just changed the contrast, hue and luminosity slightly (**Fig.09**).

For the first time, the most difficult part wasn't the painting itself but conveying the story behind the image. Maria seems to like it and I'm satisfied that everybody understands the storyline to some extent, which makes me confident that I did my job.

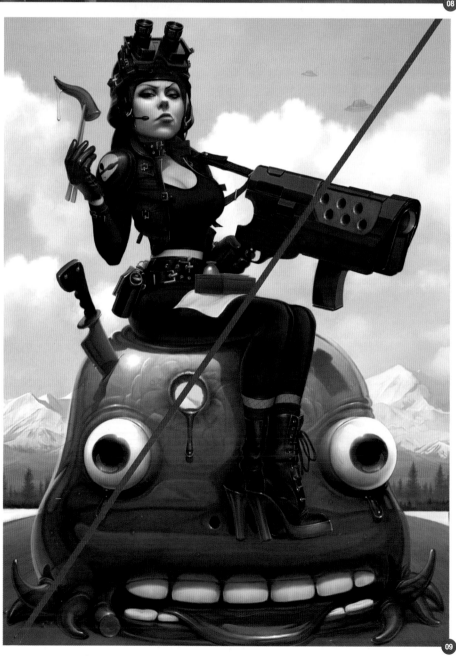

CHARACTERS

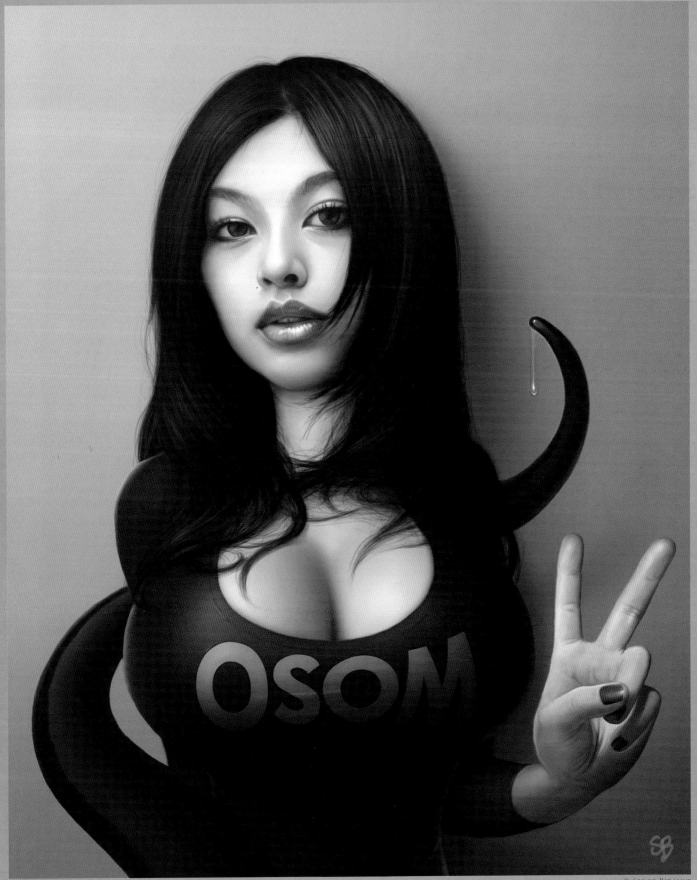

© Serge Birault

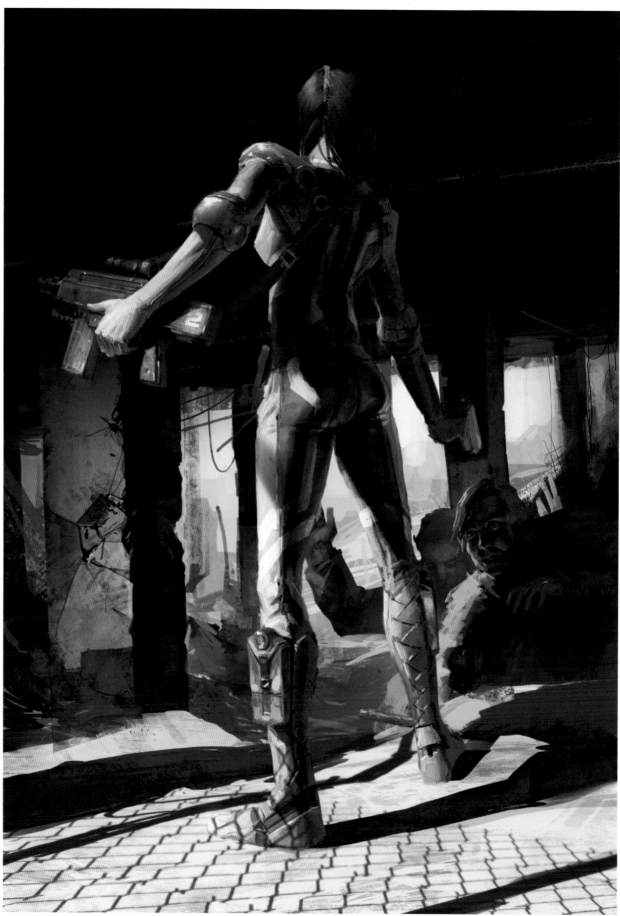

© MICHAL LISOWSKI

BREAKING LINES
BY MICHAL LISOWSKI

JOB TITLE: Concept Artist and Illustrator
SOFTWARE USED: Photoshop

INTRODUCTION

2010 was a very busy and fascinating year for me. But whenever I was able to find some free time, I always tried to jump into my personal projects and painted anything that popped into my head, even if I only had a few days in between commercial work.

> " I PAINTED EACH ELEMENT OF THE COMPOSITION ON A SEPARATE LAYER, WHICH ALLOWED ME TO COMPOSE MORE FREELY "

This piece, entitled *Breaking Lines*, was inspired by post-apocalyptic movies and games I've seen over the years. My idea was to create a scene revolving around the capture of guerrillas by Russian Special Forces. Early on I decided it should take place during the daytime because I wanted to play with light and shadow, in the hope that interesting lighting,

coupled with a sandy tone, would convey the story and post-apocalyptic atmosphere that inspired the piece.

During this stage I started thinking about the composition and wanted it to be clear who has been forced into submission and who is the victor. Throughout this article I'll try to show you the process behind the painting and attempt to explain the role of composition and lighting in my work.

SKETCHING

I wanted to portray the main character as a girl wearing a suit that would look as if it were a mix between racing overalls and a soldier's uniform. I also wanted her to display a shapely figure, hold a gun in her hand and have her back to the camera (**Fig.01**).

When I start painting I usually sketch in the overall composition, although this time I also blocked in the light source. I always try to

establish the correct pose during this stage because if the pose is solid it means I won't have to go back later and waste time making fundamental corrections. This required some research into anatomy references, as I needed to cross-check my character with photographs of people in a similar pose. I painted each element of the composition on a separate layer, which allowed me to compose more freely. At this stage I realized that it would be better to relocate some characters to structure the scene exactly as I intended (**Fig.02**).

COMPOSITION

There was a story to tell and I needed to find the best way to convey my message. The main goal was to show the domination of our main protagonist over the two defeated characters in their foxhole. I didn't want to infer who was bad or good as the intensions of the three characters was not important to me.

After roughing out the sketch I spent a few minutes checking that the composition worked as a whole. It seemed too symmetrical, so I decided to move the guerillas to the right and have the girl's gun-wielding hand convey the direction in which they are being ordered to move. With them now occupying a small area, the feeling became far more oppressive (**Fig.03**).

After the decision to conceal the main character's face I thought about how to

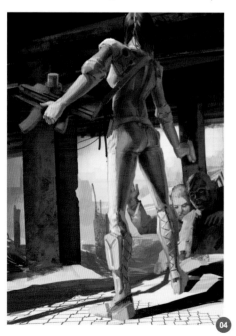

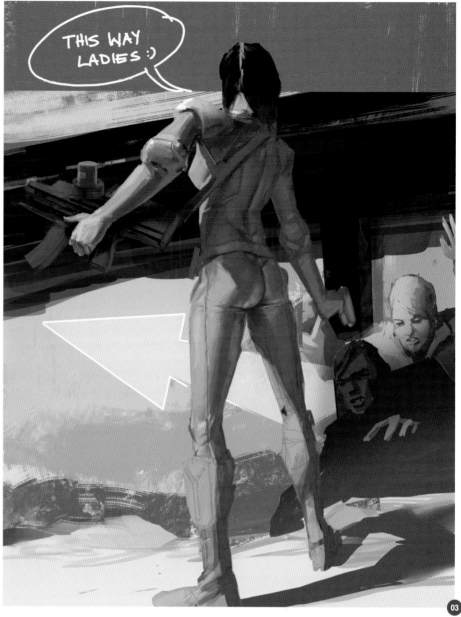

convey her sense of power and domination. Considering the fact that she has captured not one but two guys helps suggest a strong presence, but her self-confident pose also tells us who's in charge in this situation. I've tried to exaggerate this by increasing the contrast between her and the background, especially in the top area of the canvas.

RENDERING

Following the sketching phase I usually create a new layer underneath and start painting in color. After clipping the sketch layer and setting the layer to Multiply with the opacity set to 15%, I have shapes describing the forms and sketched elements. This technique gives me a good background for future work without

losing my sketch. I had already established the main character and roughly painted in the two partisans and background.

During this stage I was focused on creating a post-apocalyptic atmosphere and rendering the details (**Fig.04**).

I often refine my color scheme across the entire painting once the main distribution of color has been blocked in. The light source was already established and so I needed to paint in the shadows, which were a really important factor in this scene. I began painting the environment, avoiding too much detail and instead concentrating on showing a world in ruin. I painted some cracks and wires, using

CHARACTERS

rough brushes for the background as it wasn't necessary to paint everything as precisely as the characters, which could detract from the story. I found that the area at the bottom of the picture was too clear and consequently painted a shadow being cast from a fence. This provided interesting detail and interaction between light and shadow.

Alongside this I started adding more detail to the characters with some elements being completely repainted, such as the gun. I also created some graphic elements for the girl's suit to make it sportier, ensuring that they were consistent with the light source. There are two sources comprising of warm sunlight emanating from the upper left corner and, in contrast, a cold light opposite (**Fig.05**).

The next step involved creating a mask that corresponded to the shape of the girl, and increasing the definition between the light and dark areas. The sunlit areas needed little alteration, but the opposite part of her body had to be slightly darker in order to match the environment.

At this stage the picture was almost complete. With some local color corrections and a small amount of noise, it was done.

CONCLUSION

When I started this picture there were few things I wanted to include, not least of which was some interesting lighting and a good composition. In the end I was happy with the result but, of course, as usual there are some things I could have painted better if I'd had more time. There are still too many things that change during my painting process, which is not a problem when it's a personal piece; however it is a different matter when it's a commercial project.

05

ARTIST PORTFOLIO

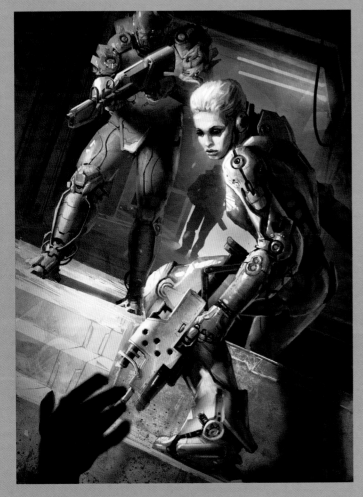

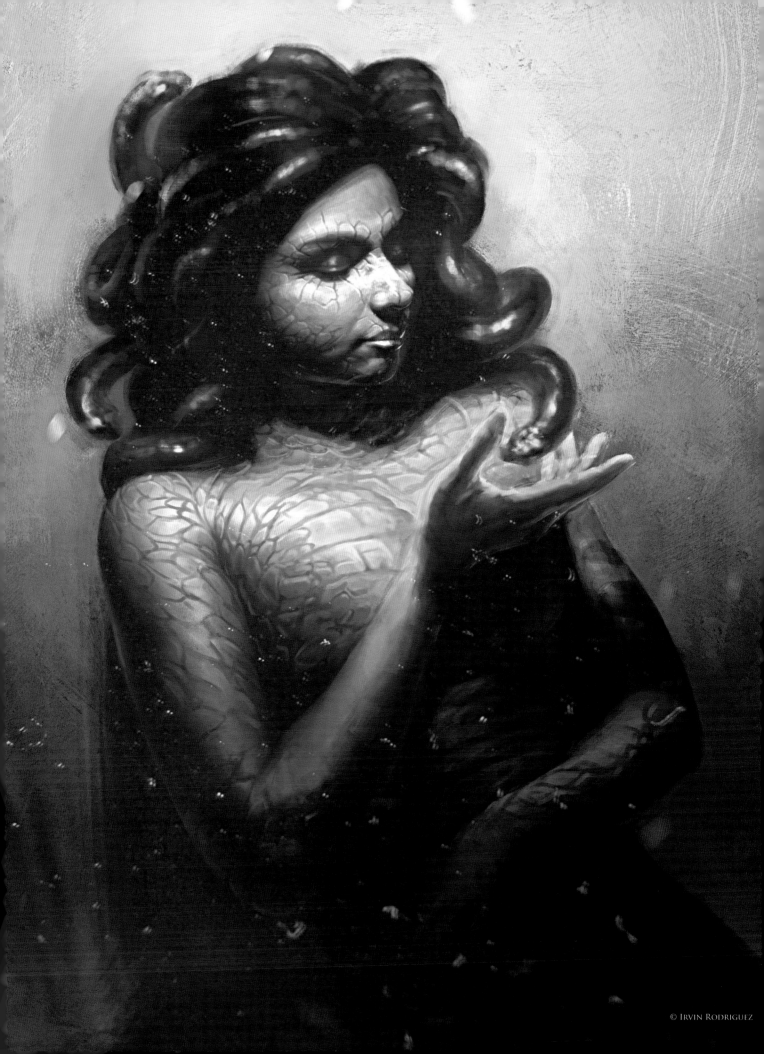

PETRIFIED
BY IRVIN RODRIGUEZ

JOB TITLE: Illustrator
SOFTWARE USED: Photoshop

INSPIRATION

For the last year or so, I have been learning with a classical figure painter who is an expert in Greek mythology. I have become quite interested in some of the Greek tales due to frequent exposure to the subject. This image is inspired by the age old Greek tale of Medusa. I wanted to create a Medusa that did not look like a monster at first glance, but instead much more human. I wanted to depict some sort of emotion with this image and present her with a soft side, which is the very opposite of how we are used to seeing her.

> " I BEGAN TO PAINT IN COLOR ON A SEPARATE LAYER SET TO THE OVERLAY BLEND MODE, WHICH I FIND IS A VERY EFFICIENT WAY OF WORKING. IT IS EASIER TO CONTROL CHROMA AND KEEP THE COLOR SCHEME UNIFIED AND HARMONIOUS "

VALUE STUDY

To begin the painting process I usually start out in grayscale and this image was no exception. I laid down a fill of 50% neutral gray, which served as my mid-tone. Working from the general to the specific, I darkened shadows and brightened forms. I always try to establish a focal point in the image right away, usually by making it the brightest part of the image or by working with edges and sharpening them in order to pull the eye towards the area (**Fig.01**).

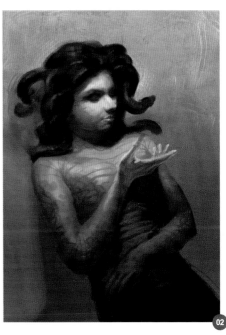

COLOR WASHES

After I had reached the point at which the values felt unified and strong, I began overlaying with color. To start with I laid down an overall hue with the Hue/Saturation-colorize options in Photoshop (**Fig.02**). After this I began to paint in color on a separate layer set to the Overlay blend mode, which I find is a very efficient way of working (**Fig.03a – b**). It is easier to control chroma and keep the color scheme unified and harmonious.

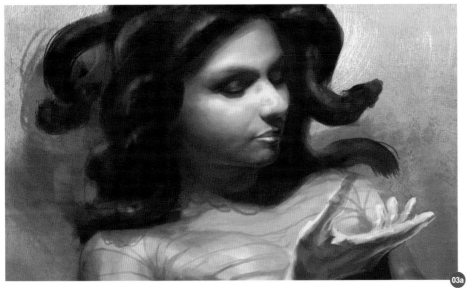

REFINEMENT

After several adjustment layers, color balance layers and color glazes, I tried to cover the entire image in opaque color for the final pass. Here is where I began to introduce details, sharper edges and really tried to push chroma where necessary (**Fig.04**). I like to work in a very step-by-step, organized way because I used to always just jump ahead and start working on the details right away. I've now learned that everything must be built on top of the previous layer of information. At least that is how I think of the picture-making process, and somehow it seems to work every time.

> " ORGANIZED CHAOS IN PAINTING ALWAYS LOOKS MORE APPEALING THAN TOTALLY TIGHT OR TOTALLY LOOSE. YOU HAVE GOT TO HAVE A FIRM STRUCTURE AS WELL AS ROOM TO BREATHE FREELY. "

At this point I really started to define the shapes and contour of the figure. I have realized that shape and silhouette is so important. People recognize shapes much quicker than rendered or colored objects. Shapes and silhouettes really determine the characteristic of whatever it is that you are painting, whether it's a human figure, an animal or architecture. As I refined the shapes of the snakes on her head, I tried to keep in mind that I wanted the snakes to look like hair. I did not want them to be scattered and arbitrary. Organized chaos in painting always looks more appealing than totally tight

or totally loose. You have got to have a firm structure, as well as room to breathe freely.

ATMOSPHERE AND TEXTURE

At this point the image was really coming

together and I wanted to create a sense of depth and atmosphere. I did this by applying some dust textures and several overlapping adjustment layers set to various blend mode combinations in Photoshop (**Fig.05 – 06**). I

like it when you can feel the air between you and the subject in the painting. I also used the Gaussian Blur and Motion Blur filters in Photoshop with copies of the texture layers, and then set them on top of the original textures using Screen and Lighten blending modes. The combination of all of these techniques gave the image a nice atmospheric feeling.

PROGRESSION

You can see in **Fig.07 – 11** how the portrait developed throughout the painting process, through the value study, glazes, opaque color and, finally, the finishing touches. This is the focal point of the painting and it required the most attention and detail.

CONCLUSION

This image definitely took many twists and turns as far as the color scheme was concerned. It was a battle to finally reach an end result and settle on the final image. I had fun painting this image and I hope to explore Greek mythology a little more from now on and create some further imagery surrounding this subject. I am glad to participate in the *Digital Art Masters* series once again; it has been a great opportunity.

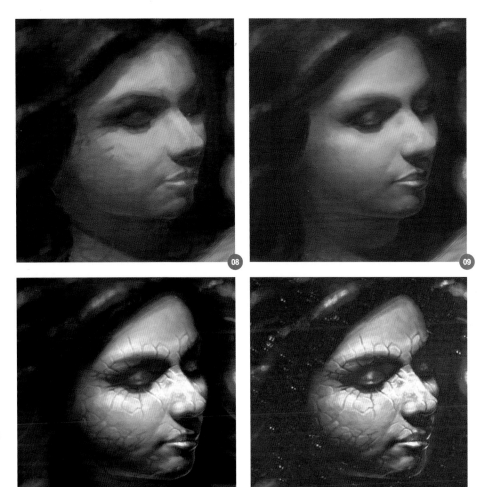

ARTIST PORTFOLIO

© Rafael Grassett – based on a concept art by Marc Brunet

Mecha Girl
By Rafael Grassetti

JOB TITLE: Character Artist
SOFTWARE USED: ZBrush, 3ds Max and Photoshop

INTRODUCTION

I've been working in the games industry for a few years and so decided to create a solid piece for my portfolio. I usually do a few sketches and try to create something from scratch, but this time I was looking for a solid design before creating my interpretation of it because that is what I usually do in my day job. I'm a fan of Marc Brunet's art so I decided to create a low poly model based on one of his concepts.

THE MODEL

The design was really solid, but there were a few things I wanted to change. I started by making a simple 3D sketch in ZBrush to find out what was working and what could be changed. Those familiar with ZBrush will know that it is really easy to work with simple geometry and forms, and it is a really good way of designing things directly in 3D, like any digital sculpting tool. So I started creating a few boxes in 3ds Max and, using ZBrush, came up with a good design for the final piece (**Fig.01**).

After that I used the SubTool master to merge all the objects into one mesh in ZBrush and started to create a geometry guide using Retopology. During this time I didn't worry too much about final loops and finishing the geometry with Retopology, as this new geometry was going to be modified in 3ds

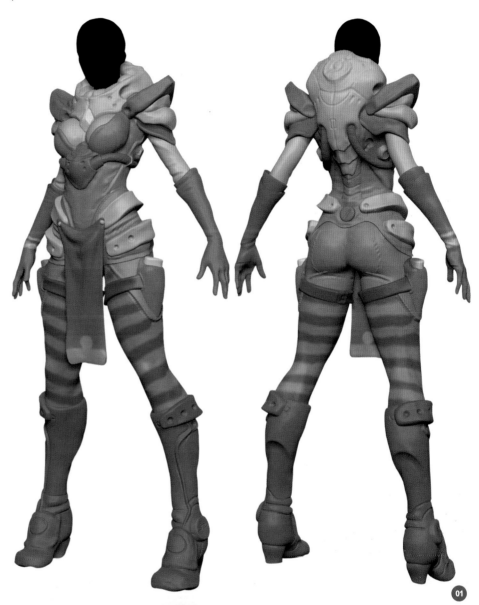

01

02

> " I WAS TRYING TO REPLICATE THE FEELING OF THE ORIGINAL ARTWORK, BUT AT THE SAME TIME WANTED SOMETHING MORE CHARISMATIC "

Max to refine and finish the model with correct loops. I did this to have more control over both the organic and inorganic parts (**Fig.02**).

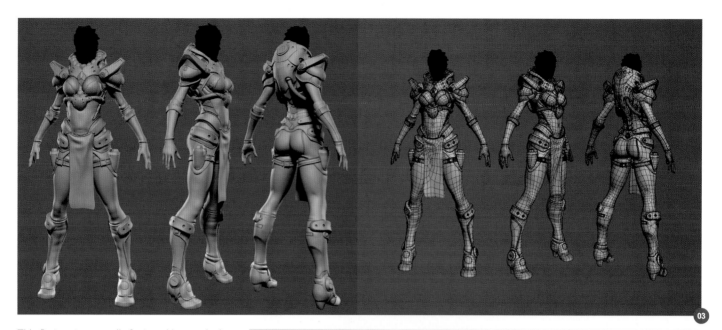

03

This first part was really fast, and in one day's free time I had a good starting base. After a few days I came up with the high res model in 3ds Max ready to use as a cinematic model, or in this case to create the low poly version in preparation for baking (**Fig.03 – 04**).

For the face and accessories I created the base in 3ds Max and finished it in ZBrush, as I didn't want to do the first pass in ZBrush and then go back into Max. I believe the face was the most difficult aspect and demanded a few tests before finding the final shape. I was trying to replicate the feeling of the original artwork, but at the same time wanted something more charismatic. Again, ZBrush really helped achieve the result I wanted during these tests (**Fig.05 – 06**).

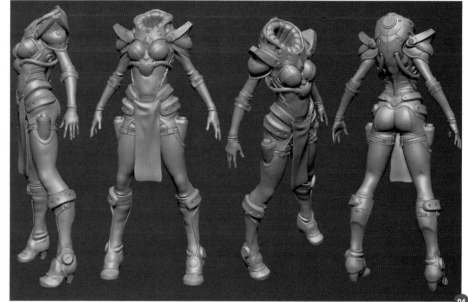

04

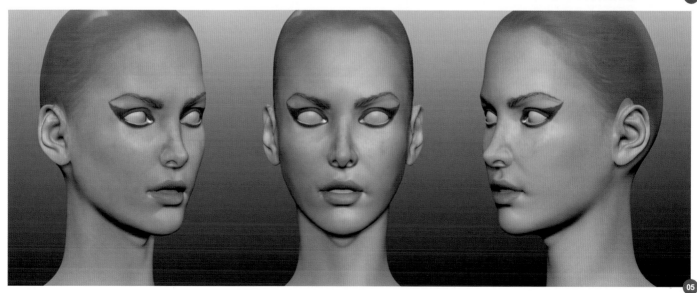

05

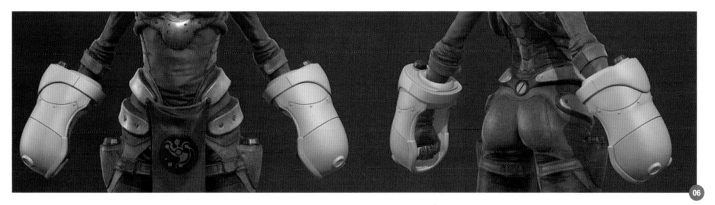

I merged everything and, in ZBrush, started to do the retopology for the low poly model. At this stage I was not worried about finishing everything in ZBrush, but rather just wanted to create some solid geometry to finish later in 3ds Max. I usually start the retopology from the main loops like the articulations, shoulder and rib loops and then weld everything. I find this is the best way to gain the most control over the final product, as the ZBrush Retopology tool doesn't have many features (**Fig.07 – 08**).

I then finished everything in 3ds Max with the final low poly model being a little over ten thousand triangles, which is a good number to settle on. After finishing the textures I could tidy it up a little more without losing any detail.

Following on I moved to the UVs, unwrapping them in Max. When working on a low poly model you have to pay attention to the UVs and the number of objects in the final model. A good approach is to generate one just for the head, one for body and one for parts that

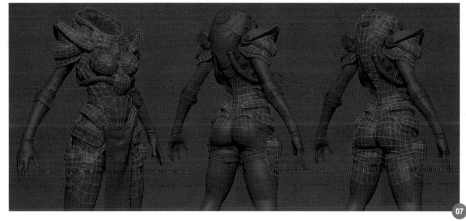

could be changed in the game, such as the accessories. In this case I split the model into "Body", "Accessories" and "Face/Hair".

Having done this I baked the high res model into the new low poly geometry using the Render to Texture function in 3ds Max. When working with numerous objects, the projection may have a few overlapping problems so I usually split the model into a few parts and then assemble them in Photoshop. It didn't

happen in this case, but it does help when working with a heavy high poly mesh.

For this model I generated the following maps: Normal, Occlusion, Light and Color. The Normal map is the map containing the details, the Occlusion map represents the shadows cast by each object, with the Light map giving the impression that there are lights present without using a specific source in the scene. To achieve this I created a few Omni lights

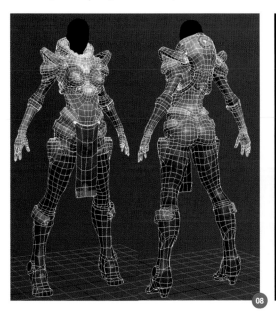

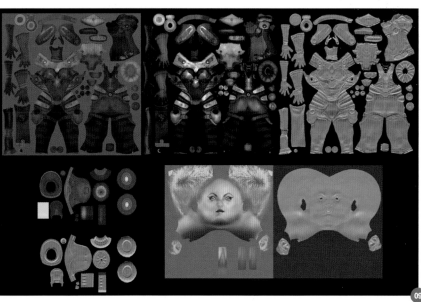

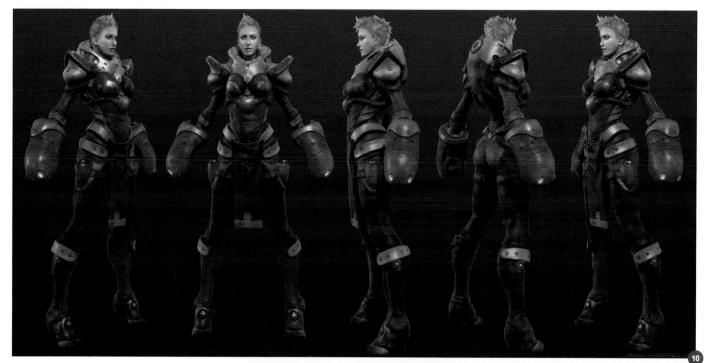

(set to a blue color) and then texture-baked them, resulting in a realistic effect across her shoulders and legs. I also applied different colors to each object and made a simple Diffuse map to help with masking.

I organized everything in Photoshop and started to build the Diffuse map, starting with the base colors of each object and using photos and the Occlusion map to add realism. The next step was to create the Specular map, providing a nice touch to the leather and metal. The same method was used for the specular color, incorporating a blue and orange color for the metal and leather (**Fig.09**).

I created the facial base colors from photos in ZBrush, using Zapplink, before fixing the seams and adding new layers in Photoshop. The hair used a base color on the top of the head and three different planes with cloning. After finishing all the textures, ZBrush was used to fix a few seam issues.

For the final presentation I built a simple rig involving a few bones for posing and also created a light rig with three spots, one white main light and two backlights.

Finally I created a single beauty shot and two presentation shots using Photoshop (**Fig.10 – 11**).

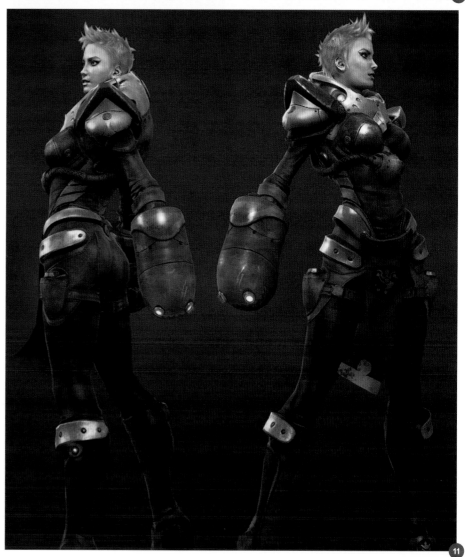

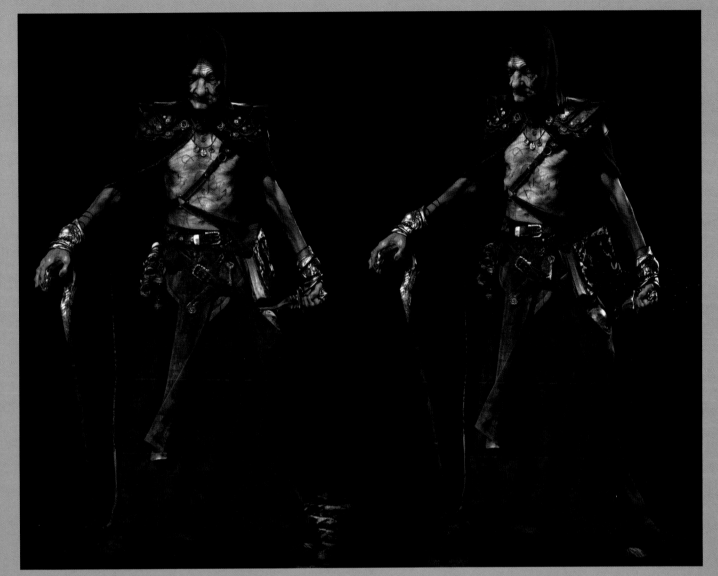

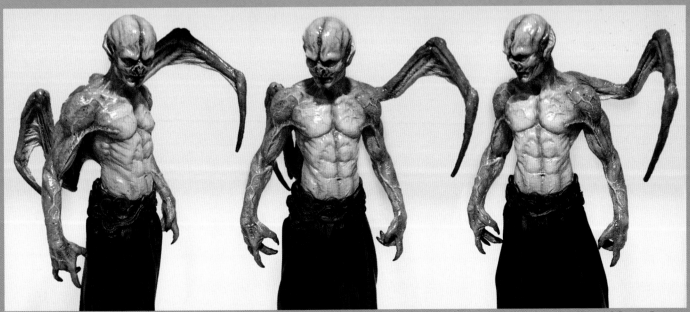

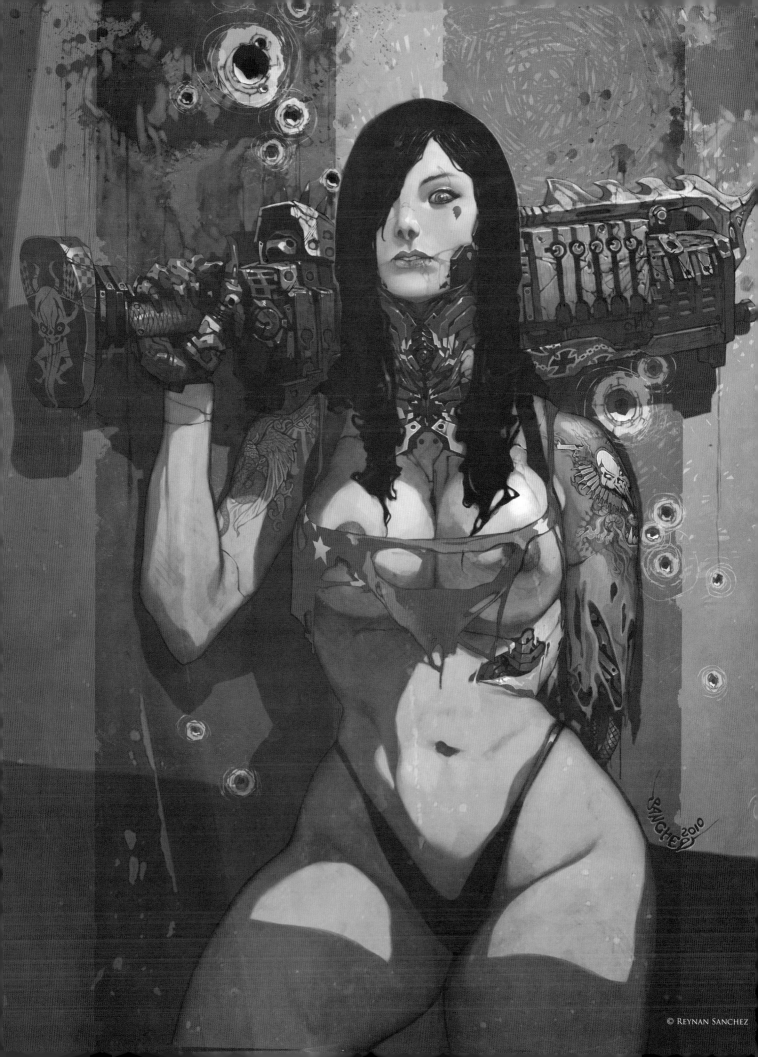

Riot Girl
By Reynan Sanchez

JOB TITLE: Freelance Digital Artist
SOFTWARE USED: Photoshop

INTRODUCTION

I have always been a huge fan of so many artists, from the Old Masters of the Renaissance through to modern day fantasy artists, of which there are too many to mention. But one artist whose work greatly influenced this piece is Simon Bisley. His take on *Heavy Metal's F.A.K.K.2* still amazes me up until this day. This piece really shows off his unique artistic style and it is hands down one of my favorite paintings of all time, so I decided to try and create something a bit like it.

> " FOR THOSE OF YOU WHO ARE INTERESTED IN KNOWING WHAT BRUSHES I USE, BELIEVE IT OR NOT I ONLY USE DEFAULT BRUSHES "

In my days as a young artist my eldest brother, who is also an artist, always brought home comic books and classic fantasy magazines, which explains why I love the classic/vintage style of fantasy artwork.

My goal here was to achieve a sexy pin-up look, similar to what we often see on some on the great, classic fantasy comic magazine covers from the 70's through to the 90's, while trying to incorporate modern stylized designs that you could possibly expect to see in current artwork.

PAINTING

Before we start, I want to emphasize that this tutorial is by no means an attempt to explain every single detail of the process. Instead it will provide more of an overview of the important and necessary steps, and occasionally some silly stuff that I think you readers will find interesting.

So, let's begin with the painting process…

I don't really have any initial concept sketches for this one unfortunately, so we can launch directly into the painting process. I sometimes do quick concept sketches before making a piece of artwork but not often, especially when creating personal artwork.

For those of you who are interested in knowing what brushes I use, believe it or not I only use default brushes (Chalk and Airbrush Soft Round) for almost every piece of artwork I create, including this one. I use these brushes for the entire painting process, including my

Eraser. Although I also use custom brushes sometimes, I try not to rely on them too much which I'll explain later.

As you can see I started to paint in some basic shapes in different tones, which identified each area as skin, hair, and metal etc. This was also the most time-consuming part of the process, as I spent most of the time producing layers again and again. I painted on a layer and then added another layer, which I then painted onto and so on. The more layers I created the more detailed it got. I did this over and over until all the shapes and forms were detailed enough. I used over 150 layers on the first image alone.

I think that the painting process that I've outlined here is as simple as any artist's approach, whether traditional or digital, with nothing really special in terms of technique. It's pretty similar and uses the same principles as I employ when using traditional mediums such as watercolors, oil and acrylics (**Fig.01**).

BACKGROUND

Once I had finished painting the girl, I merged the layers into a single image so that I could easily drag it over to a larger canvas. This canvas acted as my main background for the image, which was a bit larger compared to the previous one. This canvas also included a group of layers that I labeled as "Filter" – this color corrected everything and made the color palette more vivid, similar to a post-processing effect (**Fig.02**).

DETAILS AND SHADOWS

After everything was in place, I then repeated the same process outlined in the initial stages. I added small details along the way, like tattoos and darker outlines etc., which added up to another hundred plus layers alone before once again merging everything. On reflection

I wanted the background to be simple, resembling a wall or something, and so I added a shadow to make it appear as though there's a wall behind her (**Fig.03a – c**).

BACKGROUND DETAIL

Although the wall looked good already, it still seemed a little flat. I decided to make it look even better by adding some texture, cracks,

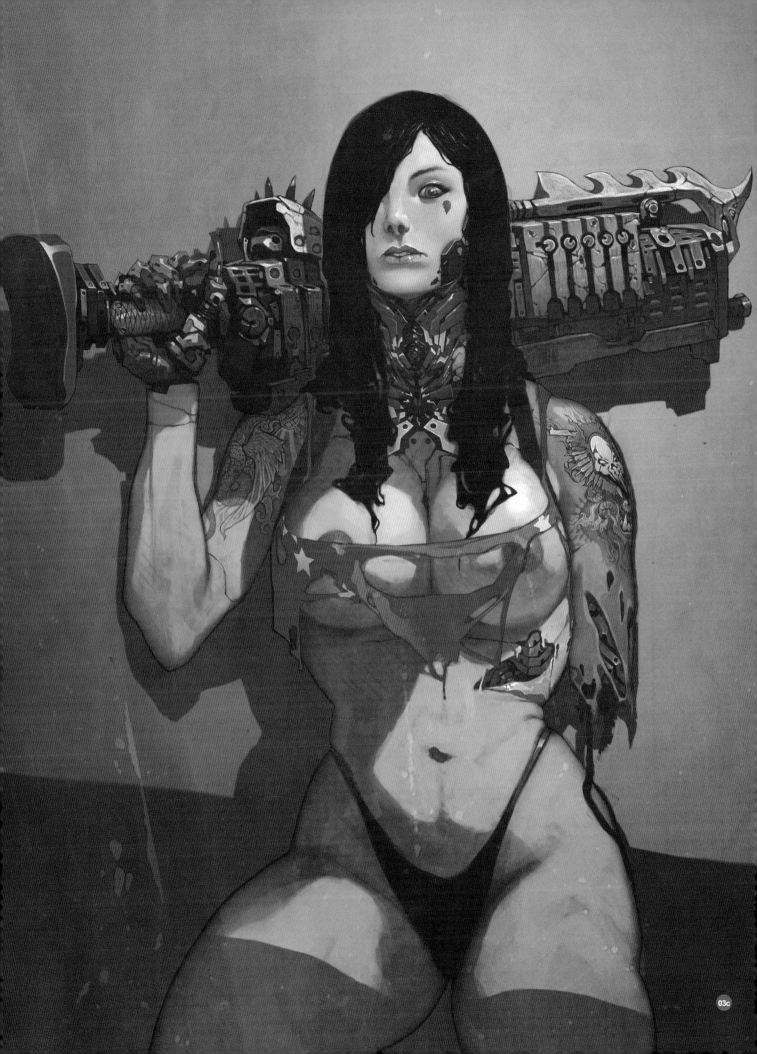

a few bullet holes and lots of scattered blood, which made the background more interesting to look at (**Fig.04a – b**).

BLOOD SPLATTERS

Before we proceed to the next step, I want to provide a brief summary on how I created the blood splatters that you can see scattered everywhere.

The first thing I did was to look for some free custom brushes that you can download over the very reliable internet. I searched for an "Ink Splatter" type of brush. Once downloaded and installed, I then chose a color that resembled blood (obviously the red color) – "Pantone 179c" to be exact. I then used it to paint both the small and large splatters, to a layer set to Color Burn. Aside from making the color more vibrant this blending mode also adds

04a

04b

Transparency without too much loss to the color intensity, making it easier to just paint over a layer without worrying about tone (**Fig.05a**).

Now let's get back to the ink splatter brush and explain why I don't rely too much on custom brushes. Although it seems that the brush will do the job and be suitable for producing good blood spatters, I'm convinced otherwise because it looks a bit too generic. To combat this I heavily tweaked its appearance by using a Chalk brush eraser set to 40% opacity. I tried to slowly and carefully recreate the appearance by erasing unwanted shapes whilst adding a few more (drips coming from the splatters). It made the blood looked more interesting and unique, rather than the uniform and common splatter look we usually see.

As you can see, I try not to rely on what the custom brush can "create for me". I try to recreate something out of it, making it look unique in some way (**Fig.05b**).

ANATOMY 101

At this stage I'd almost finished the image, but before I finalized the artwork there was one more important thing I needed to look at: the anatomy. This had been kind of broken right

NORMAL

COLOR BURN

05a

TRANSPARENCY

ORIGINAL

ERASER

05b

> THESE ARE TECHNIQUES THAT I HAVE ESTABLISHED THROUGH YEARS OF PRACTICE

from the start, a result of not using a reference I guess. I didn't notice it earlier, so I tried to fix it here.

Fortunately I had a single flattened layer consisting of the character. This layer was separate from the background, which meant it was much easier to fix the problem without touching the background.

After some tweaking, the result was very noticeable. You can see the huge difference between the two images provided (**Fig.06**). The one on the left looks very bulky and stiff compared to the version on the right, which is far sexier and more appealing. What I did

was to select some body parts using the Lasso tool and then transform them (Ctrl + T – Free Transform), choosing to Scale, Rotate or Warp the body parts I wanted to fix. I reduced the size of the ribs, made the hips wider and adjusted the shoulders and waist.

FINAL ADJUSTMENTS

At this point I was satisfied with how things had turned out and didn't plan on adding any more details, so decided to apply some final adjustments. What I did was flatten the image

and then duplicate it before applying Filter > Sharpen > Smart Sharpen. Once the image was sharpened, I lowered the opacity to 30% to avoid an over-sharpened image. After that I flattened the layers again and I was done!

CLOSING COMMENTS

So that's it! You've just had a glimpse of how unusual and sometimes messed-up my process can become when creating an image. It can sometimes be a little bit complicated, but the result is well worth it!

I incorporate techniques that I'm very comfortable and familiar with, despite them sometimes appearing complicated and not quite the standard process. Instead these are techniques that I have established through years of practice involving both traditional and digital art. Initially of course you try to get inspiration from other artists and absorb different techniques from tutorials etc., which is something I'm still doing to this day. In fact there's nothing wrong with this and indeed it's part of the learning process as long as you don't rely on it too much. Instead it is better to create and come up with something out of the things you've learned, because as an artist you don't want your own masterpiece to be almost identical to another artist's work. So try to experiment, enjoy art and have fun!

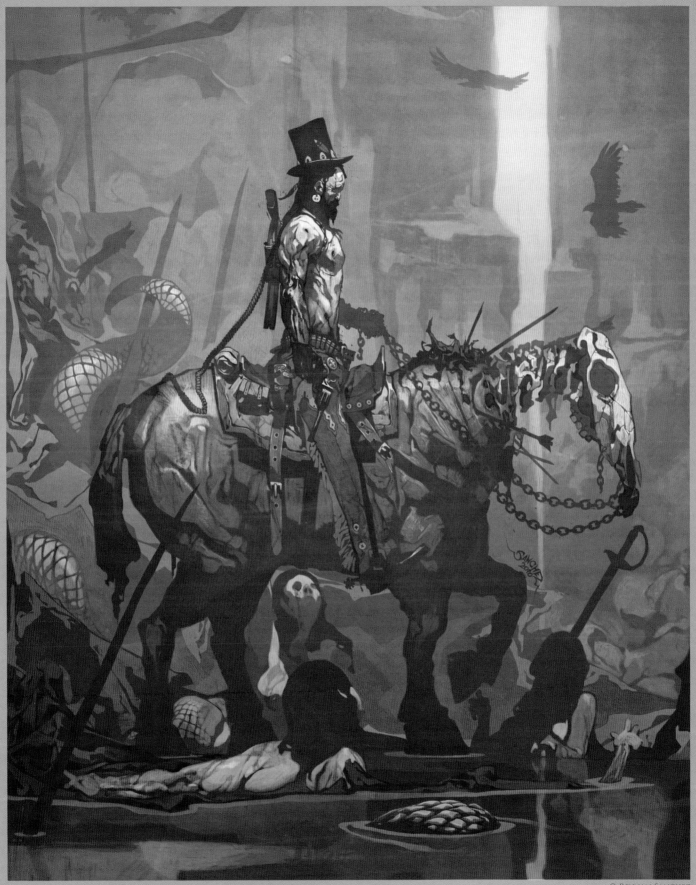

© Reynan Sanchez

PRIESTLY
By Branko Bistrovic

Job Title: Design Supervisor
Software Used: Photoshop

INTRODUCTION

Every once in a while I hit a rut. It's not really just a creative block, but an actual dislike for whatever process I'm using to create my art. At work this process usually consists of many layers, which eventually makes me itch for traditional mediums. This painting began while I was gripped by such a mood. I decided that I would paint it all with only two layers at any given time (or at least try my best). Granted, for industry work this is not the best method for a painting destined for revisions and tight deadlines. Your art director might not find it all that amusing that you've decided to throw off the shackles of too many layers if now you can't move the character over a couple of inches.

> ## DON'T UNDO COMPULSIVELY AND CONTINUOUSLY TOGGLE THE LAYER TO SEE IF IT'S THE BEST POSSIBLE SHAPE, BECAUSE IT'S NOT AND NEVER WILL BE.

Just to be clear, I think that layers and the ability to undo are priceless tools for us within the digital arts industry, where the final call isn't yours, but to me there are times where too much reliance on safety nets can be detrimental to any developing artist. Instead of thinking actively while painting, I catch myself putting down marks on the canvas and carelessly thinking, "I'll come back to it later." This eventually culminates in a bunch of layers requiring revision, which is very frustrating.

I think most artists feel that from time to time it's good to get back to "simpler" methods, which ideally would be to work traditionally, I imagine. However, if your tool of choice is digital then simply avoiding layers and obsessive "undoing"

01

can actually be quite liberating. This process is really for reconnecting with the confidence every artist should have behind their brush strokes and their ability to just place down a line/shape, and go with it. Don't undo compulsively and continuously toggle the layer to see if it's the best possible shape, because it's not and never will be. There's an infinite amount of tweaking one can do to any painting, but at some point along the way all of this back and forth can cause chronic doubt to develop in any artist.

MY PAINTING

So, here's a piece that I did with only two layers (almost) and no Ctrl + Z.

I decided to begin this piece with a quick line sketch (**Fig.01**). I usually start with blocks of values and shapes, but I felt I wanted to be a little more resolved right off the bat. For me personally, line work demands more decision making, whereas blocks of shapes and values usually lend to lots more accidental discoveries.

I had just read Eco's *The Name of the Rose* and had my head filled with monks, robes and satanic worshippers (but only in an obsessive creepy fashion…) and so an image formed in my head of an ox-like priest/monk, who was somewhat physically frail, but nonetheless very imposing. My intentions were not to linger long on the piece, so this sketch was quick and messy, but it nonetheless helped me resolve much of the shape and gesture. Keep it loose. Do not fall in love with the detail; it's too early for that.

With the sketch vaguely clear, I darkened up the background layer with cooler blues and decided to make the attire appear worn and yet regal with violets, yellows and jewels (**Fig.02**). I imagined him to be somewhat scruffy and not necessarily down on his luck, but inhabiting a grimy and hard world even for an old ox-priest.

Although tempted, I avoided a Multiply layer, instead choosing to paint directly in the background and use one layer for the character. I allowed myself to relax and not worry about losing anything precious, instead forcing myself to enjoy the process of discovery as the piece began to take shape.

I began to bring in the darks, refining the shapes and trying to think clearly and directly (**Fig.03**). It was difficult with my head already hurting. I don't like to over-think because that often results in doubt wiggling its ugly rear, but I don't like to just throw down marks repeatedly either. Sometimes I think we confuse quick painting with careless painting. Zero in on something, decide what you want it to look

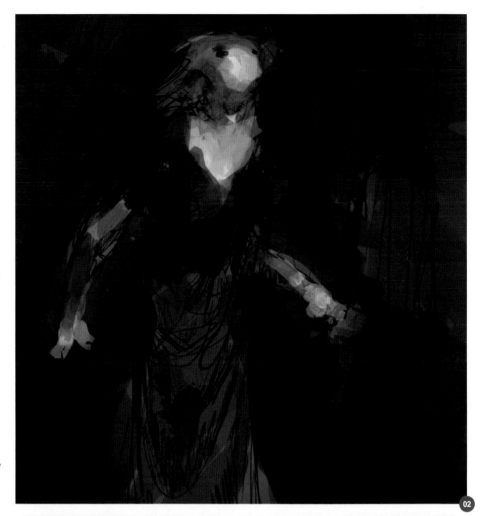

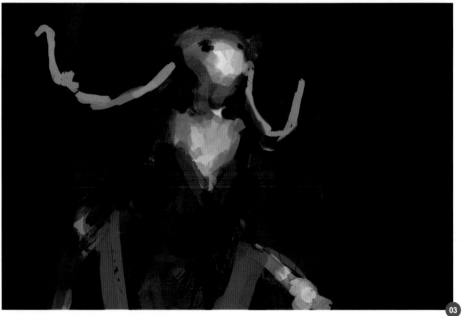

like and strike! Block it in simply and build it up until it's close to what you had in mind. Move to another part of the piece, rinse and repeat. Continuing to refine, I thought that it would look interesting if the robes were winding out of the composition, almost like tentacles (**Fig.04**). Also, giving him a walking stick resembling a halberd seemed appropriate. It's a little big for such a frail figure to wield, but who knows – maybe he was a fighter in his youth and turned

to monastic worship in his later years with this halberd being a token remnant… or perhaps he simply likes walking sticks with large pieces of sharp metal on top.

> I FEEL THAT LITTLE HINTS THROUGHOUT THE BACKGROUND USUALLY GO A LONG WAY TO IMBUE THE SCENE WITH A SENSE OF PURPOSE AND STORY.

I further refined the background layer and had a strong indication of where the image was going (**Fig.05**). I decided to have a large book/ tomb, as ancient as the place that holds it, sitting on a pedestal. Within it there might be prayers, or rituals, or testaments of forgotten lands that are now nothing but dust in the wind. I feel that little hints throughout the background usually go a long way to imbue the scene with a sense of purpose and story. To me, such artwork is more interesting and usually keeps me coming back to rediscover more.

I flipped the canvas to get a fresh perspective on the piece (**Fig.06**). At this point I was also ready to put down designs that could take hours to polish, meaning that my anxiety was starting to build, especially since I couldn't just scrap a layer if I didn't like the design. Instead I needed to think carefully to get it right, with the first step being to give him a long beard!

A few hours later, and after more sweating, I had a clear idea on the canvas and was feeling much more comfortable with where things were (**Fig.07**). I focused on solidifying the face and hands, and also modified the background, making it lighter. I decided to leave it like this and see how it looked later after a break. Throughout the process I used a speckled brush to add some graining, but focused on it more during this stage. I mainly used just the regular Hard Round brush with bumped up Scattering, Size and Roundness Jitter.

The red eyes were actually much more difficult than I had hoped and no matter how many times I applied the hue it looked extremely

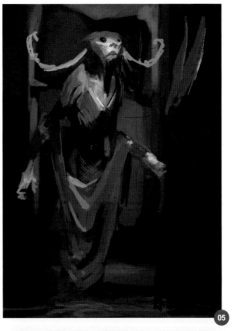
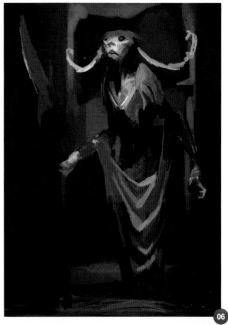

artificial, but I feel that after knocking back some saturation and toning them down I've been able to present something semi-convincing… as far as red glowing eyes go, that is.

Well here we are, almost done! Everything is pretty refined and cleaned up (**Fig.08**). For you observant readers, you might have noticed that the halberd is now glowing blue and our ox now has a little buddy. I thought I'd have to whip out a new layer to paint in the blue glow of the halberd, but then I got the idea to select the whole priest foreground layer (on which the halberd is also a part), then invert the selection so that I could paint around the edges of the halberd without actually painting over it. Once done I unselected and blended the edges together with the Smudge tool, which was tricky since the weapon needed to look sharp with crisp edges.

The little guy was just for comic relief and to reel in the younger viewers; after all, who can resist a demon-lemur thingy?!

I also went online and grabbed a texture off **http://freetextures.3dtotal.com/** to use for the floor. I used a third layer to position it with Ctrl + T, and then merged it once satisfied. I also incorporated an old paper texture and played

around with it, erasing it and searching for the best blend mode (Screen in this case), which helped give the piece some grit.

Complete! Well, at least for now. Unfortunately I broke the rules at this stage even more so than with the textures. I used an Overlay layer to push and pull the piece, and once happy flattened it, only to make another layer and paint in fog at the base. The fog came to me too late in the game, and I just wasn't comfortable enough to do it on the background layer. Still, the process was extremely

enjoyable, mainly because I had to be more focused than usual throughout the whole process and any successful render was much more gratifying (**Fig.09**).

As a side note, I submitted a few pieces for *Digital Art Masters: Volume 6* and out of all of them this is the only one which used this method – all the others buffered with more layers. Yet, in the end, this was the piece picked. Not sure what that means, but I guess it does at least confirm that all is not lost without those safety nets.

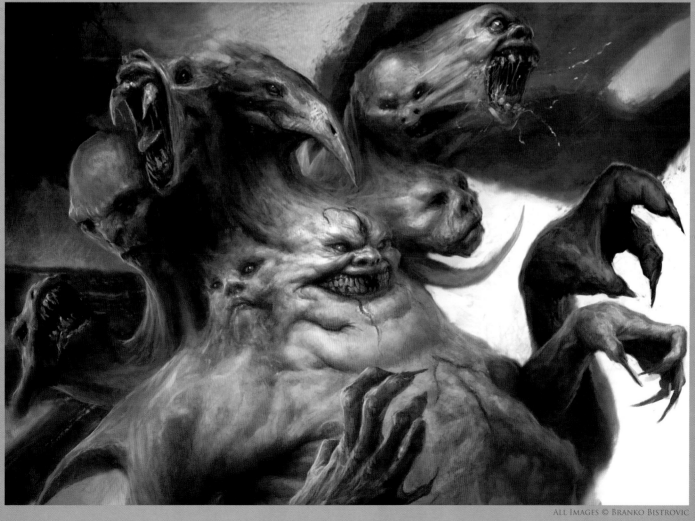

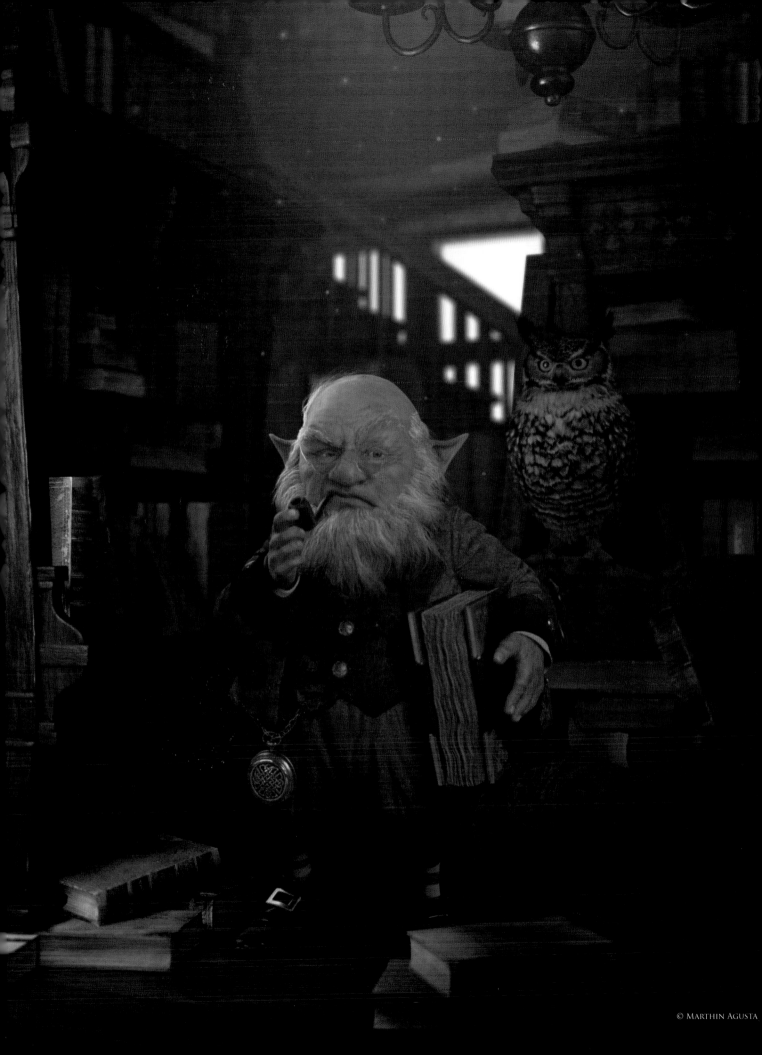

© Marthin Agusta

GOBLIN LIBRARY
BY MARTHIN AGUSTA

JOB TITLE: Character Artist

SOFTWARE USED: 3ds Max, ZBrush and Photoshop

IDEAS

Fairies have always been a very interesting subject for me. I have been influenced and inspired by many movies and books, including the *Harry Potter* and *The Spiderwick Chronicles* series, as well as artists like J.B Monge, who creates artwork with a common theme.

In this personal work, I tried to create my own interpretation of a goblin. I didn't want to make the usual green, evil, mischievous little creature, but instead wanted it to be a more intelligent and smart creature, perhaps with a grumpy attitude. As an environment, I chose a library because I thought it was suitable for this character. I tried to make it feel old and mysterious by incorporating a lot of old books and setting the light to support the mood. I always generate a list of ideas for every image I do. I write down every detail I want to include in the scene and from this list I then make a simple sketch to serve as a modeling guide. Sometimes I also attach a few reference images to support the design (**Fig.01**).

MODELING

I started by using one of my older head meshes from a previous work, and then began to tweak the topology and shape. This mesh acted as just a base, so I didn't really finalize the shape at this point. After modifying this mesh, I exported it into ZBrush. I generally use the Move and Standard brushes, with Symmetry

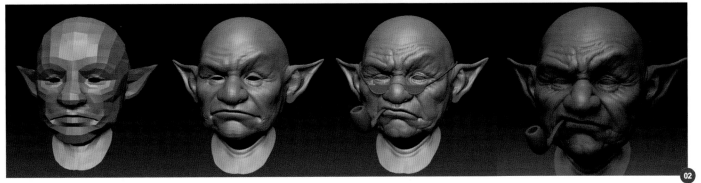

activated, to adjust the proportions. At some point, I turned off Symmetry to create the expression. It is nice to have an unsymmetrical face as it helps the head to look more natural and believable (**Fig.02**).

I also started to decide on his outfit and accessories; in this case I gave him glasses and a pipe to add more character. As the sculpt progressed I added more and more detail. I searched the internet for references of old men's faces and wrinkles, just to have a clear picture. Of course I did not create a realistic human and so exaggerated some features to make it more interesting.

For the body, I just followed the previous design. Like the head, I modeled the base mesh first and then tweaked it in ZBrush to add the folds and creases. I also added some extra props like the pocket watch (**Fig.03**).

After all the modeling was done, I decided to pose him in ZBrush. Using Transpose Master is a really fast way to pose your model and since

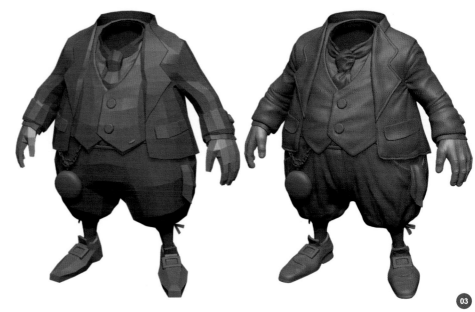

my goal was to make a still image, this was good enough. I also placed a big book in his left hand, and a pipe in the other (**Fig.04**).

I then added an owl to accompany the goblin and, as usual, I gathered some references from the internet and again started from the base

mesh. I tried to finalize the modeling in 3ds Max and after that I generated the UV maps, and created the textures. The owl texture was hand-painted using real owl references. Sculpting was the last step, which didn't involve much detail. I tried to follow the flow of the feathers to match the texture (**Fig.05**).

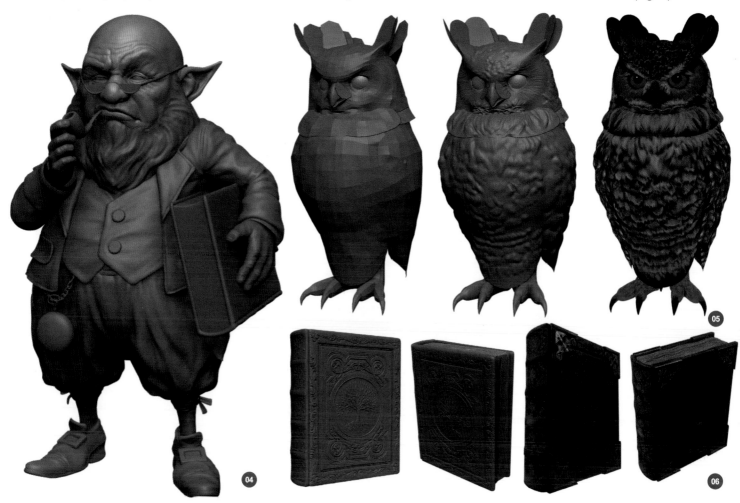

CHARACTERS

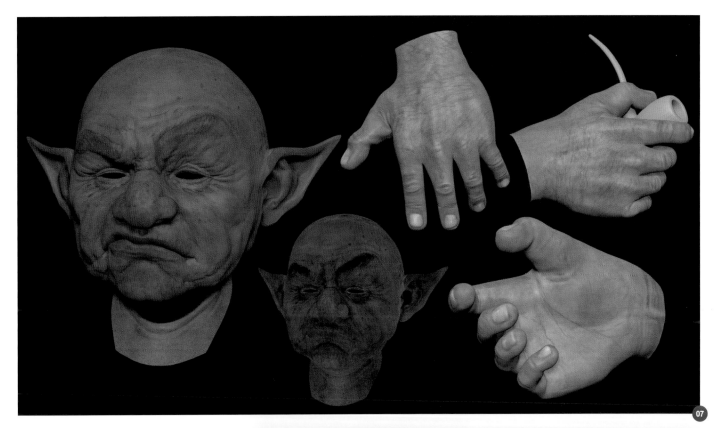

07

Since the goblin is holding quite a big book, I also tried to put some detail into it. The front cover and pages were my main focus, since they would be quite visible in the final shot. Once again ZBrush was used to add the details. For the cover, I simply created an alpha in Photoshop, which was later sculpted into the mesh to add some depth (**Fig.06**).

TEXTURING

The texturing part was quite straightforward. The skin used an SSS shader, so I required four different maps: Diffuse, Subdermal, Normal and Specular. The Normal map was baked from ZBrush, whilst the others were painted in Photoshop. Here's how the Diffuse and Specular maps look (the subdermal is not shown, but it's just a reddish version of the Diffuse map) (**Fig.07**).

After finishing all the textures, I moved onto the beard. I used 3ds Max Hair and Fur, the reason being it's easy to apply and is supported by mental ray. The main disadvantage is the render time, which is increased significantly. One thing to bear in mind when using this is to set the hair renderer into "mr prim" in the Effects menu, otherwise the render will not look good (**Fig.08 – 09**).

08

I then continued the texturing process for the rest of the body. I mainly used mental ray's architectural materials, which are extensive and save time by negating the need to do a manual setup.

ENVIRONMENT

The environment plays a very important role in this image. My first step was to create the library room and block out the placement of the props. Once satisfied, I started to model the bookshelf and the books. I used two sheets of book textures, each consisting of four different cover designs and several spine textures. Since there's little variety, it really depended on the placement of the books to make them look unique and avoid looking repetitive.

I also added a ceiling lamp to help the composition because I felt that the bottom of the image was very busy with the characters and books, making the upper part appear empty.

For the lighting, I use targeted Photometric lights and positioned them in the back, front, and right of the scene. Here's the modeling and lighting progression for the library (**Fig.10**).

Once I had all the environment elements finished, I included the character and rendered the scene. Unfortunately I had a memory issue and so decided to render the character and environment separately and then composite everything in Photoshop. As a finishing touch I tweaked the colors and also added some fog layers to enhance the overall mood.

09

10

CHARACTERS

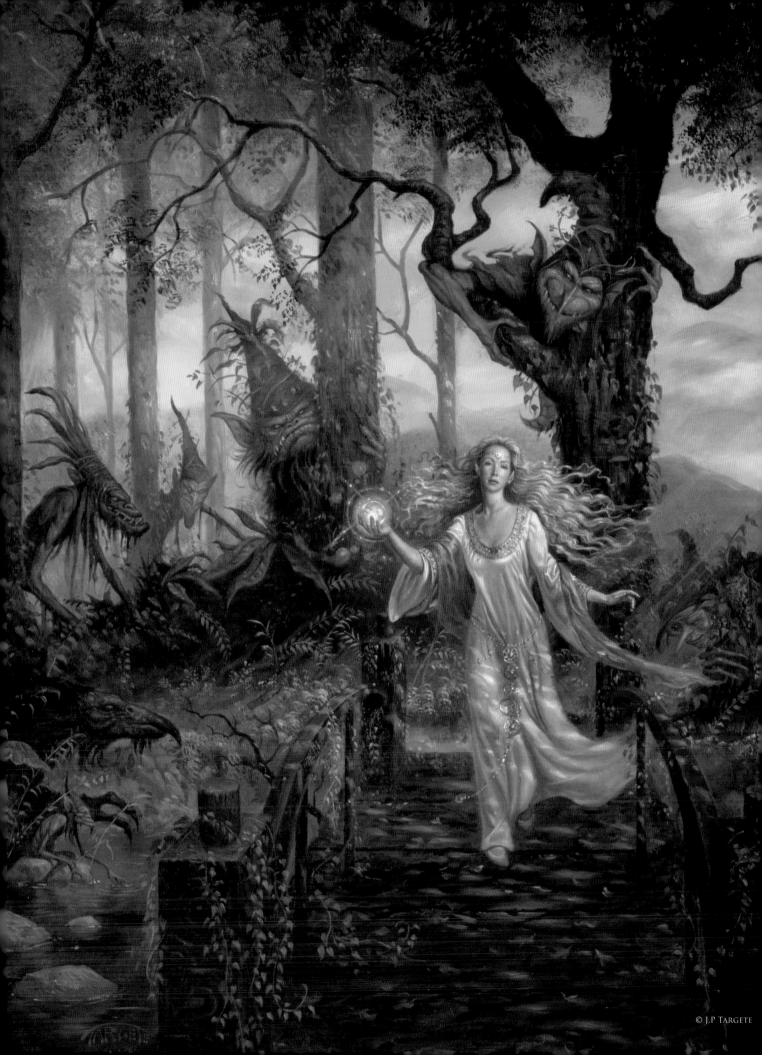

FANTASY

 Fantasy art has always been close to my heart. It has always been one of my favorite genres on both an artistic and personal level. The visceral metaphors shared between our everyday lives and those we create in our art have always intrigued me. They seem to always share in a symbiosis of ideas and emotions. I think the relevance of today's fantasy art in our daily lives is greater than it's ever been.

Fantasy art in the past has not always been considered "legitimate" by the art world. But I beg to differ because fantasy art has appeared in some of the most popular and highly regarded literature, visual art, film and music over the years. Some examples of it in visual art can be seen in the works of Michelangelo, Peter Paul Rubens, Salvador Dali, Magritte and many more. In my opinion, the symbolism and surrealism in the work of some of these artists qualifies them as works of fantasy. These artists have interpreted their ideas and passions, and given us some of the most incredible art throughout mankind's history.

Today's fantasy artists should always understand the value of what they produce. It *is* true art, and has its place in both art history and our own lives. Of course, there will always be critics and historians who will never accept fantasy art as legitimate. But I say let those same doubters ask any true fantasy artist if Frank Frazetta was ever a "true artist" and the answer will likely always be: "Hell yes!"

J.P TARGETE

artmanagement@targeteart.com
http://www.targeteart.com

ONCE IN THE WOODS
BY ANDREI PERVUKHIN

JOB TITLE: Freelance Illustrator
SOFTWARE USED: Photoshop

INTRODUCTION

This fantasy illustration was inspired by a winter forest! At the time Russia was in the grip of a cold winter and the forests looked very beautiful. I love winter landscapes and in my opinion a snowy forest is a magical vision of nature. I had the idea to create a scene depicting fabulous creatures in a winter forest with two curious and greedy dwarves straying into a troll's territory. The troll robs travelers and nearby villagers, and although rich from his escapades he is aware of the petty thieves and is looking for them. Despite their fear of the troll, the dwarves's inquisitiveness has gotten the better of them and their only salvation now lies behind a snowdrift.

> **THE DWARVES ARE CERTAINLY SMALL, BUT NEVERTHELESS THEY ARE AN IMPORTANT ASPECT – NOT UNLIKE TOLKIEN'S DWARVES**

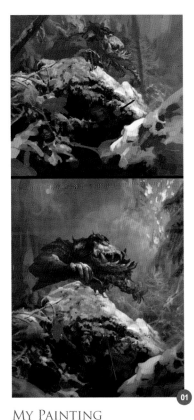

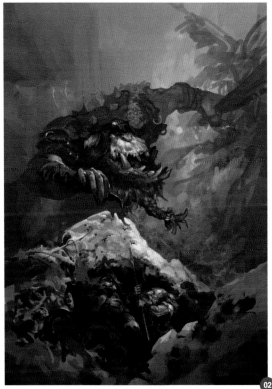

MY PAINTING

I made this work during my free time over several days with no clear idea about how the composition or image would evolve. From the outset, I knew only how the background would look with the size, shape and the location changing as I painted. I began the sketch in black and white as it helps to determine the contrast and rhythms (**Fig.01**).

After defining the format, I could establish the focus of the composition, arrange the characters and decide on their appearance (**Fig.02**). I used five different layers: the background, the dwarves, the snow on the dwarves, the troll and finally the foreground. In my opinion it's more convenient to compose the image this way as you can move the layers to find the best compositional balance.

Next, I decided to draw in the detail of the dwarves and block in the troll using only black and white (**Fig.03**). I mainly used the Standard Round brush throughout this process. The dwarves are certainly small, but nevertheless they are an important aspect, not unlike Tolkien's dwarves. I decided, however, that this was not a bad thing!

" I USED VARIOUS ROUGH BRUSHES, COMBINING THEM WITH THE OTHERS IN ORDER TO CREATE SOME RANDOM AND PARTICULARLY INTERESTING FORMS (THIS IS VERY CONVENIENT WHEN PAINTING LANDSCAPES). "

The next step was to color the image (**Fig.04**). I used different blending modes such as Color, Overlay, Soft Light, and Color Dodge, as well as incorporating new fill and adjustment layers with the aid of the Soft Round brush.

When I finally defined the landscape color, characters and composition I started to add in more detail (**Fig.05a – b**). I decided to start with the foreground, drawing snowdrifts and birch twigs using different layers for different items. As I mentioned earlier, it is easier to transform and move the elements around this way. During the process I used various rough brushes, combining them with the others in order to create some random and particularly interesting forms (this is very convenient when painting landscapes). Occasionally I used a smooth brush, but I think if you give more time and detail to the foreground it reduces the risk of overloading the background detail.

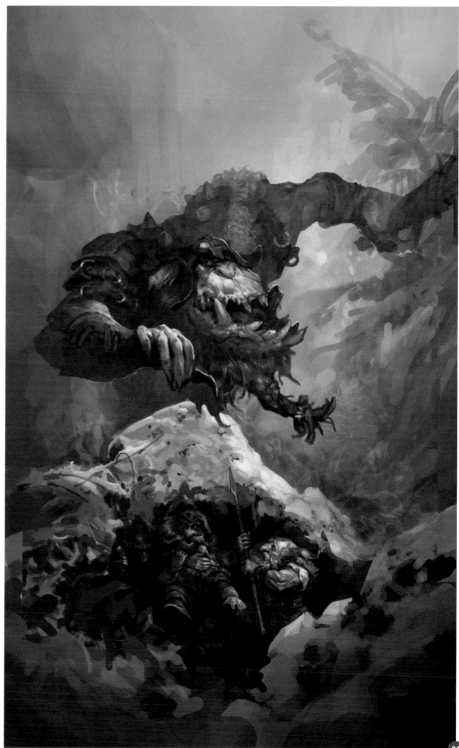

I decided to clarify the focus of the composition by using light around the center of the picture and then fading to a darker border. I used the Multiply blending mode to darken areas and Color Dodge to add highlights. I made the lighter sections warmer and softer, and the shadows cooler. I also started to detail the background, creating some common trees behind the troll (**Fig.06**).

FANTASY

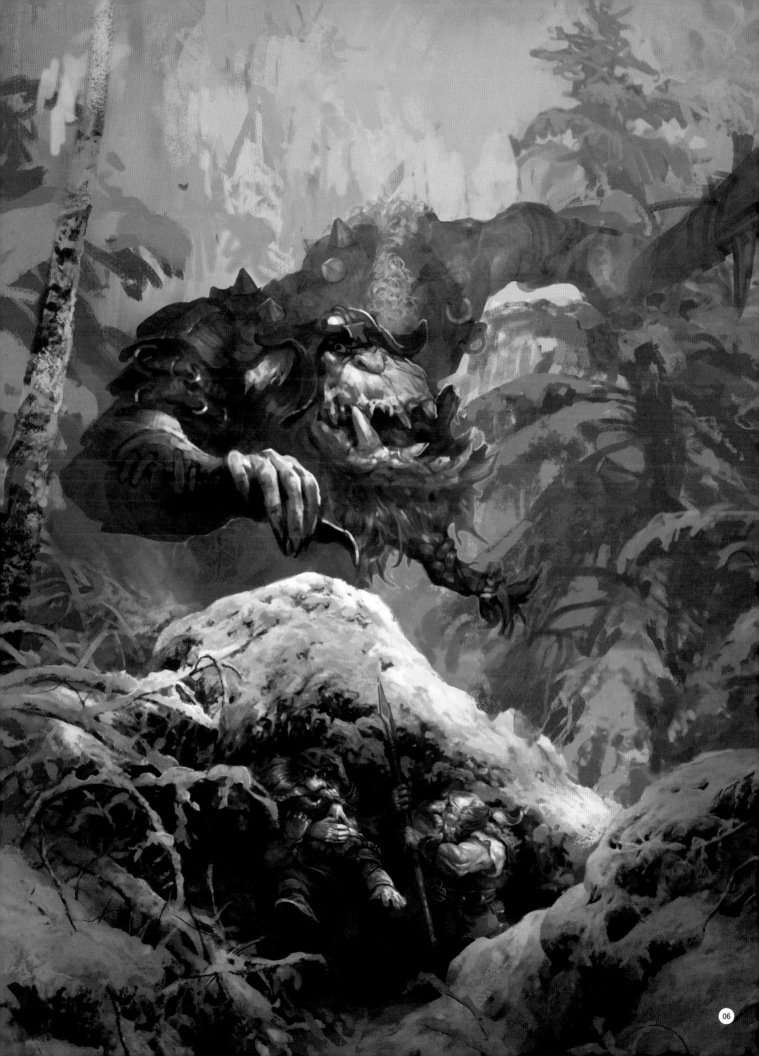

07

> I ALSO PAINTED A
> FEW LITTLE BIRDS
> PERCHED ON THE
> BRANCHES. THEY ARE
> NOT AFRAID OF THE
> TROLL BECAUSE THEY
> ARE TOO SMALL TO
> BE A MEAL FOR HIM!

Then I painted the forest in the background, along with the sky (**Fig.07**), after which I refined the troll with some further detailing (**Fig.08**).

During the final stages I completed the background by including tree branches to the right and the birch on the left. I also painted a few little birds perched on the branches. They are not afraid of the troll because they are too small to be a meal for him! Once satisfied with the picture I flattened all the layers and applied the Sharpen and Smart Sharpen filters. This gave the image more clarity by adding definition to the edges.

To conclude, I created a new layer and filled it with a gray color (in the table color picker I made the parameter B: 50%) before using the Noise filter (amount: 400%). I also employed the Stylize/Diffuse filter and set the mode to Soft Light with a low level of opacity (15%). To conclude I would like to thank everyone for reading and only hope you have enjoyed the article and it has proven helpful.

08

SEAGULLS AND DRAGON
BY PIERRE-ETIENNE TRAVERS

JOB TITLE: Concept Artist – Evolution Studios
SOFTWARE USED: Photoshop

INTRODUCTION
This picture was a sort of collaboration with a friend called Raphael Bourelly, who is a photographer. He took some pictures in Normandy that I wanted to use to create a new picture. I really liked the moody atmosphere and heavy clouds that were apparent.

MY PAINTING
To start I created some doodles in my sketchbook (which I've since lost, sadly) and picked up one of his photos. Sketching on paper is always a good thing to do because you can keep a record of your ideas wherever you are. This is also helpful for blocking in a composition quickly and building a solid vision even before starting your illustration.

I then completely blurred the picture and started painting directly over it. It's a nice way to get a quick palette from another picture, but it can prove tricky as well (**Fig.01**).

I continued painting with custom brushes, trying to keep to the initial light direction. As this stage I tried to stay loose and just block out the composition (**Fig.02**).

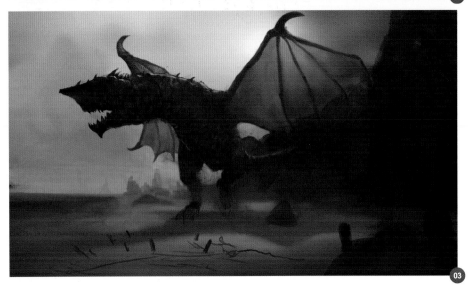

> **YOU WILL NOTICE THAT THE SHAPE OF THE BODY ASSUMES A KIND OF WAVE FROM LEFT TO RIGHT. THIS RHYTHM HELPS THE COMPOSITION, WHICH IS SOMETHING I TRY TO THINK ABOUT AT ALL TIMES**

I drew the monster whilst referring to my initial sketch on paper and although the process has since been lost, you can still see some of the lines around the feet. The design takes a lot of inspiration from *Monster Hunter*, a game I used to play a lot once. I'm still fascinated by the monster design, the animation, the scale and the feel of it is pretty much what I have tried to describe in this picture. You can still see a loose indication of a pit trap under the sand (**Fig.03**).

The monster is also used as a guideline for the eyes. You will notice that the shape of the body assumes a kind of wave from left to right. This rhythm helps the composition, which is something I try to think about at all times. The scales on the monster are a mixture of crocodile skin and painting. I often check if I can use photos, especially at work, as it saves a lot of time.

I try to do as much as possible in Photoshop and experiment a lot this way, but it can result in poor quality work when you start using photos as materials. The problem is

04

the definition, because if you start to paste in photorealistic textures, you get photorealistic details. If you are doing a matte painting then it's fine, but when it comes to using it as part of a painting then it becomes another problem. In fact, the fine details need to match the quality of the whole picture so be subtle, but do not be afraid to use it.

> ## I ALWAYS THINK ABOUT WHAT COULD BE HAPPENING IN THE PICTURE, TRYING TO CREATE A LITTLE STORY IN MY HEAD

I started to paste in more photo textures and add details in the background (**Fig.04**). I have tried to introduce a storyline into the picture by adding two characters that have set up a trap and are awaiting the monster. As a general rule, storytelling is a major part of the job, unless it's a pure concept for a character or a landscape. I always think about what could be happening in the picture, trying to create a little story in my head. If you start to consider this you can create a notion of time

in your illustration. Your picture then assumes a past and a future, and it make things more interesting. Sometimes, as you will see later, it can also harm your picture because if your composition is not strong enough it can become confused. There is often gain to

be had by introducing a human figure into a picture and it really helps determine a sense of scale.

As you can see in **Fig.05**, I started to refine some of the contrast to improve the scene and

05

also improved the cliff on the right and included a sky texture in the background. Once these components were added I started addressing the details.

This is pretty much near the end with most of the final details in place. I was content with the progress and so submitted my work for some constructive criticism (**Fig.06**).

One friend told me that the characters were useless and didn't serve any purpose in the image. It came as a bit of a shock, but after a quick test I realized that he was absolutely right. I think inviting feedback is a necessary practice if you wish to learn quickly and develop your art (**Fig.07**).

Don't work in isolation. Ask for criticism and listen to what the people have to say whether they are experienced artists or not. Even if you have years and years of experience in the industry, don't be afraid to change your initial concept if it's for the good of your picture. I took onboard my friends advice and instead of the characters, I added seagulls to bring a bit of life to the scene and also extended the right wing, which was too small. This gave the picture more room to breathe and placed the focus fully on the monster.

Fantasy

Sewer-Dwelling Monster
By Federico Scarbini

JOB TITLE: Character Artist – Creature Designer
SOFTWARE USED: ZBrush, Maya, mental ray and Photoshop

INTRODUCTION

Gathering information and references is the first very important step, because this is the foundation of your creative process and when you are asked to design a creature with very specific features you have to be very analytical.

CREATURE DESIGN

Since the environment I was dealing with was very humid, the first concern was the respiratory system. I liked the fact that including gills could lead to an interesting solution, but I was looking for something less dependent on water so my idea involved a creature that used modified gills and skin (like frogs) to extract oxygen from the humid air, but was reinforced with nostrils to help it breathe.

I wanted its hands and feet to be fin-like; this way it could have the right thrust underwater and also a good grip on the wetlands. For the bone structure I decided to draw some sketches to have a clearer idea of the monster's final look.

For me, sketching is not about trying to find the right answer. It's just a visual way of collecting ideas, getting inspired by forms and exploring one's thoughts. Lately I have started to mix different media, like digitally painting over pencil sketches or ZBrush sketches (**Fig.01a – c**).

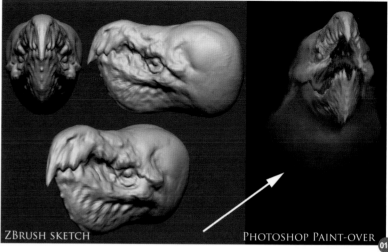

ZBRUSH SKETCH PHOTOSHOP PAINT-OVER

THE FIRST SCULPTING STAGE

Starting with a ZSphere base, my goal was to capture the gesture and some of the silhouette of the creature, so I didn't create very specific features at this stage, but instead focused on the feeling that I wanted from the figure (**Fig.02**). With my base established I started to adjust the shape using the Move brush and the Transpose tool to get the best out of my base mesh. After some tweaking I came up with a decent enough base, with the most important quality being to capture the gesture and silhouette of the model, plus an initial hint of some of its features.

REFINING THE BASE

During this stage I worked mostly with the Move, Move Topological, Standard, and Inflat tools. I focused on looking for planes and primary forms and, after adding further subdivisions, I concentrated on bone structures that determined the muscle groups.

> **I TOOK INSPIRATION FROM FISH LIKE THE FRILLED SHARK AND LOOKED AT THE IGUANA AND GIANT SALAMANDER TO HELP WITH THE DESIGN OF THE SKIN**

I then used the Clay and Clay Tubes brushes with alpha06: these two brushes work really well whilst building muscle surfaces and construction planes because the strokes appear very organic. I used Backface masking frequently when dealing with very thin surfaces such as the ears as this prevented the stroke passing through the surface and affecting the back faces. The Backface button is located in the Masking submenu under the Brush menu.

For the gills I took inspiration from fish like the frilled shark and looked at the iguana and giant salamander to help with the design of the skin (**Fig.03**).

DETAILING

Details (or tertiary forms) have to be supported by a hierarchy of secondary and primary forms so I tried to identify areas where the skin would compress through movement. I started to create localized wrinkles, with a logical direction that followed the articulation, and distributed them according to their proximity

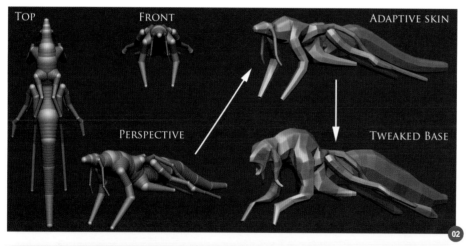

TOP FRONT ADAPTIVE SKIN PERSPECTIVE TWEAKED BASE

1 2 3 4 5 6

to the compression area (**Fig.04**). Good references are photos of real animals: analyze where these elements exist and if they have a reason to be there.

Generally at this stage I use the Standard brush with a very low intensity and build the details in layers, both conceptually and concretely, using sculpt layers (**Fig.05**). I also use the Dam Standard brush from time to time; you can find it in the brushes section of Spotlight.

> " TRY NOT TO HIDE YOUR SCULPTED DETAILS; INSTEAD PAINT ON THEM TO REVEAL THE NATURE OF THE SURFACE "

TEXTURING

Before starting the polypainting I created some UVs in Maya, using the unfold feature with some relaxing and the UV lattice deformer where necessary. With the UVs done I started the polypainting using the Standard brush with Stroke set to Color Spray and combined with alpha08 and alpha22, using salamanders and amphibians as reference. I tried to use different colors and go for variety to give the skin a realistic look. During the first pass I wanted a general variation and an initial color scheme. I placed some red/pink color where the skin was more irradiated with blood vessels (**Fig.06**).

I then used the cavity masking to paint different tones for the different depth levels. When most of the features were in place I baked the polypainting to texture to continue the job in Photoshop, where I used some photographic textures from the 3DTotal Texture DVDs (**Fig.07**). Try not to hide your sculpted details; instead paint on them to reveal the nature of the surface, using Displacement maps as a guide to accurately place your texture and paint strokes.

POSING AND MAYA SCENE SETUP

Once the model was posed with the Transpose Master and placed on a quickly sculpted ground, I imported everything into Maya, where I also add some additional environment elements like grass and some rusty iron tubes.

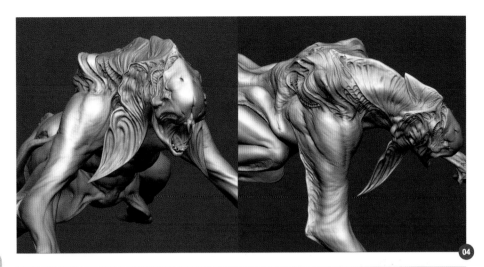

04

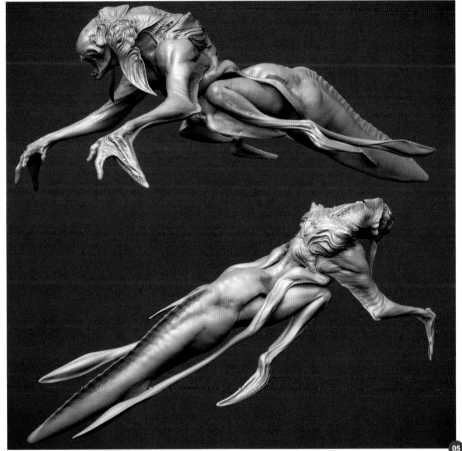

05

06

07

LIGHTING

Since I was going for a real environment, trying to mimic the environment lighting was the key to creating a realistic mood. I used Spotlights with Area Shadows and a Directional light that acted as a Rim light. To create an overall sense of drama I also placed an Area light above the creature to mimic the sky or an opening in the ceiling (**Fig.08**).

SHADING

I used the mental ray "Misss fast skin" shader for the creature, which can be a bit tricky to set up, but the key to mastering this shader is to split its setup into several steps. By adjusting the three scatter components in isolation you can effectively tune the SSS. It is difficult to say how the subdermal and epidermal layer should look, but my idea is that these layers should soften the shadowed area while revealing subtle details under the skin (**Fig.09**).

The other elements in the scene take advantage of standard Phong shaders. I chose to render out three passes: Beauty, ZDepth and Object ID (**Fig.10**).

POST-PRODUCTION

I started doing some Level and Curves adjustments, just to emphasize the tonal values and increase the contrast.

To create the sensation of moist air I used the ZDepth pass as a mask and filled a new layer with a white/bluish color. This way you have a sort of fog effect that you can tweak until you feel it's satisfactory. I then used Color Balance to give the image the right mood and made some further Curves adjustments.

Using the Z-Depth map I created some depth of field by way of the Lens Blur filter. I then made its breath visible to give the impression

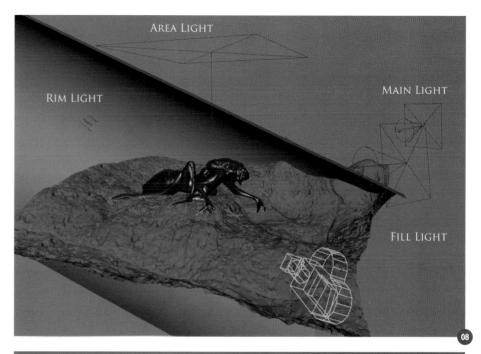

AREA LIGHT

RIM LIGHT

MAIN LIGHT

FILL LIGHT

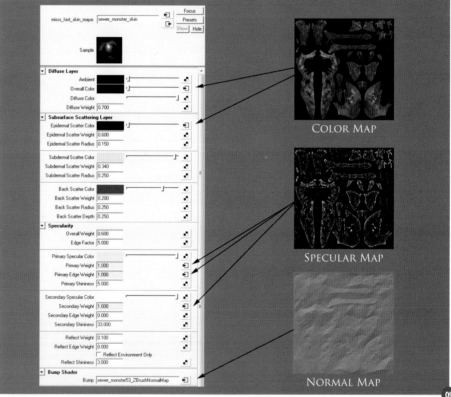

COLOR MAP

SPECULAR MAP

NORMAL MAP

that the environment is a bit cold, and as a final touch I painted in some strings of saliva between the creature's teeth using a standard round brush (**Fig.11**).

CONCLUSION

I hope that this article has provided an insight into the techniques I used to create the final image, and also helped you to understand a method of developing a believable creature and the story behind his nature and behavior.

Thanks for reading!

ARTIST PORTFOLIO

© Mateusz Ozminski

THE SECT OF CRACKED FISH
BY MATEUSZ OZMINSKI

JOB TITLE: Freelance Concept Artist
SOFTWARE USED: Photoshop CS4

INTRODUCTION

Before a piece of art comes into being, it is preceded by a personal process that goes on in your brain. Sometimes it takes place during creation; sometimes it is done beforehand. Everyday I reaffirm my conviction that successful ideas come from an artist's vision and idea, and not just his or her technical skills. There has to be a relationship built between an artist and a viewer. Even if the result is just a square on a white canvas, it is supported by a number of thoughts and arguments. The great examples are Piet Mondrian's paintings, which proved it was possible to intelligently use simple lines, basic colors and geometric shapes. Since we can logically interpret abstract art, there is no reason why fewer considerations and decisions should apply to concept art. This is what attracts me to art – ideological visions shown in a variety of unpredictable ways.

> **IN PERFECT SILENCE I CLOSED MY EYES FOR A MOMENT OR TWO, TRYING TO IDENTIFY WITH THE SITUATION, ALMOST AS THOUGH MEDITATING. I CLEANSED MYSELF FROM REDUNDANT THOUGHTS, WHICH ARE ALWAYS WITH US, AND STRUGGLED TO ENTER MY IMAGINED WORLD**

With these words I would like to introduce you to the creative process behind my painting. I do not consider brushes, tricks or effects as some of the most important aspects and do not believe this is the right way to go about achieving an absorbing image. These are

only cherries and not the foundations we should rely on. The quality of painting is a conscious choice of means and tools in order to accomplish a particular result. Therefore the basis is our purpose – an answer sought by questions.

CONCEPT

One cold morning I was clearing away snow, humming the Bob Marley song, *Is This Love* and decided that the world needed more warm colors. In that moment an image of a sun-bathed desert appeared, partly because earlier that day I had been looking through gallery images of some of the harshest landscapes on Earth. As I love to paint freehand without relaying too much on technology such as rulers, I immediately added the wreck of a huge plane or spaceship with some organic elements and desert people. In perfect silence I closed my eyes for a moment or two, trying to identify with the situation, almost as though

meditating. I cleansed myself from redundant thoughts, which are always with us, and struggled to enter my imagined world. I could feel the temperature, subtle wind, dryness and severity of the surroundings and if I'd had a healthy breakfast that morning, I would have envisioned a scene quickly. Sometimes it requires more sketching on paper and sometimes it requires some research, and perhaps even a shot of your favorite beverage. This time, it came pretty quickly!

SKETCH AND CATCH IT

I had a general outline of the scene in my head and after a while I laid the first lines down (**Fig.01a**). In spite of the simplicity, it already contained some of the most important elements which shouldn't be disregarded (**Fig.01b**). It is often the case that good preparation means better end results and quick execution doesn't really reflect the final result. Many of my images end up in the trash bin because of a lack of research or postponing important decisions, but recognizing mistakes guarantees progress.

The next step was to select the main areas and shapes using the Lasso tool (**Fig.02**). I

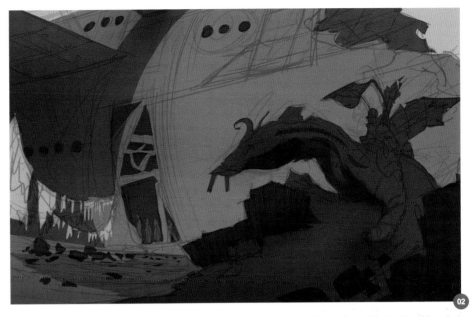

recommend planning it with layers as it vastly improves efficiency. Graphic treatment of space (foreground/background/middleground) was complemented with delicate shading using a big soft brush. Even though the shapes seemed to be pretty concrete I freely changed them, taking advantage of the digital medium.

COLORED THINKING

Having the general black and white sketch I

then applied colors using a big textured brush on an Overlay layer (**Fig.03**). Overlay mixing allows you to not only influence the color, but also the values too. During the process of painting I am constantly experimenting, searching for the most balanced solution. I limit the use of the Eyedropper tool in order to enrich the palette and add some spacial depth to surfaces. Of course, some color variation has a scientific explanation, e.g., the top of the

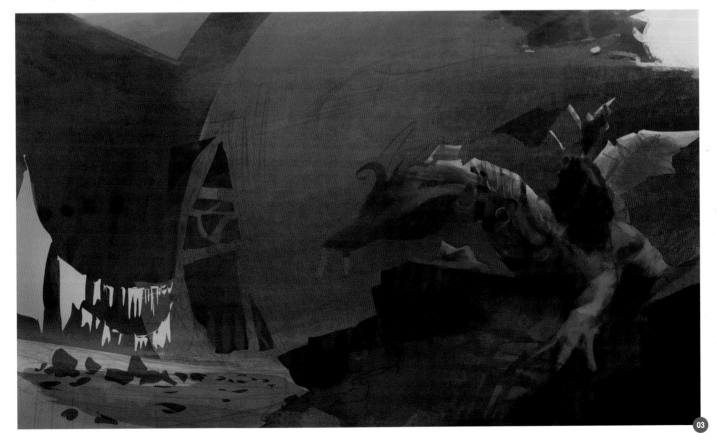

I AM ALWAYS "AMAZED HOW MUCH" VISUAL CANDY THE STANDARD SOFT BRUSH GIVES

ship catches a blue glow from the sky, whilst the underside receives light bounced from the sand. Despite this it is more fun to allow for happy accidents and avoid being constrained by rigid physics.

I wanted the character to be the main focus of interest, so I began painting him first (**Fig.04**). Important objects in the scene should be your biggest concern. The Photoshop layer option "lock transparent pixels" allows you to quickly block in color levels within a certain layer, but it needs to be turned off when changing the outline.

I felt that the red background was too imposing and, surprisingly, not warm enough. Using

Color Balance and Levels I improved it (**Fig.05**). I also applied some shadows to the main character using a layer set to Multiply, and light and saturated colors set to a low opacity, as opposed to dark tones which give dull results. I am always amazed how much visual candy the Standard Soft brush gives.

COMPOSING THE STORY
The colors still seemed too heavy so I opted to increase the division between the foreground

and background (**Fig.06**). It was during this exact moment that the story of *The Sect of Cracked Fish* crystallized. People appeared inside the ship along with a destroyed engine, and an additional hole in the fuselage added lightness to the giant construction. Compositionally it also emphasized the foreground characters within an "orange frame", exaggerating the contrast and color. I imagined them being located in the shade with the sky reflecting across the shiny elements, such as the shields and armor. This shadow also covers the drying laundry, which I know is hanging too high.

> " **THE BIGGEST ADVANTAGE OF PAINTING IS THE FREEDOM IT AFFORDS AND I ENCOURAGE PEOPLE NOT TO ADHERE TO EXCESSIVE "CORRECTNESS"** "

Adding awnings to the aforementioned damaged plane suggested it is inhabited (**Fig.07a – b**). I decided to lighten the foreground character, worrying it could turn out too dark in printing. I also assumed that he's illuminated by the surrounding light, together

08

with the red light bouncing from the ship, which is especially visible along the edges. This helps to merge the main character with the background.

In order to emphasize the main characters I decided to amplify the atmospheric perspective (**Fig.08**). The green tint reflects a little artistic freedom, but it could be justified by different atmospheric conditions on the planet. The biggest advantage of painting is the freedom it affords and I encourage people not to adhere to excessive "correctness". It is sometimes worth settling on aesthetics rather than logic – please note the subtle haze just above the surface of the desert.

The final step concerned color correcting and adding details. After consulting with my family and friends I introduced some modifications to the foreground rocks and added a few light stripes along the wings to help suggest their shape.

CONCLUSION
I would like to underline that the most significant virtue of art is individuality and it is profitable to look for our own way of doing things. I found my inner voice, which will never say to me: "Man, just do cool pictures and it will be fine." What really matters is conveying a story, mood and emotion. Technical skills shouldn't be extolled too much. These two conclusions ignited my self-developement as not so long ago I was thinking completely the opposite. I am very thankful for the opportunity to share some of my processes with you and hope that my painting made you wonder about the content and story.

> " I FOUND MY INNER VOICE, WHICH WILL NEVER SAY TO ME: "MAN, JUST DO COOL PICTURES AND IT WILL BE FINE". WHAT REALLY MATTERS IS CONVEYING A STORY, MOOD AND EMOTION "

THE DWARVES
BY JESSE VAN DIJK

JOB TITLE: Senior Concept Artist – Guerrilla Games
SOFTWARE USED: Photoshop and 3ds Max

INTRODUCTION

Large scale battles are something I like to paint anyway, so imagine my joy at being asked to do an over-the-top, epic painting for a special reprint of Markus Heitz's *The Dwarves* series.

The four-book saga was initially released a few years ago, but since it was such a major commercial success internationally a special edition was reprinted for Christmas 2010. The idea the publisher approached me with was to have a single illustration cover all four books at once – but at the same time they wanted each of the individual books to have a cover that would still enable stores to sell it separately.

> **THIS ALLOWED ME TO HAVE THE CASTLE VANISHING INTO THE DISTANCE, INCREASING ITS PERCEIVED SIZE**

Compositionally, this meant I could use a very wide angle lens – good for epic shots – but also that I had to continually work on five compositions simultaneously; the overall shot and the four individual shots. Another challenging aspect was that the image needed to be pretty high res, with a minimum width of 7200 pixels. This isn't the problem it was a few years ago, but still made everything a bit slower and less responsive.

SKETCH

The publisher had outlined what they were expecting: a large siege, by orcs and the like, of a huge dwarven stronghold. There wasn't really any sort of scale limit to the scene, as long as the viewer would be able to discern individual soldiers.

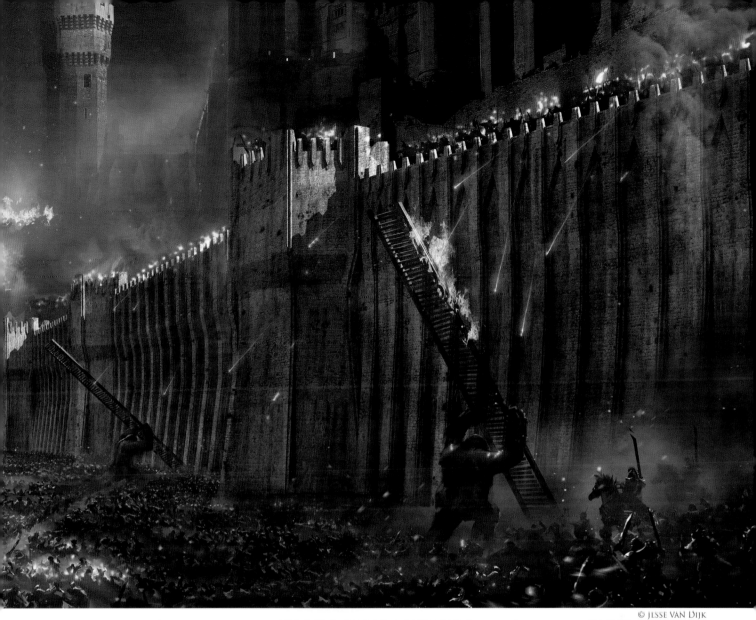

What I started off with was a thumbnail sketch of a long, horizontal stronghold with four towers that would coincide with each of the four separate books (**Fig.01**).

However, this led to a very boring overall composition, so I tried replacing one of the stronghold towers with a line of siege towers brought to the battlefield by the besiegers. This allowed me to have the castle vanishing into the distance, increasing its perceived size considerably. Also I grabbed some photo references to create some placeholder stronghold towers.

To quickly paint a mock-up army of thousands, I took the default Round Photoshop brush and simply increased its Spacing and Size Jitter. If you keep individual rows of dots on separate layers, you can quickly light some of them with the Dodge tool, and keep others dark (**Fig.02**).

FANTASY

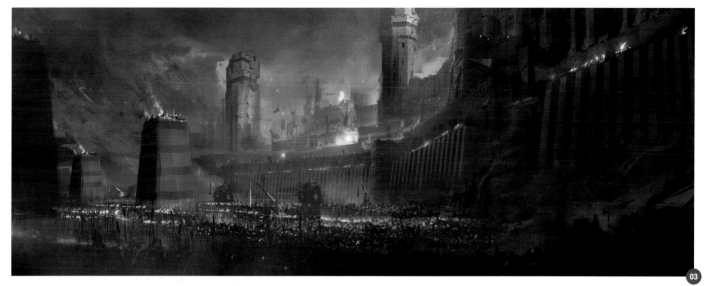

This black and white sketch, with the red frame to indicate where the individual covers would be, was approved by the client, so the composition was pretty much nailed down. The main thing to determine before moving on was the color scheme. To underline the sinister motives of the attacking army the event takes place at night, so I kept the colors generally within the same reddish range, except for some hotspots of saturation, like the many fire sources in the scene.

Also, I wanted to really emphasize the scale of the stronghold. By introducing an oft-repeating buttress along the walls, the angle at which the

camera is facing the walls became much easier to read. It also suggested heavy reinforcement to the wall, which suited the generally accepted nature of sturdy dwarves (**Fig.03**).

STRONGHOLD DESIGN AND 3D MOCK-UP

One of the things I really wanted to show was the fact that this was not just a generic high-fantasy castle, but a dwarven stronghold. I intended to illustrate this predominantly through the wall and tower designs. So before I went on to detailing my color sketch I started off on paper to do some sketches of the tower designs (**Fig.04**).

Using hard, angular and simple shapes, I ultimately settled for a design to take into 3D for a rough mock-up. Doing things in 3D has many benefits. It allows you to experiment with designs and see how well they work in the final image straight away. Rebuilding the camera also forces you to carefully consider horizon locations and lens angles. I was planning to do a rough model for the siege towers in this case (such a simple, geometrical structure can be built quickly) and having a scene in which to place them later on would save lots of time getting the perspective right (**Fig.05**).

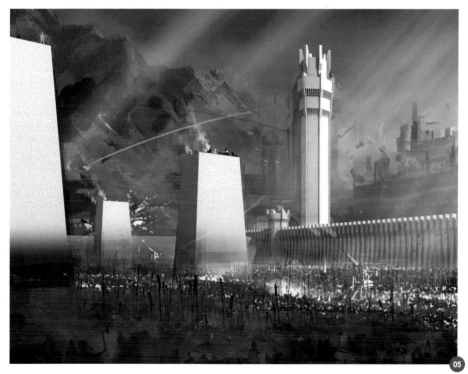

FANTASY

However there are also many downsides to 3D, as it can be very time-consuming, and also not everything actually looks better when it conforms perfectly to perspective. This is especially the case with such wide angle lenses where lots of distortion will occur in the corners. In these cases I deliberately chose to "override" the 3D output and use painted content instead.

> ## WHAT I WAS LOOKING FOR WAS MERELY THE SUGGESTION OF DETAILS OF INDIVIDUAL UNITS

In the end, I did not use any of the 3D designs I had done for the towers. I figured they would be covered by the book titles anyway, so seeing as I wasn't happy with them at that point, I decided to ditch them altogether. Thankfully I liked the wall design more so I kept that.

BUILD ME AN ARMY

Although I had painted armies previously, I had never done so while looking at the scene from the attackers's perspective. This meant I could no longer use my "Scattering Round brush with Size and Brightness Jitter" approach – it worked fine for the sketch, but my client had stated he wanted to be able to distinguish individual soldiers, so I needed more detail than a simple round dot.

The first thing that came to mind was to create a "soldier brush" – but the main problem

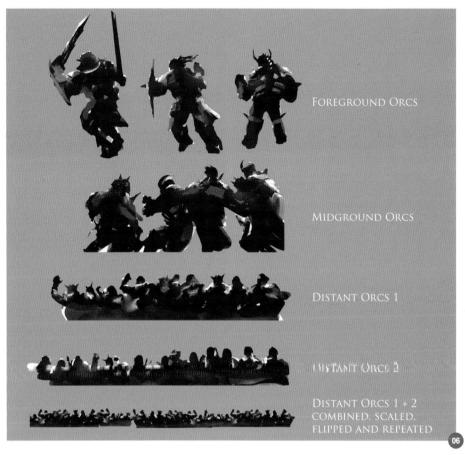

FOREGROUND ORCS

MIDGROUND ORCS

DISTANT ORCS 1

DISTANT ORCS 2

DISTANT ORCS 1 + 2 COMBINED, SCALED, FLIPPED AND REPEATED

06

with this is that Photoshop's brushes can only consist of a single color. You can use Brightness Jitter, like I had done in the sketch, but that will affect the entire brush tip. What I needed was to have cloned instances of soldiers that contained both shadowed areas as well as highlights. With this in mind I sketched four different levels of soldiers on separate layers (**Fig.06**).

I used the soldiers from the top row to place in the foreground, and the midground guys

behind it, and so on. I deliberately refrained from putting any sort of meaningful detail in them – I felt that had I not done this, I would have had to spend far more time designing armor, weapons and such, which was never my intent. As contradictory as it may sound, what I was looking for was merely the suggestion of details of individual units – not the actual details themselves.

To separate the rows of orcs from each other I used layers of painted smoke. With regard to

07

the structure of the attacking army I liked the idea of "ordered chaos" – clearly there should be some form of organization to the army, portrayed in this case by the "paths of dust", heading towards the vanishing point, but other than that, it's mostly just blind fury and chaos. After completing the rows of soldiers, the image looked like **Fig.07**.

> ❝ **THE FRONT OF THE SIEGE TOWER HAD TO BE ABLE TO WITHSTAND PROJECTILES FROM THE CASTLE WALLS, SO I SUGGESTED A WICKER COVER OVER WHICH COW SKINS WERE PLACED** ❞

Since I still had all the rows of soldiers on separate layers, I could manually color balance them to conform to the overall color scheme.

INTEGRATION OF ALL THE ELEMENTS

After having completed the 3D mock-up and the rows of soldiers, the most pressing problems had been solved and it was basically downhill from there.

I spent some time on the siege tower model, because it would be the set piece of one of the

four books. I built the skeleton in Max, and then mapped and textured it as well (although not carefully; but that would never show). The front of the siege tower had to be able to withstand projectiles from the castle walls, so I suggested a wicker cover over which cow skins were placed (which were usually soaked in urine to prevent them from catching fire too quickly, apparently). For the skin texture, I initially tried some photos of real cow skins, but funnily enough, what ended up looking much better was a simple rock texture on top of the wicker (**Fig.08a – b**).

What remained was the texturing of the castle wall (which I did in 2D in Photoshop) and some unique soldiers (like the trolls and horse riders). Using a similar approach as I had for the rows of orcs, I littered the scene with torches.

In the end there was so little time left it was necessary to cut corners here and there. For example, the huge fire in the castle was put there simply because I had no more time to paint a proper castle there. Ultimately, I preferred the fire since it really "pops out". Deadlines can be a blessing!

FANTASY

© JESSE VAN DIJK

BAROKO
BY BLAZ PORENTA

JOB TITLE: Freelance Artist
SOFTWARE USED: Photoshop and ArtRage

INTRODUCTION

When I received an invitation to work on the new Siddharta project my smile stretched from one ear to another. Not only are they one of my favorite bands, but the project itself was epic as well. My job was to paint thirteen wide landscape illustrations, one for each song, and the cover, which was the start and the end of the whole story. I worked closely with the band's lead singer and their art director, who were also responsible for the main concept of the album. My biggest challenge in this project was to capture the soul of each song by choosing which allegories to use to portray the lyrics and what colors best suited the melody.

IDEA

Baroko is a rock ballad with both romantic and surreal lyrics. A story is set between two river banks connected by a small bridge, with post-war debris and lost souls on one side and a child-like dreamscape on the other. On the bridge there is a couple, who despite all the madness that is surrounding them, find each other and are floating away into the sky. Despite being a romantic song, it is also a rock song with some hard and unpolished guitar riffs. That's why the painting itself shouldn't be too polished and soft, but rather heavily textured, with visible brush strokes, and even sketchy in some places.

PAINTING

The process started like many of my paintings, using a grayscale sketch to search for a composition (**Fig.01**). I roughly put down some story elements, in the form of messy shapes, that could be open to further interpretation later on through listening to the demo track.

FANTASY

At first, the concept for the left side of the image dictated madness and mystery, and only later changed to a more child-like innocent set. At this stage there was still a hint of different theme park attractions, such as a roller coaster, carousel and some clown faces. Debris from a downed plane and lost souls filled the right side of the canvas, depicting post-war remains. Lost souls were going to be facing away from the viewer, saying goodbye, although not knowing where to go. They are waiting for something.

At this stage, I tried to be very spontaneous with my brush strokes. I used the Basic Round brush and a square brush, which created some very interesting jagged lines. For me, these kinds of lines breathe life into an image, so I don't worry even if they stay visible until the final stage of the process. When I was happy with the overall composition, I used Overlay and Color blending modes for the layers in Photoshop to colorize the image. While Color

mode helps with hues, Overlay corrects the tonal values where necessary (**Fig.02**). I was looking for the right color scheme to go with the melody of the song, as well as sticking with the dawn setting behind the story. My first choice was a combination of violet-blue hues for the night sky, being a bit darker on the left side so the theme park would glow and stand out more from the background. The sun will rise from the

right, so I used pink and yellow to convey the morning light spreading over the clouds.

It was time to send the image to the art director for approval. We agreed that the theme park was not fitting into the story, so we tried something less aggressive instead: a magical tree (**Fig.03**). I left the red glow in the tree canopy to maintain a strong contrast

04

with the background sky. I also started defining everything else in the image as equally as possible. It is important not to get stuck on one particular part of a painting and forget about everything else, especially when you are working to a deadline.

> ## THE NIGHT-TIME
> ## WAS TOO GLOOMY
> ## AND THE MAGICALLY
> ## GLOWING TREE
> ## DIDN'T FIT INTO THE
> ## STORY EITHER

I continued to use basic brushes from the Photoshop library, sculpting and defining shapes and making minor changes to the light whilst searching for the right mood to best fit the melody of the song (**Fig.04**). The clouds in the back were way too flat, so I needed to model them a bit. Although they often look flat when we look to the sky, they are actually very three dimensional. To paint something, we need to understand it, which is why one should always look for good references and study them.

Creating clouds in this piece started with some soft shapes, which defined the basic form. I then continued with a hard round brush to sculpt it and create more volume. For the last step I used a scratched brush, which helped blend some parts together by adding a messy and painterly edge (**Fig.05**).

The more and more I listened to the song, the more I realized the color scheme wasn't working anymore. The night-time was too gloomy and the magically glowing tree didn't fit into the story either. I inverted the contrast between the tree canopy and the background, making it much lighter. The image suddenly

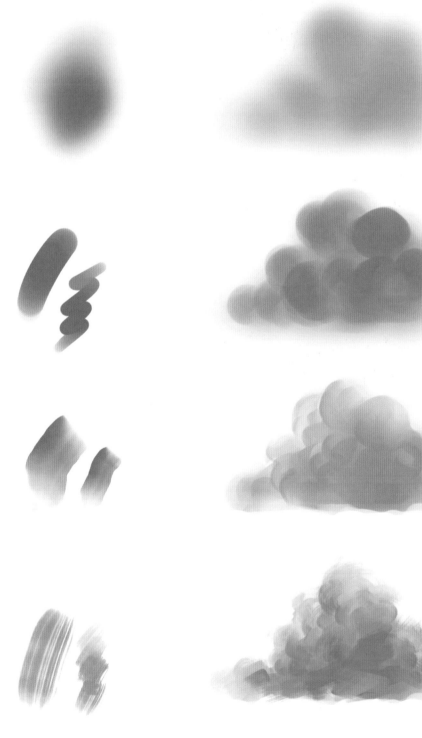

05

FANTASY

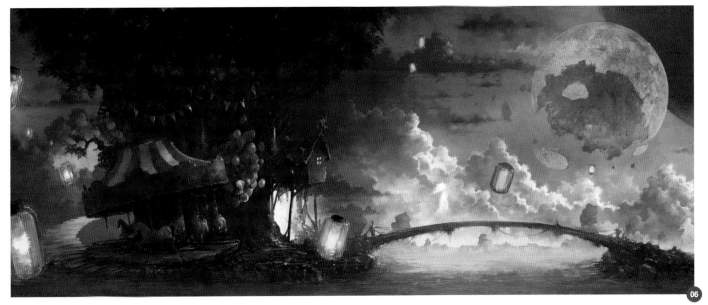

became full of life. One more check with the art director gave me a green light on the changes. The left side was now somehow a magical and mysterious place, but with a pure and innocent touch, incorporating a tree house, forgotten carousel, balloons and an entrance into the fairytale land. A smaller moon became brighter, which brought it closer to the viewer, creating more depth in the image (**Fig.06**).

At this stage I also started using lots of different brushes, many of them with scattered edges and textured characteristics. This is how I avoid

I DIDN'T NEED TO PAINT EVERY SINGLE LEAF OR SECTION OF BARK ON THE TREE, OR DRAW THOUSANDS OF SMALL WAVES ACROSS THE WATER'S SURFACE

getting a digital or airbrushed look and it also helps define different materials more quickly.

Since everything was working now I could continue to the final stage of the process through detailing. It was very important to know exactly what to polish and what to leave as it was. We too often put too much effort into all

kinds of details that only confuse the viewer. In my case, I didn't need to paint every single leaf or section of bark on the tree, or draw thousands of small waves across the water's surface. It is enough just to provide some hint of the texture and a clear silhouette of the object. Everything else becomes clear and the missing areas are filled in by the viewer's

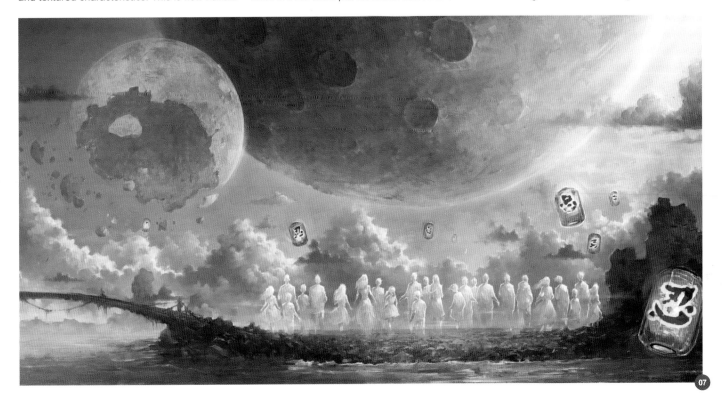

08a

imagination. I did, however, need to paint more
detail on and around the two moons. Craters
on the big moon were essential to describe the
object, and a smaller moon was missing some
parts as if it had blown up (**Fig.07**).

LAST TOUCHES

As I mentioned previously, I was striving for
a very rough and sketchy style, although it
had to look like a complex and finished piece.
I achieved this during the final stages where
I played around with some rust textures on
Overlay layers, placing them in carefully
chosen places and setting the right amount
of opacity. On top of that, I also imported the
image into ArtRage where I applied some thick
brush strokes here and there, playing with the
Palette Knife and smudging several edges
to make them look like accidental mistakes. I
love these "mistakes" as they make the final
painting look so much more alive (**Fig.08a – c**).

CONCLUSION

Every painting is a new experience, from
which I learn. That is why I love to work so
chaotically and let the flow of inspiration guide
me throughout the process, no matter how
many changes it may bring. It brings many
challenges, and consequently many new
answers as to how to create something.

08b

08c

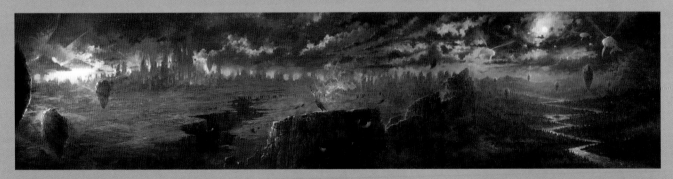

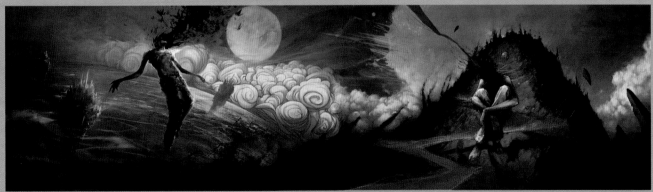

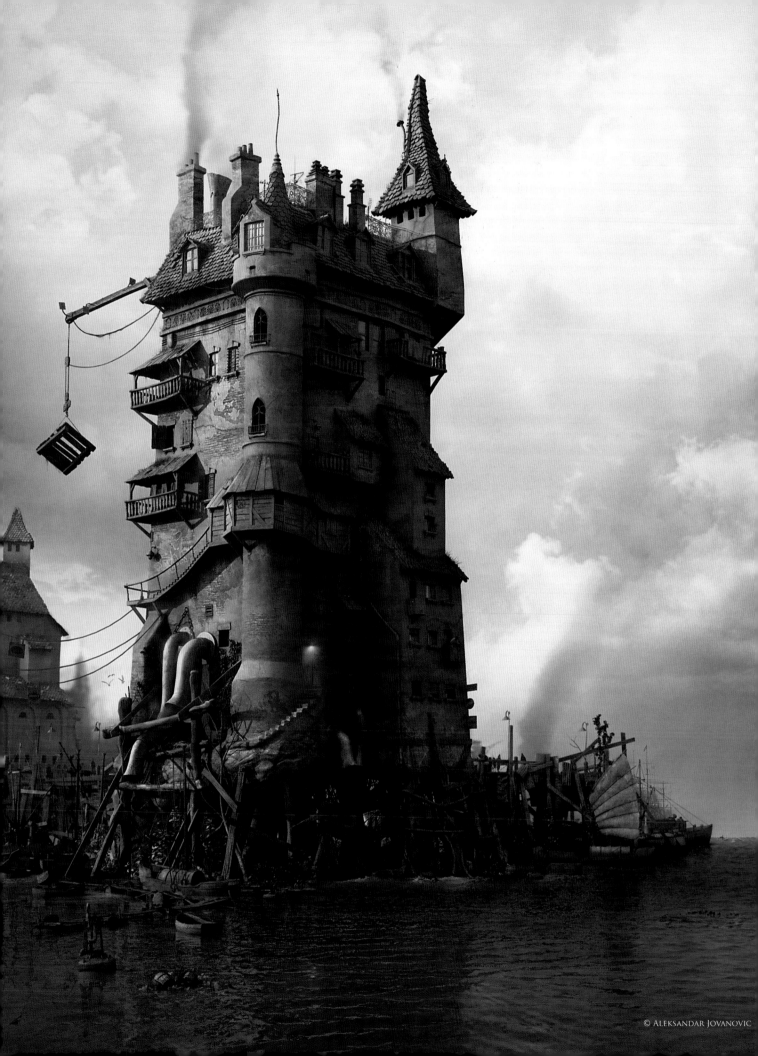

© Aleksandar Jovanovic

Harbor
By Aleksandar Jovanovic

Job Title: Concept and Texture Artist
Software Used: Maya, ZBrush, Photoshop and mental ray

Introduction

Harbor is my latest personal project. It evolved from an idea to create an old and rusted place surrounded by water in some sort of futuristic dreamscape. I have always loved this kind of scenery and finally had some time to invest into making one of my own. Traditionally I use a combination of Maya and mental ray for modeling, texturing and rendering, and ZBrush for fine details such as rocky surfaces and pipes. Finally Photoshop helped the compositing, over-painting and color correction. For this project I decided upon a fairly large resolution (1910 x 3000). The scene was huge, intensive to composite and render, but nevertheless served as excellent practice, involving around four to five million polygons in total.

Concept

First of all, I made a quick sketch in Photoshop, spending no more than 20 minutes defining the composition and most important elements which were going to serve as a base for everything else (**Fig.01**).

During the pre-production stage I usually block in my scene using primitive geometry

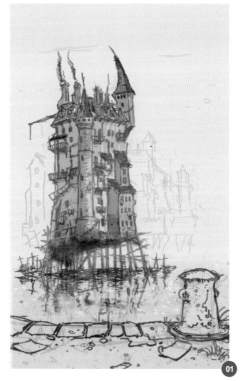

such as cubes and planes, which serves as a good starting point. Following this I usually do one rough render and bring the image into Photoshop before doing a quick paint-over to plan and arrange the components. This is a simple process, but helps visualize ideas fairly quickly. I made some other slight adjustments in Photoshop by painting in some other buildings, water and sky, along with

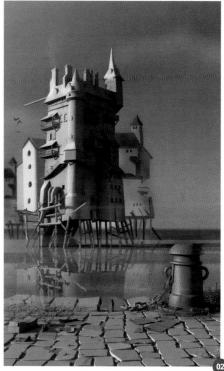

making some minor color corrections. This is a creative stage where I can easily experiment without constraints. Back then I realized that my main focus should be on the large building in the front, so I abandoned the idea of the foreground dock (**Fig.02**).

One way I like to work is to separate certain elements and reference them later in one large final scene. I therefore had one scene with a large building with everything modeled and textured, one scene with just the docks, one including just the boats etc. In the end I referenced them all in one scene with a lighting setup and produced the final render. By doing this I was able to manipulate the individual components and have them updated in the final set almost in real-time.

Modeling

Modeling the main building was relatively easy, but the amount of detail required an extensive period of time. Since I love all the fine details, I spent a lot of time refining them. Many of them are polygons, but I also included

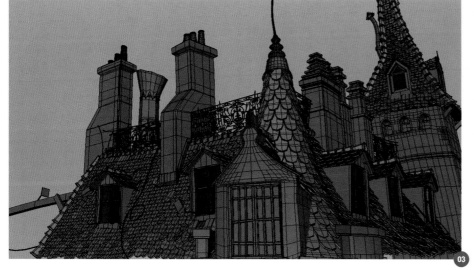

"SMALL DETAILS
LIKE THE BROKEN
WINDOW, FALLEN
ROOF TILES AND
GRASS ALSO LENT A
NICE EXTRA TOUCH"

some Subdivision and Nurbs. One of the tools I favor when finishing a model is a Lattice, which users of 3ds Max will know as the FFD modifier (Free Form Deformation). I use it to add irregularities over the entire surface. For example, I used the Lattice tool to deform the roof, roof windows, terrace and chimney. Small details like the broken window, fallen roof tiles and grass also lent a nice extra touch. Variation across elements like the wooden planks and logs were sculpted in Maya courtesy of the Sculpt tool. I first modeled the basic shape of the wood, subdividing it once or twice, and

then sculpted the surface very intuitively with different shapes and brushes. This tool is not as powerful as ZBrush or Mudbox, but can be very handy from time to time (**Fig.03 – 07**).

Fine details for large elements like the rock cliffs and pipes were done with the help of

ZBrush (**Fig.08**). All shapes were sculpted with custom made alphas and the Standard Mallet and Clay brushes.

TEXTURING

With the exception of the water, which used the Mia Material X, all parts used simple

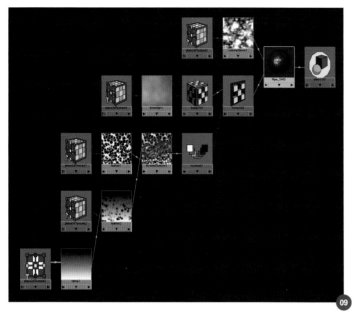

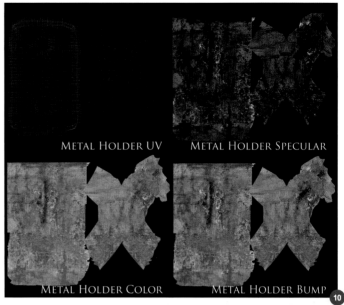

METAL HOLDER UV METAL HOLDER SPECULAR

METAL HOLDER COLOR METAL HOLDER BUMP

Lambert and Blinn shaders (**Fig.09**). Most of the textures were layered one on top of another and projected onto the geometry, with some even using layered procedural maps including Fractal, Cloud and Noise. Only a few objects were unwrapped as it would have been very time-consuming to unwrap everything, and I was pretty happy with the method of projection. Certain parts of the image were textured directly in Photoshop as it saved some time, especially where dirt was concerned (**Fig.10**).

For many of the pieces using custom made textures, Color, Bump, and Specular maps were created in Photoshop. I used Maya ocean for the water, but only for generating the Displacement map (**Fig.11**). I didn't like the look of the ocean shader in the render, so for

the shading I used Mia Material X with a higher reflectivity and blue tint. The ocean shader was then placed in the Displacement slot, which yielded a much better and more realistic result.

> " THE FIRST IDEA WAS TO CREATE AN ENVIRONMENT WITH A COMPLETELY DIFFUSE LIGHT, BUT I REALIZED THAT SOME DIRECTIONAL LIGHT WOULD LEND A CERTAIN DYNAMIC AND LOOK BETTER "

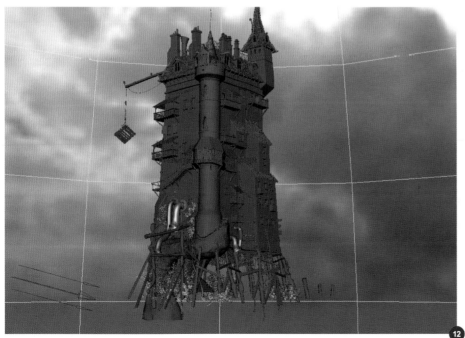

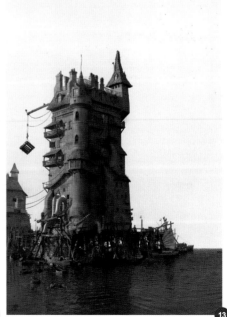

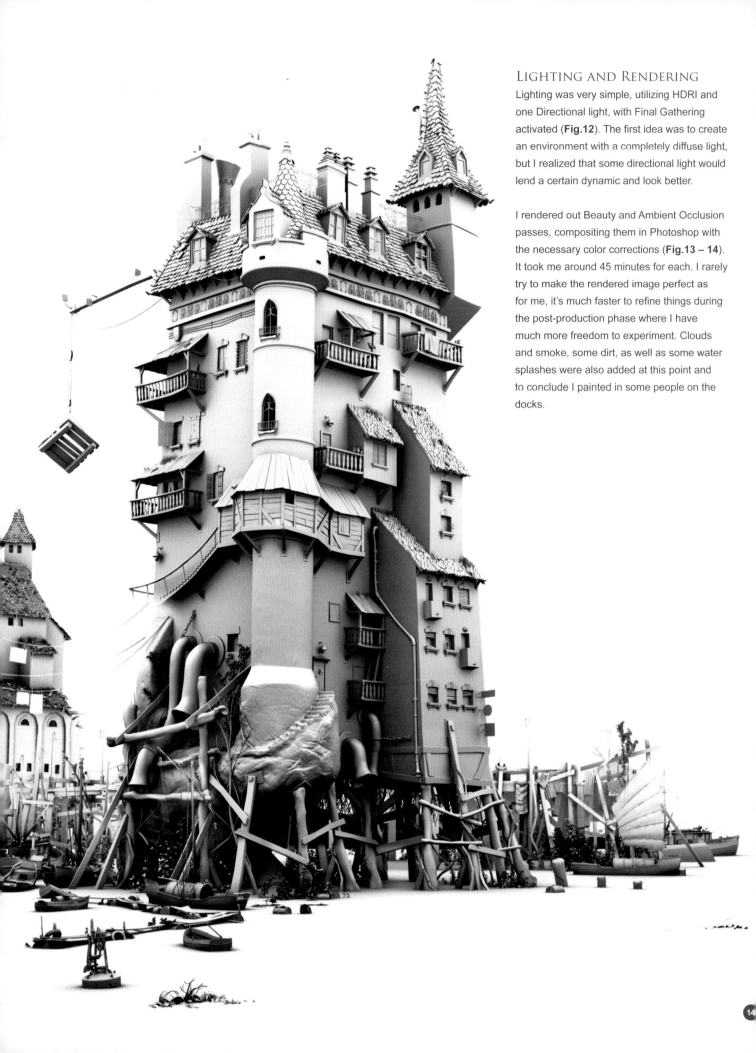

LIGHTING AND RENDERING

Lighting was very simple, utilizing HDRI and one Directional light, with Final Gathering activated (**Fig.12**). The first idea was to create an environment with a completely diffuse light, but I realized that some directional light would lend a certain dynamic and look better.

I rendered out Beauty and Ambient Occlusion passes, compositing them in Photoshop with the necessary color corrections (**Fig.13 – 14**). It took me around 45 minutes for each. I rarely try to make the rendered image perfect as for me, it's much faster to refine things during the post-production phase where I have much more freedom to experiment. Clouds and smoke, some dirt, as well as some water splashes were also added at this point and to conclude I painted in some people on the docks.

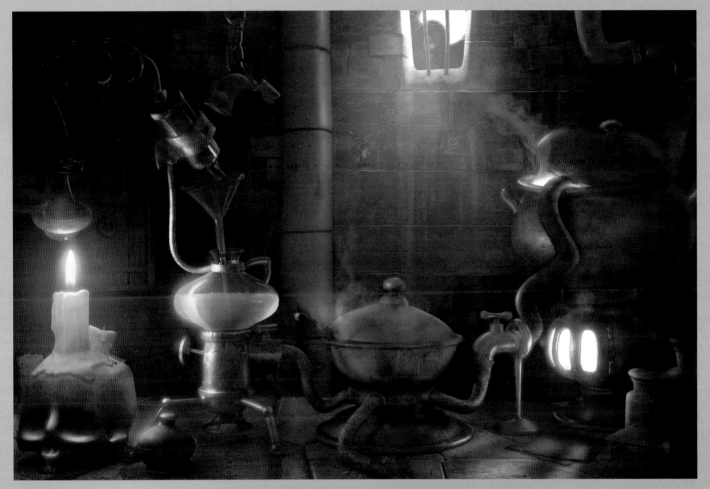

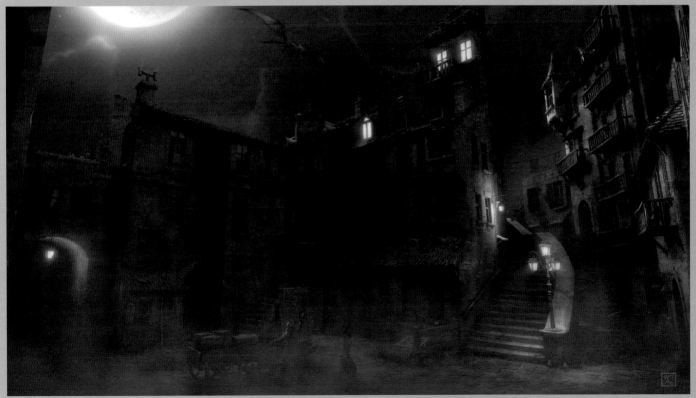

FANTASY

Sci-Fi

Science fiction is a wonderful genre. Where else can creative minds quench their thirst for unknown worlds, alternate realities and visions of the future? And where else can you create fantastical machines and explore their everyday relationships with mankind?

These creative imaginings of our future selves are a perfect fusion of entertainment design, technical know-how and the breadth of an artist's life experience and imagination.

Ultimately it is the brilliant imagination of artists that helps bring these vivid creations to life, as a perfect single snapshot of a window into our future.

Chee Ming Wong

chee@opusartz.com
http://koshime.com

© NICONOFF

FLAPURSITY
BY ALEKSANDR NIKONOV

JOB TITLE: Concept Artist – Nival Online
SOFTWARE USED: Photoshop CS4

PROCESS

I started by sketching the composition using blurry spots. I made some quick sketches from different angles using brushes with varied opacity, Jitter and Flow Jitter levels. I divided the work into three viewpoints: foreground, middle and background. I tried not to add excessive details, because for now the goal was the composition. I then chose the sketch I liked and started working with it (**Fig.01**).

 IT OCCURRED TO ME TO CREATE BUILDINGS SUPPORTED BY A TREE, AS OPPOSED TO HAVE THEM LEVITATING IN THE AIR

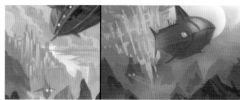

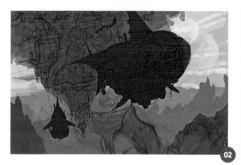

I began to draw lines over the sketch. Because there was a chance that things would change during the following stages, I didn't try to finalize anything now. I imagined how the ship and the city would look. Using a lot of line work helped clarify the concept and forms. This method can be used both with simple photos and photo textures, in a semi-transparent layer above the sketch. It occurred to me to create buildings supported by a tree, as opposed to have them levitating in the air (**Fig.02**). Paying attention to the focal points (the ship and city) I superimposed a compositional grid in order to create a harmonious balance (**Fig.03**).

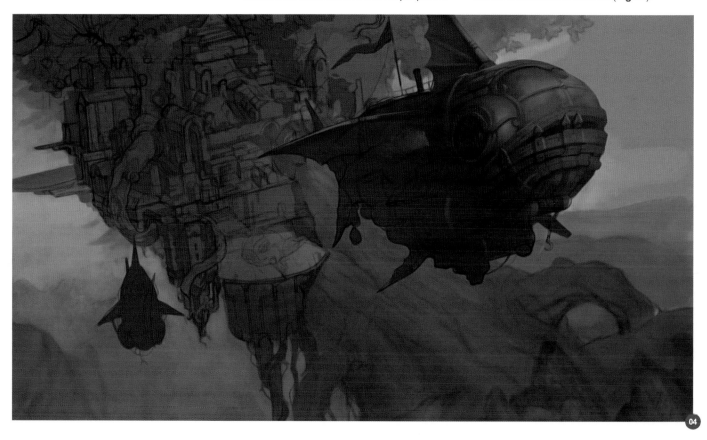

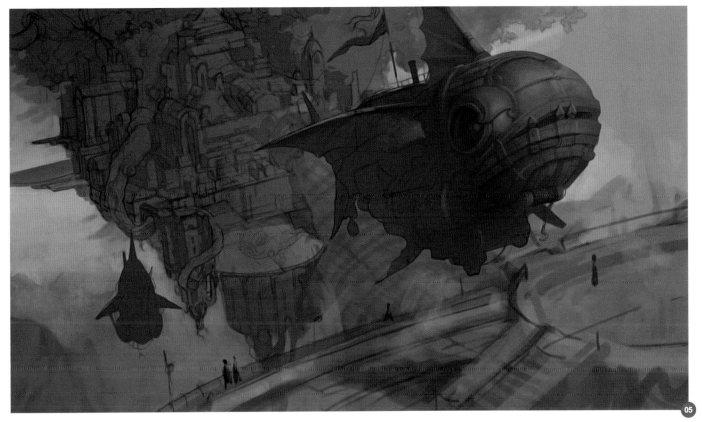

05

I then started working with tone, amplifying the contrast of the nearest objects and intensifying shadows. I didn't like the ship being situated in the center and the square format looked awkward so I decided to widen the image (**Fig.04**). I had an idea to include a quay in the foreground showing some figures, but the composition lost its dynamism. I worked through the tonal range in order to clarify where

to put accents and balance the black and white. During this process you should avoid too many black or white spaces as this will intrude on the coloring later (**Fig.05**).

As soon as the tonal range was established I set about adding color. I chose colors that would dominate the work and filled in with gradients, working with different blending

modes – Soft Light, Overlay, Multiply etc. For the distant scenery I worked in layers set to Lighten and Screen to convey the atmospheric perspective. I then added corrections and details in Normal mode (**Fig.06**).

At the end of the painting process I usually make some variations with the help of Color Balance, Photo Filter and Color Range. In this

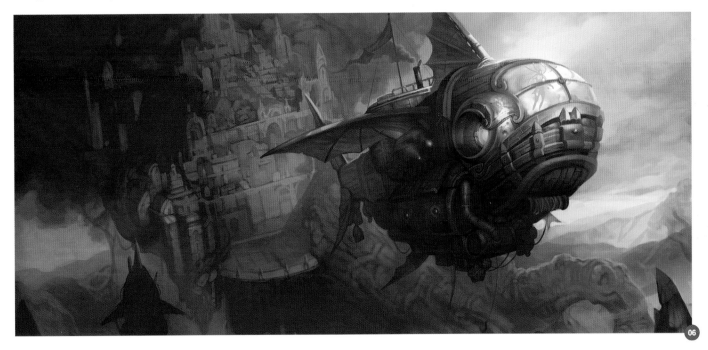

06

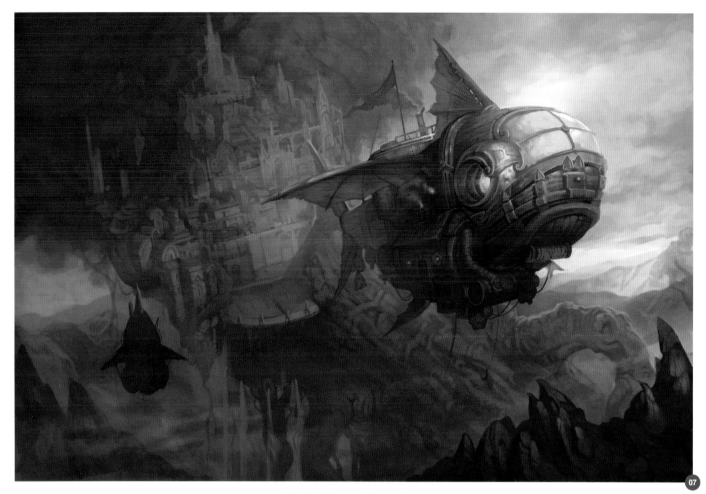

07

> ❝ I DREW A PAIR OF
> WINGED FISH IN
> THE FOREGROUND,
> DRAWING THE
> VIEWER'S EYE TO THE
> COMPOSITIONAL
> CENTER, WHICH IS
> THE CITY ❞

case I created a more airy and cloudy quality from the initial green-yellow gamma by just tuning the color balance settings (**Fig.07**).

With the artwork almost complete the rest of the work involved adding and refining details. I opened a preview in the small window whilst working in a zoomed version (Window > Arrange > New Window for...). I cleared up blots and added effects such as smoke, cabin glare and the lights in the city etc. I drew a pair of winged fish in the foreground, drawing the viewer's eye to the compositional center, which is the city. As a final touch I adjusted the contrast and brightness levels to complete the picture (**Fig.08**).

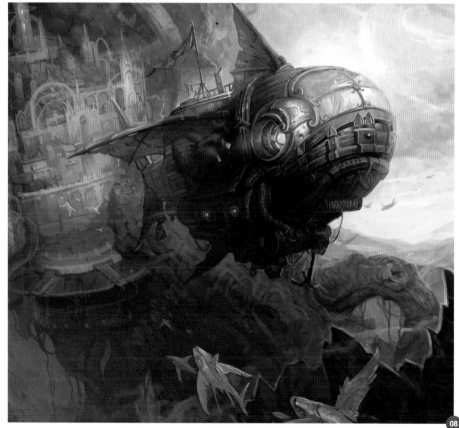

08

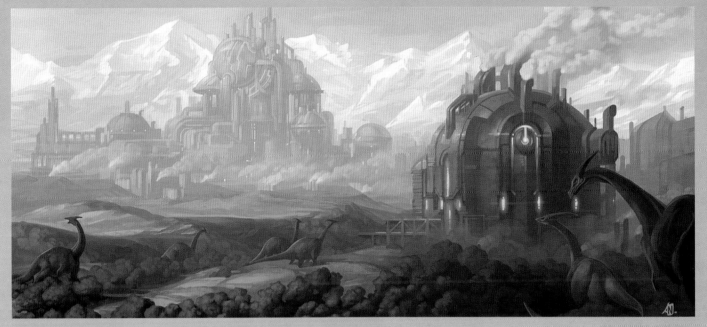

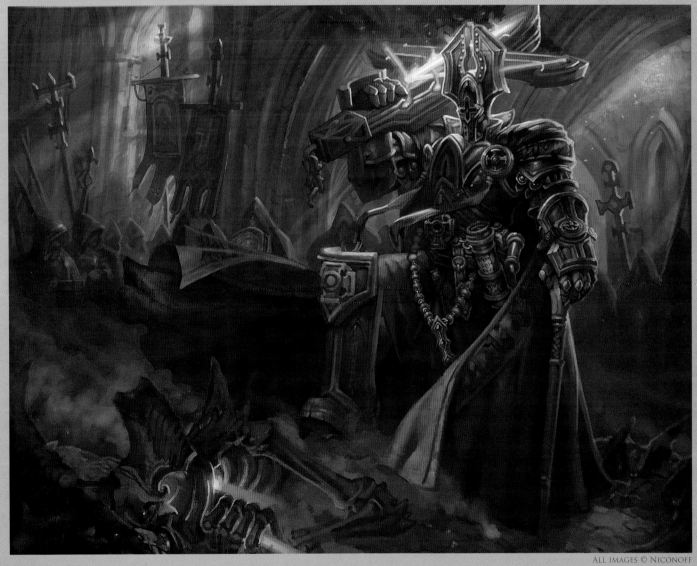

RESTRICTED AREA
BY DANIIL V. ALIKOV

JOB TITLE: Texture Artist

SOFTWARE USED: Maya, mental ray, Photoshop, ZBrush and UV Layout

INTRODUCTION

Hello! This is an article about the making of my image *Restricted Area*. Instead of discussing the modeling process and shader settings etc., I'm going to focus on how the raw idea evolved into the final piece.

MY IMAGE

Ideas surround us. They come as they are or we can make them from things we see in the world. It was about two years ago when the idea of a locust-concrete mixer came to me. I'd seen a concrete mixer go past me on the street and the angle of the bowl reminded me of a grasshopper's belly. It was at that moment that the idea for *Restricted Area* was born. I started to think about how I could make this enormous heavy-duty, insect-shaped machine show emotion. My intention was to convince the viewer that the machine was real and able to work. I took pictures of a lot of concrete mixers, analyzed the photos and tried to understand how these machines were made and worked. Then at last there came the moment when I

decided I needed to "think on paper". So the very first sketch was created, where I made a simple collage using a concrete mixer and grasshopper photos.

As this was very rough, I can't say much more about it. But after further development this idea became more shaped and detailed. Here are some of the sketches I made (**Fig.01**).

I tried different technical and stylistic variations. Attempting to move from the general to more specific, I started thinking about the mechanics of the thing after I'd established the rhythm, contours and proportions. However all of these things were changed and re-made afterwards. I also made several sketches illustrating how this idea could exist if it was a different type of insect (**Fig.02**).

Little by little I fine-tuned the variants until I achieved the desired appearance (**Fig.03**).

I was now faced with the task of establishing the machine's function which required creating all of the basic mechanical parts.

As usual I gathered tons of reference images of robots, heavy duty machinery, engine pictures etc. I tried to understand how such a machine might look and was inventing and changing things throughout the modeling phase. I then moved onto painting the textures and fine-tuning the shaders. I moved closer and closer to the final model with each new detail and every test render (**Fig.04**).

When I was completely satisfied with the model, I started to think about the environment (**Fig.05**).

Initially the idea was to show the locust-concrete mixer standing in the restricted area behind the fence and looking through it, but this notion developed later on and the composition was transformed (**Fig.06**).

The fence was broken and the restriction area eliminated, although I kept the maintenance staff there as their presence tells us the machine is in a functional condition and is still being used. I made a decision to add an

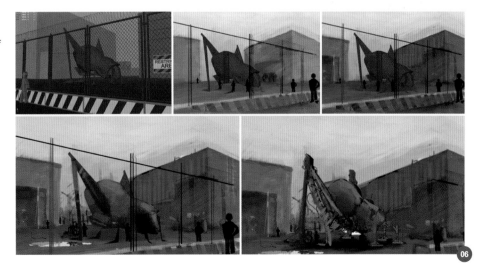

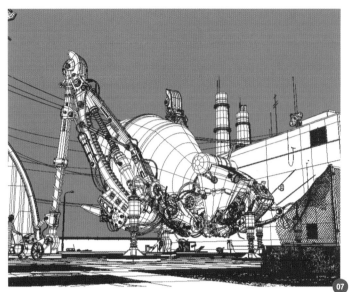

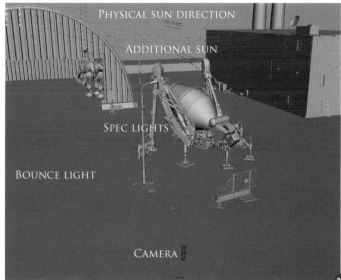

PHYSICAL SUN DIRECTION

ADDITIONAL SUN

SPEC LIGHTS

BOUNCE LIGHT

CAMERA

open hangar with the elephant-excavator (my remade work from 2005). It brought much more variety and added detail to the composition (**Fig.07**).

During the development of the idea, geometry was being added. The shaders and the textures were being tuned constantly along with the lighting until I found the desired mood and atmosphere (**Fig.08**).

> " I DECIDED TO IMPROVE THE ATMOSPHERE BY ADDING SIGNS OF AUTUMN BEFORE MOVING ONTO RENDERING "

I used a Physical Sun and Sky system, plus some additional light sources in the scene. I also did plenty of test renders to make sure I was happy with the result (**Fig.09**).

I'd like to say here that when I started the piece, I knew I was going to depend a great deal on post-production. This gave me more freedom with the texturing and rendering of the more complicated sections as I knew I could add the missing parts later in Photoshop.

I eventually achieved a desirable lighting solution (**Fig.10**). I think the feeling of early morning worked well. Further to this I decided to improve the atmosphere by adding signs of autumn before moving onto rendering.

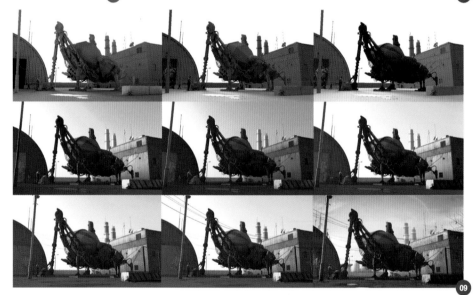

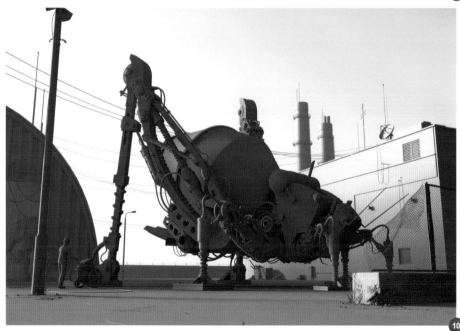

The hardest task was rendering out the Beauty pass. Due to the large size it took about twelve hours. There were also three additional passes to render: Occlusion, Color ID and Z-Depth. These passes helped me to achieve the much needed volume and depth, and were also used as technical layers in the compositing (**Fig.11**).

It didn't take too long to assemble and fine-tune the picture, and voila – it was finished! What a glorious moment! The idea was fully realized, all the technical issues were solved and that day when I made the first sketches was now so far away.

I hope it was interesting to read my story. Have a happy art process and good luck with your own ideas!

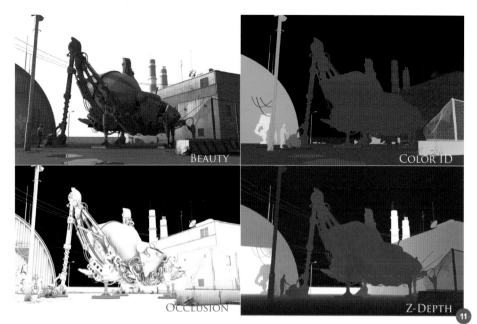

Artist Portfolio

CITY CANYON
BY STEFAN MORRELL

JOB TITLE: Freelance Illustrator
SOFTWARE USED: 3ds Max, Photoshop and finalRender

INTRODUCTION

With *City Canyon* I wanted a claustrophobic atmosphere rich in city textures. Something resembling *Blade Runner* crossed with my stereotypical view of a future cityscape. The buildings in this scene are part of a model I made some time ago and the spaceship is from an unfinished project, which to this day remains unfinished.

> ❝ TO HELP SELL THE DENSELY BUILT UP ATMOSPHERE I USED A VERY LONG CAMERA LENS TO COMPRESS THE SCENE AND BRING EVERYTHING FROM THE BACK INTO THE FOREGROUND ❞

I like to finalize the overall composition as early as possible and usually keep them fairly formal and easy on the eye (**Fig.01**). Once the camera is fixed in 3ds Max I add more detail to the scene.

To help sell the densely built up atmosphere I used a very long camera lens to compress the scene and bring everything from the back into the foreground. The ship and platform were carefully positioned at the very bottom of the image with the intention of them being silhouetted against steam plumes. I initially used FumeFX to add the steam, but later settled on painting it all in post. The scene polycount is around 600,000 (**Fig.02**).

The ship in **Fig.03** (still a work in progress) was modeled using subdivision techniques. It has a lot of areas that still need to be detailed, but since I had a firm idea of how the ship would be seen I figured I could get away with a front view (**Fig.04**).

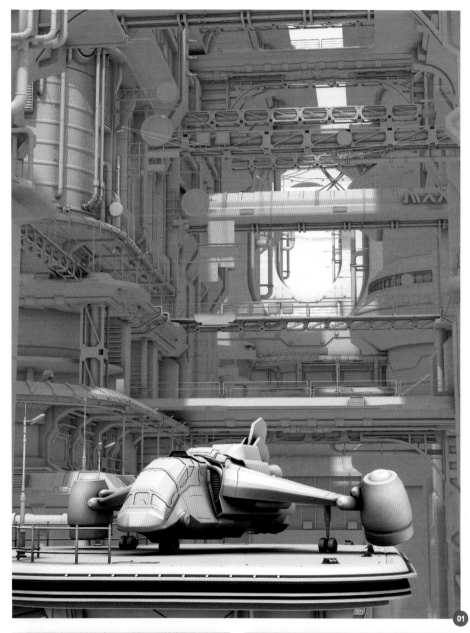

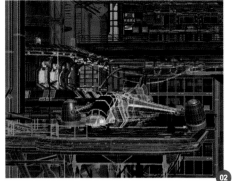

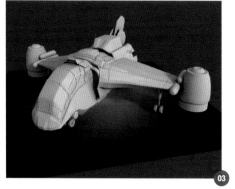

> **"PHOTO RESOURCES ARE USED TO ADD VISUAL NOISE AND RANDOM DETAIL, WITH THE TEMPLATE TEXTURES MAKING USE OF AMBIENT OCCLUSION AND DIRT MAPS TO HELP BRING OUT THE DETAIL"**

With an unfinished model there was no point wasting time on a careful UV layout, so I applied a simple box map. It was also my intention to further paint the ship in post, which eased my mind about the lack of decent UVs. When rendering the image I used Cebas finalRender as it's a very fast tool and one I'm familiar with now. I used the Daylight system and added a Direct light as the sun, switching viewport shadows on to be sure the light was landing where it needed to. I added a few extra light bounces so that the trench of buildings got a good amount of light. I rendered the final

image at around 6,000 (the larger the better) as it allows more control when painting details during post-production.

TEXTURES

The textures are a mix of hand-painted templates (**Fig.05 – 07**) and simple tiled images. A lot of photo resources were used to add visual noise and random detail, with the template textures making use of Ambient

Occlusion and Dirt maps to help bring out the detail. I'm not interested in absolute photorealism so baking these into the texture map was not a problem.

The tiled maps were kept quite small with the largest being 1024 x 1024. As opposed to tiling them within the Material Editor, I like to extend my UVs beyond the texture boundary and adjust them according to how they look in

the viewport on the actual models. I find it is easier to place grime strips this way. The tiles were either from my personal collection or from CGTextures.com.

THE HUMAN TOUCH/FOCAL POINT

Towards the end of making this image it became clear I needed another focal point other than the ship and adding a human figure seemed the best option. The figure is essentially a painted element based on a photo and further painted/detailed in Photoshop before being carefully integrated into the

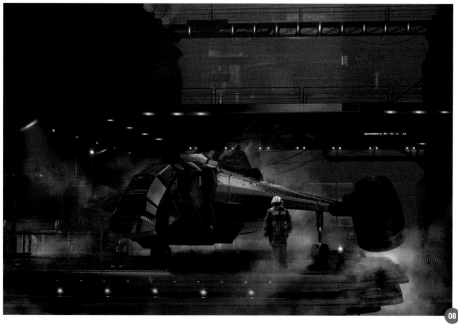

image. I added some shadows and reflections underneath to help "ground" him in the scene. In addition to painting the figure, I added many extra details such as glowing lights, street signs and texture overlays etc (**Fig.08**).

I used several layers of painted atmospherics/ smoke, which were generated using Z-Depth passes in 3ds Max (**Fig.09**).

The final steps in the image involved color correction using Curves and Color Balance in Photoshop. To put a little color back into the shadows I used a Gradient map that was then

faded back to 5% or 10% using Screen mode. As a final pass I painted in some brighter highlights on a layer set to Color Dodge, usually using a variation of a pale yellow.

CONCLUSION

I'm quite happy with the image and have since had it printed onto a large canvas, which now hangs in my hallway. It's a great conversation piece and when seen on such a large scale the viewer can really appreciate all the details.

As a final bonus the image was also awarded a CG Choice award from CGSociety.

ARTIST PORTFOLIO

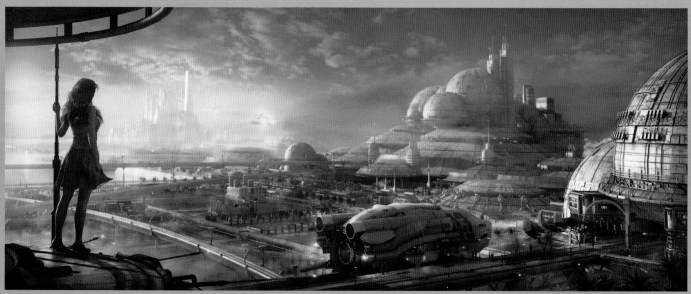

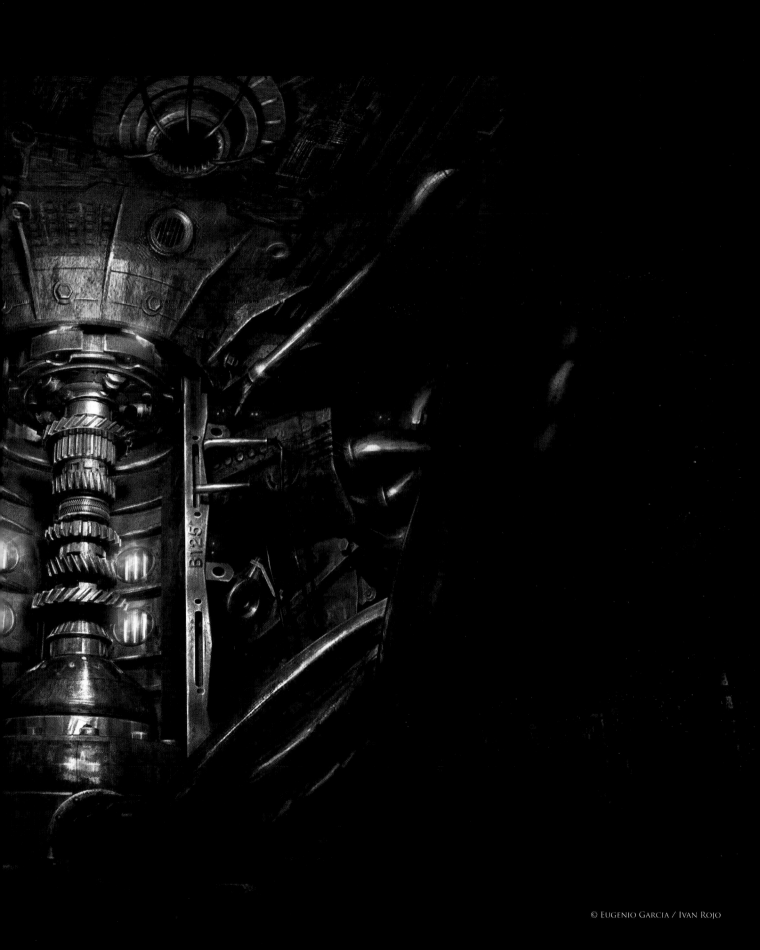

Camara 4
By Eugenio García Villarreal

JOB TITLE: 3D Director – D10Studio
SOFTWARE USED: LightWave and Maya 2009

Getting Started

This image was created for a digital agency in Mexico called GrupoW as part of a web campaign entitled "Alter Machine". The main idea was to use an animated sequence to travel through six compartments within in a big engine.

> ## THE TERMINATOR AND STARCRAFT WERE PARTICULARLY GREAT REFERENCES IN TERMS OF THE FINAL LOOK

After completing the job, I decided to use the scenes to do some stills with this image being one of the areas. Our inspiration was engines and their various parts, and so we searched for images of cylinders, gears, turbos and other related topics. The image involved a lot of high poly modeling as well as a lot of post-processing in Photoshop, so this article is split into three important topics; modeling, lighting and post-work.

The main modeling was done by Ivan Rojo, a great 3D artist here in Mexico. When we started the project we barely imagined how much modeling we needed, so we needed to be patient as there were a tremendous number of pieces to create in each room.

To begin with we carried out a lot of web research for the various engine parts. *The Terminator* and *Starcraft* were particularly great references in terms of the final look and mood. All the images had an industrial quality and were aged and oiled, with small numbers of light sources.

The modeling was done mostly in Maya 2009. Some of the modeling was easy and incorporated Booleans, extrusions and simple

Transformation tools (looking at your chair screws helps a lot!). Here are some of the simpler models (**Fig.01**).

The more complex models utilized similar tools, but we took more time over these.

Luckily Google was there for photo references, a practice I repeat a lot as these help when creating detailed and plausible designs. Some of the pieces drove us mad, but with time and patience we learnt a lot more about modeling during the job (**Fig.02**).

These are some of the main models in the scene (**Fig.03**).

The Maya modeling tools made the project possible. Although I sometimes had problems with Booleans, by adding geometry in certain places I was able to solve some of the issues. Sometimes I exported the low poly object and added Booleans in LightWave. I suggest using all the available tools and not to be afraid of experimenting. Maya is a comprehensive package and by exploring the tools and being patient it is possible to learn a great deal.

TEXTURING, RENDERING AND POST-WORK

For this part of the process I already had all the pieces modeled by Ivan Rojo. We did some 3D sketches directly in LightWave, adding certain pieces whilst taking others out. It was a long process, but we were looking for a nice composition whilst all the time trying to make the central piece the main focus. Surrounding this were a lot of metal pieces, wires and lights making the whole thing mysterious and industrial, with the goal being to convey a large space (**Fig.04**).

With all the pieces in place, the next step was texturing. For the render, I used a basic metal texture together with a simple shader

to show reflection and specular bounces with the intention of doing a lot of post-work later (**Fig.05**).

The scene setup is pretty simple, with just a LightWave Area light focused mainly on the central piece. The scene was rendered with an FPrime, at 5000 x 2500 using nothing but a traditional Area light with no radiosity (**Fig.06**).

POST-PROCESS

I imported everything into Photoshop CS4 and first of all made some color corrections. I then

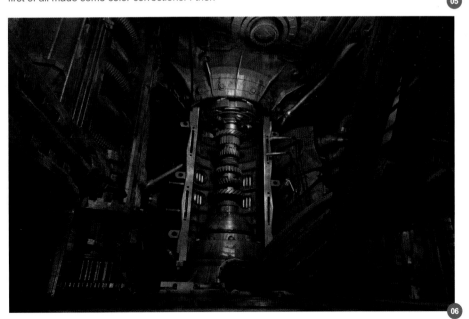

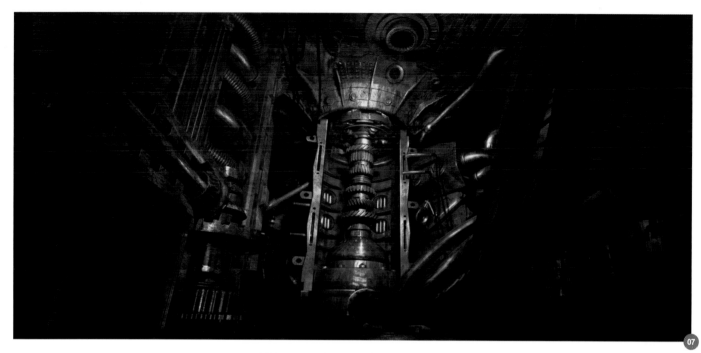

> ## WITH A LOT OF RESEARCH AND PATIENCE YOU CAN ACHIEVE YOUR AIMS AND ALSO LEARN NEW AND HELPFUL TECHNIQUES

played with the Levels and used some photo filters to achieve the right mood (**Fig.07**).

Later on, I did an RLA pass for the depth of field, adding some Lens Blur. I added some metal textures, using a number of blending modes such as Overlay, Screen and Multiply.

I took advantage of a few methods in a matte painting style to get small details correct, such as the sharp edges and rusty surfaces (**Fig.08**).

Later on I did some re-touching with the Dodge and Burn tools to highlight some areas whilst darkening others. Once I was happy with the result I merged everything and continued drawing as I don't like to get lost amongst a multitude of layers. I put in some light spots and glows around the brighter zones by way of Round brushes, and also used my sharpen brush to add textures in certain places.

We took about ten days to complete this project and had a lot of fun along the way. It proved that with a lot of research and patience you can achieve your aims and also learn new and helpful techniques. As a last word I would like to thank Ivan Rojo, who did a great job on the modeling, and the people at D10Studio who gave me a lot of advice throughout.

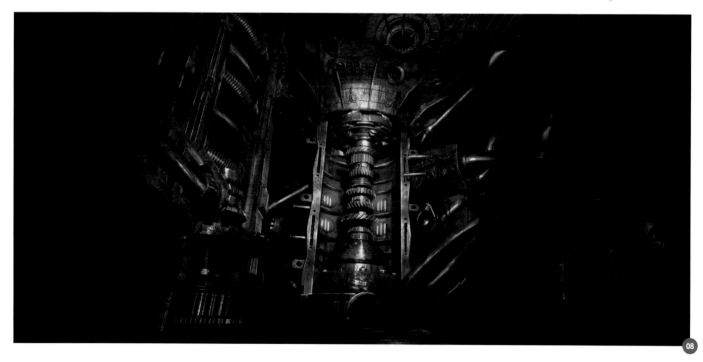

CARRIER
BY NEIL MACCORMACK
JOB TITLE: Freelance Artist
SOFTWARE USED: LightWave 10 and Photoshop CS5

INSPIRATION

Normally when starting an image I would work on a concept sketch or pencil drawing as a reference before starting any of the 3D work. This time however I didn't use any drawings and simply started with a box in LightWave. I knew that I wanted to portray an action scene featuring a ship landing in a rocky desert environment, and I also knew I wanted it to

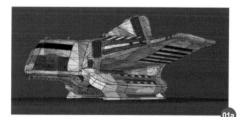

appear as a mixture of 2D and 3D. The time of day dictated the palette, along with the surrounding environment. With all this in mind I started modeling the main ship and took each step as it came.

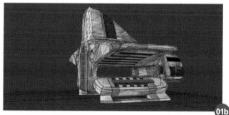

MODELING

You will be able to tell from the main ship model (**Fig.01a – b**) that the modeling isn't the most complicated part of the image. Unless I am preparing a model for animation or for

film, I don't generally concern myself with high resolution details unless necessary. I used a standard box modeling technique, beveling out some details on the ship to form an overall design. I added some fans and grills at the back for the engines, and on the wings, to hopefully make it appear as though there was far more detail than there actually was.

The rocks and environment followed the same principals, with the basic shapes being extruded from a box once again, and then subdivided and tweaked until I was happy (**Fig.02**).

The smaller foreground land vehicle was altogether more complicated and was actually created for a different project than this, but I

thought the shape and design fitted well into the atmosphere of the image and so I added it in later on (**Fig.03**).

TEXTURING
With the intention of over-painting this 3D render in Photoshop, I knew I wasn't going

to go into too much detail on the texturing. I created some basic UV maps in Photoshop for the ship and added some standard metal textures to the model. The rocks were done in a similar way using a rock texture mapped onto the object in Cubic mode so I never had to create any UV maps at all.

04

SCENE AND BACKGROUND

With all the models done and textured I
then started to think about my scene and
composition. I created a matte painting in
Photoshop that would form the background of
my 3D scene and then camera-mapped this
onto the ground plane I had constructed earlier
(**Fig.04**).

Once this setup was tweaked I started loading
the objects into the scene until I found a
satisfactory composition. This included a
second low resolution ship in the background
to add more depth to the scene. I chose a
slightly tilted camera angle in the final scene as
I felt it made the image slightly more dramatic
and showed off the best angle of the ship. You
can see how this looks through the camera in
the 3D layout in **Fig.05**.

LIGHTING

As I had already painted the background
this gave me a huge start with the lighting
as it depicts the time of day and general
color scheme. As an environment, I wanted
something desert-like and knew the sun
would be a reddish-brown color, quite low in
the sky and producing long shadows. I used
LightWave's Radiosity to simulate the Bounce
light, using the background matte as the light
probe source, which generally gives the lighting
a more realistic color.

In **Fig.06** you can see the Open GL render
of the scene, complete with lighting and
background fog, and again I used the matte
painting as a source.

05

06

RENDERING AND POST

The final render was 4068 x 1740 pixels, which I think took around 12 hours to render. You can see how the original render looks directly from the 3D program in **Fig.07** before any painting or color correction took place.

Once I had my render in Photoshop I decided to dirty up the image and alter the colors to make the scene more dramatic. This meant darkening everything somewhat and tweaking the colors to add more blue into the palette. I also painted in some smoke and dirt over the ship to create the impression it was either landing or taking off, and also to make it interact more with the environment.

I overlaid some more metal images across the ship to add extra texture, painted in the lights and concluded with some other rock textures to complete the image. **Fig.08** shows the final image with all the layers active in order to give you an idea of the total amount of work done in Photoshop.

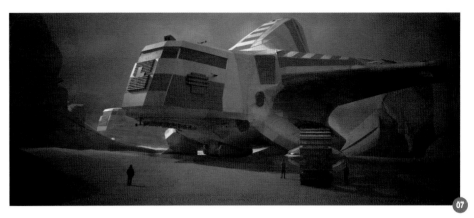

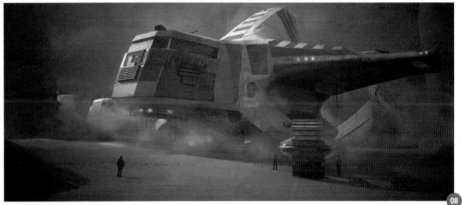

ARTIST PORTFOLIO

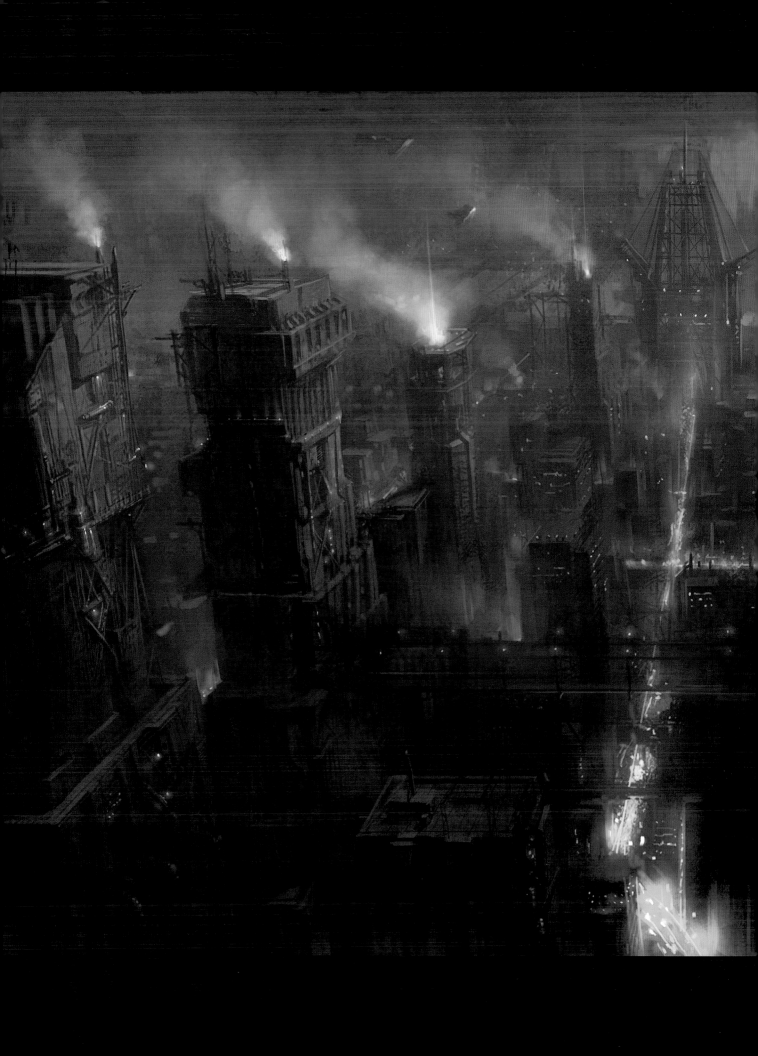

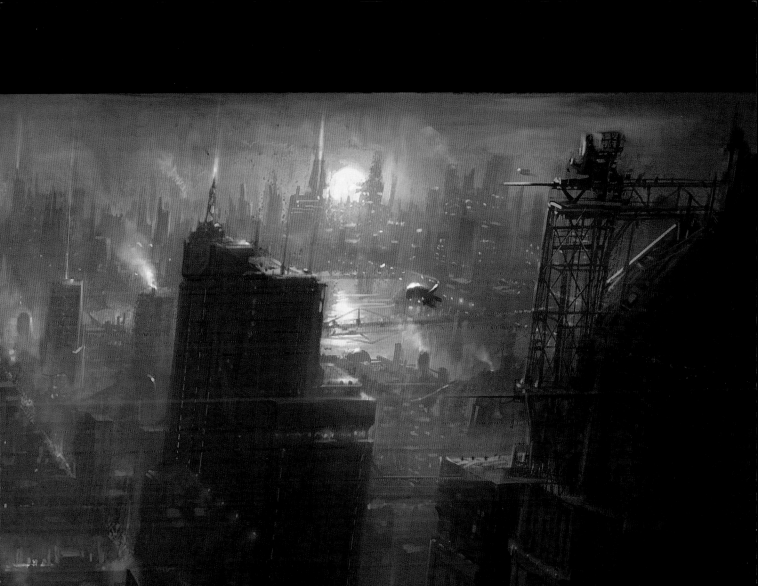

Parallel Industrial City
By Seung Jin Woo

Job Title: Concept Artist and Illustrator
Software Used: Photoshop

Introduction
Fantasy and sci-fi themes have always been my favorite genres as they excite my curiosity. They drive me to imagine and paint a world that is fictional but also believable. Within the likes of other creative fields like films, novels and games, they allow for the creation of imaginative and unique worlds.

> THE GAS AND FUMES CREATE A DARK, HAZY ATMOSPHERE HIGHLIGHTING THE SILHOUETTES OF THE STRUCTURES AND THE RED SKY REFLECTING OFF THE DISTANT WATER

My creative process usually starts with strings of questions like: "What would the atmosphere be like in this world? How would it smell and feel? What sort of people live here and how do they carry on they daily lives? If I was here what would I do and how would I interact with the world?" These sorts of questions allow me to justify and establish the lifestyle and overall mood, which I believe is the most important aspect of painting a fictional world.

The main theme of this painting is an industrial city in the near future, somewhere in a parallel universe and suffering from heavy pollution. The gas and fumes create a dark, hazy atmosphere highlighting the silhouettes of the structures and the red sky reflecting off the distant water. The greens in the foreground contrast with the warm red sky and help emphasize the depth and mood of the painting.

Concept and Thumbnail Sketch
My first task was to figure out an exciting composition and view of the busy city. Like

most other artists, I usually sketch up small rough thumbnails to quickly explore a few ideas, mainly dealing with the composition and less with details (**Fig.01a – d**).

Perspective and Color Settings
Once I was satisfied with a sketch, I began to work out the main elements of the image – mostly the large shapes and silhouettes of the city structures as they directly affect the composition. To assist this process, a simple perspective grid was used as a guide, helping ensure everything fell into the right place. I used one-point perspective in the main, but added in a very faint second vanishing point.

This helps emphasize the scale of the large
structures, but also allowed me to include
numerous attractions (**Fig.02**).

I chose to go with red as the main color
scheme with contrasting greens acting as
a complimentary color. Overlay and Color
blending modes were used to apply the color in
the roughed-in green-grayish sketch in **Fig.02**.
From here, I started working out some of the
bigger shapes and silhouettes on a new layer
in Photoshop (**Fig.03**).

Painting Objects
With all the basic elements set in place, such
as lighting, color scheme and composition, I
proceeded to design some of the key structures
and buildings. Whilst doing so I constantly
checked to make sure everything conformed
to the perspective set earlier. I focused on
establishing the building planes affected by the
lighting and atmospheric perspective (**Fig.04**).
I also used textured brushes to create the
right feeling for the surfaces and break up the
strokes (**Fig.05**).

Atmosphere and Depth
I continued to add in atmospheric details like
the wind-affected smokes. Greens and grays
were used in contrast with the warm reds to
create further depth. I merged all the layers into

a single one to aid the workflow as it allowed me to toggle between many brush blending modes. It achieved the same results as using Layer blending modes, but without having to create individual layers for each effect (**Fig.06**).

DETAILS AND RENDERING

It's always important to take note of scale throughout a painting. I started adding in the finer details to emphasize the scale, using references such as roads, streetlights and vehicle lights. I worked on the details in a more controlled and "tighter" manner, following my initial sketch and adding details including the bridges and other key elements. I used the Color Dodge blending mode to strengthen the red in the sky (**Fig.07**).

As the image progressed and neared the end, I used adjustment layers to help tie together the overall tone of the painting, adding more contrast to strengthen the lights and the darks. I also enhanced the large shadowed areas with extra details comprising of building lights and spaceships to further liven up the scene (**Fig.08**).

The final stage of the painting concerns correcting the perspective, depth and color as it is very easy to get carried away with certain details, often overlooking the bigger picture or

deviating from the initial concept. With a few more adjustment layers and corrections the painting was complete.

CONCLUSION

Working out technical issues like the perspective and color schemes can often be very stressful and maybe even distracting. Looking back, I realized that while these technical issues are of importance, it was more crucial to explore the initial idea and story. It led me to believe that these issues shouldn't dictate the outcome of the work, but should be used as a tool to communicate an idea.

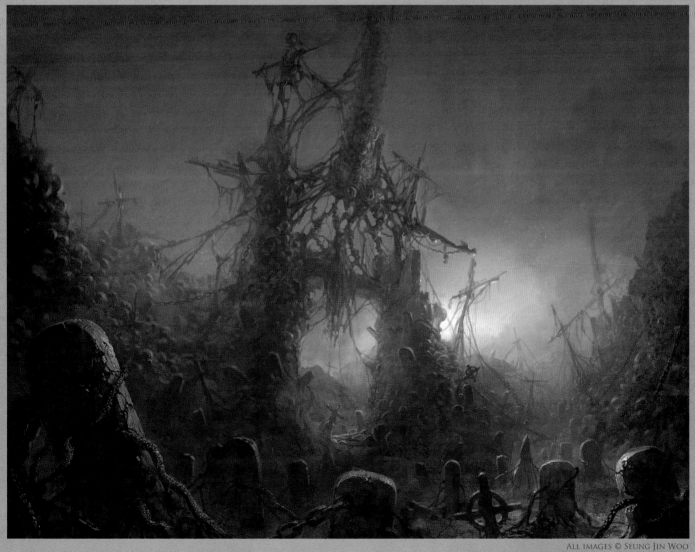

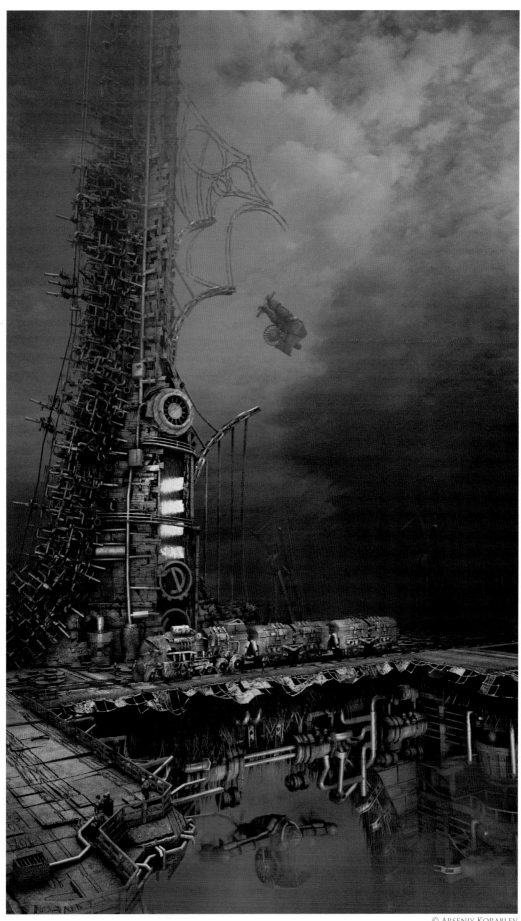

Rusty sky
By Arseniy Korablev

Job Title: Freelance Artist
Software Used: 3ds Max, V-Ray and Photoshop

Introduction

Greetings to all readers! My name is Arseniy Korablev; I am 17 years old and live in a small Russian city. I am currently studying general education and art. I have used a computer since visiting my father at his office (he is a programmer) when I was a child and it was then I discovered 3ds Max. Back then I was only eight years old and working in 3D seemed very interesting, albeit difficult (which is why I'm still learning and developing my techniques).

At the age of 12 I was presented with a new computer and approximately one month later I acquired 3ds Max. I began pressing every button in the panels before studying the program. Without the manual it was interesting, but slow. After roughly 6 months I began to participate in weekly competitions based around speed modeling. I was creating simple three-dimensional models, but this didn't really teach me how to produce 3D art. I therefore began participating in more advanced competitions and attended an art school. In the beginning I considered it useful for learning and improving my skills. I began to draw and study more and my work improved greatly. In fact I am still studying at art school and in September of 2010 I received an award from CGSociety. In the near future I want to increase my portfolio and then break into the industry. I am still studying and so my work is done for personal reasons and limited to competitions. When working I use 3ds Max, V-Ray and Photoshop.

At the time of writing this article I consider *The Rusty Sky* to be my best work. I always hope to improve my work in each new project I undertake. Time was not really an issue in this case; I began in August and wanted to finish before being employed!

The process of creating my work of late has become similar to individually working on a

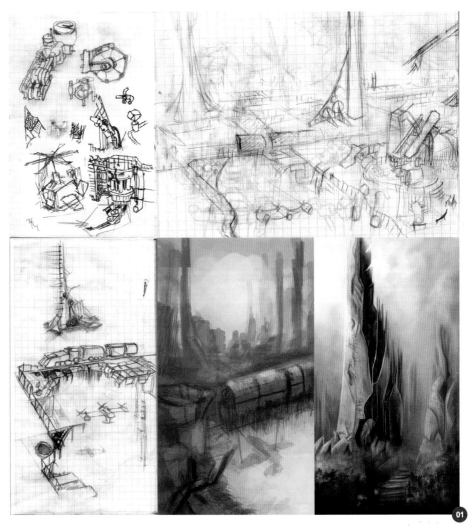

game project or film sequence. During the early stages I draw several sketches and focus on separate elements to save time later. I then prepare the materials, consider the composition and lighting as well as how each component relates to one another. Only after all this do I start to model and texture the objects. After this stage is complete I add the lighting and render the scene before concluding with any necessary post-production work in Photoshop.

Having been inspired by some professional drawings and drawn my own sketches on paper, I began the modeling for this image. For certain details additional sketches were drawn. I also composed a sketch on the computer in less detail as the color and mood were the

main concerns. I was also inspired by some of my old work to create a tower (**Fig.01**).

Modeling

Having finished the basic idea, I started modeling and applying the materials. For novices I advise that you do not necessarily need to study all of your 3D tools. In my case I find that only Editable Poly tools, splines and a few modifiers are important, alongside a little knowledge of V-Ray.

A convenient method of creating the pipe work is to draw a spline on the object and use the Sweep modifier. It is possible to make a spline on the actual mesh and then select the "Create Shape From Selection" button whilst in Editable

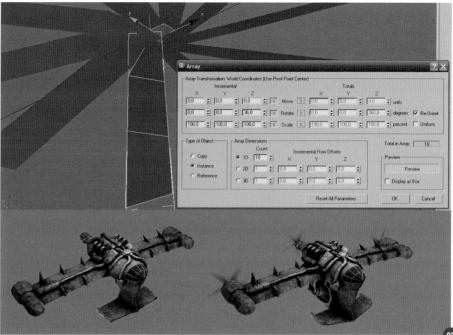

Poly > Edge mode (**Fig.02**). In order to create a mesh with the necessary detail the edges can be deformed with the help of Paint Deformation and a Lattice.

When creating the propeller I simply used an Array to copy one blade from the center (**Fig.03**).

Here are some of the details on the train. This shows the stages of the development, where I utilized the Symmetry modifier with some additional elements (**Fig.04**).

If any components proved unsuccessful I simply removed them, or alternatively I re-assembled them, which in this instance helped construct the tractor. The details are composed of both train and environmental geometry (**Fig.05**).

I then added some people to help the picture look more interesting.

FOG AND GRASS

At this stage I started creating the clouds and basic architecture. I advise approximating a composition with several boxes or planes. The clouds were composed of several planes and a Displacement modifier (**Fig.06**).

SCI-FI

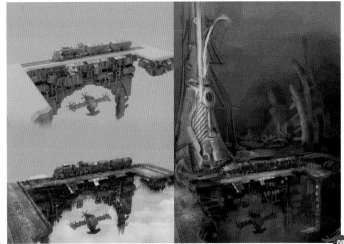

The grass was made in a similar way, using flat polygons with an Opacity map. To avoid any sharp transitions I then refined them in Photoshop (**Fig.07**).

Having finished the platform and train, I began some further detailing and experimented with the color scheme before continuing with the tower (**Fig.08**).

> **BASIC ART SKILLS ARE IMPORTANT WHEN IT COMES TO BEING CREATIVE AND CONTRIBUTE TO THE OVERALL QUALITY OF THE WORK**

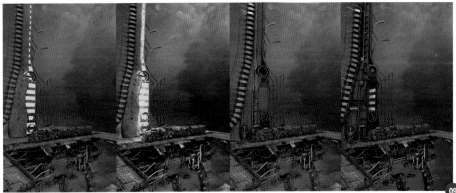

MATERIALS

For the sake of convenience I prepared the materials early on. Almost all of the structures were made with a mix up of V-Ray Dirt and Bump maps.

DETAILS

All of the scene objects were made from sketches with the help of the Spacing tool (Shift + I) which copies objects along a spline. With the help of Scatter I made numerous copies of the pipes and the boards, which were placed along the tower (**Fig.09**).

ILLUMINATION

V-Ray provided the lighting with two Key lights positioned above and to the side of the scene, and two in the center to create sharper shadows which used complementary colors (**Fig.10**).

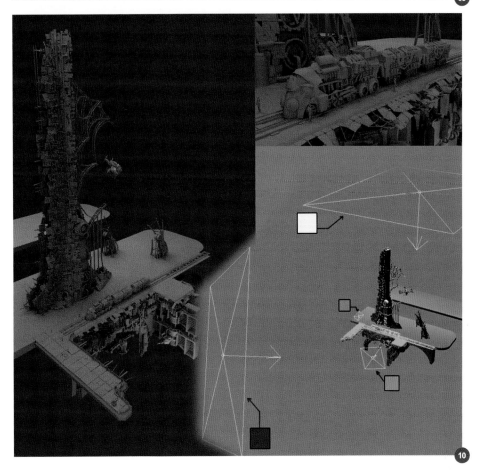

I BELIEVE THAT AN IMAGE SHOULD LOOK BOTH BEAUTIFUL AND ATMOSPHERIC

At this stage the work was almost complete, with a defined color scheme and composition. Some of the missing detail was added in Photoshop during the post-production (**Fig.11**).

POST-PRODUCTION

This wasn't a particularly difficult stage and it was a part of the creative process that I really enjoyed. I believe that an image should look both beautiful and atmospheric, changing the mood of the spectator and forcing them to trust in an artist's vision. Finally the work should be technically proficient. I added a lot of these aspects as painted elements using brushes and blending modes such as Color Dodge, Overlay and Soft Light. I also added fog in certain places and also used Z-Depth (**Fig.12**).

CONCLUSION

Basic art skills are important when it comes to being creative and contribute to the overall quality of the work and this is this reason I chose to attend art school. There is theory behind Still Life and Landscape painting and these can teach us lessons about composition. The subject of "computer graphics" was taught to me by Vyacheslav Solovov (Internet name: Gorislav Masterov), an extremely good teacher and artist. With the exception of Photoshop, he acquainted me with some artistic practices that I was completely unaware of. Unfortunately, he has recently left his teaching position here, but I have been able to apply the 3D knowledge he taught me in my own work. While I do not practice drawing much, I do sometimes sketch for my personal pleasure or for 3D work. To improve your skills it's necessary to work as much as possible and also to become inspired to create something amazing and original.

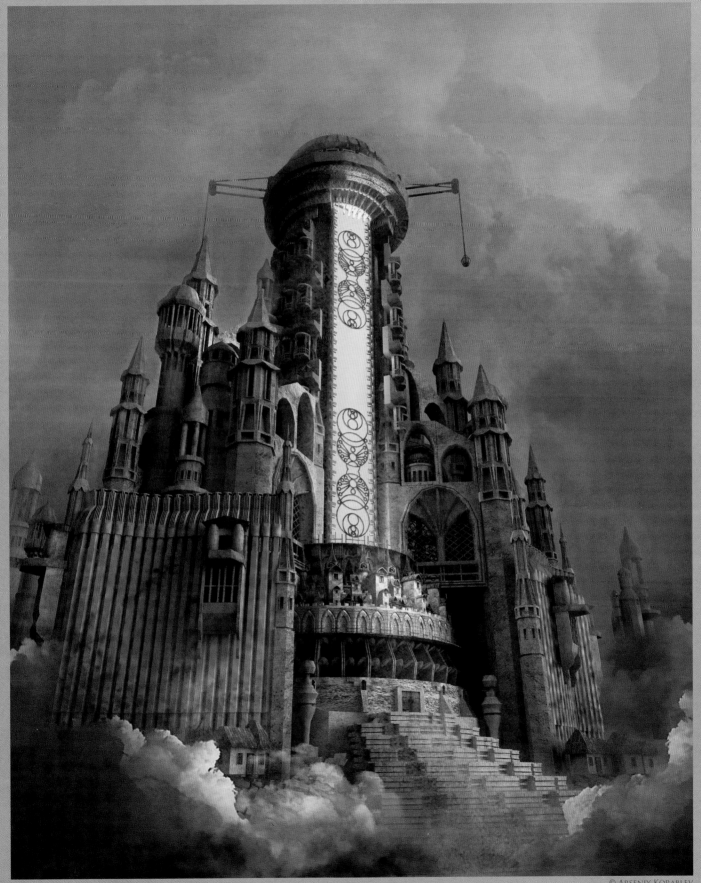

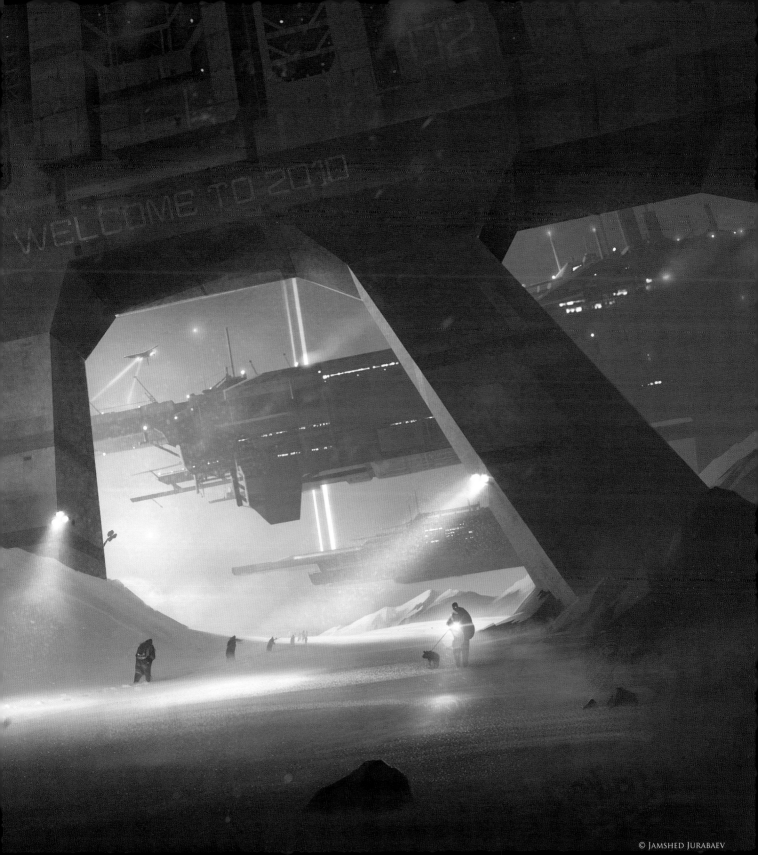

WELCOME TO 2010

WELCOME TO 2010
BY JAMSHED JURABAEV

JOB TITLE: Art Director
SOFTWARE USED: Photoshop

INTRODUCTION

My brother Surat Toimastov is a professional photographer who travels a lot and shoots different places here in Tajikistan. Looking through his amazing pictures sometimes I am really shocked by how beautiful and mysterious these places can be. So the story of this image begins with this photo, which was taken somewhere in the Pamir Mountains (**Fig.01**).

> " AFTER ESTABLISHING THE MAIN COMPOSITION AND SHAPES, I FOCUSED ON CREATING THE RIGHT MOOD "

MY PAINTING

I was really inspired by this photo and started to imagine some kind of industrial structures or industrial complex just behind the horizon line.

I took the photo and quickly put the main forms and ideas down as a quick sketch (**Fig.02**). I

© SURAT TOIMASTOV

wanted this structure to rise over the top of the mountain to really emphasize its size. I also wanted to have the people in the image arriving at some kind of arctic base or something similar, so I put some guards and flying machines along their path (**Fig.02**).

After establishing the main composition and shapes, I focused on creating the right mood

(**Fig.03**). I wanted to go with a blue/cyan type palette that could reinforce the cold and snow-filled atmosphere, which is common at these high altitudes. I also added some spotlights to make the place come to life.

Up to this point there were no difficult technical issues in terms of the drawing; everything was simply created by using basic Photoshop

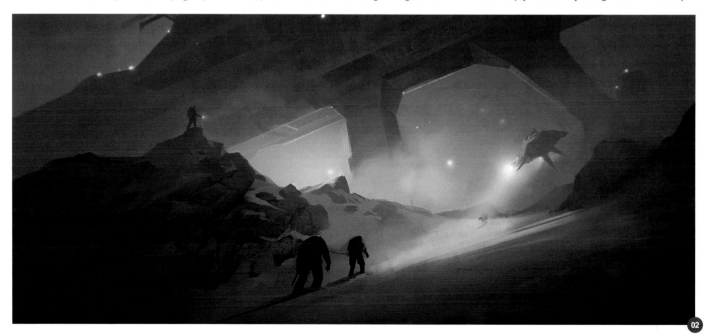

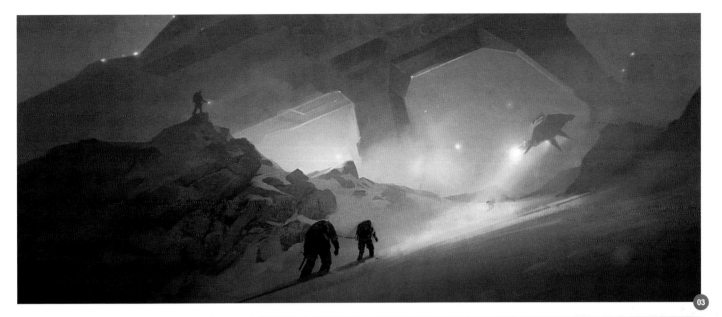

brushes. The only thing I want to mention is my use of the Lasso tool (L). To create these sharp and straight lines I selected the desired region with the Lasso tool and painted inside it with a brush.

Besides the mood, I was also thinking about a title for this image and ended up with: "Welcome to 2010". You can see it painted on the main building. Why not? I thought that this image could reflect my own wish to move to somewhere more technological and sophisticated in this brand new decade.

Anyway, let's return to the painting. After I was happy with the overall structure of the image, the long process of detailing started. If you are trying to paint industrial or technical items it is good to use a perspective grid (**Fig.04**). For this you can use the Line tool (U).

I plotted my perspective grid with different colors, each standing for a vanishing point. The amount of vanishing points depends on the structure and camera angle you choose.

Of course, at this stage basic perspective knowledge is very helpful otherwise the image won't work regardless of the amount of detail.

I think that in the case of this particular image, correct perspective was one of the crucial things. To reinforce the vertical perspective, I painted in some spotlights aimed directly towards the sky.

After setting up the right perspective, I started to detail the main building (**Fig.05**). This was the most time-consuming part of the creative process, using a lot of Lasso selections and painting. To make it more realistic I used textured brushes to simulate the concrete material of the building. Looking through photo references is the best way of becoming familiar with industrial buildings such as factories and

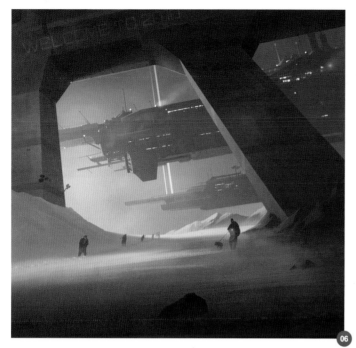

06

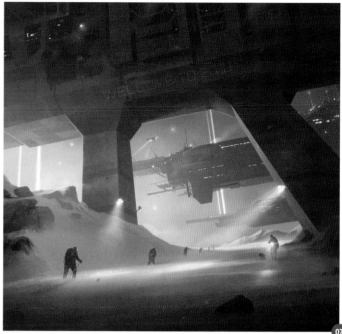

07

nuclear reactors etc. Even if you are trying to create something original, you have to base it on something that people are familiar with.

I placed a lot of pipes, bridges and containers inside the main structure and included a construction site on the left of the image. I wanted this thing to look like it was still under construction.

Now it was time to detail the background (**Fig.06**). You can see that I painted in two more buildings to create more depth and reinforce the scale.

> ❝ IT IS GOOD TO OBSERVE THE WORLD AROUND YOU. THERE IS SO MUCH GOING ON AROUND US AND ALL WE NEED TO DO IS OBSERVE AND REFLECT THESE THINGS IN OUR PAINTINGS ❞

To make the place come alive I also added a lot of lights, smoke, walking people and small details that suggest action and motion (**Fig.07**).

You can see the details that I added more clearly in **Fig.08a – f**. Some of these might

seem tiny, but I still like to include them. When painting things like smoke, flares and falling particles, it is good to observe the world around you. There is so much going on around us and all we need to do is observe and reflect these things in our paintings.

After I'd finished painting the details I added a Radial Blur (Zoom) to the whole picture, helping add a cinematic effect to the image. I also added a little bit of graining, again to simulate that cinematic feel. And here's the finished image (**Fig.09**).

08a

08b

08c

08d

08e

08f

There are three important steps that I would advise you to try to follow when you're creating an image. First, try to set up a cool composition and mood. This can come from a very brief sketch, but if it looks interesting as a thumbnail then it will probably be cool when you detail it. Second, set up your perspective and make things look correct. If you are working on a character design then take your time to set up the proper anatomy. And third, bring in lots of tiny details that will make your art stand out.

Of course, these are not rules but just suggestions and procedures that can improve your art. If you have any questions, feel free to ask me via email. Thank you and good luck!

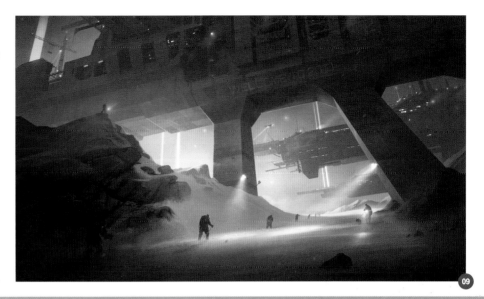

ARTIST PORTFOLIO

ALL IMAGES © JAMSHED JURABAEV

OLD SHIP
BY TOMASZ STRZALKOWSKI

JOB TITLE: Freelance Artist
SOFTWARE USED: ZBrush and Photoshop

INTRODUCTION

The creation of the gigantic ship in this work began as it usually does, with an idea and sketch. However, the end result only remotely resembles the initial drawing. The idea started to evolve during the creative process. I often paused, looking back at the model and reflecting on the direction it was taking. There is a moment during the creative process that I always enjoy as it reminds me of discovering something, always different and always new.

THE SCENE

When I find the right effect and my expectations are realized, it is a very enjoyable, sublime feeling that further motivates me and nourishes the imagination. The compositing was carried out in Photoshop, whilst the modeling, texturing and rendering were performed from scratch in ZBrush. After creating the base design (**Fig.01**), I tried to exercise precise control over the whole mesh

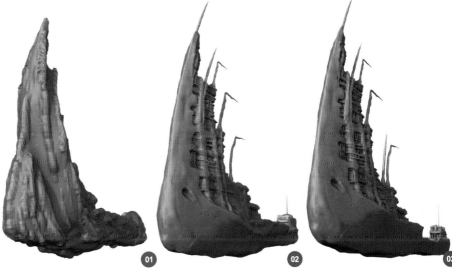

throughout the process (**Fig.02 – 03**). I needed some trial versions of the composition so I created a number of versions that I could look over quickly and decide if an element would fit in with the desired final effect.

Upon reaching a desirable state I transferred it onto the 3D object and then I worked on the details. At a certain point the model contained a substantial number of polygons so I had to find a way to optimize it (**Fig.04 – 05**). I planned

to blend the ship and the ground smoothly, so I cut off the inner part of the ship from its outer part which allowed me to optimize the thickness. The inner part was also divided with respect to the visibility and density of detail, along with the proximity. The next stage was the addition of smaller separate elements like masts, railings, parts of the board etc., which were created in ZBrush using Shadowbox (**Fig.06**). After completing the basic models I tried to finish them and add them to the whole

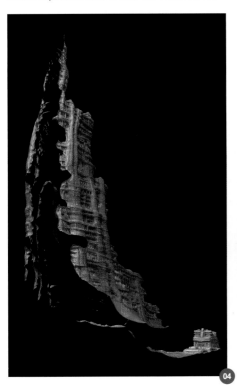

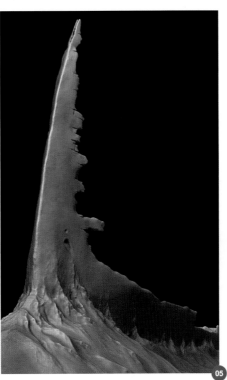

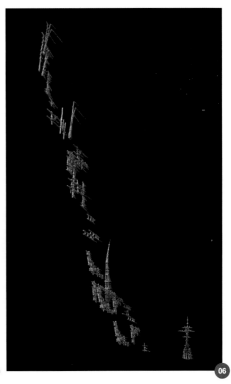

as separate meshes. They were also modified for a better result. Having achieved the right effect I combined all the tiny objects into one to simplify future work.

Texturing was also carried out in ZBrush with the Spotlight tool making things easier. It allowed me to perform the procedure on the high poly model without any need for the low poly version, thus saving time. I continued working with several textures, painting directly on the object which gave me a good deal of control. Using various masks helped me to paint more accurately and enabled a quicker texturing process (**Fig.07**).

The composition seemed harmonized once I had balanced the perspective and camera position with the polished details and change of background. The trial versions helped the process and were used as a good guide in tying everything together without deviating too far from the initial idea. The next step was to render everything in ZBrush using all of the layers, e.g., Diffuse, Ambient Occlusion, Shadow, Object mask, Depth mask, Specular and additional ambient lighting (**Fig.08 – 12**). After many hours of trial and error I found the appropriate settings and could finally sit down to the final rendering in high resolution.

When all the rendered files were complete I could assemble everything in Photoshop. This way I had full control all the time and could easily modify the various parameters, such as specular, intensity of lighting, density and the extent of the mist. After creating the

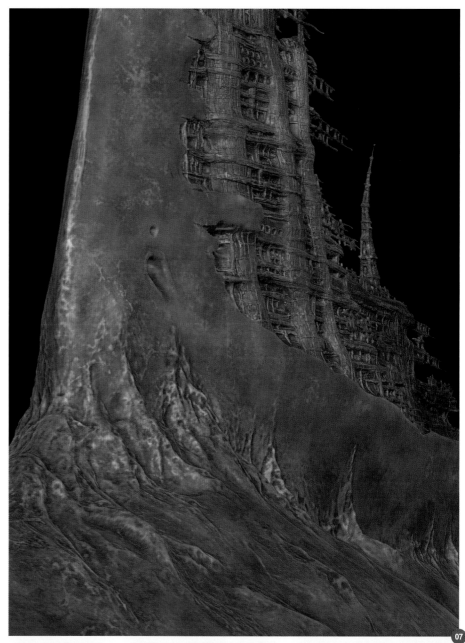

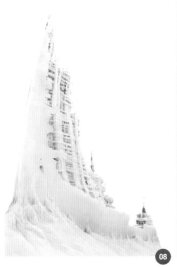

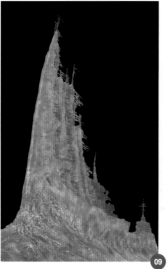

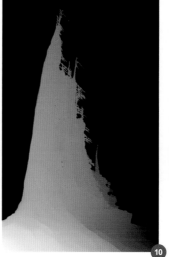

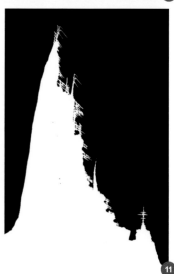

background in Photoshop (**Fig.13**) I put the work away for a day or two to gain a more objective opinion. This proved to be very useful, as I could approach the task with revived enthusiasm and patience. Balancing the composition was a delicate job as each change introduced an improvement and sometimes worsened everything, but at least allowed me to see it in a different light. It is very difficult to assess your work objectively, this requires a number of questions being asked before the final version is decided on. In the past I have opted to readdress the composition on more than one occasion. I was intent on achieving the best possible balance between the time spent on the work and its finished state. Nevertheless the moment of deciding when the work is complete can be difficult. The experience I gain from creating my work helps with subsequent projects and I am always hopeful that each will prove fruitful in the future.

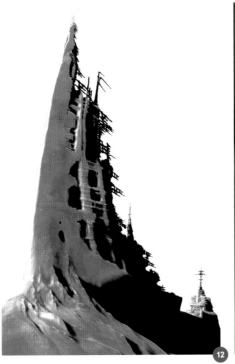

ARTIST PORTFOLIO

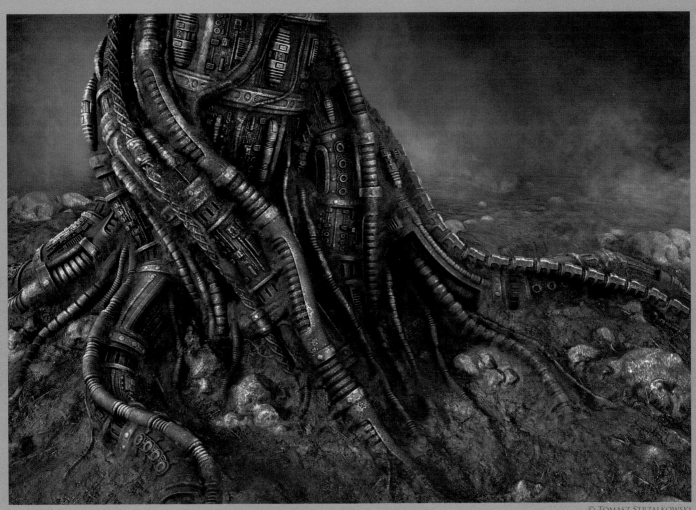

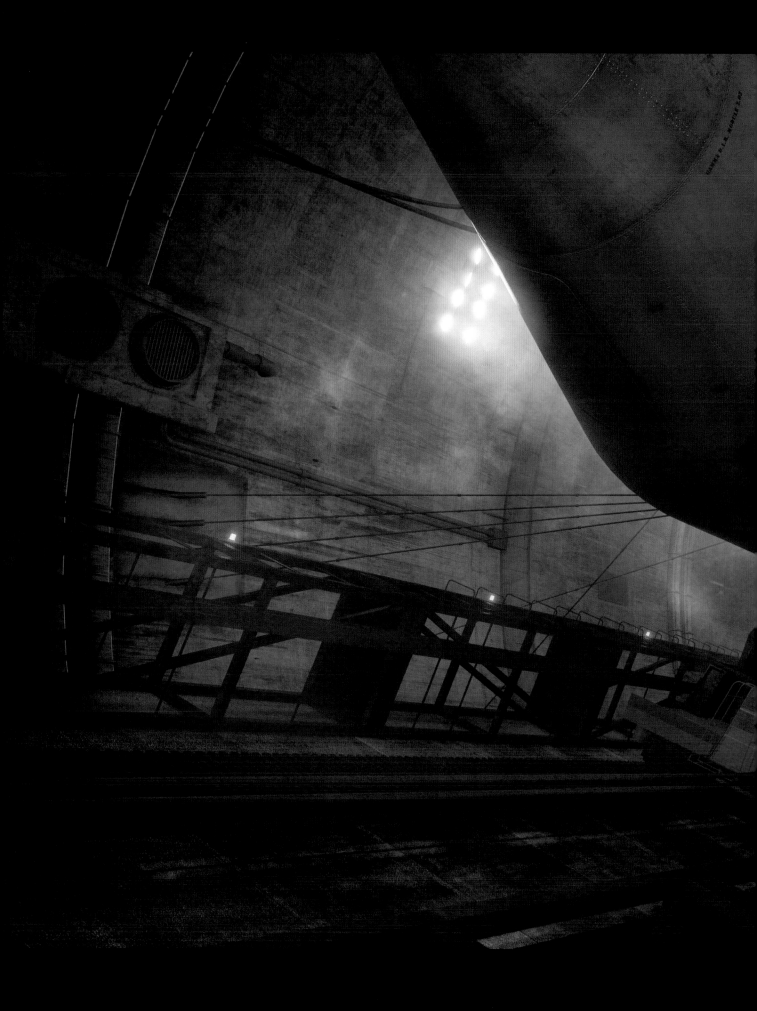

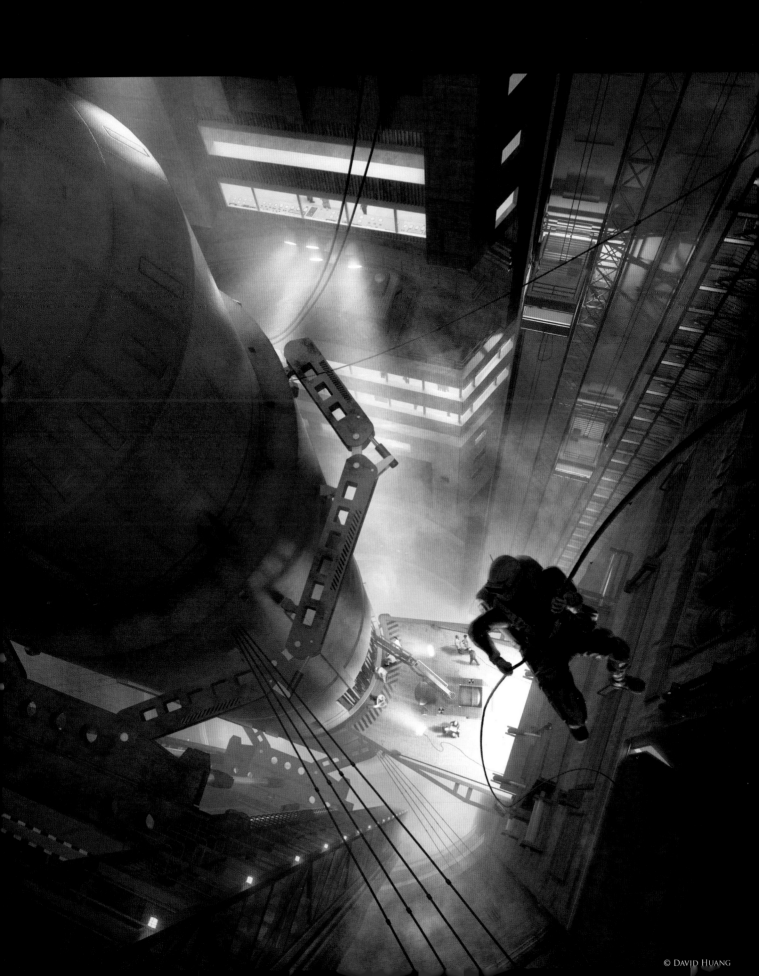

Drop Vertigo
By David Huang
JOB TITLE: Concept Designer and Digital Artist
SOFTWARE USED: 3ds Max, V-Ray, and Photoshop

INTRODUCTION

Drop Vertigo was created in 2009 for the "Secret Agent" challenge organized by CGSociety.org. It's a special project to me because it was my first time participating in an online art competition, and I found it artistically productive to work within new constraints. I learned a tremendous amount within a short span of time and had a lot of fun along the way.

I only discovered the competition about two weeks before the deadline, so I had to make quick decisions and customize an efficient workflow. Around that time I had come across a picture from *Time* magazine of a missile held in a storage silo and the image somehow stuck; I decided to create a scenario of a covert warhead being armed within a vast underground structure, with a spy about to infiltrate the facility. A pretty conventional take on the theme admittedly, but I figured I would do something interesting with scale, perspective, and composition, aiming to create an image with a dramatic visual impact.

> " I LOOKED UP REFERENCE IMAGES OF MISSILES, COLD WAR ERA MILITARY FACILITIES AND UNDERGROUND STRUCTURES SUCH AS TOKYO'S MASSIVE SUBTERRANEAN DRAINAGE SYSTEM "

VISUAL DEVELOPMENT

For inspiration I looked up reference images of missiles, Cold War era military facilities and underground structures, such as Tokyo's massive subterranean drainage system. I then started by sketching some thumbnail studies to settle on a rough composition before drawing a larger sketch for more detailed development

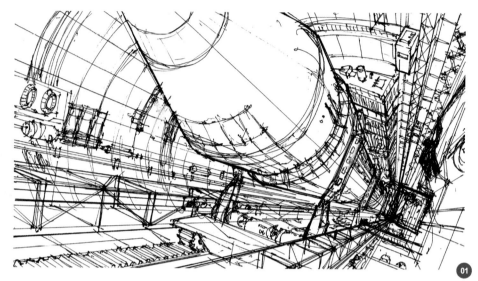

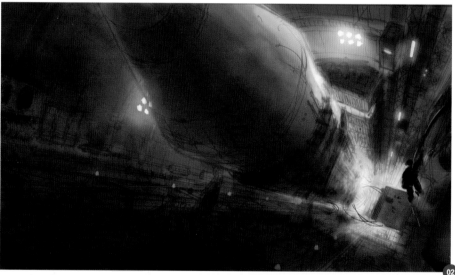

(**Fig.01**). I chose to have the missile penetrate the top of the frame, which I thought was more threatening and helped suggest movement even though the object is static. Against the outward vectors of the missile, I drew the spy rappelling down in the opposite direction to convey the sensation of dropping into the depths of the picture space.

Next I did a rough color painting to develop the lighting, mood and atmosphere (**Fig.02**). I had in mind a fairly dark image with a limited color palette, almost like a black and white photo. I wanted the deep focal point of the image to be the brightest area to further attract the viewer

towards the vanishing point. I also wanted this to contrast against the silhouette of the spy who would be in a dimly lit space to emphasize the secretive nature of his activity.

Speaking of the spy, I wanted to convey a sense of mystery and suspense that would make the viewer question why he was there. Perhaps he is there on reconnaissance, planting a detonator or stealing information. His use of a rope to infiltrate the base is partly inspired by one of my favorite characters from a favorite movie of mine: Robert De Niro's freelancing handyman and enemy of the state Archibald "Harry" Tuttle in *Brazil*.

SCI-FI

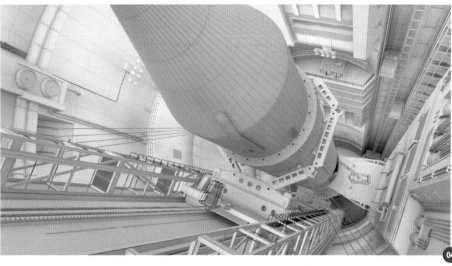

3D PRODUCTION AND SETUP

Given my time constraints, the strategy for my 3D workflow was to minimize time spent on things that would be much faster to do in 2D, such as atmosphere, dirt and decals, as well as certain lighting effects. Therefore my 3D process was quite simple and I won't focus too much on it; instead I'll show some simple steps I used to set up the work carried out in 2D. The only other thing I would say is that I sketched a lot while working in 3D; to me, the design process flows better with rapid feedback between drawing and modeling.

The entire scene was modeled in 3ds Max, using poly editing of primitives, and then rendered out in V-Ray. I imported a plan drawing (**Fig.03**) to use as a template and the color perspective for rough camera matching. Modeling the geometry was fairly straightforward, and you can see the moderate amount of detail I put into the scene (**Fig.04**). For materials I used textures from **www. CGTextures.com** and employed basic UVW mapping. The only object I had to unwrap was the missile, but even this was heavily painted over during post-production. I set up V-Ray lights for key, accent and fill illumination as needed. I used an Irradiance map for the Global Illumination and Light Cache for secondary bounces, with the Image Sampling set to Adaptive DMC. More importantly I saved out various render passes in order to have the ability to fine-tune each of the elements later on. The raw render I produced (at 5120 x 2770 pixels) was far from complete (**Fig.05**), but serviceable enough to take to the next level in Photoshop.

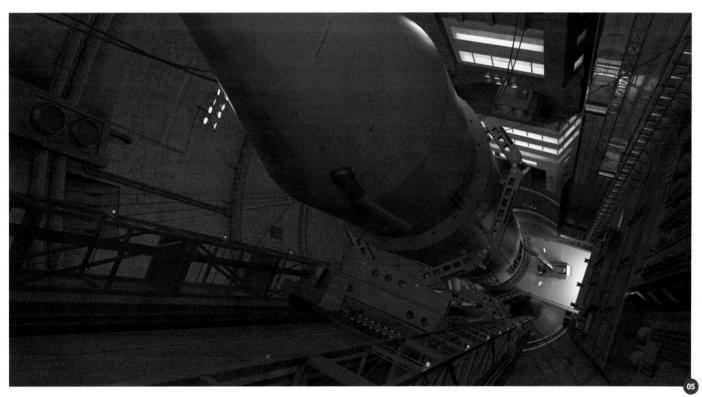

The final step in 3D was to render out various channel selections for use in Photoshop, a huge time-saving step for post-work. I made a copy of the 3ds Max file, eliminated all the lighting and Global Illumination, and then set up standard 3ds Max materials with maximum Self-Illumination using red, green and blue colors assigned to the diffuse slots. I applied these colors to any objects in the scene that I wanted selection control over, and quickly rendered them in Targa format (**Fig.06**). An important detail to remember here is to keep the anti-alias settings the same as the original rendering to avoid "halos" in the alpha channels.

> " BY THE END OF THE
> PROJECT, I HAD
> DEFINITELY BEGUN
> TO IDENTIFY WITH
> THE SUBJECT –
> HAVING TO WORK
> AGAINST THE CLOCK
> AND IMPROVISE
> ALONG THE WAY "

2D PAINTING AND FINISHING

From this point all the work was done in Photoshop. I started by copying all of the alpha selections into the base file by dragging the individual red, green and blue channels over

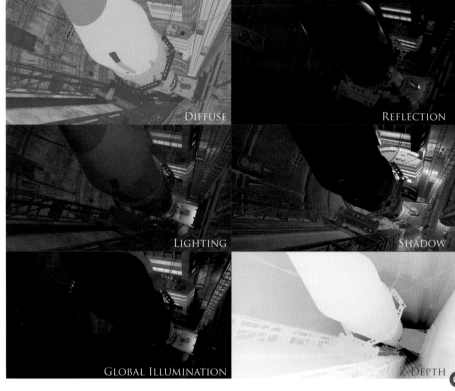

while holding Shift + Ctrl (Windows), which aligns them perfectly with the base layer. These channels could now be used for quick layer mask selections.

I applied adjustment layers to the overall image using Curves, Levels and Color Balance, tuning individual elements as needed using the layer masks. I brought in the Diffuse, Reflection, Lighting and other render passes to bolster certain textures and effects (**Fig.07**) Next I painted in dirt and grunge everywhere, using custom brushes, focusing on crevices, corners and seams. I also used more grunge maps from CGTextures to create the aging and wear and tear on the various elements. The spotlight beams were overlaid photos from my own reference library set to Screen mode. Then I added smoke emanating from below using custom cloud brushes. For the atmosphere I painted in some fog against the Z-Depth as a layer mask.

Finally I had to put in the spy as the deadline was rapidly approaching. I rigged a poser figure in 3ds Max and rendered him out as reference for backlighting and scale, and then repainted him entirely in Photoshop. I imagined him looking kind of like a paratrooper with a backpack and masked helmet, using a rappelling cord for his descent. The paint job was rather rough and wasn't the strongest part of the image, but was just enough to introduce a narrative element to the picture (**Fig.08**).

Creating this image was a challenge for me, but by working nights I managed to more or less get it done in time for the deadline. By the end of the project, I had definitely begun to identify with the subject – having to work against the clock and improvise along the way. Overall it was both a chaotic and fun project to take on and I only hope I was able to share some helpful pointers for the next time you find yourself similarly dropped into a tight situation.

Irongore vs. The Invaders From Space

By Dennis Allain

Job Title: Designer and Illustrator
Software Used: Cinema4D and Photoshop

The Challenge

In January 2010 the website CGTalk was sponsoring a design/illustration competition entitled, "CGSociety Challenge XXV: B-Movie". This was to be a creative challenge to "bring life back into, or create a classic B-Movie". There were three categories: still, video, or audio. Since I was, and still am, a big fan of science-fiction and horror, I decided to enter the competition because it would provide me with an opportunity to illustrate a subject matter that I really enjoy. The fact that there was a real due date for the final entry also made the exercise worthwhile and forced me to be disciplined in my execution.

> " I BUILT THE HERO ROBOT FROM EXISTING 3D PIECES COMPRISING A TANK, TRAIN, ARTILLERY AND MISCELLANEOUS MACHINERY "

Beginning

The way I typically approach a design problem is to go straight to the 3D environment. I tried several programs back in the late 90s and eventually settled on Cinema4D. Currently I am using Cinema4D R11.5 Studio bundle. While working in 3D I can quickly test lighting, detail and camera views. For this particular image, I settled on an "Earth vs. alien" concept and chose an urban environment. I am not good at rendering people so I quickly gravitated to a more mechanical motif (**Fig.01 – 02**).

The first order of business was to start with our "hero". I built the hero robot from existing 3D pieces comprising a tank, train, artillery and miscellaneous machinery. Often I will build

pieces that better portray the intended design as was the case for the hero's eye and chest plate (**Fig.03**).

The villains (the flying saucers) seemed to be in-keeping with the B-Movie concept and I wanted them to have a futuristic aesthetic that would have been conceived by an illustrator living in the 1950s. There had to be two versions; a flying version to help populate the sky and a walking version at ground level. I will typically spend hours researching imagery on the internet for inspiration. For the saucers I looked for ray guns, alien craft, sci-fi imagery, etc. I saved these images in a reference folder and periodically referred to them for inspiration and guidance. To save time, I try to utilize pre-built 3D models as this helps free up time to spend on design, painting and experimentation (**Fig.04 – 05**).

I have wanted to create a city scene for some time now. I felt this could be a great setting for the epic battle that my characters would be engaged in. I imported the 3D characters from their own files into the center of the main scene file. Here I began dropping buildings around them to help start testing the final layout. I wanted a smaller building at the front and larger structures in the back. I also placed an elevated railway in the scene to help lead the viewer's eye into the composition (**Fig.06**). This appeared to work well and provided an element in the story that could have a subtle interaction with our hero – the source of his weapon (the train car club!) (**Fig.07**).

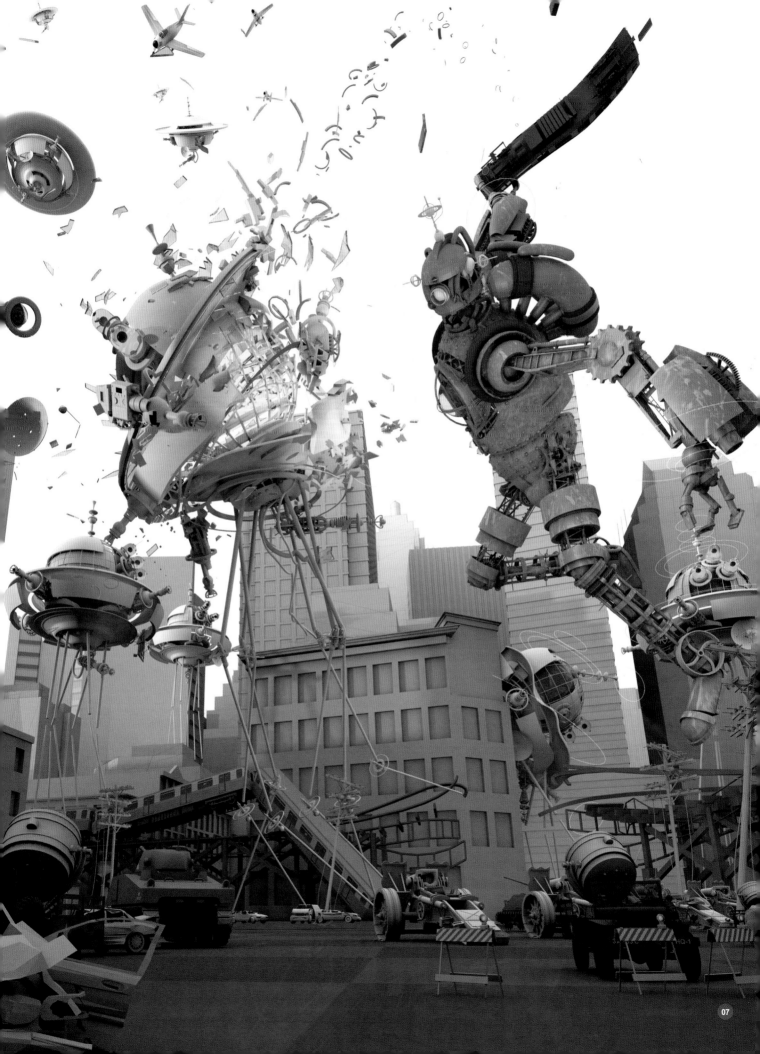

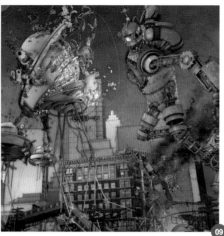

> IT IS MY BELIEF THAT THE MARK OF A TRULY SUCCESSFUL IMAGE IS ONE THAT CAN TAKE THE AUDIENCE BEYOND WHAT IS ANTICIPATED

FINAL STAGES

All of my work is created first in 3D and then finalized in 2D. I started using Photoshop back in 1995 in an attempt to help keep up with the demands of tight production schedules for the architectural projects I was involved with. My tastes throughout the years have always gravitated towards traditional artwork. My hope was to use computer tools that were readily available to me, in a manner that related more to the hand-drawn/painted world and less to the typical computer artwork being generated at the time.

When I "paint" in Photoshop, I bring the Cinema4D base render in and begin laying down washes of color for the sky and ground areas. Starting with bigger areas helps build my confidence while at the same time quickly provides a sense of progress (**Fig.08 – 10**).

I had decided early on to paint the explosion and smoke in Photoshop. This adds flexibility and a certain randomness that is more related to a hand-drawn aesthetic than it may otherwise be in a more precise medium. The challenge however, was to integrate the physical nature of the explosion (heat, color, highlights, etc.,) onto the surrounding environment. I tried to accomplish this by

selecting natural looking brushes to add color and highlights to elements closest to the blast (**Fig.11**). Months ago I downloaded brushes created by Yang Xueguo called "Blur's Good Brush 4.0". Although there are lots of brushes to choose from, they are great to experiment with and for creating natural textures.

CONCLUSION

Subject matter aside, my goal while developing an artistic expression for a design concept is to engage the audience and provide that

audience with an image that is capable of telling a multitude of relevant stories. Designs and illustrations that my studio develops often have a singular subject, be that an architectural structure, environment or character. It is my belief that the mark of a truly successful image is one that can take the audience beyond what is anticipated and create a view into a world that succinctly portrays the design concept, while simultaneously enriching the viewers' experience with a collage of additional sub stories or "moments".

© Dennis Allain

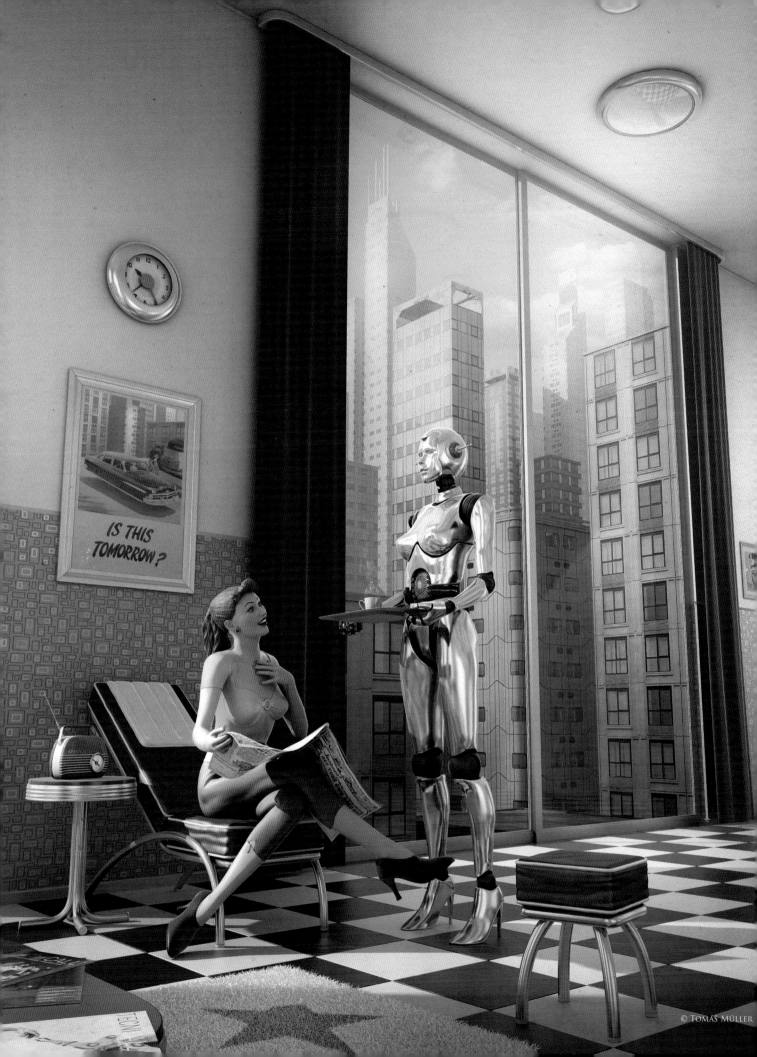

IS THIS
TOMORROW?

© Tomas Müller

Is This Tomorrow?

By Tomáš Müller

JOB TITLE: Freelancing Commercial Artist

SOFTWARE USED: 3ds Max, Mudbox, V-Ray and Photoshop CS4

INTRODUCTION

Last year I was asked to do a cover illustration for a science magazine called *Technicall*. The main theme of the magazine issue was Robotics. I was given full freedom of expression and since I love sci-fi imagery I was pretty excited about the project. First of all I needed a direction for the theme and style. I often create classic high-tech images as concept art, so after a few sketches and ideas I ended up with a kind of future-retro feeling which best suited the purpose. Personally I love something about every decade of the twentieth century, but there are a few decades I love more for their atmosphere, design style and feeling than the fifties. There are so many cool things about the fifties to choose from, especially pin-up art and B-grade sci-fi movies. I decided to try and end up with an interesting fusion of these two genres. A secondary influence was one of my all time favorite artists, Hajime Sorayama, so this illustration is also a bit of a tribute to him.

> " I LIKE PAINTING ONTO AN UNFINISHED RENDER AS IT GIVES ME A GOOD IDEA ABOUT WHETHER SOMETHING WILL WORK OR NOT "

CONCEPT

After a few quick sketches I decided to move directly into 3D and figure out what kind of perspective and composition would work best. Composition was my main problem since everything was bound by the magazine layout, which included a logo and the main article in the bottom right corner. Therefore it was a bit difficult to come up with a functional and yet pleasing composition, which also worked with the text and logo. I did lots of WIP sketches throughout the whole process by bringing test

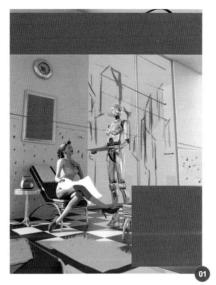

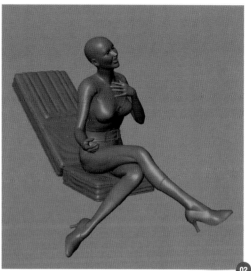

renders into Photoshop and trying to figure out the best positions for all of the objects in the scene. This was important in deciding how I could tell the story in the right way without interfering with the layout. Usually I like painting onto an unfinished render as it gives me a good idea about whether something will work or not.

MODELING

After preparing quick base meshes in 3ds Max I did most of modeling in Mudbox. The models were prepared as separate parts and then imported, remodeled and finally detailed (**Fig.01**). Since I didn't use any detailed textures there was no need for any re-topology. As you can see in **Fig.02 – 04**, the models

were quickly unwrapped and imported into 3ds Max as high res meshes, before being smoothed and prepared for rendering. Some of the smaller detailing was done in 3ds Max via the polymodeling tools (**Fig.05**). Unwrapping was applied only to the parts where textures were used like the face, hair and interior objects. It was necessary to not only be creative, but also economical, and resist spending unnecessary time on the processes. For instance, I decided at a later stage to use a modeled base mesh for the hair, combined with hand-painted textures and Opacity maps, compared to a hair plugin that can be time-consuming to set up (**Fig.06**).

> " IN ORDER TO MAINTAIN AN ILLUSTRATIVE STYLE I MINIMIZED THE TEXTURING AS MUCH AS POSSIBLE, OPTING INSTEAD TO CREATE THE ATMOSPHERE THROUGH SHADERS, COLORS AND LIGHTS "

TEXTURING

Texturing was actually the easiest part of this illustration. Most of the textures were painted in Mudbox with others either downloaded from some well-known texture sites or made from reference photos. Photo textures were used mainly on the clock and furniture. I knew that this piece was going to be about the little details so I also prepared some custom versions of fifties advertising in the form of wall pictures. In order to maintain an illustrative style I minimized the texturing as much as possible, opting instead to create the atmosphere through shaders, colors and lights.

LIGHTING AND RENDERING

The scene was rendered in V-Ray using one warm Directional light (standard 3ds Max light), one blue V-Ray Skylight and a couple of V-Ray Plane lights behind the windows to increase the exterior light (and also for increasing the number of samples in the scene). It's basically a simple setup often used for daytime interior scenes (**Fig.07**). All the shaders conform to the visual style I had in mind, which was partially flat but rich in color. I decided not to use any

realistic-looking effects, like Sub Surface Scattering etc. All the shaders in the scene are based on similar materials that are slightly modified for each part of scene (wall, metal, skin) to make the models look different, but still maintaining consistency.

BACKGROUND

The background scenery was done separately in Photoshop (**Fig.08**) using a combination of photo textures and digital painting. Later on the background was inserted behind the window during the post-production process. Before starting the background I carried out a few simple renders of some boxes corresponding to the scene perspective, which would eventually represent the buildings. This guaranteed an accurate perspective before I began the painting process. No special brushes were used during the painting, just three default Standard brushes in Photoshop.

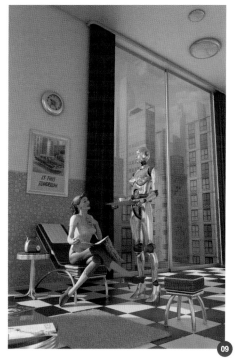

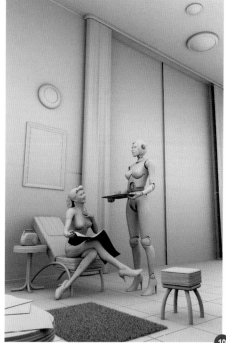

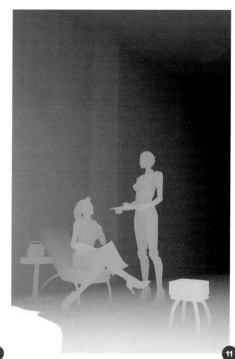

The color scheme of the 3D scene was based on the color of the sky and sunlight in order to successfully integrate the background.

> ❝ I WAS SATISFIED WITH THE RESULT, ❞ WHICH CONFORMED TO THE STYLE I WAS THINKING ABOUT FROM THE VERY BEGINNING

POST-PRODUCTION

Photoshop CS4 was used for compositing, color correcting and finishing the image. Several passes were rendered along with the final render to increase the illustrative look. These include the main render (**Fig.09**), Ambient Occlusion pass (**Fig.10**), Z-Depth (**Fig.11**), window reflections and a couple of masks for selective tweaks. Warm color toning was added (**Fig.12**) with the help of a couple of adjustment layers, Color Curves and Gradient masks.

CONCLUSION

Ultimately I was satisfied with the result, which conformed to the style I was thinking about from the very beginning. The client was also happy so it was another job done! I'm glad to have had the opportunity to share this work with you and hope you enjoyed this article.

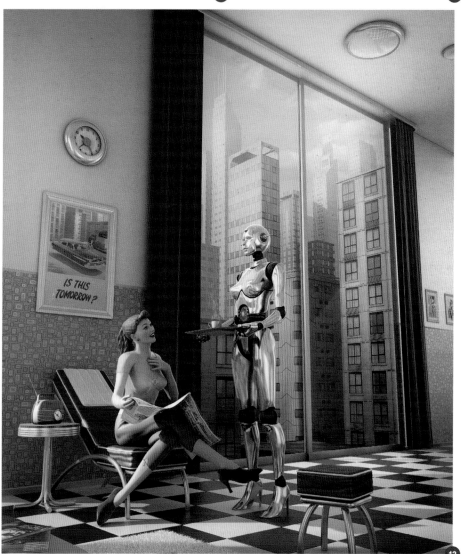

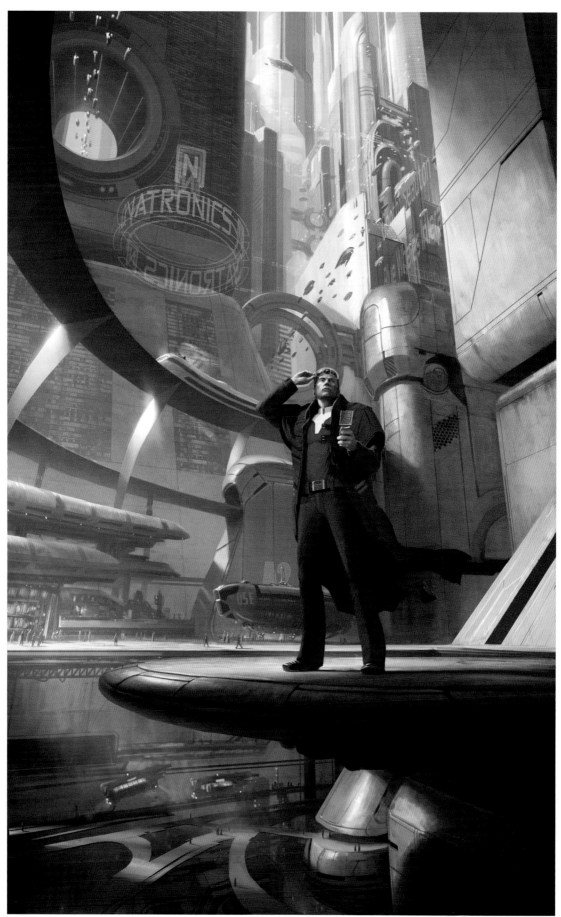

© Marcin Jakubowski

GAME DEC CITY
BY MARCIN JAKUBOWSKI

JOB TITLE: Freelance Concept Artist
SOFTWARE USED: Photoshop

INTRODUCTION

I was asked to depict a future city from the novel series *Gamedec*. Gamedec (Game Detective) is a private eye who investigates suspicious cases in virtual reality. In the world of the *Gamedec* series, people live in bustling multi-level cities with dense populations; however they spend a lot of their time in virtual reality, which has become as important as reality. In this image I wanted to show the structure of the city and its span, from bright and clear skyscrapers to the darker and gloomier lower levels. There's a Gamedec in the centre who has just realized that he might just be in someone's game.

> " THE MAIN IDEA WAS TO SHOW THE CITY IN MORNING LIGHT. I HOPED IT WOULD CONVEY AN INTERESTING INTERACTION BETWEEN THE LIGHTS AND DARKS "

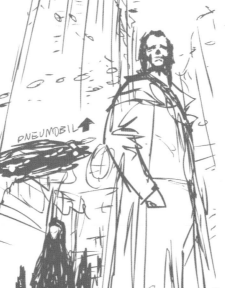

SETTING UP

No matter how clear the vision I have in mind I don't skip the sketch phase (**Fig.01a – d**). The sketch is a plan of my work and stops me forgetting my initial ideas. It doesn't need to be detailed or a masterpiece. Many artists begin by blocking in the shapes and establishing the values, but I prefer line art and a few simple color layers beneath. I created two rough color schemes with opposing light sources (**Fig.02a – b**). The main idea was to show the city in morning light. I hoped it would convey an

interesting interaction between the lights and darks. I liked both versions and it was hard to decide which one I should follow up. Finally I chose to develop the darker scene because I thought that it would be easier to create a sense of depth.

Before I was ready to move on to the painting, I had to resolve some perspective issues. I used 3D software to set up the main solids (**Fig.03**). Without it I probably wouldn't have created the right shape for the elevated railway. I updated the sketch and was ready for the next step.

> IT WAS AFTER ADDING MY FAVORITE ATMOSPHERIC EFFECTS LIKE FOG, STEAMERS AND SHINING METAL THAT I FELT COMFORTABLE

PAINTING

I enlarged the sketch to the final resolution and added some texture in Overlay mode to provide some variation in the color. I then had to clear the sketch and define the main form of the buildings. It took me some time to experiment with different shapes so I avoided painting any details at this stage (**Fig.04 – 06**).

When I was sure that the background was going in the right direction I started to develop the main character. I tried out a few gestures

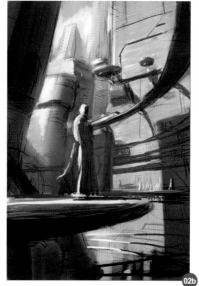

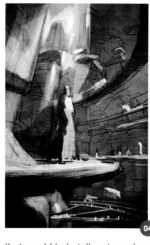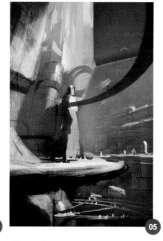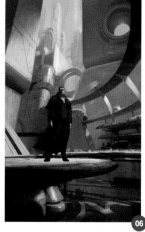

that would help tell a story about a Gamedec who had just received a worrying message (**Fig.07**). The image came to life when I painted the flying cars, people on the platform

and windows on the main building, but it was after adding my favorite atmospheric effects like fog, steamers and shining metal that I felt comfortable (**Fig.08**).

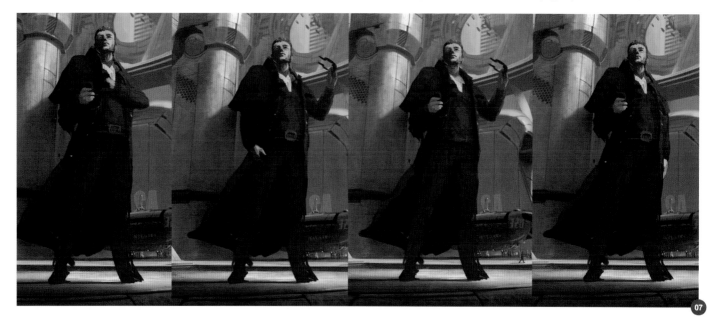

SCI-FI

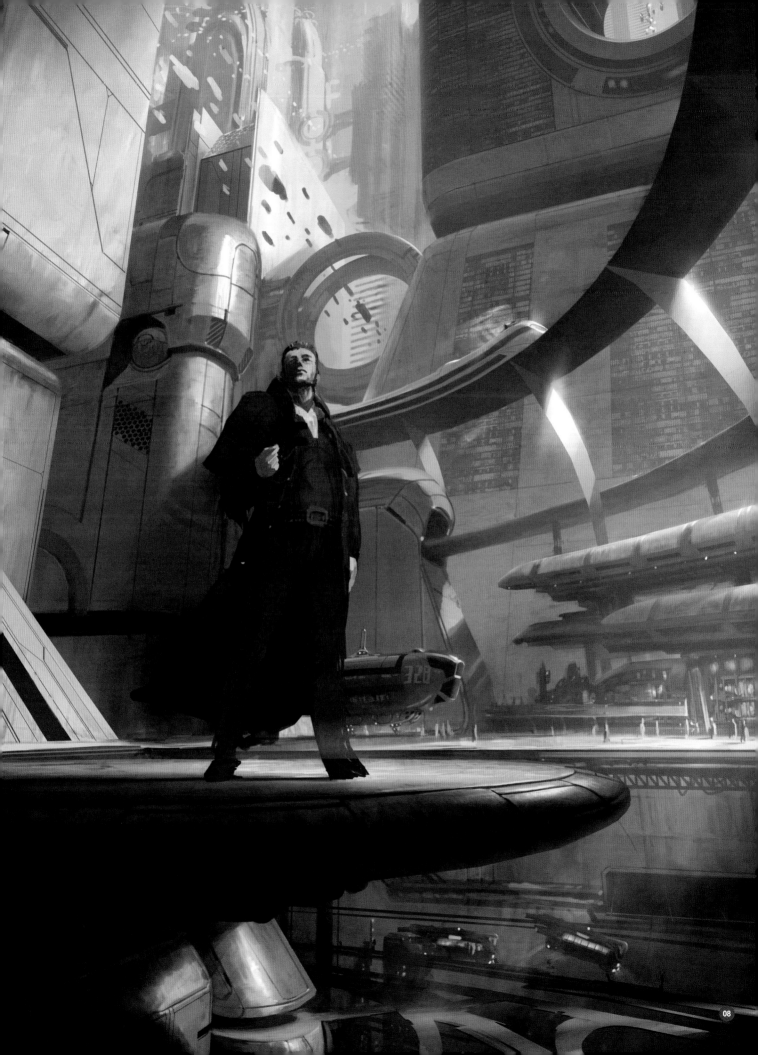

> ## "PLACE SOME TINY OBJECTS OF A KNOWN SIZE IN FRONT OF THE BIG STRUCTURE. HUMAN FIGURES, BIRDS AND TREES ARE GOOD EXAMPLES BECAUSE OUR BRAIN UNDERSTANDS THEIR SIZE"

The thing that still needed serious work was the area with the skyscrapers in the centre. I really wanted to retain the blue color for the sky and combine it with shiny glass buildings. I was looking for a feeling of clarity and great distance, but the results were distracting and too intensive. I spent some time trying to find a satisfying solution (**Fig.09**).

In the meantime I noticed that a mirrored image was more spacious. It's because we usually look at images from the top left to the bottom right and after flipping the canvas the near yellow metal building wasn't such a barrier any more (**Fig.10**).

DETAILS

The image is over 5600 pixels in height so I had the possibility of putting a lot of detail into it (**Fig.11 – 13**). Nevertheless I tried to avoid the temptation to zoom in and scratch every one of the 19 million pixels fully because I'm not a fan of over-detailed images. I only painted the things that were necessary to give an

impression of a living city. During this stage I also fixed some of the bugs and perspective inconsistencies. With the completed background I could finally focus on the main character. Painting such an important element at the very end probably wasn't the smartest move. I was tired of the image so I pressed myself to finish it as quickly as possible. Throughout the whole process of painting I employed only simple default brushes. Working on many layers slows me and my PC down therefore I used as few layers as possible. Important selections and objects were saved in a separate file. When needed I just loaded them and dragged while using the Shift key to maintain the correct position.

MONUMENTALISM

Scenes containing monumental buildings, huge structures and massive natural formations are great when we want to show how small and insignificant a man is. It can be depressing and scary, but also moving and emotional in positive way.

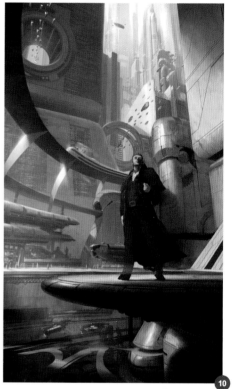

There are certain techniques that can be used to paint impressive and convincing large objects. First is the matter of scale comparison. Make a background from a huge object for smaller things (**Fig.14**). Place some tiny objects of a known size in front of the big

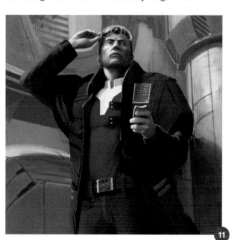

structure. Human figures, birds and trees are good examples because our brain understands their size. For tall structures it's a good idea to paint some covering clouds.

The additional sensation of size comes from the structure and details within the surface (**Fig.15**). Repeating patterns of the windows, small parts of the spaceship, groups of trees or rocks can help build the suggestion of scale. Distance also creates a feeling of size. Distant objects are less saturated and have

less contrast. They blend with the thick atmosphere (**Fig.16**). I don't use the contrast sliders because it usually results in a poor effect. Instead, I try to use the right colors from the very beginning. To tweak the contrast I pick up the color of the sky and use a soft brush in Lighten mode. This way the light areas stay untouched and the dark areas are lightened towards the sky color, thus giving the impression of great distance. Any monumental scenery can be ruined with the wrong point of view and wrong proportions. The safest and obvious method is by using three point

perspective with a vertical canvas, but this rule shouldn't be viewed as absolute. It is always worth experimenting and not adhering strictly to any given rules.

Conclusion

Painting such complex scenery was quite a challenge for me. The budget and time were exceeded, but the image was worth the effort. The main character and some elements of the architecture could be done better, but I had to stop somewhere. I'm nevertheless happy to have this image in my portfolio.

Artist Portfolio

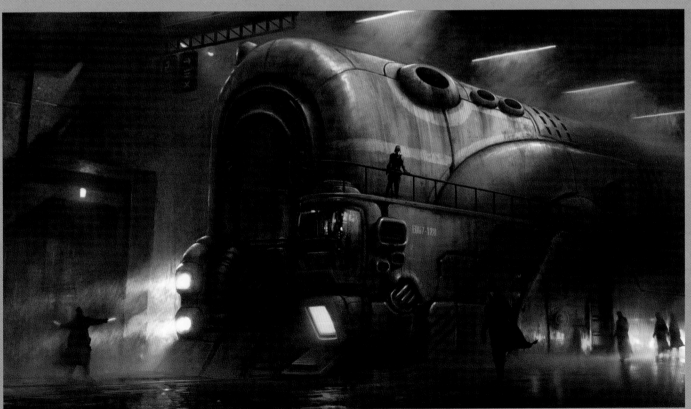

© Marcin Jakubowski

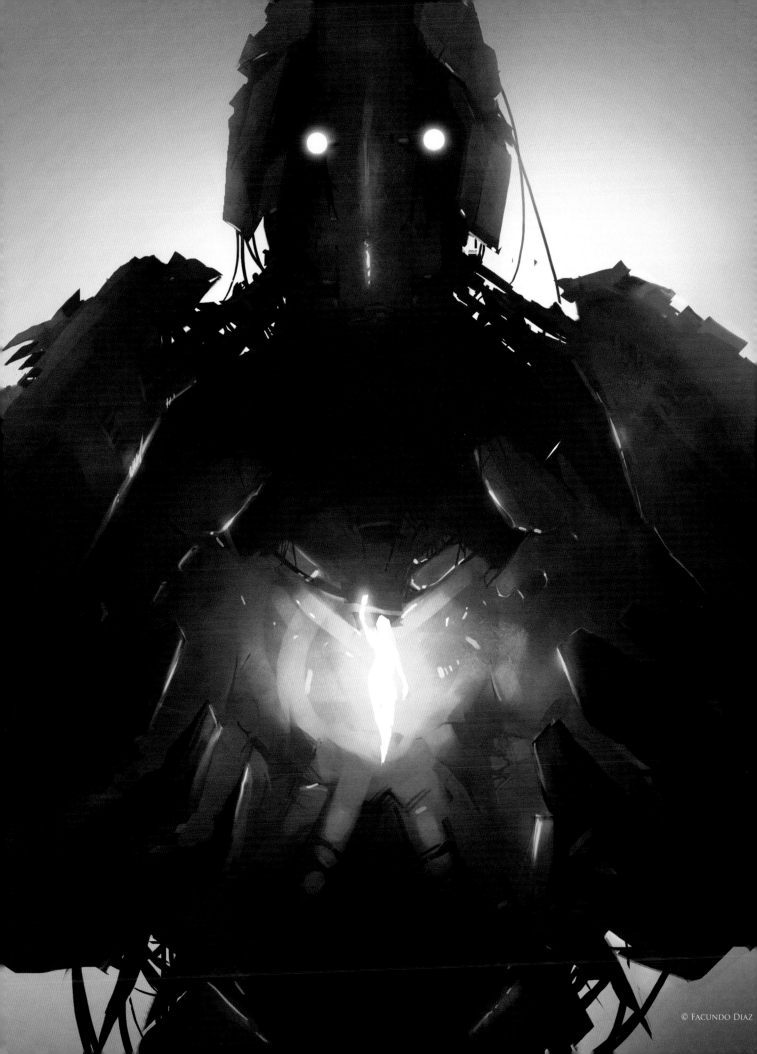

MAKE A WISH
BY FACUNDO DIAZ

JOB TITLE: Freelance Graphic Designer and Illustrator
SOFTWARE USED: Photoshop

INTRODUCTION

Make a Wish was one of the most interesting works I have had the opportunity to create since working as a digital artist. I had many great ideas in my mind that suggested this powerful scene of a mythical fairy, and a curious destructive robot whose only purpose in life was to battle until the end of his life.

MY PAINTING

Before starting to paint, I tried to imagine the robot's expression. I wanted to portray astonishment and intense curiosity in his face. I knew it was going to be a difficult task because robots and mechs don't have versatile faces and most of the time they have a fixed expression. So I focused first on the head of this giant mech. I made several sketches to find the perfect expression, but I had to start again a number of times because the feeling was wrong. I tried to simulate the mouth, nose and eyebrows to get the look right and at the same time make them part of the robot, but alas with no success. One day I realized that maybe I should tackle the problem from a different direction. The next day I concocted the most unexpressive look I could have created, with just the most important parts of the human face included: the eyes. And the result was brilliant!

It was truly a big challenge to design the face, but finally I ended up with an interesting look. I wanted people to picture the robot's expression by themselves and guess about the curiosity in his eyes. I feel this gives the work a deeper meaning (**Fig.01**).

When the head was complete I continued with the rest of the body, shoulders, torso and arms, which were quickly painted. The robot needed a strong appearance, so I decided that the whole body should have many broken parts and lots of mechanical gears (**Fig.02 – 03**). The

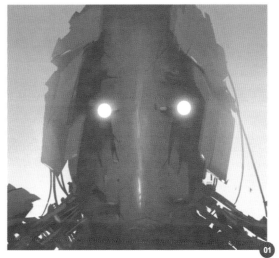

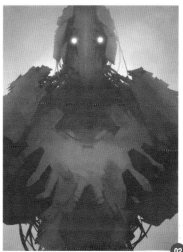

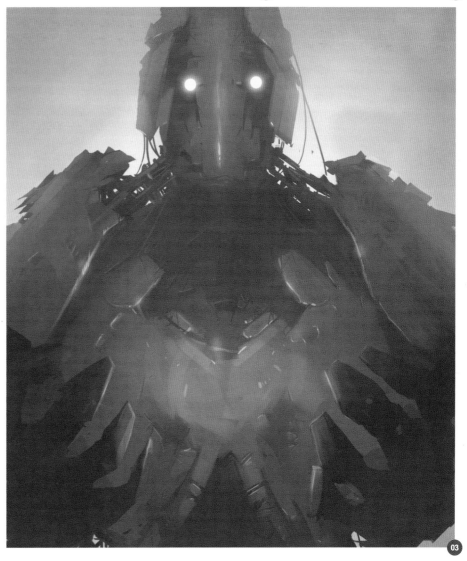

armor has an old look as if it has been fighting for a long time, suffering the consequences of war caused by the human race. This effect was mainly achieved with the help of textures. Another important aspect of this piece was to reflect the glow emanating from the fairy across the robot's body, so I painted most of the detail into the shadows and reflections (**Fig.04 – 05**).

> ## IT'S IMPORTANT TO BEAR IN MIND THAT THE MORE LOGICAL THE DESIGN, THE MORE PLAUSIBLE IT WILL BE

The process I went through whilst painting this piece revolved mainly around a classically centered composition, which focuses the view on the most important object: the robot. I then thought about how the armor was going

look. Would he have big shoulders and how would his chest and arms look? I went on to paint the highlights with lighter values where the light was hitting and added darker values where the light was absent. I also added a very smooth and subtle gradient in the background and across the robot's body. This helped the image feel more realistic. I continued shading

the most important parts until I could see logic behind the mechanics, something with volume and a 3D feel (**Fig.06**).

It's important to bear in mind that the more logical the design, the more plausible it will be. I used a hard edged brush and added as much detail as I could using lighter and darker tones of grey. After this I started experimenting with different colors. Browns were commonly my first option, but eventually I changed to others, such as green and blue. Then I realized that brown is a color that makes the armor look older, so I left it. At the end of the process I used several layers with the Overlay mode to bring up the robot's body, making the final impression more powerful (**Fig.06**).

The background story is also very important and completes the idea behind the piece. "Not too far away from the present day, a new war rises upon humanity and many mechanical devices, including this robot, are sent to fight with the humans. Having been specially created to aid the war, with their own prefabricated artificial intelligence, one robot stops for a second in the middle of the battle and finds this beautiful, mysterious creature that grants him any wish he so desires. Being curious, the robot holds the creature in his cold broken hands and stares... What could his wish be...?"

I thought of this idea and I came up with so many answers, so many endings and, in fact, I was very happy to discover how much interest people had in this piece. Is he going to wish for eternal peace or maybe save his own life, or is he going to take revenge on those who put him there in the first place?

CARTOON

Cartoons and cartoon characters have fascinated us for a long time. Regardless of if you are a young or old artist – or even a hobbyist – there's no denying that all of us enjoy cartoons. They are a break from reality and not only amuse us, but also have the ability to inform, enthral, shock, titillate, sadden or surprise us due to tho increasingly inventive ways in which their creators push and explore the medium. They are not just light-hearted fun; they can involve serious themes and tell poignant, emotional stories as effectively as any mature live-action film or novel.

Many modern cartoons (especially animated feature films) have had a tendency to employ cutting-edge CG to tell the story. However the fundamental principles of cartoon character design have been the same since they were established in the earliest cartoons we know and love by Disney, Hanna Barbera, Warner Brothers and many more. Good, evil, serious, wisecracking, strong, weak; we all know the looks attributed to such characteristics from being brought up with cartoons and animated films for large parts of our lives.

For creators, the fun and appeal of cartoon characters can be approached in a myriad of ways, as shown in the coming chapter of this book. Each great example of cartoon work showcases the artists' individual styles and interpretations, as well as their approach to the theme in different ways. After all, anything is possible when you don't have to stick to reality.

ANDREW HICKINBOTTOM
chunglist2@btinternet.com
http://andyh.cgsociety.org/gallery

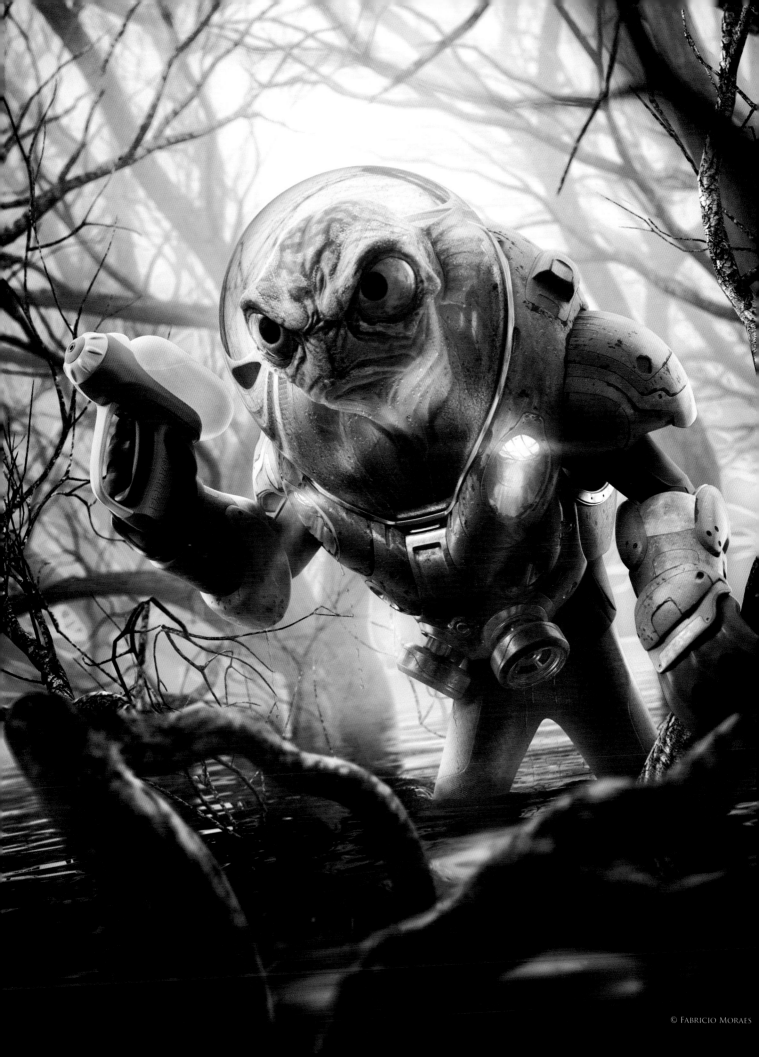

FISH MAN
BY FABRICIO MORAES

JOB TITLE: Character Artist
SOFTWARE USED: 3ds Max, mental ray, Photoshop and ZBrush

INTRODUCTION
I always loved Blizzard's *Starcraft* mariners, which was the main inspiration behind this work. I also like realistic cartoon styles and so I thought about how I could mix these two genres and inject some humor.

I sketched this fish-like humanoid, which required a special suit to leave the water (**Fig.01**). The water pistol added the comic element, which I wanted to keep clean and colorful to contrast with the rest of the scene and make it more noticeable.

I started this work in 2008, but due to a lack of ideas and time I stopped until the beginning of last year. Of course, after two years I had different ideas and the concept underwent some changes. My work colleagues gave me a lot of ideas that helped to improve the work. I think it is essential to hear the opinions of others as they always have a different vision that can add something new.

MODELING
No special techniques were used to make this work. I used ZBrush to model and texture the head and 3ds Max to box model the rest of the body. ZSpheres are a quick way of making base meshes, so I used them to get an overall idea of the head. With the form done I sketched some details such as the gills (**Fig.02**).

The next step was the retopology so that I could work with a better mesh. I exported the high poly base mesh into Max and used the Graphite Modeling tools to reconstruct a new mesh over the old one. After creating the UV mapping for this new mesh, it was exported back into ZBrush so I could work on the details and textures (**Fig.03**).

The armor was a little trickier because it needed to be a mixture of a realistic and

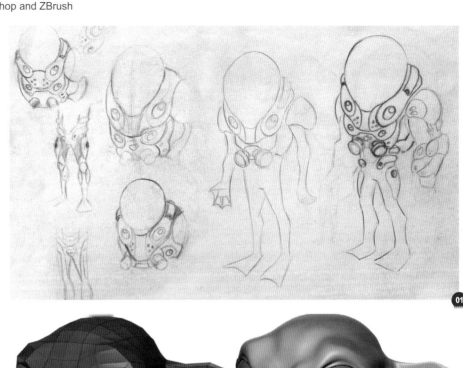

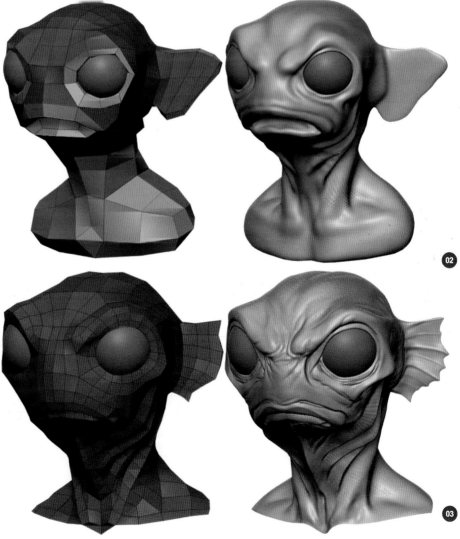

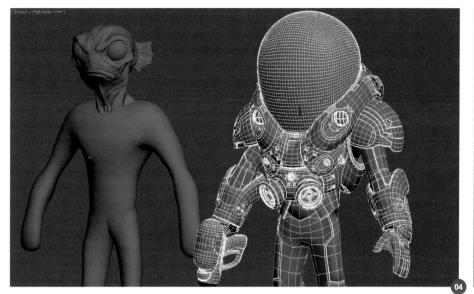

cartoon style. I took a lot of references from Blizzard's mariners, but I didn't want Fish Man to look as powerful, which is why I left the arms uncovered and showing a thin silhouette.

> " THE SWAMP WASN'T DIFFICULT TO MODEL; MY REAL CONCERN WAS POSITIONING THE TREES SO THAT THEY COULD BE REFLECTED IN THE FRONT OF THE ARMOR "

He remained cartoon-like, but at the same time I wanted him to look realistic in some way, so I was forced to consider how his armor would articulate. In other words it needed to look functional, so I imagined how it could be assembled if it really existed.

I first made a very simple base mesh for the body to get a better idea of its proportions, after which I modeled low poly versions of the main parts to see the overall design. After this I was able go into the details, making the joints and various components mentioned previously (**Fig.04**).

I imagined Fish Man coming out from a swamp during a humid, cloudy afternoon. The swamp wasn't difficult to model; my real concern was positioning the trees so that they could be reflected in the front of the armor

and also permit light to pass through them. I had to place trees all around the character to compose the scene.

After having posed the character, I exported a plane into ZBrush to create the ripples for the water, which were exported as a Displacement map to use with the Displace modifier (**Fig.05**). Before applying the modifier I subdivided a small part of the mesh close to Fish Man so

I could optimize the poly count and generate more detail only where I really needed it (**Fig.06 – 07**).

TEXTURES AND SHADING
I employed ZBrush's ZAppLink plugin to texture the head and project photo selections onto the mesh using Photoshop. This came in handy since I am very familiar with Photoshop and using this procedure is similar to manipulating

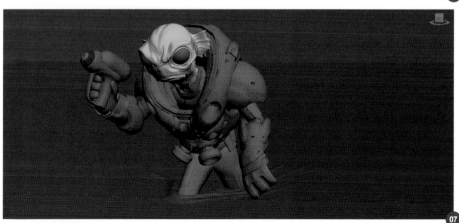

photos over a 3D mesh. One good photo of a fish was enough to make the texture of the head (**Fig.08**).

My idea behind the armor was that it shouldn't look too old. The intent was to create an appearance that was not too rusty or damaged. Some photos of rusted metals, scratches and painted metals were enough to make all the armor textures.

All of the armor utilized mental ray Arch & Design materials, with glossy reflections. A map was applied to each material to vary the intensity of the reflection. Making a reflective or even a very glossy material helps an object to fit in an environment, which is why I had to include all the trees despite some being off camera. Reflecting the environmental elements and light between the trees helped cement the character in the scene. Here is an example of the torso material with the rest of the armor following in a similar way (**Fig.09**). Of course all of these glossy reflections came at a high price in terms of render time.

LIGHTING

As I mentioned before, the atmosphere is very humid and cloudy. To achieve this I couldn't use Direct lights and crisp shadows; everything needed to look smooth with soft shadows. The main light is a huge Sky Portal that covers the whole scene to simulate the cloudy sky. The other lights illuminate specific areas on the character that were too dark and add some specular highlights to help the armor look wet.

The culmination of lights still failed to make the scene look close to being finished. I was always aware that Photoshop could be used to improve the overall look very quickly. The most important part of this stage was retaining the information of each render such as reflection, specularity and volume.

RENDER AND POST-PRODUCTION

The render was the toughest part. Everything was rendered at the same time, including the depth of field. I incorporated this because there was extensive interaction between the various elements, such as the trees reflecting in the armor and the water. The Depth of Field pass enables a smoother transition between

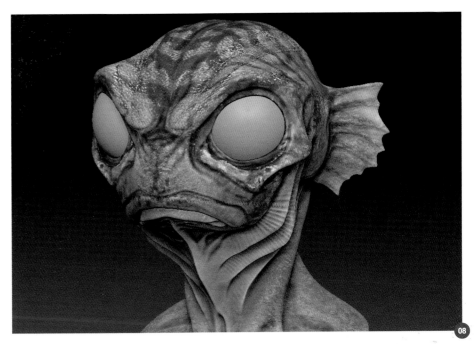

the areas compared to being done in post-production. All these elements would be very difficult to put together during post-production without causing some undesirable effects. Too help deal with each element separately I rendered oul a colored mask (**Fig.10**).

With a render of the complete scene and a mask separating the main elements, (character, helmet, gun, water and trees) I could start the post-production. The first thing I did in Photoshop was improve the lighting by increasing the contrast, overexposing the background and making the foreground darker. This way I could achieve a more mysterious and dramatic look to the scene (**Fig.11**).

I always create an empty layer set to Overlay over the element I want to improve and start painting gray tones to emphasize the volume by adjusting the highlights and darker areas.

After tweaking the lights and volumes, it's time to adjust the colors. An appropriately colored Gradient layer set to Overlay did the trick and also brightened the top of the composition, which further improved the lighting (**Fig.12**).

Using customized smoke brushes, I painted in some background fog. I painted a lens flare effect and a glow coming from the sky using a solid brush, which helped create the foggier look that I was looking for (**Fig.13**).

I couldn't achieve the desired wet effect on the armor in 3D, so opted to use photographic drops of water together with a High Pass filter to normalize the tones before setting the blending mode to Overlay (**Fig.14**).

CONCLUSION

This guy was fun and challenging to make. I overcame a lot of technical barriers such as render time, working with an intensive scene, textures issues and other little things that pushed me back.

I was satisfied with the result and sometimes joke with people saying I couldn't finish this earlier because I had to wait for the technology to evolve. This is not entirely untrue because my old computer couldn't handle the render when I started!

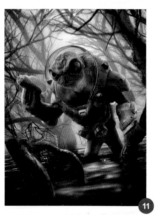

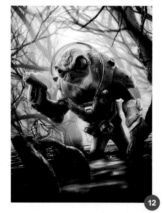

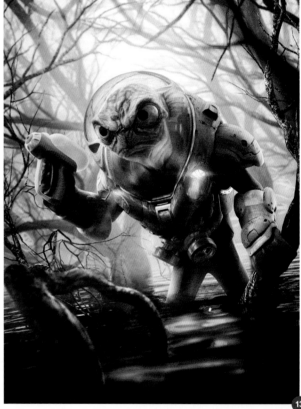

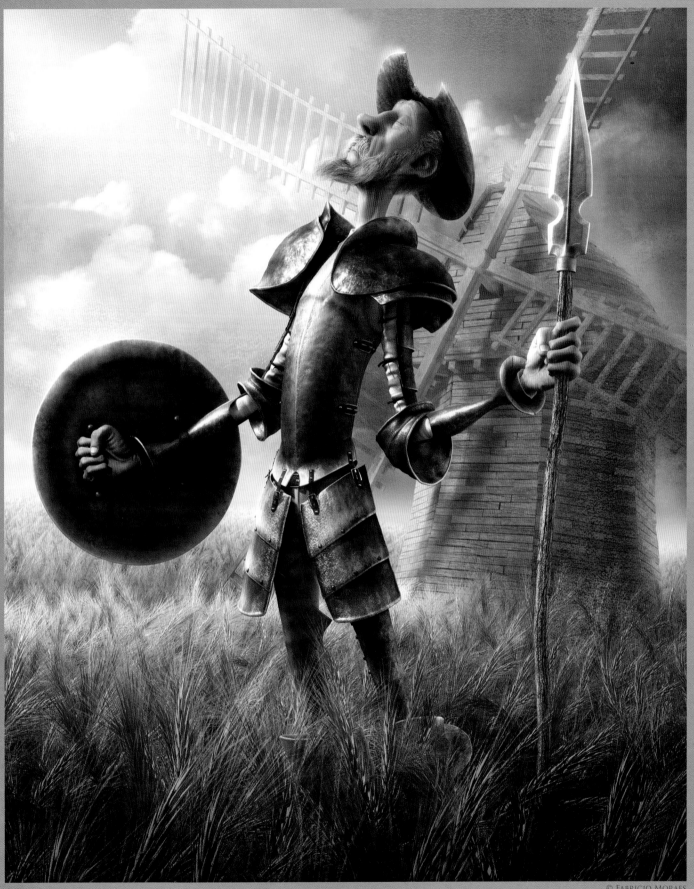

© Fabricio Moraes

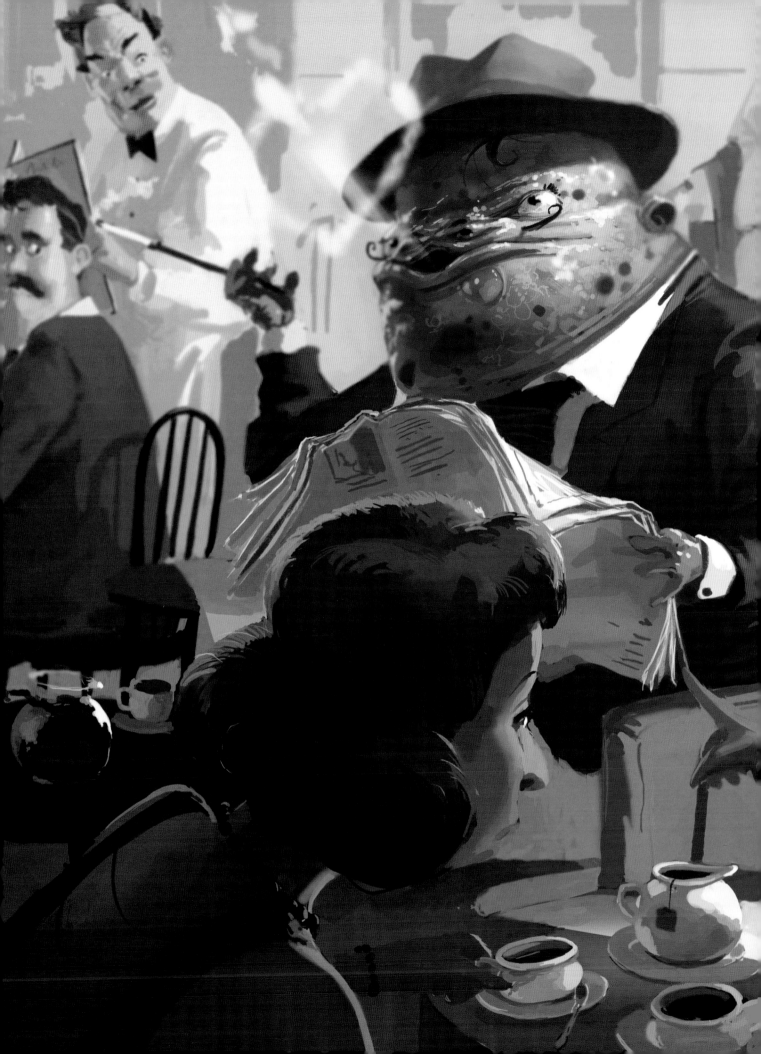

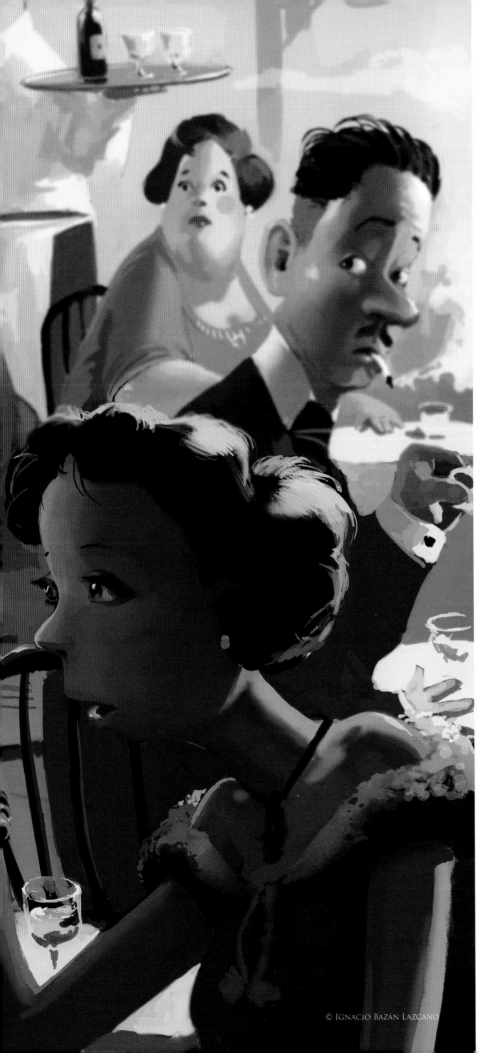

I Love Paris
By Ignacio Bazán Lazcano

Job Title: Freelance Artist
Software Used: Photoshop CS3

The Idea

The idea of painting a toad reading the newspaper in a restaurant full of "normal people" came to me while I was enjoying an aromatic coffee in one of the picturesque bars you can find in Buenos Aires. I've always liked observing people to study their gestures and the way they are dressed. Buenos Aires has a mixture of races and cultures, with each having a unique style that differentiates one from another. The ritual of drinking coffee, however, is something that brings everyone together.

" I'VE ALWAYS LIKED TO PLAY WITH THINGS SLIGHTLY DISENGAGED FROM REALITY "

The architecture of Buenos Aires is very similar to Paris. Early in the last century my country was one of the world's powers. If there is anything that has always characterized Argentine people, it is that we have always looked towards Europe and the Old Continent – especially to France and England. Perhaps for this reason, I decided that *I Love Paris* was the best name for my picture.

I've always liked to play with things slightly disengaged from reality and think that the simplest way of creating humor is to use

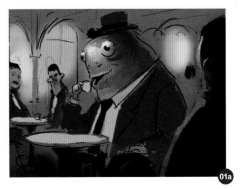

01a

283

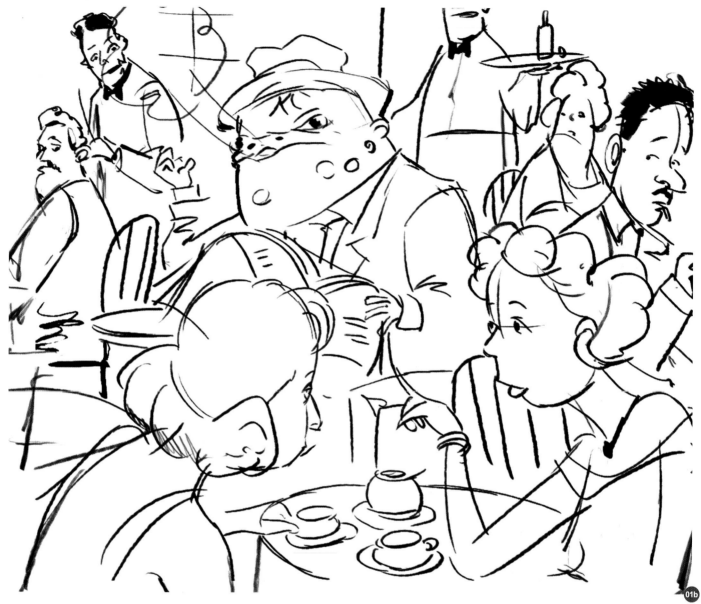

01b

everyday items and exaggerate them. In this tutorial I will explain the criteria behind drawing and painting in a cartoon style:

- Creating characters
- Colors
- Coloring and final detail

It's good to start with a couple of sketches to help establish creative direction (**Fig.01a – b**).

CHARACTER CREATION

Character creation is the most amusing stage, especially when you consider the associated professions, personalities, gender, habitat and many other variables that help define each character's design. Something that makes all the difference with cartoons is the possibility of overdoing features and defining each character's profile in a much more acute and precise way.

For this scene, I tried to think about the most suitable characters for a French café set in the early 1920s. I had to consider the appearance of the waiters and also the social status of the customers with regards to their professions, clothing etc. (**Fig.02**).

COLORS

For these kinds of drawings you often have to work with flat and saturated colors. Simple

 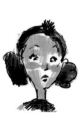 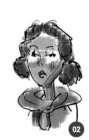

02

CARTOON

backgrounds help emphasize the characters making them more prominent. Commonly used colors are often more impressionistic, such as purple shadows and orange highlights. The best examples we can find are in Disney movies.

To add spacial depth in a composition it is a good idea to choose cooler background colors and warmer ones for the foreground figures (**Fig.03**).

If we want to further highlight a key figure it often proves useful to use a different palette to make it stand out from the rest. Everything, for example, can be painted with a warm palette of reds and a single element highlighted with cooler colors or vice versa (**Fig.04**).

Basic Colors

To start coloring I added a new layer set to Multiply and chose purple as the background

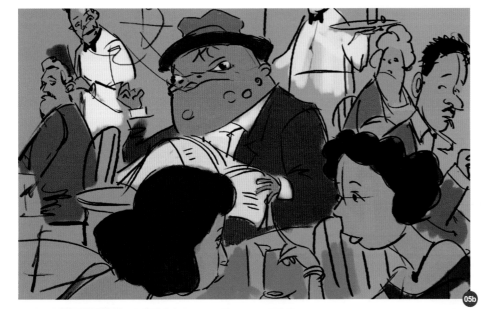

CONTRAST

CONTRAST

CONTRAST

color (**Fig.05a**). I then proceeded to color each element of the drawing, covering characters, background, objects etc (**Fig.05b**). As each one has a base color along with the background, we need to know in advance how the color composition will look. To make it more structured, one can paint a full color sketch and make an approximate composition as a guide (**Fig.05c**).

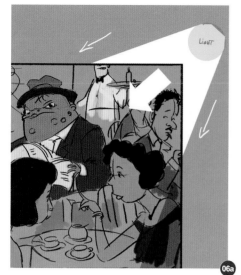

Once the base color was established the next step was to add a third layer set to Normal blending mode and start adding volume to each item. As always, before doing this I needed to be aware of the light source (**Fig.06a – b**). The toad is the main focal point and so needs to be highlighted to attract the viewer's attention.

VOLUMES

To define the volumes I applied drop shadows on the opposite side to the light. I think of each shape as a simple geometric element and this way it is easier to add illumination (**Fig.07**).

To give the scene a sense of realism, I placed a backlight in the shaded zone. Beware of incorporating too many highlights as this may interfere with the picture's clarity and how the viewer reads it. It is better to try and reserve a single spot for the highlight (**Fig.08a – c**).

Lighting is often the hardest part and can often make or break an image. A well lit

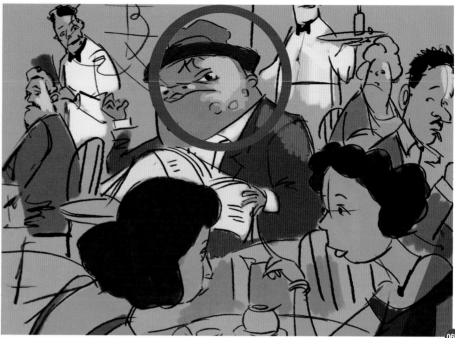

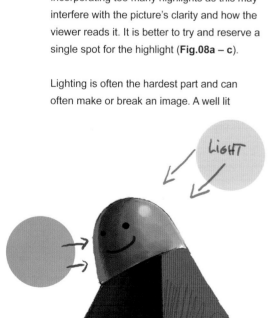

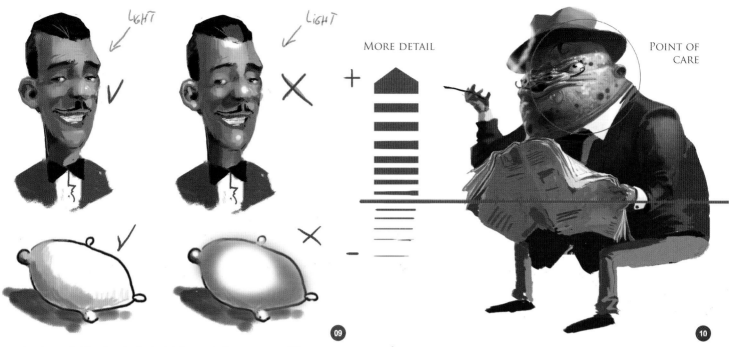

drawing sells! Another typical mistake made by amateurs is to place highlights in the centre of the drawing, thus creating a "pillow effect". Try to adhere to the direction of light and observe where it falls (**Fig.09**).

I use a simple brush, preferably without any texture so that I can achieve a finish, suited to the style of the drawing. I usually work with a default Round brush tip with around 70% opacity.

DETAIL

At this stage I stopped working on general items to focus more on particular subjects. We often see extremely detailed drawings

> THE VIEWER'S ATTENTION CAN BE GUIDED BY
> USING WHITE IN THOSE SECTIONS WHERE THE
> LIGHT IS AT ITS MOST INTENSE. IN THIS CASE IT
> WAS ON THE TOAD'S FACE

that don't have a clear focal point, and consequently make our heads spin, drowning us with too many elements. To finish an image economically and accurately without wasting time, it is crucial to only detail and polish those areas we wish the viewer to focus on. If details are restricted to key areas, the result will prove to be a success (**Fig.10**).

The viewer's attention can be guided by using white in those sections where the light is at its most intense. In this case it was on the toad's face and background characters. I therefore outlined the background elements to create some contrast and organize the elements (**Fig.11a**).

To help focus the light on the toad I placed two partially lit women in the foreground. This effectively simplified the composition and helped draw attention to the main character (**Fig.11b**).

In the following step-by-step example, it shows how I went about painting the toad's jacket (**Fig.12**).

Finally, to lend the drawing a photographic effect, I selected the background characters, gelled them into one layer and then blurred them. This provided a more detailed and realistic quality without too much extra effort (**Fig.13**).

CONCLUSION

As always my idea is that readers can understand the basic concepts of painting and can apply them to any type of tool. Most of my tutorials focus on color and composition, which is often a frequent failing. In my view these concepts make the difference and allow a work to stand out above others.

CARTOON

© IGNACIO BAZÁN LAZCANO

CARTOON

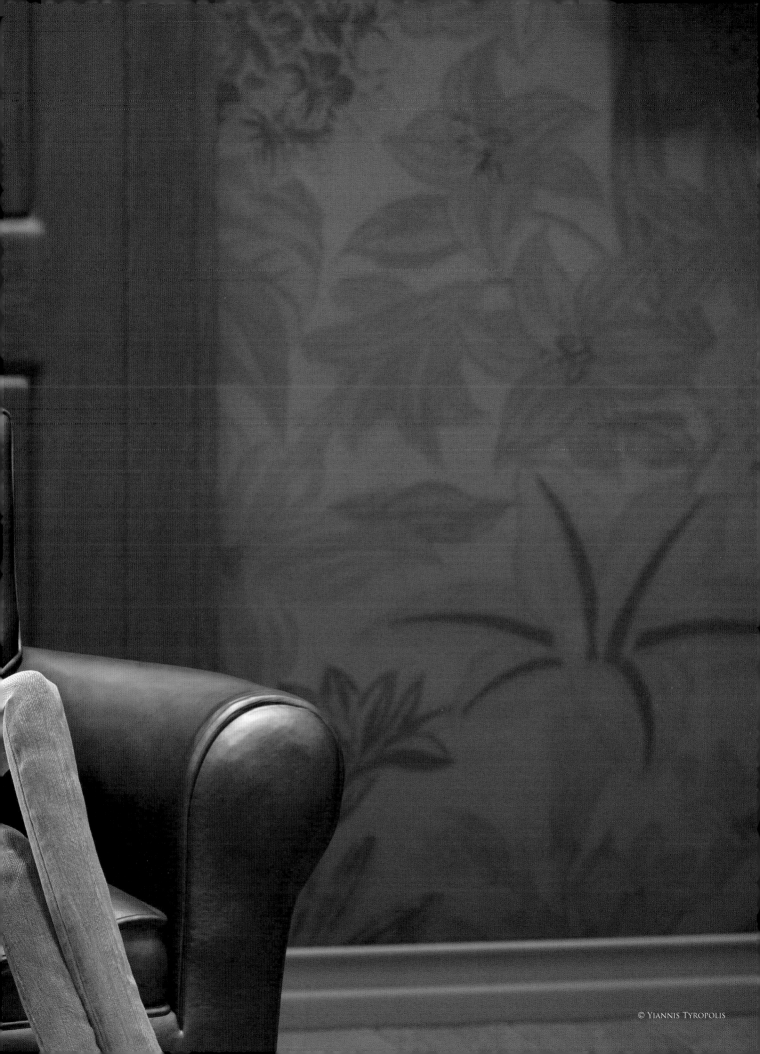

"AND HOW DOES THAT MAKE YOU FEEL, HMM?", DR THINOSE

BY YIANNIS TYROPOLIS

JOB TITLE: Freelance Artist
SOFTWARE USED: ZBrush 4 and Shake

INTRODUCTION

I had the pleasure of being a beta tester for Pixologic ZBrush 4 and the result was this cartoon character, Dr Thinose! In the past I had a dislike for the polished 3D renders that were very common in the pre-digital sculpting era. Even though I can now enjoy some perfect 3D renders, I'm always more interested in the less polished or "hand-made" look prevalent in stop motion, clay motion or 2D animation.

This was the case with Dr Thinose; my intention was to make him look like a "doll",

but with both realistic and stylized clothes. I didn't have any direct references, but was subconsciously influenced by stop motion filmmakers such as Tim Burton and Henry Selick, as well as live action movies by Woody Allen, Wes Anderson and the Cohen brothers.

WORKFLOW

The process was also unusual because I was testing ZBrush 4 and experimenting without a

specific goal. I can divide the process into three stages: the portrait, the full character and the full scene.

MODELING AND TEXTURING

My general workflow is to start with a character design (**Fig.01**), then sculpt freely in ZBrush using ZSpheres or similar boxy meshes as a base, and then modify the topology in ZBrush to finalize the details. Eventually I configure the

final animation topology before continuing to make blend shapes in ZBrush using the Layers feature. In this instance I didn't make a final animation topology, but instead made some blend shapes to experiment with his subtle expression.

I mainly used the ClayBuild, TrimDynamic, Rake, Slash2 and hPolish brushes. I also used ClipCurve to accurately cut into my sculptures. The head was most important and, indeed, the only part of the portrait phase. I started with a poly sphere, working very roughly and exploring the basic shapes outlined in my concept sketch. I finished with a variation of the Rake brush and some random brushes for noise (**Fig.02a – b**).

> ## RENDERING WAS THE MOST ELABORATE PART AS I WAS USING COMPLETELY NEW FEATURES IN ZBRUSH, FAR FROM MY USUAL MAYA AND MENTAL RAY ROUTINES

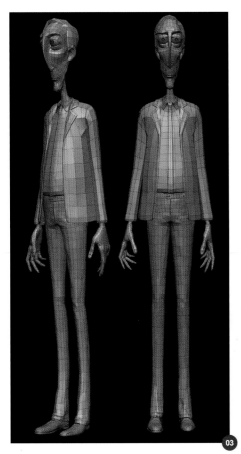

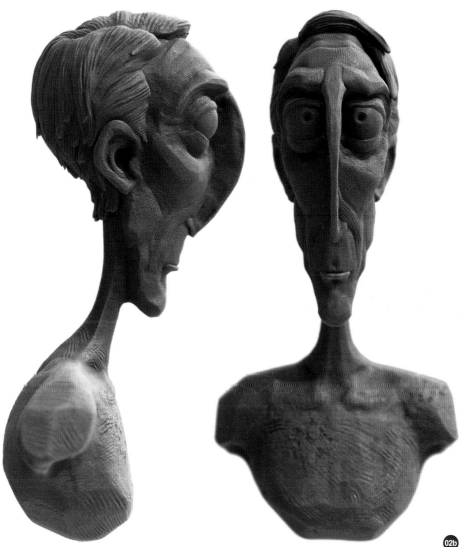

For the hair I started with a poly sphere to define the basic shape and continued with the Slash2 brush for the initial strand direction.

The hands began life as a ZSphere mesh. Using the ClipCurve, I quickly trimmed the planes to make rough shapes and then sculpted them into a simple gesture.

The jacket was made from simple ZSpheres and then retopologized early on without projecting any detail. With a skin thickness above zero in the Tool > Topology sub-palette, the jacket now had a volume. The shirt was treated similarly.

ShadowBox was used to start the shoes, which were then sculpted into the desired shape with ZSpheres being used to create details like the shoe laces. Mid-level detail was sculpted using the ClayBuildup and TrimDynamic brushes.

For the higher level detail on the clothes I used some manipulated photos to paint directly onto the polygons using the Light Box feature in ZBrush. Due to this technique there was no need for UVs. Using the Mask by Intensity tool (jeans, shirt, jacket, shoes) I picked up some details from the texture to further refine using the ClayBrush and Standard brushes (**Fig.03**).

RENDERING

Rendering was the most elaborate part as I was using completely new features in ZBrush, far from my usual Maya and mental ray routines. I experimented with methods similar to those I use in Maya. I almost always use multiple render passes that I compose in Apple Shake. Rendering in layers allows for flexibility and extensive choices in Maya, but in ZBrush it is a necessity. There is no way to make these renders with one pass. All the final renders were composited in the same way, but

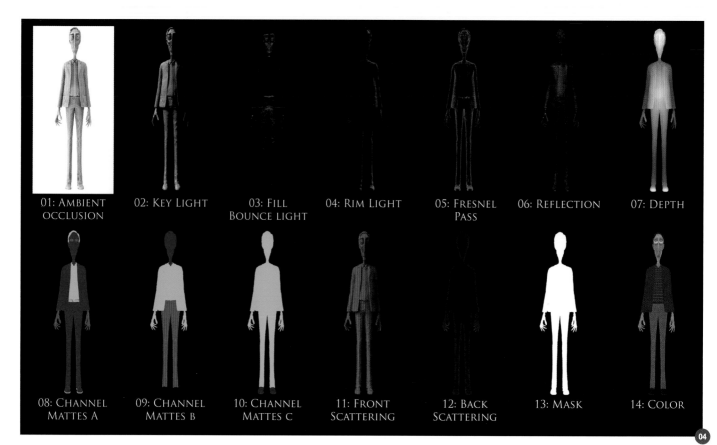

01: Ambient Occlusion

02: Key Light

03: Fill Bounce light

04: Rim Light

05: Fresnel Pass

06: Reflection

07: Depth

08: Channel Mattes A

09: Channel Mattes B

10: Channel Mattes C

11: Front Scattering

12: Back Scattering

13: Mask

14: Color

I'll use the un-posed character as an example. You can see the passes in **Fig.04**. With these layers you can make a "post-shader" for every material/element in the scene and have complete control over the intensity and hue of every light. I prefer to do complicated composites with Apple Shake, but you can achieve identical results with Photoshop. You can see how I would do the exact same compositing in Photoshop in **Fig.05**.

> **I WAS INFLUENCED BY ONE OF MY FAVORITE HBO SERIES, "IN TREATMENT", AND DECIDED HE WAS A PSYCHOTHERAPIST**

I used the new Timeline option to set keys for the camera so I could go back for an extra render or correction. With this workflow the only thing that you have to get right for a 3D render is the position of the lights and their shadow attributes. The results were different composites that represent semi-photorealistic materials like clay, jade and plasticine. I managed to achieve a plasticine/silicone type

material, with sub surface scattering properties apparent in skin, combined with the clothing materials.

THE FINAL SCENE

After completing the character I wondered if I could create and render a full scene inside ZBrush as a movie frame. It was very important

at this point to establish a background story. I could go on and on about Dr Thinose's peculiarities, anxieties and sensitivities, but I will refrain. Perhaps in the future I'll use him in a short so you can learn more about him. For now I can say that I was influenced by one of my favorite HBO series, *In Treatment*, and decided he was a psychotherapist.

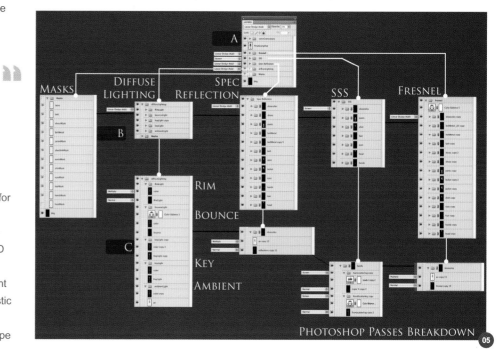

PHOTOSHOP PASSES BREAKDOWN

CARTOON

I created some props, manipulated some older ones to fit in and used my own photos for texturing and polypainting. I wanted to portray him in his office listening to a patient. Within the context of animation, I understand the importance of a pose. Before posing the actual character with Transpose, I experimented with a similarly proportioned character rig inside Maya, which was then imported into ZBrush to use as reference.

Even with a subtle expression I created different shapes for his facial features comparable with the way I animate, for example: left eyebrow up, jaw forward etc. Having these various shapes in a different layer means I can manipulate them in real-time akin to a blend shape slider in a major 3D suite.

I was initially going for a black and white low-key lighting. I placed a Key light above the character to highlight his shape and forehead, keeping most of the face in shadow. I liked how it worked in the initial tests, but as I was aiming for a full color piece, the Key to Fill ratio changed to a more balanced one (**Fig.06 – 08**). Having the lights separate meant I could adjust accordingly.

Compositing matched the previous examples with additional channel mattes for the props and backgrounds. The final frame was 4096 x 4096, cropped to a close 4:3 format. The final touches entailed some subtle photographic

RIM 06 · KEY 07 · BOUNCE 08

how does that make you feel?
09

effects such as Depth of Field, Vignetting, Chromatic Aberration, and Noise (**Fig.09**).

CONCLUSION

Creating this piece was a very interesting experience and I'm pleased with the result even if I can see ways to improve it. The limitations of ZBrush as a rendering application pushed me to be creative and think quite differently from normal, but as a result I believe I gained a valuable insight into material and light properties.

ARTIST PORTFOLIO

Minas
Katsouzidis

© David Smit

HIPPI-PIPPI-POCALYPSE
BY DAVID SMIT

JOB TITLE: Freelance Artist
SOFTWARE USED: Photoshop CS4

HIPPIE-PIPPIE-PARDON-ME?

This illustration is actually part of a bigger project, which is why in this project overview I'm not only going to talk about how I created this illustration, but also how the whole concept came about and why.

HIPPIE-PROJECT

Just like everybody I know who draws (and I mean everybody!), I've wanted to make my own project for a long time now. To create something where I cannot only pour out my heart, but which manifests my conceptual philosophical attitudes in something more than just a piece of color.

I wanted to create a sub-genre of speculative-fiction in which I could inject some personal and important values (in other words: what I

think is cool!). One of these conceptual pillars was that there was nothing wrong in the world. There was no big "good vs. evil" battle. No "bad guys trying to take over the world", no "orc warlords fighting steam-punk wizards with blue glowing swords"; just good people, doing their thing and aware that all their problems are small and luxurious. It's a world of peace, where self-development and self-expression are central. A world where diversity is encouraged, working is optional, money doesn't exist and all the basic needs are cared for by technology.

I'm not sure why it took me a while to connect all that to hippies, but eventually (whilst in the shower) I did! In that shower session I came up with the basic premise: imagine a future world where back in the 60s and 70is the Hippies had won!

That was somewhere in 2010, and since then I've been developing the whole project slowly and carefully into a more solid state.

MISE-EN-SCÈNE

After a period of sketching and trying to find a solid visual ground to build upon, I realized it was time to create a preliminary "Mise-en-scène". This comprised of an illustration featuring all the things I had thought of at that time: funky anatomy, colors, light, fashion design, motor homes, the organic community and the open atmosphere.

The great thing about doing a Mise-en-scène is that a lot becomes clear after doing it! I should probably make a new one now with more updated details!

INSPIRATION

Before I started this illustration I had already done quite a few sketches and preliminary work, most of which failed horribly of course. I misjudged the toughness of doing a project like this, where you pretty much have to design everything. I made some vehicle designs (this was before space was included in the project) (Fig.01).

I wanted people in this world to appear stylized, as well as realistic. I felt that funky anatomy along with vibrant colors and a semi-realistic lighting would suit the whole project best and provide a unique signature (**Fig.02 – 04**).

THE ILLUSTRATION

This illustration took a long time to finish and may actually have been one of the most difficult illustrations I've done so far. Even though I had a clear idea in my mind, it was difficult to keep going. If an illustration takes too long to finish,

your vision gets clouded and you can no longer see it for what it is. That's the point where you either have to keep pushing, hoping you won't mess it up, or let it rest for a while with the possibility that you will never return to it.

SKETCH

I made a really small sketch in my sketchbook, just to put my idea down quickly. I find doing this on paper with a simple pencil is the easiest way to keep me focused on the general idea without losing myself in details. Once I found

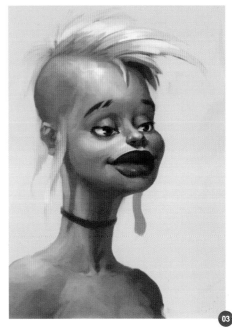

the angle and general idea, I recreated the thumbnail with some simple lines in Photoshop (**Fig.05**).

It's a crude setup, all about the placement of people, details and open spaces etc. It's not yet about the actual design of things. The red line is the general path I wanted the eye to follow as it's the area filled with detail and interest.

LINE ART

About a year ago I would have gone straight into painting after this stage, but nowadays I like creating a slightly more solid setup, with design and line art in place before continuing (**Fig.06**). Both approaches have their

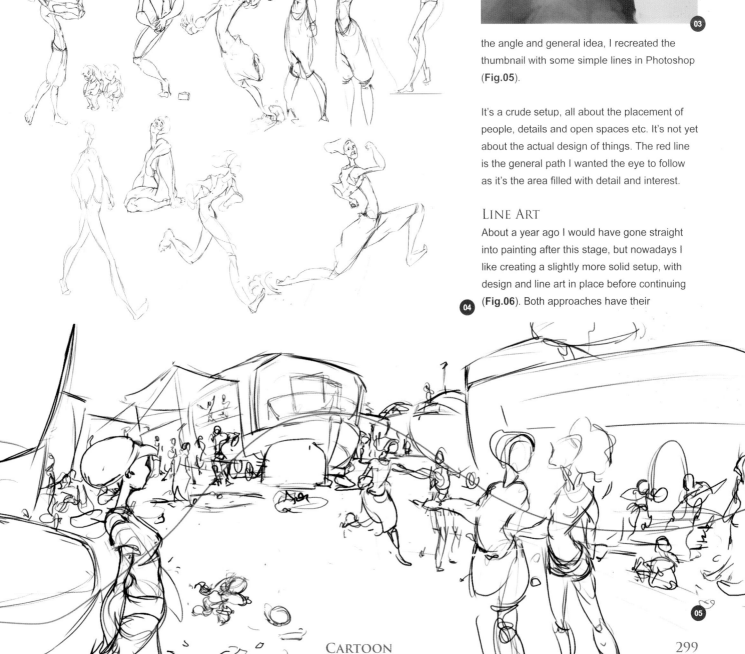

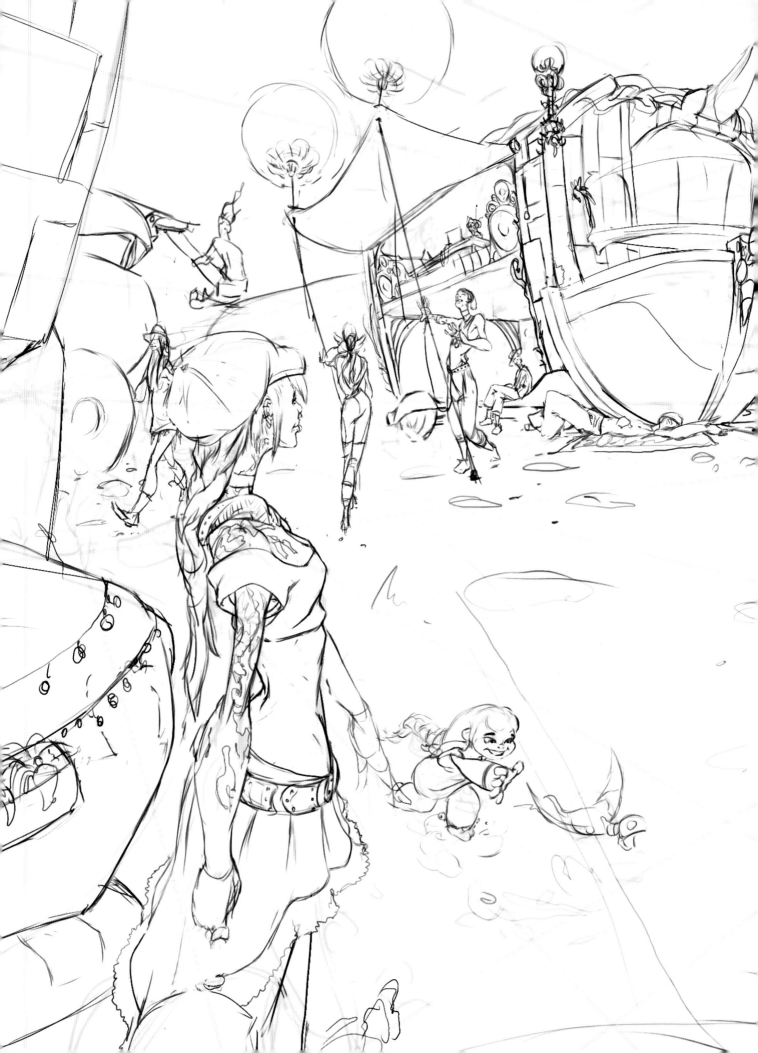

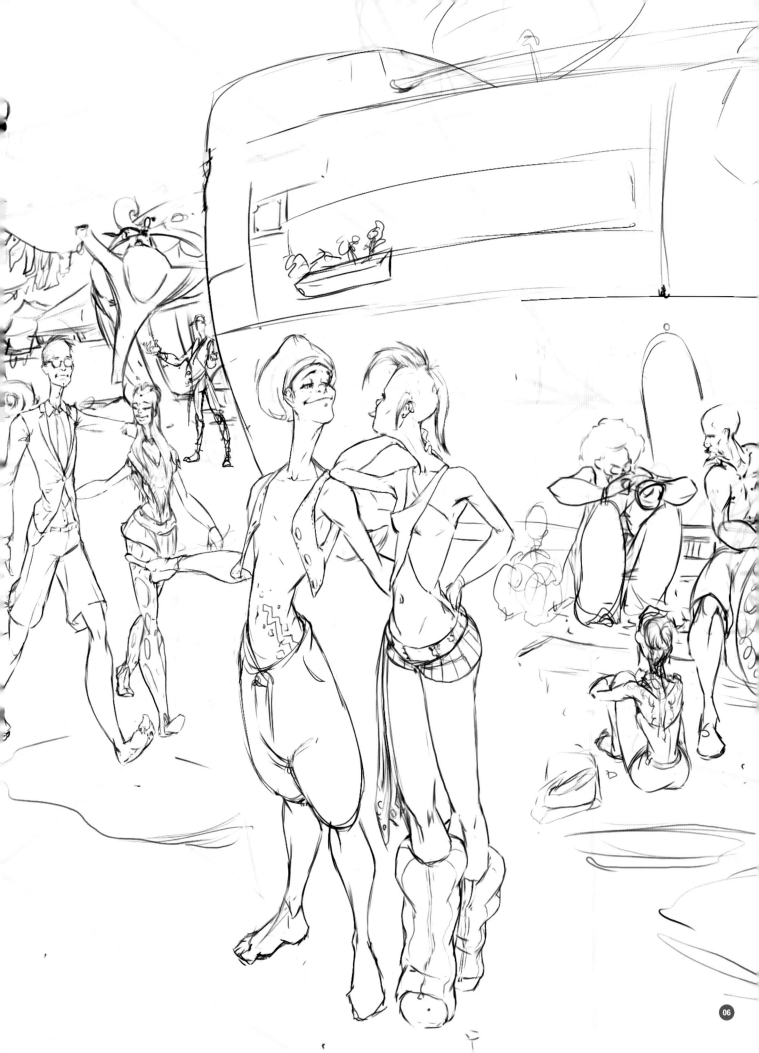

advantages, but I like using line-art because it reassures me that my designs are okay before continuing.

As you can see I've created a crude perspective setup. I don't like to spend too much time on perspective (I find it boring) and often tend to ignore formal perspective if it's a scene where things can be a bit funky and loose.

I'm not sure if I use perspective incorrectly because I want things to be funky and loose or if perhaps things tend to become funky and loose as a result of not using it correctly!

Basic Colors

This setup pretty much failed (**Fig.07**). Sometimes this works and sometimes it doesn't. When I was trying out a few rough colors and patterns, I couldn't convince myself of one thing or another. It's hard if things don't go as you want them. Usually it means that I want two or even three completely different

things from a single illustration (not a good sign). However I decided to push as it still provided a bit of structure to work with.

Start of the Actual Painting

One of the things I like to do when I actually start painting is to get at least one face or a part of the illustration about 90% complete (**Fig.08**). It keeps me interested and I can see where the rest is going if something is already at a certain point. It defines the light, color, brush work, detail and expression etc., supplying a guide for the rest of the painting.

Halfway Point

This part is the hardest. Here you can see how it will look, if things don't go wrong, but it also reveals all the things it hasn't become (**Fig.09**). With every brush stroke I put down during the painting process, alternative possibilities of what could have been disappear.

For me it's really important that I change my state of mind at this point. I really have to get my mind into a state where I no longer care

about time or other goals, and only about painting each little thing. I don't allow any doubt to creep in otherwise I know it will become a lost cause.

Finishing

Whereas the previous stage was the hardest, this is the part where it becomes fun again – the details! I'd been holding back with details and highlights until now, but it was time to release the brakes! At this point I went in and painted small flowers, car paint, flags, clothing hanging from ropes and tattoos etc. With every little detail, the image became exponentially better (**Fig.10**). Details really gave the illustration the life it needed. It's important to remember though that the details should serve the general composition, which is why I tried to add details that served the general path I wanted the eye to follow.

And that's it! The Mise-en-scène is done. I should start making a new one, and maybe I'll get the chance to go over that process in the next volume of this book!

BARRIO GUY
BY JOSE ALVES DA SILVA

JOB TITLE: Freelance Artist

SOFTWARE USED: 3ds Max, ZBrush, V-Ray and Photoshop

INTRODUCTION

In personal projects I enjoy keeping everything loose and avoid crystallizing things too soon. One of the most rewarding stages is concept development and I like to make it last. Sometimes the project drifts in a different direction from what I originally plan and *Barrio Guy*, who was supposed to be a stereotypical Latino male, ended up as a bald Caucasian bully because it better suited the visual style.

> " AFTER GENERATING AN ADAPTIVE SKIN I USED THE CLAY BRUSH TO ADD VOLUME AND SCULPT THE MUSCULAR MASS VERY LOOSELY, AS IF CLAY WAS BEING ADDED TO A WIRE SKELETON "

Variety of style is common in painting; however in digital sculpture it is a lot rarer. My intention with this piece was to explore the visual language of the sculpture, introducing

a graphic style associated with comics. Deep dark areas and visual contrast became a goal during the process and the way to achieve it was through hard edges and a stone cut look, producing hard transitions in light.

BLOCKING THE FORM

Without an initial sketch, ZBrush's ZSpheres were used to quickly explore form and proportion. ZSpheres give a very clear idea of volume and allow you to manipulate the structure like a skeleton by rotating around joints (**Fig.01**).

After generating an adaptive skin I used the Clay brush to add volume and sculpt the muscular mass very loosely, as if clay was

being added to a wire skeleton. "3D sketching" is the expression that best describes this part of the process. It does, however, come with a drawback: topology is awful and doesn't follow the surface's landmarks (**Fig.02**).

Retopologizing allows you to fix this. I used TopoGun to create a low poly mesh on top of the high resolution sketch, which would provide a good sculpting base with a good edge flow and a denser mesh in the places where finer detail was going to be added, such as the face and hands (**Fig.03**).

POSING AND DETAILING

In ZBrush I projected the high frequency details of the sketch onto the new topology. Using

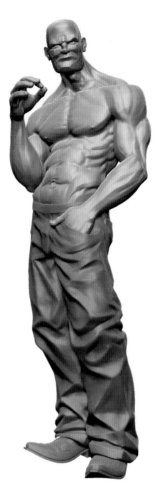
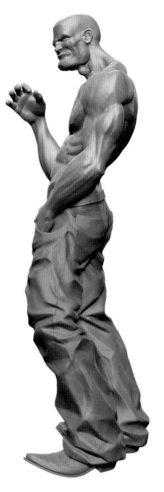
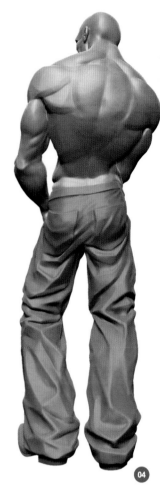

the Transpose tool, I posed the character to achieve a defiant stance. The posing was established before the detailing because the form depends on the pose; cloth will drape and muscles will bulge according to the body position.

The upper body muscles were detailed using the Clay Tubes brush, with strokes following the muscle structure and then incorporating the Smooth brush. Certain proportions were continuously rectified with the Move brush. Notice how the head got flatter and wider, the shoulders gained more mass and the neck got shorter and wider compared to the original sketch. To finish up, the mPolish brush was used to flatten the chin, forehead, pectorals and most of the muscle groups to achieve a chiseled look (**Fig.04**).

TEXTURES

I used the UV Master plugin to unfold the UVs. It is perhaps not the best tool for professional work, but it is fast and allows the creation of a continuous texture without too much trouble. To create the skin texture, I used ZBrush's

Polypaint to emulate the process used in silicone prosthetics. I painted in layers, using a noisy airbrush to achieve the natural color variation that we see in skin.

I started by painting what is happening under the skin, representing areas with cool and warm colors as well as the veins that can be seen underneath. Different yellow and orange tones were used to paint the surface randomly on top of a red color while varying the brush

size to achieve different scales of noise. The veins were painted in a dark blueish color in order to remain visible through the skin (**Fig.05**).

The outer skin was painted on top of the subdermal Polypaint, using low pressure and covering the base unevenly so that the structures underneath remained visible. This makes the skin look natural as the information below is felt by the viewer.

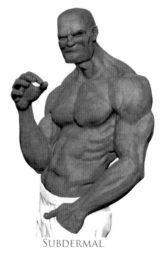

SUBDERMAL EPIDERMAL

The Polypaint was then saved as a texture. The textures for the trousers, boots and belt were created in Photoshop using overlaid dirt and scratches from photos to simulate wear and tear (**Fig.06**).

> ❝ THE CHARACTER IS
> LOCATED UNDER ❞
> A STREET LAMP, SO
> IT WAS NECESSARY
> THAT THE VIEWER
> FELT ITS PRESENCE,
> EVEN IF IT WAS NOT
> APPARENT

LIGHT SETUP

V-Ray was chosen as a render engine, not only because of its fabulous VRayFastSSS2 shader, which was used for the character's skin, but also for the predictability and speed of its light simulation.

In this image, the light needed to achieve three main goals:

- **Location**: The character is located under a street lamp, so it was necessary that the viewer felt its presence, even if it was not apparent.
- **Feeling**: I wanted the character to look menacing, so the absence of light was also important. Long shadows falling from above, combined with completely dark areas – especially on his face – help to convey a sense of disquiet.

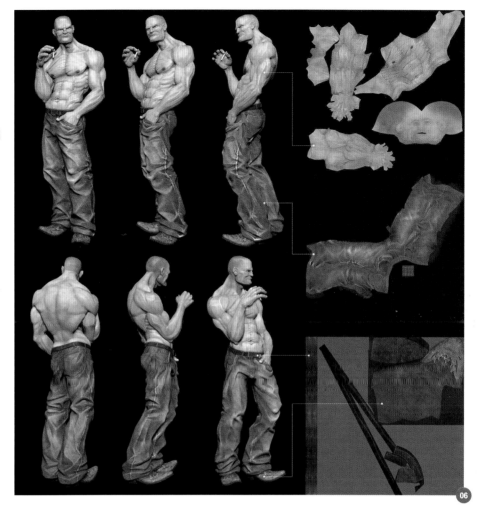

- **Style**: The character was intended to resemble a cartoon and so the color code should follow some of the language associated with comics, such as high contrast, dark areas, rim lights and bold colors.

The Key/Main light is the one coming from the street lamp. I created a white V-Ray light plane coming from above, but slightly to the right, in order to create long shadows and also to keep the left side of the character in darkness (**Fig.07**).

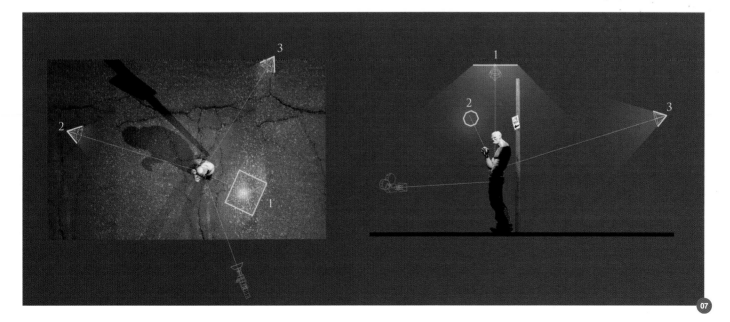

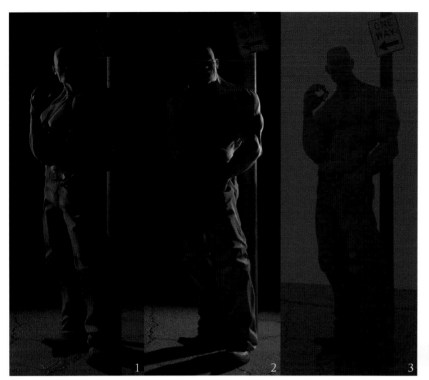

1 2 3 4 5 08

In **Fig.08**, I have created a turquoise green Spotlight coming from the left and hitting the surface at an angle to reveal the sculptural details and define the left side of the character's silhouette. I chose turquoise green so that the cool color contrasts with the warm colors of the character's skin revealed by the main white light. It was also positioned in order to leave an unlit area between the green light and the white light, to create a mysterious space (1).

> ❝ AS THE RIGHT SIDE WAS ALREADY ILLUMINATED, THE ADDITION OF THIS ORANGE LIGHT RESULTED IN A WARM, BRIGHT, WHITE RIM ❞

Another Rim light with a light orange color was created on the right to strengthen the character's silhouette. As the right side was already illuminated, the addition of this orange light resulted in a warm, bright, white rim (2).

As a Fill light, I opted to use an Environment light. In the V-Ray settings I set Environment to a very dark blue and the Global Illumination was turned on. This acted like a Dome light, with dark blue being cast from every direction.

The background was also set to dark blue, which allowed it to blend with the environment and also helped to create a contrast that emphasized the warmer palette of the character (3).

COMPOSITION

An Occlusion pass (4) and a Z-Depth pass (5) were also rendered. In Photoshop I placed the light passes on top of each other with the Linear Dodge blending mode allowing me to adjust each layer's intensity.

The Occlusion layer was applied using the Multiply blending mode to add some extra shadows and dirt. The Z-Depth layer was used to mask a layer with the background color in order to make the ground fade away into the distance.

To complete the image I made a slight color correction, increasing the contrast to ensure that the dark areas were deep black. Finally, the cigarette smoke was added in Photoshop (**Fig.09**).

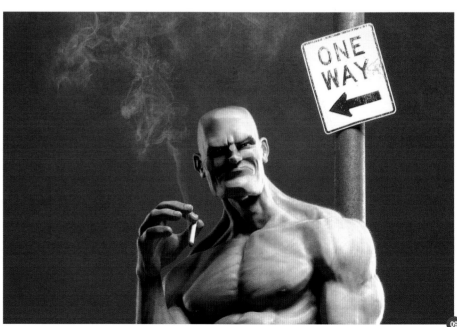

09

MY LITTLE FRIEND
BY GEDIMINAS PRANCKEVIČIUS

JOB TITLE: Concept Artist and Illustrator
SOFTWARE USED: Photoshop

INTRODUCTION

I noticed that 3DTotal was calling for entries for *Digital Art Masters: Volume 6* and when there is an opportunity like that you can't miss it. I instantly decided to create a piece dedicated to this book as I love books and especially the *Digital Art Masters* series. An honorable place is reserved for *Digital Art Masters* on my bookshelf.

After thinking over the ideas that tend to come into my mind from time to time during precious

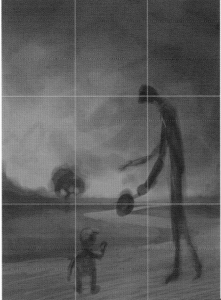

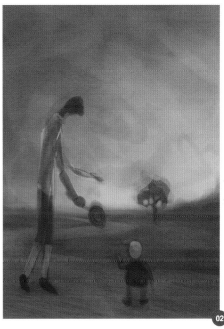

> " I FELT AS THOUGH A FRESH SPRING BREEZE WAS BLOWING IN, REQUESTING A CHANGE OF DIRECTION DIFFERENT FROM MY ORIGINAL EXPECTATIONS "

moments of inspiration, I settled on one that I felt comfortable with. Unfortunately a large number of these ideas remain as only ideas; you can always find some excuse or a more important job to do. At that particular time this book helped me to revive an old idea. Thank goodness there are such things as competitions and painting exhibitions which will always inspire you to create something new. It is always a pleasure and a huge honor to appear side-by-side with my favorite artists.

WORKFLOW

My first idea was to paint an old guy, giving something to a little kid. The location would be somewhere miserable; a sad place near a huge old forest or something similar. I imagined something resembling the style of the old Flemish Masters; specifically Pieter Bruegel whose work blows my mind.

When working on the composition I used the simple Rule of Thirds (**Fig.01**). The rule

states that an image should be divided into nine equal parts by two sets of equally-spaced horizontal and vertical lines, and that important compositional elements should be placed along these lines or their intersections. Those subscribing to the technique claim that aligning a subject with these points creates more tension, energy and interest in the composition, as opposed to placing the focus in the centre.

For a more complete picture I applied some colors, using the Overlay blending mode, over the black and white sketch (**Fig.02**). A basic brush was used for this with the Hardness set at 100%, Spacing at 10% and some Shape Dynamics and Texture enabled (**Fig.03**). Maybe everything would have gone according a plan if it weren't for my keenness to experiment. During the process I couldn't resist experimenting with various brushes that I'd made myself or downloaded from the net courtesy of other Photoshop users (**Fig.04**). Painting a gloomy sky was neither a visual or

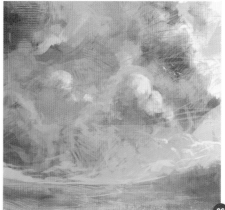

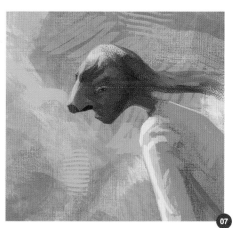

emotional success (**Fig.05**) and I therefore brightened everything. The palette increased rapidly and as a result I lost control of the drawing, which ironically started to control me (**Fig.06**). Brushes and colors repeatedly spoke to me in beautiful phrases, beckoning me to use them over again. I felt as though a fresh spring breeze was blowing in, requesting a change of direction different from my original expectations. I guess all of this is somehow reflected in the work and is left to the viewer's interpretation. If I had to describe this picture in one sentence I would say it is about having the opportunity to choose.

> **EVERYTHING DEPENDS ON YOU AND THE CHOICES YOU MAKE. IF YOU KNOW WHAT YOU WANT, WHAT ARE YOU WAITING FOR?**

At one point I had the main character looking at me (**Fig.07 – 08**) as if wanting to say something, but this later changed.

CONCLUSION

You and only you alone are the master of your body and mind. Everything depends on you and the choices you make. If you know what you want, what are you waiting for? If you have an idea, don't hesitate – go ahead and translate it into reality. When an idea is born it doesn't only exist in your head, but in a global world too where anyone in the world can appreciate it. There is tons of great advice on composition, perspective, color and lighting… let your heart decide and don't forget to use your mind and body.

CARTOON

© Gediminas Pranckevičius

The 2011 Digital Art Masters

ALEKSANDAR JOVANOVIC
jovanovic.cg@gmail.com
http://www.inbitwin.com

DAVID SMIT
david@davidsmit.com
http://www.davidsmit.com

IGNACIO BAZÁN LAZCANO
i.bazanlazcano@gmail.com
http://www.neisbeis.deviantart.com

ALEKSANDR NIKONOV
speedbrush@gmail.com
http://niconoff.cghub.com

DENNIS ALLAIN
dennis@dennisallain.com
http://www.dennisallain.com

IRVIN RODRIGUEZ
hola@irvin-rodriguez.com
http://irvin-rodriguez.com

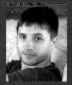

ANDREI PERVUKHIN
earfirst@gmail.com
http://pervandr.deviantart.com

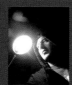

EDUARDO PEÑA A.K.A CHINO-RINO
caareka20@hotmail.com
http://chino-rino2.blogspot.com

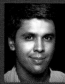

JAMSHED JURABAEV
jama_art@tag.tj
http://jamajurabaev.deviantart.com

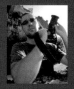

ANDRZEJ SYKUT
eltazaar@gmail.com
http://azazel.carbonmade.com

ERIC DURANTE
etdurante@gmail.com
http://www.eric3dmesh.com

JASON SEILER
seilerillustration@gmail.com
http://www.jasonseiler.com

ARSENIY KORABLEV
3dars@mail.ru
http://arsdraw.deviantart.com

EUGENIO GARCÍA VILLARREAL
eugenio@d10studio.com.mx
http://www.d10studio.com.mx

JESSE VAN DIJK
jesse@jessevandijk.net
http://www.jessevandijk.net

BLAZ PORENTA
blaz.porenta@gmail.com
http://blazporenta.blogspot.com

FABRICIO MORAES
fab.moraes@hotmail.com
http://fabmoraes.cgsociety.org

JIAN XU
jian.xu@hotmail.com

BRANKO BISTROVIC
bisvic@gmail.com
http://bisvic.blogspot.com

FACUNDO DIAZ
facu_kw@hotmail.com
http://www.fdportfolio.com.ar

JOSE ALVES DA SILVA
joalvessilva@netcabo.pt
http://www.artofjose.com

DANIIL V. ALIKOV
info@alikov.net
http://www.alikov.net

FEDERICO SCARBINI
fede@federicoscarbini.com
http://www.federicoscarbini.com

LOÏC e338 ZIMMERMANN
loiczimmermann@gmail.com
http://www.e338.com

DAVID HUANG
david@cliphitheryon.com
http://www.cliphitheryon.com

GEDIMINAS PRANCKEVIČIUS
gediminaspr@gmail.com
http://www.gedomenas.com

LUC BÉGIN
equador3d@yahoo.com
http://www.lucbegin.com

THE 2011 DIGITAL ART MASTERS

MARCIN
JAKUBOWSKI
marcin@balloontree.com

http://www.balloontree.com/

PIOTR
TATAR
czarny323@gmail.com

http://www.reflectvision.pl

TOMASZ
JEDRUSZEK
info@morano.pl

http://www.morano.pl

MAREK
DENKO
marek.denko@gmail.com

http://www.marekdenko.net

RAFAEL
GRASSETTI
rafagrassetti@gmail.com

http://grassettiart.com

TOMASZ
STRZALKOWSKI
t.strzalkowski@space.home.pl

http://tomstrzal.cgsociety.org/gallery

MARTA
NAEL
martanael@gmail.com

http://martanael.daportfolio.com

REYNAN
SANCHEZ
reynansanchez_artiz@yahoo.com

http://artizako.cgsociety.org

TONI
BRATINCEVIC
toni@interstation3d.com

http://www.interstation3d.com

MARTHIN
AGUSTA
marthin84@yahoo.com

http://threedsquid.cgsociety.org

RUAN
JIA
ruan_jia@163.com

http://www.ruanjia.com

VIKTOR
FRETYÁN
radicjoe@yahoo.com

http://radicjoe.cgsociety.org

MATEUSZ
OZMINSKI
artozi87@gmail.com

http://artozi.deviantart.com

SERGE
BIRAULT
serge.birault@hotmail.fr

http://www.sergebirault.fr

YIANNIS
TYROPOLIS
yiannistyropolis@hotmail.com

http://trungpad.cgsociety.org/gallery

MENY
HILSENRAD
meny@studio-aiko.com

http://www.studio-aiko.com

SEUNG
JIN WOO
moonworker1@gmail.com

http://www.moonworker.net

MICHAL
LISOWSKI
maykmail@tlen.pl

http://michallisowski.com

STEFAN
MORRELL
stefan_morrell@hotmail.com

http://stefan-morrell.com

NEIL
MACCORMACK
Neil@bearfootfilms.com

http://www.bearfootfilms.com

TITOUAN
OLIVE
digitalia3d@gmail.com

http://digitalia3d.teria.fr/

PIERRE-ETIENNE
TRAVERS
petravers@hotmail.fr

http://pethings.blogspot.com

TOMÁŠ
MÜLLER
temujin@temujin.cz

http://www.temujin.cz

INDEX

DIGITAL PAINTING
techniques

DIGITAL PAINTING
techniques

VOLUME 2

> "I have never seen one book that has such a diverse collection of inspiring techniques and subject matter, generously shared by incredibly talented artists."

Dylan Cole | Senior Matte Painter: *The Lord of the Rings: The Return of the King*, *Superman Returns*; Concept Artist: *Alice in Wonderland*, *The Clash of the Titans*; Concept Art Director: *Avatar*

Digital Painting Techniques: Volume 2 provides another thrilling opportunity to learn from some of the most accomplished and skilled digital artists from around the world, including top industry professionals Jason Seiler, Jesse Van Dijk, Chee Ming Wong and Carlos Cabrera. The second volume in this up-and-coming series covers a wide variety of themes and topics and provides in-depth tutorials to aid and inspire any digital artist, whether beginner or veteran. Custom brushes, speed painting, characters and fantasy are just a few of the subjects covered in the chapters of this must-have book, with each tutorial providing a logical and professional approach to creating a digital painting of the highest standard. With additional features including a gallery of stunning artwork and links to free downloadable content, *Digital Painting Techniques: Volume 2* contains a wealth of inspiration and advice, making it a worthy addition to any artist's bookshelf.

VOLUME 1

Digital Painting Techniques: Volume 1 offers a comprehensive cross-section of tips and techniques from some of the most accomplished digital artists in the industry today. A wide variety of popular subjects are covered from aliens, creatures and humans through to robots, cityscapes and natural environments. The styles covered include speed painting, offering a more traditional impressionistic style and setting up custom brushes.

Softback - 21.6 x 27.9 cm | 288 Premium full color pages | ISBN: 978-0-240-52174-9

3DTOTAL.COM
Visit 3DTotal.com to read more about our *Digital Painting Techniques* book series